THE **Chicago Tribune** BOOK OF THE

CHICAGO BULLS

THE **Chicago Tribune** BOOK OF THE

CHICAGO BULLS

A DECADE-BY-DECADE HISTORY

MIDWAY

AN AGATE IMPRINT

CHICAGO

Chicago Tribune
R. Bruce Dold, Publisher & Editor-in-Chief
Peter Kendall, Managing Editor
Colin McMahon, Associate Editor
George Papajohn, Investigations Editor
Margaret Holt, Standards Editor
John P. McCormick, Editorial Page Editor
Marie C. Dillon, Deputy Editorial Page Editor
Marcia Lythcott, Associate Editor, Commentary
Associate Managing Editors
 Amy Carr, Features
 Robin Daughtridge, Photography
 Mark Jacob, Metro
 Cristi Kempf, Editing & Presentation
 Joe Knowles, Sports
 Mary Ellen Podmolik, Business

Printed in China

The Chicago Tribune Book of the Chicago Bulls
ISBN-13: 978-1-57284-202-1
ISBN-10: 1-57284-202-4
First printing: November, 2016

Library of Congress Cataloging-in-Publication Data has been applied for.

10 9 8 7 6 5 4 3 2 1 16 17 18 19 20

Midway is an imprint of Agate Publishing. Agate books are available in bulk at discount prices.
agatepublishing.com

Contents

Michael Jordan takes flight during the 1988 NBA All-Star Game at Chicago Stadium.

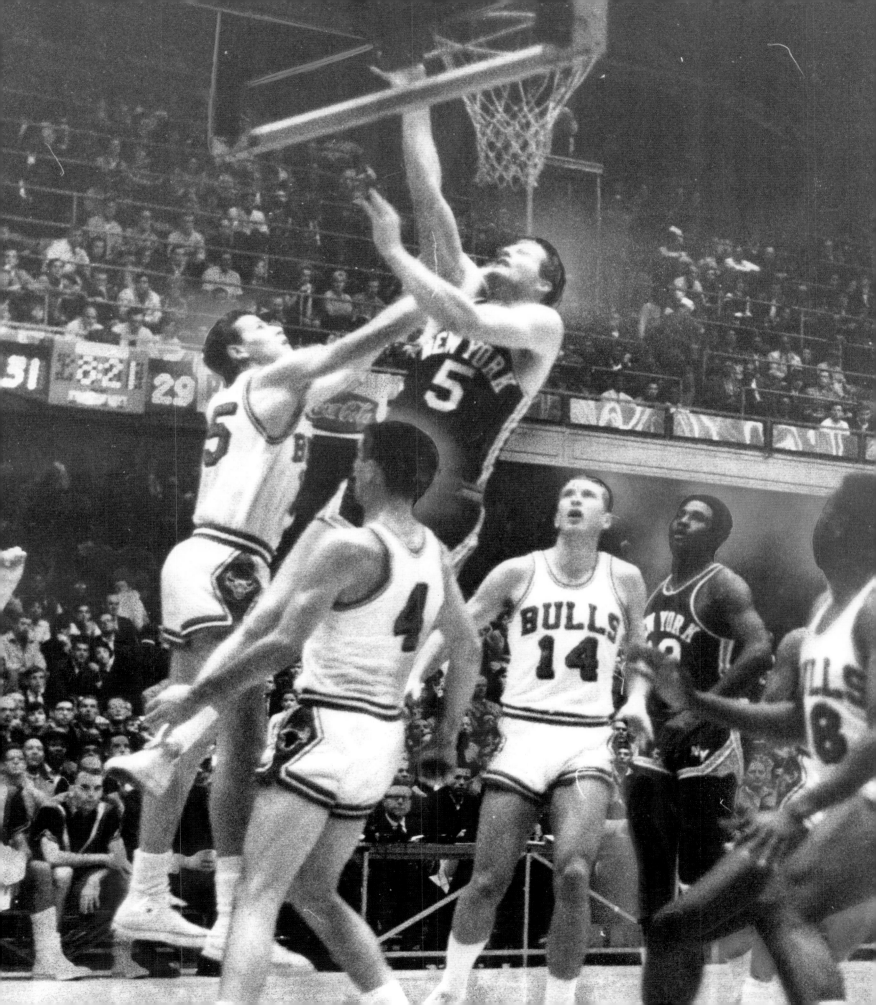

Introduction

'JUST GIVE US TIME'

By Paul Sullivan, Mike Conklin, Robert Markus, Bob Sakamoto

When Johnny "Red" Kerr was head coach of the Bulls during their 1966–67 NBA debut season, he never left home without it.

A popular credit card?

No, a pocketful of dimes.

"Those are the days that we'd always have coins in our pockets before going to games," Kerr said, "so we could call the press afterwards.

"I'd dial up the papers' sports desks and say something like: 'Hi, this is John Kerr, coach of the Bulls. The Bulls won tonight, 110-106, and Bob Boozer was our leading scorer with 26 points.'

"The desk guy would say: 'Boozer? How 'ya spell that?' I'd say: 'B-o-o-z-e-r,' and then the operator would jump in and say, 'Please deposit another dime.'"

Such were the trials and tribulations of selling a product that was initially as popular in Chicago as slush. Kerr, Boozer and the baby Bulls tried to succeed in a town where previous pro basketball teams, the Stags, Packers and Zephyrs, had failed miserably.

Fifty years, six NBA championships and hundreds of sold-out games later, the Bulls are an unqualified success— something few would have predicted back in 1966.

"We built a ballclub and tried every conceivable promotion tried by man," said Pat Williams, who was perhaps the most instrumental figure in the Bulls' early success, after taking over as general manager in 1969 at the age of 29. "Our job was to, as quickly as possible, expose the sport to Chicagoans.

Most of them weren't interested. We had to give them a show every night."

It didn't always work. One night, only 594 came out to see the Bulls lose to Seattle.

"The commissioner wrote a very searing letter to (original owner) Dick Klein," said Bulls publicist Ben Bentley. "It said, 'Don't give out any figures like that.'"

The games were played that first Bulls' season in the dusty International Amphitheatre near the stockyards on the South Side. Public address announcer Don Harris' introduction of Boozer (he pronounced it "B-o-o-o-o-o-zer") was about all that resembled the sideshows accompanying today's games in the United Center.

Chicago won its first regular-season opener on the road, 104-97 in St. Louis. The Bulls returned to the Amphitheatre to beat San Francisco 119-116 in front of an estimated 4,200 fans in the home opener. This was followed by a third straight victory in which Chicago beat the defending Western Division champion Los Angeles Lakers 134-124.

"I was sitting there with a 3-0 record and I liked coaching a whole lot," recalled Kerr.

The Bulls eventually cooled off on the floor, but still made the playoffs with a 33-48 record. Kerr, who had played high school basketball just a few blocks from the Amphitheatre at Tilden Tech before starring at Illinois and in the NBA, was named Coach of the Year in his rookie season on the bench.

The club averaged a respectable (for then) 4,772 fans per game. There was a WGN-TV contract.

Opposite: Keith Erickson (left) contests a shot by the Knicks' Dick Van Arsdale during New York's 124-105 victory over the Bulls at the Amphitheatre on Oct. 23, 1966.

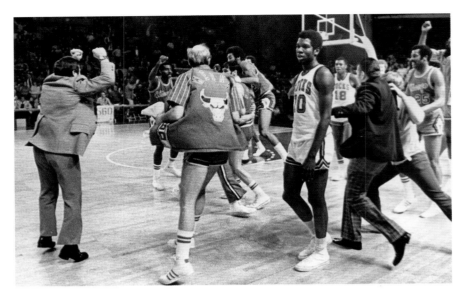

Dick Motta (left) exults amidst a group of jubilant Bulls—and a dejected Bob Dandridge of the Bucks—after his team's 92-90 victory in Milwaukee on Feb. 15, 1974.

Could it get any better for an expansion franchise? No. It got worse.

In less than a year after that first season, the cash-strapped franchise was in disarray. If it was possible to peak in your first year, the Bulls had done just that.

Both the team's record and crowds dwindled heading into the 1970s and, to some, Chicago seemed on its way to a fourth pro basketball franchise failing to make it here.

Would it be R.I.P. Stags ('46–'50), Packers ('62), Zephyrs ('63) and Bulls?

No. The franchise would be saved by the unlikely Dick Motta, who replaced Kerr as coach for the 1968–69 season. Klein had plucked Motta from Weber State, a low-profile school in Utah. The jump was immense, but Motta learned quickly how to survive in big-time basketball.

From 1971 to 1975, Motta's Bulls compiled a 260-150 record in the regular season. They stretched the Lakers to a full seven-game series in the second round of the '71 playoffs before being eliminated. They were on their way.

The crowds got bigger. From a franchise-low of 3,790 per game in their third season, the Bulls were averaging 10,000 per contest in the first half of the 1970s with frequent sellouts for pivotal games.

The peak continued to build to '75. With the hourglass running low for Chicago's roster and Motta's fuse getting shorter, the club topped Kansas City in six games in the first playoff round that season before facing Golden State in the conference finals.

Tickets to the Stadium games never were hotter. The Bulls took a 2-1 series lead on the Warriors. They went up 3-2 before dropping the final two games, including one on their own floor.

Golden State went on to sweep the title in four games from the Washington Bullets. The next season, the Bulls' record was 24-58—at the time, a low-water mark for the franchise—and Motta was gone.

There would be seven different coaches, dozens of new players, and only one more playoff appearance before the arrival of a guard from the University of North Carolina who would change the course of the franchise and take it to new and unimaginable heights.

According to the prevailing wisdom at the time, to win big in the NBA, you had to have a big man. Six weeks after the Bulls made Michael Jordan the third choice in the 1984 draft, that rule was being rewritten.

"In two or three years," said George Raveling, who was then assistant coach of the U.S. Olympic basketball team, "there's going to be a major controversy in the NBA. It will concern how Michael Jordan was allowed to be drafted third instead of second or first."

The two men drafted ahead of him, of course, were big men. The Houston Rockets, drafting first, chose Hakeem Olajuwon, a powerful 7-foot center and eventual Hall-of-Famer. Next up, Portland picked Sam Bowie, a 7-1 center who had come back from a broken leg to help take Kentucky to the Final Four.

So Jordan fell into the Bulls' lap. Right up until draft day, Bulls general manager Rod Thorn had explored trade possibilities, but he decided to keep the pick. With a crowd of Bulls fans in the draft headquarters at the Hilton hotel chanting "Jordan, Jordan," Thorn gave the throng what it wanted.

He also gave Chicago the most electrifying performer in sports.

The Bulls had not made the playoffs in the three years before Jordan arrived. They did not fail to make them again until Jordan left. They had not played to a single sellout crowd, home or away, in two seasons before he came. Within two years they were selling out regularly.

And, of course, they never had advanced to the NBA Finals. The little miracles Jordan performed almost immediately. The major miracle—the first of six NBA titles—took him seven years.

He didn't do it alone and he knew all along he could not. He said as much from the day he showed up to sign his contract, the largest in the history of the team.

But the truth is, he could do such wondrous things with a basketball in his hands that it sometimes looked as if he could carry a team by himself.

Jordan lifted the Bulls to that rare place occupied by the greatest teams in the history of sports. The Bulls of the 1990s inspired a generation of fans and left an indelible imprint on the game that surely has

The history of the Bulls does not begin with Michael Jordan's arrival in Chicago nor does it end with his departure. From their debut season in 1966 to the current day, the Bulls have been making headlines and drawing crowds.

This book—the second in a series of Chicago Tribune books documenting Chicago's love affair with its major sports teams—traces the growth of the Bulls from a seat-of-the-pants operation struggling to pay its bills to a sports and marketing empire now valued in the billions.

In the franchise's earliest days, the Bulls' first head coach, Johnny "Red" Kerr, traveled with a pocketful of dimes so he could call the various news outlets—many of whom weren't regularly covering the fledgling NBA team—from the nearest pay phone to give them a post-game report. Today, the Bulls are a brand known around the world. Their impact on modern-day sports, and on popular culture, is immense and indelible.

The Tribune has been with the Bulls from the beginning, following the team as it moved from its humble South Side home court at the old International Amphitheatre, to the glory days at the boisterous Chicago Stadium and later at the sparkling United Center, sometimes called the House That Jordan Built.

Wrapped around the Bulls' six championships are periods of unexpected and sometimes unprecedented success, tempered by times of turmoil and drama. This is the franchise that defied expectations by making the playoffs as a first-year expansion team, and the same franchise that defied logic by repeatedly dismissing accomplished coaches and replacing them with unproven no-names.

Much like their namesake, and much like the city they call home, the Bulls aren't known for subtlety. Their grandiose pre-game introductions—you know, with the mirror-ball light show, the other-worldly theme music and the hyper-dramatic "And now"—started well before the team had won a single championship. Pretentious? Maybe. Presumptuous? For sure. Effective? Let's just say that before long, couples were using the "Bulls music" as the walk-up music for their wedding parties.

Whatever the Bulls do, they do big. Case in point: In a span of seven seasons, the Bulls won 60 or more games three years in a row (including a then-record 72 in 1995–96) and then lost 60 or more games three years in a row. That's a ride wild enough to give a rodeo cowboy whiplash.

This book showcases the work of the Tribune writers, photographers and editors who chronicled that journey—a journey that took the Bulls from a small corner in the Sports section to the front page of the paper. Special thanks goes to photo editors Michael Zajakowski and Marianne Mather and director of photography Robin Daughtridge for their work combing through the Tribune's vast archives and making the tough decisions on what to include and what to leave out. We're also grateful for the contributions of Bulls beat reporter K.C. Johnson, who wrote the chapter introductions, and the guidance and coordination of development editor Amy Carr.

Finally, at Agate Midway, this book's publisher, I'd like to thank Morgan Krehbiel, who in addition to spearheading the complex effort of coordinating its production, also created the design and layout of this handsome book. And along the way, Agate publisher Doug Seibold, sales and marketing manager Zach Rudin, and editorial assistant Colton Gigot—impassioned Bulls fans all—made a few useful suggestions regarding the book's content, for which thanks.

surpassed even the wildest dreams of the franchise's founders.

In Game 1 of the best-of-five playoff series against Boston in 1986, Jordan, playing on a still-healing broken left foot, scored 49 points in a 19-point loss. In Game 2, he set an NBA playoff record with 63 points, this time in a four-point, double-overtime loss.

So anguished was Jordan after the finale—a 122-104 defeat in Game 3—that he sounded more like a weary veteran than a player just completing his second year.

"It could get very frustrating," he said, "if I have to go through stages year after year where everyone is looking to you to drag along or to carry the team. That shouldn't be the case."

Yet asked if he one day might consider leaving Chicago and playing for one of the league's elite teams, Jordan was emphatic.

"No," he said, "we're going to hit it. Just give us time."

They hit it out of the park and gave Chicago the time of its life.

The United Center stands as a testament to the spectacular growth of the Bulls, now one of the league's marquee franchises. The Bulls are no longer Chicago's "other" professional sports team, no longer a fledgling trying to gain purchase on uncertain ground.

They are Chicago's modern dynasty, the gold standard by which all of the city's "other" teams will forever be judged.

This is their story.

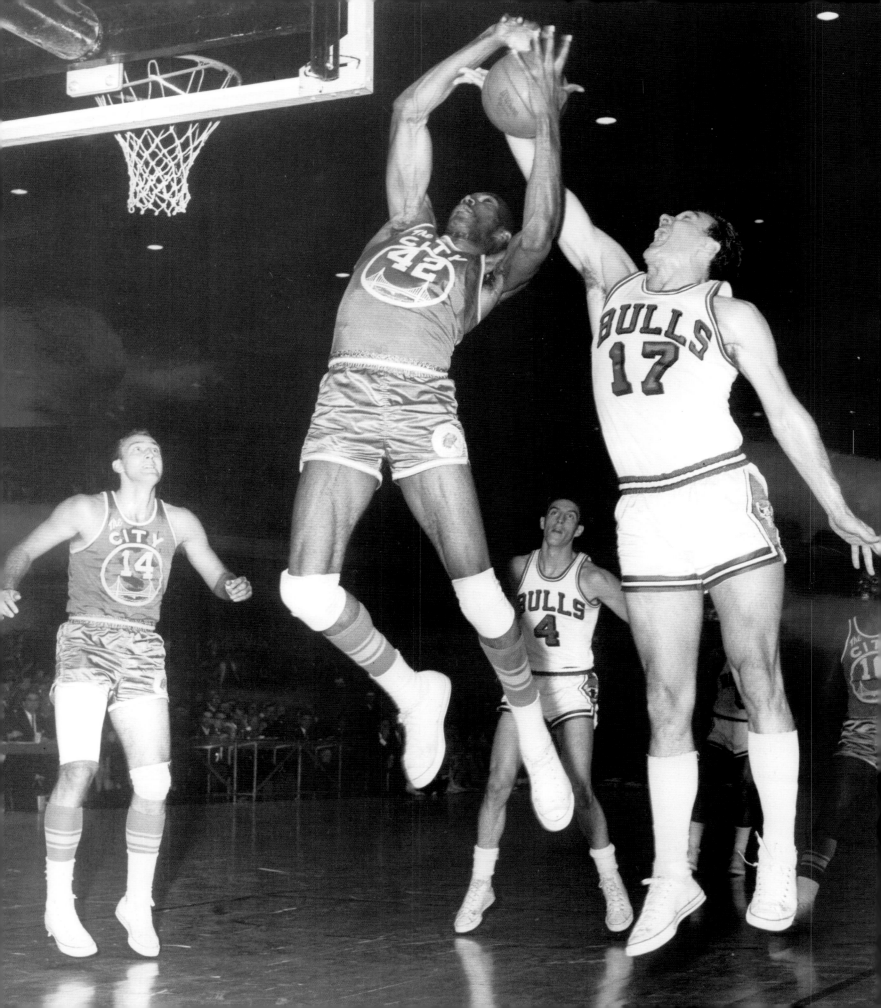

THE
1960s
BIRTH OF THE BULLS

Local businessman Dick Klein finally secured the NBA's 10th franchise for the 1966–67 season after uniting enough investors to meet the buy-in price of a skeptical league, which was mindful of previous failed attempts to start pro basketball in Chicago. These Bulls were different. Led by coach Johnny "Red" Kerr and stocked with solid expansion draft talent that included Bob Boozer and Jerry Sloan, the Bulls remain the only expansion team to make the playoffs, going 33-48. A shrewd trade landed Guy Rodgers, who led the league in assists. The Bulls played that first season at the International Amphitheatre. But symbolic of the long odds the franchise overcame to succeed, the lone home playoff game was staged at the Chicago Coliseum because the Amphitheatre made more money on trade shows. Sloan and Rodgers were All-Stars. Kerr won Coach of the Year honors. The second season brought another playoff berth and more change. Rodgers got traded for Flynn Robinson, whose 41 points gave them their first playoff victory in a first-round exit to the Lakers. Surprisingly, Kerr got forced out and resigned. Relatively unknown Dick Motta got hired from college's Weber State. And the seeds of success for the next decade were sown further with the acquisition of Bob Love for Robinson and Chet Walker. New general manager Pat Williams acquired the latter.

Opposite: Len Chappell (right) battles San Francisco's Nate Thurmond for a rebound in the Bulls' first home game, a 119-116 victory over the Warriors at the Amphitheatre on Oct. 18, 1966.

1960s HIGHLIGHTS

BULLS MEET HAWKS IN NBA DEBUT TONIGHT

Oct. 15, 1966
Bulls win debut game, defeating the Hawks 104-97 in St. Louis. Bulls' opening night lineup is Bob Boozer, Len Chappell, Don Kojis, Guy Rodgers and Jerry Sloan.

January 19, 1966
The Chicago Bulls are awarded an expansion franchise, bringing the National Basketball Association to 10 teams for the 1966–67 season.

March 25, 1967
Bulls swept by Hawks in opening round of playoffs, losing Game 3 in St. Louis 119-106.

March 30, 1967
Johnny "Red" Kerr named NBA Coach of the Year.

June 22, 1967
Bulls move home games to Chicago Stadium.

BULLS LOSE; ELIMINATED IN PLAYOFFS

March 31, 1968
Lakers eliminate the Bulls from the playoffs with a 122-99 decision in Game 5 in Los Angeles.

Nov. 23, 1968
Bulls trade Flynn Robinson to Milwaukee for forward Bob Love and guard Bob Weiss.

1965 **1966** **1967** **1968** **1969**

Oct. 18, 1966
Bulls play their first home game at the International Amphitheatre, defeating the San Francisco Warriors 119-116.

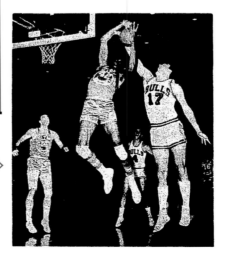

May 27, 1968
Bulls hire Dick Motta as new head coach.

Sept. 2, 1969
Bulls acquire forward Chet Walker and swingman Shaler Halimon from Philadelphia in exchange for forward Jim Washington and a player to be named later (Bob Kauffman).

Birth of the Bulls: Several professional basketball franchises had failed in Chicago, but as this piece from the Chicago Tribune Magazine—published on Oct. 9, 1966, days before the team's first NBA game—points out, there was something different about the Bulls.

Chicago's last chance

The Stags lurched through four financially disastrous seasons here before dying, and the Packers/Zephyrs hung on for two years before sneaking off to Baltimore. That's two strikes. And now comes Dick O. Klein, who argues with effervescent enthusiasm and boundless optimism that his new team, the Bulls, can't miss in Chicago's third try for basketball success.

If you tune to Channel 9 on Saturday at 8 p.m., you will observe about a dozen tall, muscular young men in short pants romping onto a basketball court in St. Louis. The word "Chicago" on their shirts won't be a misprint.

These will be the Chicago Bulls, making their debut in the National Basketball Association against the powerful St. Louis Hawks. And on Oct. 18, the Bulls will play their home opener in the Ampitheatre.

So for the third time in its roller-coaster existence, the NBA will attempt to put major-league basketball over in Chicago. As a stronghold of big-league baseball, football and hockey, Chicago has proven that it will pay handsomely to see the pros. Basketball? That's another story.

The Chicago Stags, a charter member of the pro league in 1946, limped into oblivion after four seasons and the Chicago Packers (later renamed Zephyrs) proved a resounding flop in half that time. Chicago, it has been said, just isn't a basketball town. The NBA, on its record here and in other places, has proven to be somewhat less stable than the rock of Gibraltar. In charting the manipulations of its inner circle through the years, some cynics have labeled it the "wheeler-dealer association."

Add the soaring costs of starting a franchise in any sport these days, the incredibly complex blend of business acumen and sports savvy required to make the operation take hold and grow, and the perils of starting as a "have not" in a league ruled by the "haves." Put them all together and hum to the title tune from that hit Broadway show, "Forget It." Right?

Wrong.

The Chicago Bulls intend to defy the odds. The mere fact of their presence is testimony to the patience, persistence and determination of one man. The Bulls exist because a former Northwestern basketball player wanted them and was willing to work to create them.

The man is Dick O. Klein of Kenilworth, who turned 46 last month. He's an ex-athlete, successful business man, persuasive talker, thorough organizer and boundless optimist. All these traits helped in his relentless pursuit of a Chicago franchise. Only the most extreme optimist would consider facing what Klein has gone through to give Chicago its third—and doubtless final—chance for success in the NBA. To illustrate, let's look at the labored path the league has traveled.

Major-league basketball is accepted as beginning with the birth of the Basketball Association of America in 1946. Thirteen cities, including Chicago, signed the original agreement, with Maurice Podoloff, former American Hockey League president, as commissioner. In that initial season, however, only 11 teams were fielded. Six of those entries are in the present 10-team NBA lineup, but only two—Boston and New York—have played all 20 years in the same city. The others have shifted to new sites, dropped out for varying periods, or disappeared into the vast limbo of franchise failures.

The early years were so grim, acceptance so limited and war with the rival National Basketball League so costly that the league in 1949 was on the verge of foundering. The owners reached a decision to disband after the 1949–50 season if they continued to lose money.

But the NBL saved the day by caving in first. The leagues signed a merger agreement on Aug. 3, 1950, creating the 18-team National Basketball Association. However, the new league, far too unwieldy and operating in many towns on a shoestring, suffered an appalling casualty rate in its first season.

A lot of money was lost in the process, although it wouldn't seem much today, after a single pro football franchise has sold for $10 million. The dead wood had been weeded out, however, and the league began a slow, painful growth. But the franchise-shift shell game was by no means ended, and neither were the manipulations.

Veteran franchise owners had survived the small-town era—Walter Brown in Boston, Ned Irish in New

York, Ed Gottleib in Philadelphia, Ben Kerner in Milwaukee and St. Louis, and Fred Zollner in Fort Wayne, Ind., and Detroit, to name some—and they weren't about to let anyone else make decisions concerning their teams. They had the perfect foil in the amiable Podoloff, who was content to beam approval on owners' decisions, issue rosy forecasts of prosperity just around the corner, draw his salary and never, never rock the boat.

So this strong-willed inner circle charted the course for the NBA, assured of Podoloff's rubber-stamp endorsement. It served the owners' short-range interests, but left a vacuum in the vital area of planning for overall growth and stability.

Specific complaints of fans interested in the league's welfare centered on the scheduling (often downright ludicrous), the caliber of the officiating, allotment of gate receipts and owners' resistance to attempts to form a players' association.

Scheduling still is a problem, because most franchises don't own their arenas and must take whatever dates are available.

Officiating, always a sensitive area, should improve with the establishment of a full-time professional staff headed by Dolph Schayes, one of three 20,000-point scorers in NBA history. In earlier days, some officials, disgusted by abuse from owners who sat on team benches and incited the home fans to fury at each adverse decision, simply gave up. Referees could chase coaches and players out of the game when they went too far, but couldn't order owners off their own benches. Neither could Podoloff, who cheerfully insisted that near-riots "added to the color of the game."

Unlike baseball and football, visiting teams in the NBA do not share in the gate receipts. This reflects the "I-made-mine-now-you-go-out-and-make-yours" philosophy that permeates the league.

These long-time problems have to be put into today's context, however, because things are different now. The revolution that has propelled the NBA into full-fledged major-league status took place on the basketball court. While the league's kingpins were wheeling and dealing, the players were playing. The sheer ability they display at times approaches the incredible.

Techniques in all sports have undergone vast improvement since World War II, but none more than basketball. The pros' prowess in shooting, scoring and ball-handling is phenomenal. Not generally recognized, though, is the fact that defensive skills have kept pace. The days of "garbage baskets," goons and hatchet men are over.

Since the War . . . A Revolution on the Court

Pro basketball has evolved into a fast, bruising, exciting game. Stalling and unnecessary maneuvering have been eliminated by the rule stating that a team loses the ball if it doesn't shoot within 24 seconds.

The basketball metamorphosis happened while a dynasty was being built in Boston. With two superstars, Bob Cousy and Bill Russell, plus total team effort and coach Arnold (Red) Auerbach, the Celtics have won eight consecutive league championships and nine in the last 10 years, a record which stands alone.

These accomplishments brought the Celtics national renown. With its perennial kings, the NBA began to shed the anonymity that cloaked it in places other than the eastern basketball hotbeds of Boston, New York and Philadelphia.

But the NBA image still was being tarnished in smoke-filled rooms. The West Coast was ripe, so the Minneapolis franchise was shifted to Los Angeles and Philadelphia's to San Francisco in the early '60s. Philadelphia has always supported its team, and moving it west made as much sense as did tearing baseball's Dodgers out of Brooklyn. The problem later was solved in typical NBA style by moving the faltering Syracuse franchise to Philadelphia.

Now the eight-team NBA was ready for expansion. On Jan. 17, 1961, it voted franchises to Chicago and Pittsburgh. Under the guidance of David A. Trager, Chicago insurance executive, the Windy City entry lasted two dreary years, but Pittsburgh managed to top that handily. Its second stay in the league lasted less than 24 hours.

Meanwhile, back in Chicago, Dick Klein, though doubtless aware of the league's long-standing policy of patting a new franchise on the back with one hand while rifling its pockets with the other,

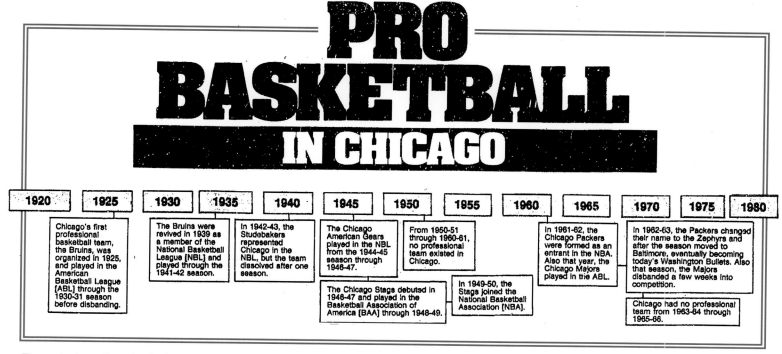

PRO BASKETBALL IN CHICAGO

| 1920 | 1925 | 1930 | 1935 | 1940 | 1945 | 1950 | 1955 | 1960 | 1965 | 1970 | 1975 | 1980 |

Chicago's first professional basketball team, the Bruins, was organized in 1925, and played in the American Basketball League [ABL] through the 1930-31 season before disbanding.

The Bruins were revived in 1939 as a member of the National Basketball League [NBL] and played through the 1941-42 season.

In 1942-43, the Studebakers represented Chicago in the NBL, but the team dissolved after one season.

The Chicago American Gears played in the NBL from the 1944-45 season through 1946-47.

From 1950-51 through 1960-61, no professional team existed in Chicago.

In 1961-62, the Chicago Packers were formed as an entrant in the NBA. Also that year, the Chicago Majors played in the ABL.

In 1962-63, the Packers changed their name to the Zephyrs and after the season moved to Baltimore, eventually becoming today's Washington Bullets. Also that season, the Majors disbanded a few weeks into competition.

The Chicago Stags debuted in 1946-47 and played in the Basketball Association of America [BAA] through 1948-49.

In 1949-50, the Stags joined the National Basketball Association [NBA].

Chicago had no professional team from 1963-64 through 1965-66.

The early days of pro basketball were marked by franchise instability and fan indifference. A parade of teams came and went before the Bulls and the pro game finally caught on in Chicago.

went into high gear in his bid to land a team. Klein, a big, genial man with a disarming habit of speaking frankly, came by his interest in sports naturally. He played high school football in Fort Madison, Ia., basketball at Northwestern and Great Lakes naval training center, and even pitched for one season in the Cleveland Indians farm system. After discharge from the Navy, he played for the old Chicago Gears, but abandoned that to enter business.

He built up his own firm, D.O. Klein and Associates, which peddled premiums to merchandisers. Though not the world's most glamorous profession, it managed to provide more than the bare minimum of food, clothing and shelter for Dick, Mrs. Klein and their three sons. Equally as important, it gave him the know-how and confidence to undertake the biggest selling job of his life.

The long trek toward opening night in St. Louis began in October, 1962, when Klein heard that the staggering Zephyrs might be for sale. He met with the stockholders, discovered the price was in the neighborhood of $600,000, and told them he was interested.

Klein does not now have, nor has he ever had, that kind of money. From the first, his chief capital has been personal characteristics which tend to make people believe that he can make pro basketball go in Chicago. He is the major, if not the sole reason why the NBA has returned. Klein believes that not only are the Bulls here to stay, but that they'll be a winner on the court and at the box office before too long. Talk to

him for a while and chances are you'll start believing it, too.

His first efforts at assembling a group to buy the Zephyrs were made in the fall of 1962. In February, 1963, he and selected backers met Trager to talk turkey. No firm agreement was reached, however, and when Klein returned from a vacation the following month, he found that the Zephyrs were gone. So he formed the Chicago Professional Basketball Corporation, the vehicle by which he eventually tracked down the elusive quarry.

Klein admits he didn't know much about the league and the men in it then, but his education soon began. He made a study of good (i.e., profitable) NBA franchises and used that as the basis for a five-year projection of a new team's potential. He went to St. Louis and Cincinnati for personal instruction from Kerner and Tom Grace, inquiring about club operations from salaries to laundry.

His determination and thoroughness drew accolades in virtually every NBA front office when officials were asked about him. The admiring chorus includes J. Walter Kennedy, former mayor of Stamford, Conn., who had replaced the venerable Podoloff as league president. Kennedy now says he's sold on Klein and his backers, but his response to the early overtures from Chicago was a series of polite phrases, freely translated as "Go 'way, boy, you bother me."

Klein at that time had neither today's gilt-edged set of backers nor the money to plunk on the table. Money

talks, and until he had enough, not even Klein's eloquence could prevail.

Klein is a marketer by profession, and probably by instinct. He button-holed hundreds of prospective investors with a presentation stressing the fact that he had a marketable product with sufficient profit potential to make the risk acceptable. In the sports boom since World War II, a lot of money has been poured down the drain by normally sensible men, who tossed chunks of it into various athletic enterprises so they could sit in box seats, second-guess the coach, and be referred to on TV as "sportsmen." To his credit, Klein didn't sell such illusions.

"To attract investor interest, I showed them the figures from basketball operations in four cities," Klein said. "The quick-buck artists soon faded. We have people with the courage to face some grim early figures."

Klein has projected a maximum loss potential of $285,000 and a minimum of $100,000 over the first two years. "The third year, we'll make a little money," he said. "At the end of five years, the investors will have their money back and the Chicago franchise will be worth a minimum of $6 million. By then, it will be as hard to get a ticket for a Bulls game as it is for the Bears and Black Hawks."

This could be optimism stretched past the limits of credibility, but Klein doesn't think so. He owns more than twice as much of the Bulls as any other single investor, giving him plenty of incentive to put the club over by marketing a "better product." Will this business-type approach work in sports?

"You're damn right it will," he snaps.

While Klein was forming these ideas, learning about the league, and attracting investors, the NBA expansion committee voted down any new franchises in 1965. A more painful blow came from Kennedy, who informed Klein that the $750,000 price tag on a Chicago franchise was out. Henceforth, he said, groups not willing to start negotiations at $1.5 million could save their breath.

"The new price level was a setback to my group," Klein said. "Three investors dropped out, but the others went along. They had agreed to participate for X dollars each, so the new price meant they'd either have to invest more money or accept a lower proportionate share of ownership."

Klein's Determination Finally Pays Off

Klein explained that he wanted a balanced group of backers, each holding approximately equal shares. This, he said, is what happened when he reshuffled backers for the final push, with each investor in for about 10 percent.

The group behind him now is powerful. It includes such familiar names as Elmer Rich Jr., E.J. Higgins, Harold Mayer, Newton Frey and Greg Barker. A late entry was Lamar Hunt, multimillionaire and pro football owner. The only shareholder not from Chicago, he got in after assurances that he would not attempt to gain control.

The big breakthrough came fast. Reassured last fall that Klein and his merry men were in earnest, Kennedy invited them to New York to meet the expansion committee. Klein marshaled his figures and headed for the big pitch, accompanied by two key investors, Rich and Mayer.

The committee, Chairman Kerner, Gottlieb and Irish, three of the canniest seat-of-the-pants operators in the NBA, was ready and waiting for Klein. They had a franchise agreement plan which the novice, Klein, was supposed to snap up without hesitation, and they wanted to see the color of his money.

The central assumption was that since the last Chicago franchise had failed despite being awarded the No. 1 college draft choice, the emphasis this time would be on stocking the new team with experienced players. Chicago was to be assigned low college draft picks, which didn't offer much hope of unearthing rookie talent.

This, of course, overlooked the fact that Michigan's Cazzie Russell was certain to be snapped up first in this year's college draft. Logic would have dictated the awarding of Cazzie, a native Chicagoan, to Klein. But the NBA puts neither logic nor the interests of the new guys ahead of the Old Guard's wishes. Both Irish's New York Knicks and Zollner's Detroit Pistons, last in their divisions, wanted Russell. Klein was told that if Chicago wanted in for 1966–67, Russell was out.

Klein wanted in, all right, so he turned his attention to what they would give him. By far the largest slice of the $1.6 million the league demanded for a Chicago franchise would go to the nine other clubs for the two players each would throw into a stocking pool, from which the Bulls would fill their roster. Each of these 18 players would cost the Bulls over $175,000.

Indemnity? Payola? Blackmail? Call it what you like, but that was the deal. The original plan called for each of the nine clubs to freeze 8 of the 12 players on its roster, offering Chicago a choice of two from the remaining four.

Somehow, Klein managed to persuade the committee to recommend freezing only seven on each club. This may seem like a minor point, but Klein regards it as a major victory.

"That gave us nine players the other teams wanted to keep," he said, whipping out another chart that showed that only 17 of 27 players chosen in the first three rounds of the 1965 college player draft made it in the NBA. A flock of these high choices later was grabbed by Klein.

Though the deal was now acceptable to Klein, it still had to be approved by the NBA board of governors, with at least seven "yes" votes required. Rich, whom Klein calls the prime mover among his backers, also went to New York for the decisive meeting. Klein and Rich cooled their heels for over five hours while the board met to vote.

At 3:15 p.m., Kennedy summoned Klein. "Welcome aboard, partner," he said. Only those unfamiliar with the league would conclude that the manipulating was over. There was, it seemed, a slight hitch in the agreement. The wheeler-dealer association was at it again.

The "slight" hitch developed because New York and Detroit were strongly opposed, holding out for a year's delay. Zollner and Irish complained that giving up two established players would hurt their weaker clubs more than the others. Only a late switch by Franklin Mieuli of San Francisco provided the seventh and decisive vote for approval.

As balm to the dissidents, a special amendment was hammered out. It provided that the first six players cut by the Bulls among the 18 drafted from the other clubs could be claimed on waivers, with those lowest in the standings—New York and Detroit—getting first crack at them. Only if all other clubs waived

on him, however, could a team reclaim a player it had originally sent to the Bulls.

Thus, for the $1,000 waiver price, the Bulls will lose all rights to players who, only a few months before, cost them about $175,000 apiece! Since the Bulls can keep 15 men until Jan. 1, a minimum of three players obtained in the pro draft must be cut loose before opening day. A few rookies, like Dave Schellhase of Purdue, will make the team, so the probability is that all six of these expensive acquisitions will be snatched away.

News of this cute arrangement was broken to Klein by Kennedy, who had thrown his prestige behind approval of the Chicago group. Explaining his switch to vote for approval, Mieuli said, "Kennedy made the deal. I felt it was our responsibility to back him up."

Relieved, Kennedy concluded that the deal was signed, sealed and delivered, and so informed the press and wire services. On Klein's part, though he was willing to accept the 11th-hour switcheroo, it was not settled until he had met with his backers, told

A former athlete who once played for the Chicago Gears, Dick Klein overcame numerous financial and operational obstacles to land an NBA expansion franchise.

There's Even a 'Chicago Bulls Victory March'

them of the change and got their approval. "I wanted to be sure anxiety to get the team hadn't caused me to make a bad decision," he said.

Now that the goal had been reached, the real work could begin. As Bulls general manager, Klein set out to build an organization that would do things the way he wanted. Klein's aim is to market his product with maximum efficiency, calling attention to that fact with unceasing promotion. He breaks down his approach in ways that would startle some NBA pioneers who worked out of offices located in their hats.

Each step of the Bulls' growth has been programmed into a separate area familiar to industrial operations: research, design, production, financing, marketing. Promotional ideas include both merchandising tie-ins and an incessant flow of gimmicks to attract fan interest. There is even a "Chicago Bulls Victory March."

John [Red] Kerr, former pro star and now coach of the Bulls, watches intently as the team runs thru a pre-season practice session.

Until Klein drafted his 18 players in April, he was busy setting up those areas of responsibility. Now his men are moving into their assigned tasks as the Bulls organization gets off the ground—Jerry Colangelo, former University of Illinois basketball player, and Riley Morgan in the front office; Ben Bentley, a Chicago veteran, as publicity director; and head coach John (Red) Kerr and his assistant, Al Bianchi.

Klein thought his prize pick was Nate Bowman, a 6-foot-10-inch center drafted from Cincinnati in hopes that he would become the good big man all NBA contenders must have. But fate intervened in training camp when Bowman suffered a hairline ankle fracture that will keep him out of the early-season lineup. It was a severe blow to Kerr, the amiable redhead who played for Chicago's Tilden Tech and the University of Illinois before launching a 12-year career in the NBA.

Kerr, 34, was signed to a three-year contract as coach soon after the Bulls drafted him from Baltimore. In an NBA innovation of sorts, his old Syracuse playmate, Al Bianchi, was given a similar pact as assistant coach.

Kerr has a reputation around the league as a nice guy, but contrary to the bit of folklore attributed to another noted Chicago sports mentor, he has never finished last. He doesn't want it to happen in his first year as a coach.

"You have to be in command from Day 1," Kerr said. "I want the players to be relaxed with me, but I'll crack the whip when I have to."

The techniques of basketball are second nature to Kerr. They were drilled into him by years of countless repetition, and he's confident he can transmit them to his young charges.

He's presently hard at that endeavor, juggling various combinations, experimenting with platoons, trying to mold the baby Bulls into a cohesive unit. The major task, he knows, will be overcoming the mistakes of youth and inexperience, with the league standings serving as an ever-present barometer of his success.

Bianchi will be on the road much of the time, sizing up the other clubs, but he expects to be on the bench for most Bulls games. A special project of his is assisting Schellhase in making the difficult transition from forward to guard.

And now it's show time. The Bulls are ready to be trotted out for inspection.

Klein, who created the whole thing virtually out of thin air, will be there on Oct. 15 when the Bulls take the floor for their first NBA game. As members of the five-team Western Division, they can make the playoffs by finishing anywhere except last. Such an accomplishment would surpass the expectations of everybody.

Everybody, that is, except Dick Klein. 🏀

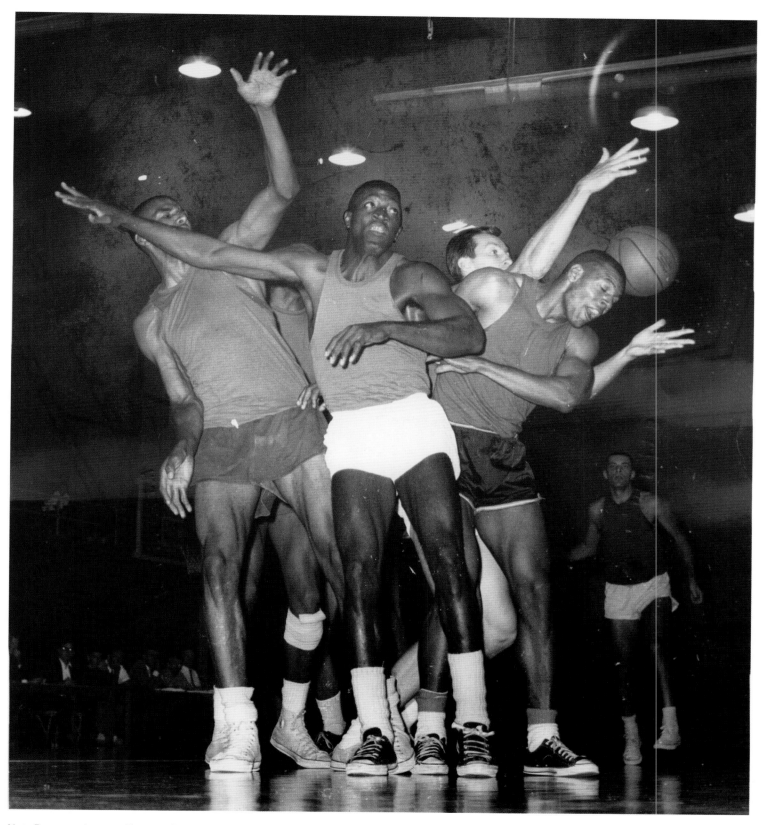

Nate Bowman, Laverne Tart and Gene Summers (left to right in foreground) can't corral a loose ball that winds up in the hands of Dave Schellhase during a Bulls' rookie-camp scrimmage at DePaul's Alumni Hall in August, 1966.

As an expansion team, the Bulls had hoped to get the No. 1 pick in the college draft and use it on Chicago-born star Cazzie Russell, but the Pistons thwarted their plan.

'They're not going to be patsies'

Jan. 28, 1966

The Bulls are coming to town, but Cazzie Russell isn't.

With those twin revelations at an introductory press conference, the National Basketball Association returned to Chicago. The new franchise, signed and sealed only minutes before the announcement, was placed in the hands of Dick Klein by NBA president Walter Kennedy.

Klein, 44, of Kenilworth, a sales promotion executive and former Northwestern University athlete, will be the "take charge" man for the group which owns the new team, to be known as the Chicago Bulls. It will enter the league for the 1966–67 season.

Other members of the group are E.J. Higgins, chairman of Pepsi Cola bottling company; Harold M. Mayer, Oscar Mayer Company vice president; Elmer Rich Jr. of Bacon, Whipple and Company, an investment security firm; and Newton P. Frye Jr., partner in the law firm of Schiff, Hardin, Waite, Dorschel and Britton. They paid $1.6 million for the franchise.

The team, replacing Baltimore in the Western Division (Baltimore switches to the Eastern Division), brings the professional league up to 10 teams. Most home games will be played in the Amphitheater, Klein said, adding that he hopes to make a success of the third NBA venture in Chicago by offering a "better product."

Storm flags were hoisted immediately, however. It developed that Russell, the Chicago product who is everybody's All-America at the University of Michigan and a cinch to be the No. 1 NBA draft pick this year, won't be a Chicago Bull.

Under the existing agreement, the Bulls will get two players from each of the nine other teams. Each team will freeze seven of the 12 players on its roster and the Bulls will select two of the remaining five men.

The list of players picked by the Bulls will be announced before the draft, scheduled for May. In this year's draft, the Bulls will get the 10th (last) pick in the first round, third and fourth picks in the second round, and 10th pick in all succeeding rounds.

Thus, the chances of Cazzie, the local boy who made good at Michigan, doing the same as a Chicago pro went out the window. Most of those present had assumed the Bulls would be given the No. 1 draft pick (i.e., Russell), and their reaction was vociferous.

Kennedy, the NBA president, bore the brunt of

EXPANSION DRAFT

On April 30–May 1, 1966, the NBA held an expansion draft to stock the Bulls' roster. The existing nine NBA teams could protect seven players; the teams had originally asked to protect eight, but Bulls' general manager Dick Klein negotiated a deal to cut the protected number to seven. In return, Klein would pick last—instead of first—in each round of the upcoming college draft. This meant that the Bulls would not get a crack at Chicago native and University of Michigan All-American Cazzie Russell, who was considered the best college player available. Klein reportedly also worked out a deal with Boston's Red Auerbach, agreeing not to draft Celtics star K.C. Jones

Bowman, Sloan Among 1st Players on New Bulls

if Auerbach would advise the Bulls on other players to select.

The Bulls chose 18 players, two each from the nine teams. Two of the players they drafted—Johnny "Red" Kerr and Al Bianchi—retired before the 1966–67 season. Kerr became the Bulls' first head coach and Bianchi joined Kerr's staff as an assistant.

But, Dick, The Bull Never Wins

Dick Klein, head of Chicago's new franchise in the National Basketball association, has fun spoofing team's nickname, the Bulls.

the vigorous dissent. He was "blitzed" by a phalanx of writers asserting that without Russell as the nucleus of growth on the floor and at the gate, the new venture was doomed.

"We can't win 10 games without Russell," one growled. Threading through the obstacle course of wires, lights and cameras planted by the electronic media marvels, Kennedy led the dissidents into a corridor and put up a gallant rear-guard defense.

The major problem with Russell, he explained, was the adamant refusal of Fred Zollner, Detroit Pistons owner, to give up rights to him. As perennial Western Division cellar-dwellers, the Pistons would get first shot at Russell in the draft.

The compromise formula under which the Bulls will get 18 experienced NBA players rather than Russell was worked out in expansion committee meetings, with Klein present, Kennedy pointed out. "If drafting Russell was a condition of getting the franchise, they wouldn't have gotten it," he said.

Kennedy insisted that the Bulls, in the long run, would be the better for it, strongly objecting to statements that they would be pushovers in their first

season of NBA competition.

"We'd be damn fools to foist a team on Chicago that would finish 50 or 60 games out," he said. "This point has been overlooked—the new formula was carefully worked out. We believe it will give Chicago an experienced, balanced team. I wish Chicago could get Russell, too, but they're not going to be patsies."

Kennedy said that Klein's group had won the Chicago franchise over the bids of four other syndicates, one headed by Lamar Hunt, owner of the Kansas City Chiefs of the American Football League. The price was reported to be the highest ever paid for a pro basketball franchise.

Player	Pos	Previous team	NBA exp	Player	Pos	Previous team	NBA exp
John Barnhill	G	Detroit Pistons	4	Jim King	G	Los Angeles Lakers	3
Al Bianchi	G	Philadelphia 76ers	10	Don Kojis	F	Detroit Pistons	3
Ron Bonham	F	Boston Celtics	2	McCoy McLemore	F/C	San Francisco Warriors	2
Bob Boozer	F	Los Angeles Lakers	6	Jeff Mullins	G/F	St. Louis Hawks	2
Nate Bowman	C	Cincinnati Royals	0	Jerry Sloan	G/F	Baltimore Bullets	1
Len Chappell	F/C	New York Knicks	4	Tom Thacker	G/F	Cincinnati Royals	3
Barry Clemens	F	New York Knicks	1	John Thompson	F	Boston Celtics	2
Keith Erickson	G/F	San Francisco Warriors	1	Gerry Ward	G	Philadelphia 76ers	3
Johnny Kerr	F/C	Baltimore Bullets	12	Jim Washington	F/C	St. Louis Hawks	1

Above: Head coach Johnny "Red" Kerr led the Bulls to a 33-48 record and a playoff berth in the team's debut season.

Opposite: San Francisco's Nate Thurmond controls a rebound despite the efforts of the Bulls' Keith Erickson during the Warriors' 137-121 victory at the Amphitheatre on Nov. 1, 1966.

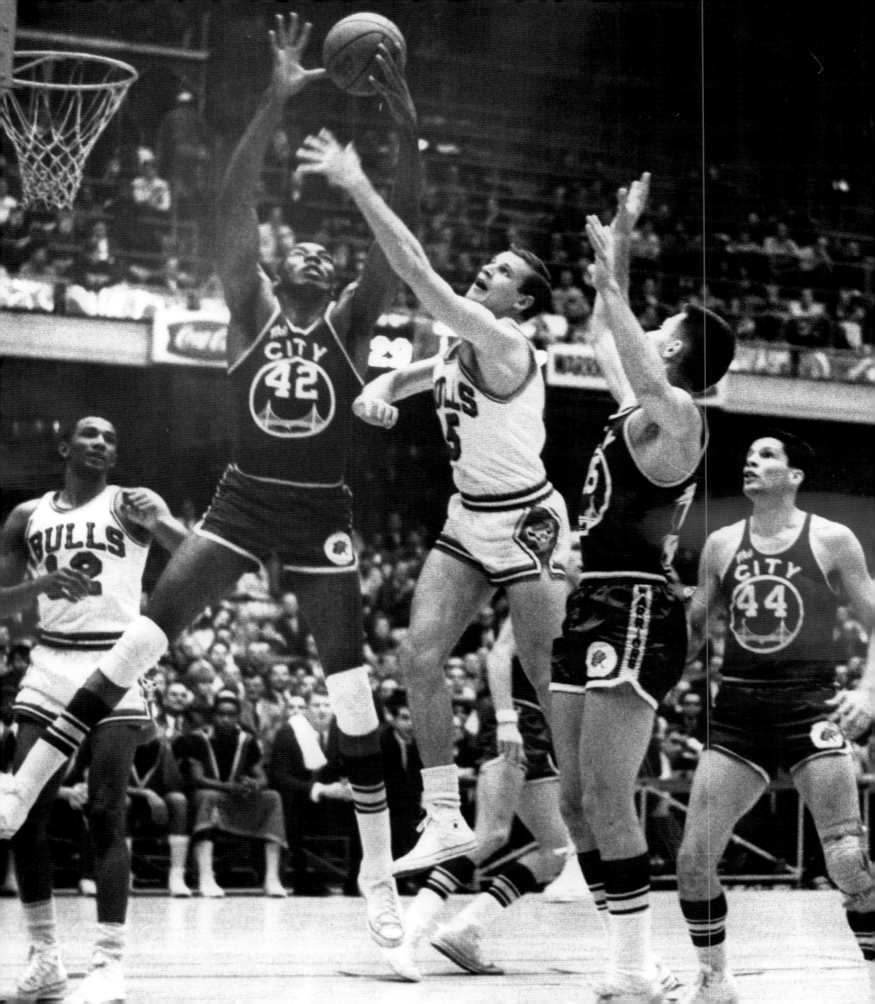

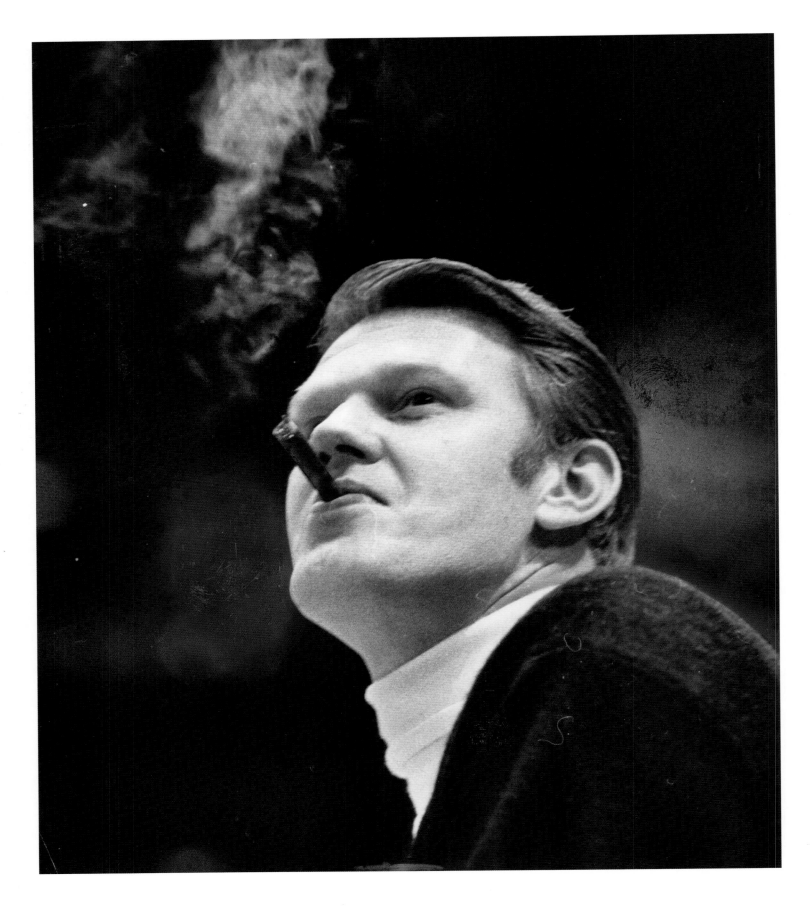

Johnny "Red" Kerr

FIRST AND ALWAYS, A BULL

HEAD COACH
1966–68

EXECUTIVE/ BROADCASTER
1973–2008

He was a high school and college basketball great, an NBA champion and an All-Star, a front-office executive and a respected broadcaster, but Johnny Kerr always will be known as a Chicago Bull.

Perhaps the best ambassador the Bulls will ever have, Kerr's nickname, "Red"—for his hair color—couldn't have been more appropriate. In many ways, Kerr was Mr. Bull: the first coach in franchise history, NBA Coach of the Year that 1966–67 season, later the club's business manager and finally its television and radio analyst for 33 years.

The media job was one he fulfilled with great passion and his trademark sense of humor, cutting back only recently to the pregame and halftime shows.

He was a South Side boy born July 17, 1932, to Matthew, who died of pneumonia at 32 when Johnny was 3, and Florence. His father was of Scottish descent; his mother, Swedish.

Kerr rose to prominence, quite literally, with an 8½-inch growth spurt before his senior year at Tilden High School. It was only then that he left his first-love sport of soccer for basketball, and as its 6-foot-9-inch center, he soon led his team to the 1950 Public League championship.

Recruited to the University of Illinois, Kerr captained the Fighting Illini to a Big Ten title and an NCAA Final Four berth in 1952. He finished his career with a school-record 1,299 points, the third-highest total in conference history, in his three years on the varsity. Kerr was the ninth Big Ten player to be awarded the Silver Basketball by the Tribune as the league's most valuable player.

The Syracuse Nationals used the sixth pick of the 1954 NBA draft on Kerr, and the rookie rewarded them by averaging 10.5 points and 6.6 rebounds while helping them to their first and only NBA championship.

Kerr played in the game that ended with one of the most famous radio calls in history, Johnny Most's "Havlicek stole the ball!" That came in Game 7 of the 1965 Eastern Conference finals between John Havlicek's Celtics and Kerr's Philadelphia 76ers, formerly the Nationals.

Kerr played 12 years in the NBA, playing the same position in the same division as Bill Russell and Wilt Chamberlain while carving out a career in which he established himself as one of the most dependable and finest passing centers in the game.

"I had the touch of a blacksmith," Kerr once cracked with his typical self-effacing humor. "If I took six shots in a game, they'd check the windows."

Just the same, Kerr retired a three-time All-Star with 12,480 points, 10,092 rebounds and the NBA record for consecutive games played with 844. He was held out by coach's decision in the 845th, but the record stood until the 1983 season.

"Sure, I was proud of the record," he said. "Then I got a telegram from a fan: 'Congratulations, you're only 1,288 behind Lou Gehrig.' It helped me keep things in perspective. Besides, the record was more Betsy's (his wife) than mine. She led the league in hot water bottles and tape for 12 years."

Kerr's great lifetime achievement, he said, was marrying the love of his life, Betsy Nemecek, a Riverside girl he met at Illinois.

According to Kerr's high school yearbook, he was headed for Bradley University. Irv Bemoras, an Illini player, inveigled him to Champaign, and that was that. "It looked like a college was supposed to look," Kerr explained.

His new teammates alertly foiled a Peoria raiding party sent to recapture the pilfered pivotman, while Johnny began to realize he'd made the right decisions. Especially when he walked into a campus jukebox hangout and met Betsy. They married in 1954, a week before Kerr began his NBA career.

Opposite: Johnny Kerr was known for his quick wit and sense of humor, which he displayed to great effect during his years as a TV and radio analyst.

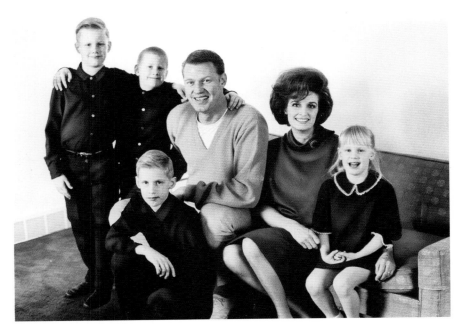

Bulls coach Johnny Kerr poses at home in 1967 with his family (left to right), sons Matt, Billy and Eddie, wife Betsy and daughter Essie.

It was an enduring love story, though not without tragedy. The couple's first-born, John Jr., died in 1960 at 3 of meningeal encephalitis. The sudden illness and death of John Jr. demoralized Kerr and he spent a long time grieving.

"There was a team party after the season and I was still moping around," Kerr related. "(Syracuse coach) Alex (Hannum) took me aside and growled, 'It's time you stopped feeling sorry for yourself.' I got mad, which is what he wanted, of course, and I started getting a grip on myself."

In the early '70s, the Kerrs took in the three daughters of Betsy's sister and brother-in-law, who died within months of each other of cancer and a stroke, respectively. One of the daughters, Laurel Ellis, was later murdered in her college dorm room.

Kerr's final heartbreak was losing his sweetheart after 46 years of marriage when Betsy died in October 2000, leaving her husband and the couple's four sons, one daughter and 10 grandchildren.

Kerr, as always, found solace in his life with the Bulls, his friendships with fellow broadcasters, the coaches, the players of the game.

When Kerr took over his hometown team in its inaugural season of 1966–67, several pro basketball franchises—the Bruins, Gears, Stags, Majors, Zephyrs and Packers—already had tried and failed in Chicago.

But spurred on by the energy of Kerr, marketing director Jerry Colangelo, public relations man Ben Bentley and owner Dick Klein, the upstart Bulls built from other teams' rejects and somehow survived. Kerr came aboard in the expansion draft even though he had no intention of playing; Klein told him he would pick him first and make him the coach.

"In a way, coaching an expansion team was a break," Kerr said. "We didn't know what we had, so we didn't know how bad we could be. We could do things differently with our material."

They said of those Bulls that as coach, Kerr was the best center they had, and it was no exaggeration. The team was undersized but quick, so Kerr compensated by employing a scrappy, clawing defense and a fast-paced offense that sometimes, he said, "looked like the YMCA out there."

Kerr told their handful of fans: "Bulls is our name. Defense is our game. Look in the Yellow Pages under 'Excitement.'"

Still, after starting the season 7-6, they lost 14 of their next 15, prompting critics to predict the Bulls would go the way of their predecessors. Early in the season, St. Louis Hawks coach Richie Guerin even predicted the expansion team would be lucky to win 10 games.

"We hung Guerin's statement on the dressing room wall," Kerr said. "It helped. Helped me remember never to say such a thing about another club."

While players and coaches of other pro teams in Chicago could command appearance fees, the Bulls coach spoke for free at nearly every opportunity he had.

"We did bowling banquets, Little League dinners, B'nai B'rith luncheons and youth group breakfasts," Kerr said. "I'm non-denominational. [One day] I helped sell bonds for Israel at noon, played handball at the YMCA after lunch and then held a scrimmage at DePaul in the evening."

And while he sold the Bulls, Kerr also sold the NBA to a scrutinizing audience that knew the league only as a bunch of guys in funny uniforms who fired up shot after shot with nary a speck of defense.

"Everybody on Boston uses his hands on defense," Kerr explained as he taught his young charges the Celtics' (illegal) way of playing defense. "Of course, you have to understand that the Celtic uniform comes with an extra pair of hands."

That attitude was perfect for Jerry Sloan, the first player the Bulls selected in the expansion draft, a 6-5 guard who led the team in rebounding.

Kerr was respected as one of the best minds in the game. But he was nothing if not funny.

"I'm always looking for a hot hand," he once said of his first Bulls team. "Then I milk him. Make him shoot till he cools off. Unfortunately, this year I've run through the whole lineup and couldn't find a hot hand."

Once, in a game against Philadelphia, Kerr was

giving out defensive assignments and told his center, Erwin Mueller, "You watch Chamberlain."

"So Wilt scores 40 in the first half," Kerr recounted. "I'm really boiling when we get to the locker room. I yell at Mueller, 'I thought I told you to watch Chamberlain.' And he says, 'I did, Coach. Gee, he's great, isn't he?'

"It broke me up. Broke up the whole squad. Loosened us up too. We went out and beat 'em, despite Wilt."

Far from the 10-win prediction, Kerr willed the Bulls to 33 victories and became the first head coach in any of the four major American sports to take an expansion team to the playoffs in its first season.

The Bulls were eliminated by St. Louis in the first round 3-0, and a year later Kerr left the Bulls and their bull-headed owner, Klein, at the behest of Colangelo, who had been hired as general manager of the expansion Phoenix Suns.

It was there he first tried his hand at broadcasting, teaming with Hot Rod Hundley.

After Phoenix, Kerr was lured to Virginia and the American Basketball Association, where he joined former teammate, Bulls assistant and longtime friend Al Bianchi and became the general manager of the Squires.

There, Kerr signed Julius Erving to his first pro contract and discovered George Gervin on the playground.

As the ABA foundered, Kerr felt the pull to return home to Chicago. Pat Williams recently had left the Bulls, leaving a general manager's vacancy, and Dick Motta took over the basketball operations in addition to his coaching duties but hired Kerr as the team's business manager, a job he held from 1973–75.

Kerr credited Jim Durham with graciously getting him into broadcasting by passing him the microphone during Bulls games. Soon Kerr was hosting a halftime show, and Kerr stayed behind the mike from then on.

Kerr prided himself on never having missed a single minute of Michael Jordan's Bulls career . . . and on their resin-bag exchange—Jordan clapping his hands together before each game as the dust blew all over Kerr—beginning in Jordan's first exhibition game, enduring as Jordan's superstitious pregame ritual and the duo's schtick.

Kerr's resume also included insurance investment consultant, president of Kerr Financial Services and

JOHNNY "RED" KERR

- » **Born:** July 17, 1932 in Chicago
- » **Height:** 6-9'
- » **Weight:** 230
- » **College:** University of Illinois
- » **Years in NBA:** 1954–66 as player, 1966–70 as head coach
- » **Hired by Bulls:** May 3, 1966

author of "Bull Session," published in 1989. The great void is that Kerr was not named to basketball's Hall of Fame in his lifetime despite his contribution to one of the sport's greatest franchises as well as the fact that he is one of fewer than two dozen players to amass more than 12,000 points and 10,000 rebounds.

"I've made it clear time and time again," Kerr cracked, "that if I'm chosen posthumously, I will not attend the induction ceremony."

Kerr once called basketball the most demanding sport there is behind soccer.

"Basketball isn't supposed to be a contact sport," he joked, "but all I know is I've had my nose broken, stitches taken all over my face and around my eyes, and my bridgework is courtesy of George Mikan and Wilt Chamberlain. And then there's the legs. As I got older, I seemed to get shorter. [I'd] start working out each year, and the basket was higher. Used to stand and stare at it and wonder how I ever jumped that far off the floor. Well, I never could jump anyway."

In a little more than a year over 2003 and '04, Kerr had an operation on his artificial left hip, a toe amputated and a stent placed in his heart. But in an interview with the Tribune's K.C. Johnson, he said he had no intention of giving up broadcasting or any of his other loves.

"One of my granddaughters said she admired me not for basketball," Kerr told Johnson with the trademark twinkle in his eye, "but because I can karaoke and moonwalk."

> **"Basketball isn't supposed to be a contact sport, but all I know is I've had my nose broken, stitches taken all over my face and around my eyes, and my bridgework is courtesy of George Mikan and Wilt Chamberlain."**
>
> —KERR

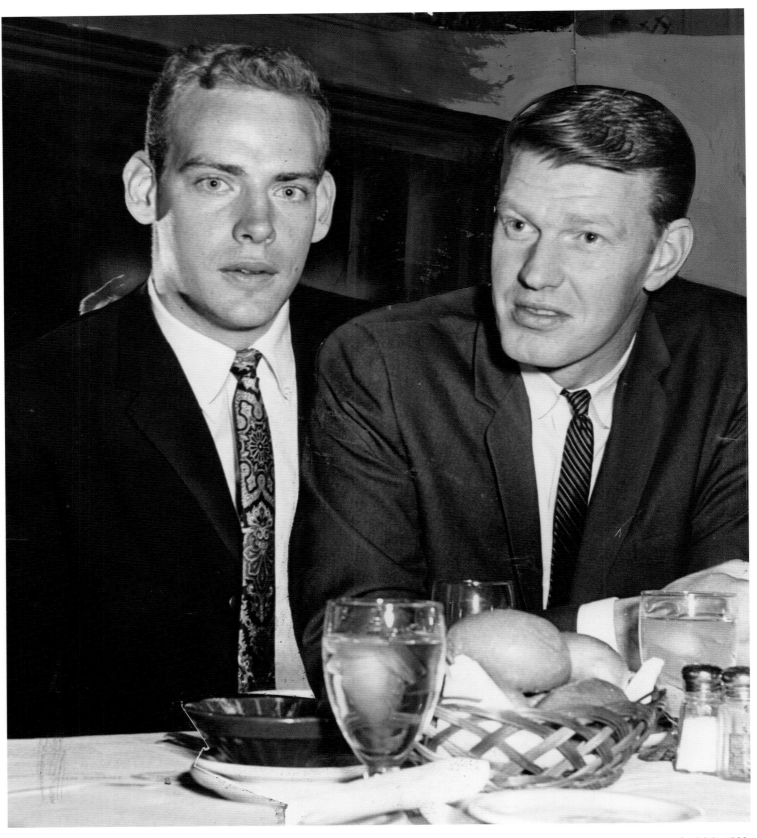

Dave Schellhase (left), shown at lunch with Johnny Kerr, led the nation in scoring as a senior at Purdue and became the Bulls' first draft pick in 1966.

Dave Schellhase

'IT REALLY WASN'T A GREAT PLACE FOR A COLLEGE GUY'

8 POINT GUARD

1966–68

Somebody had to be first. Dave Schellhase remembers vividly how he felt when he became the Bulls' inaugural NBA draft pick on May 11, 1966.

After Schellhase averaged an NCAA-leading 32.5 points per game as a senior at Purdue, the expansion Bulls of coach Johnny "Red" Kerr made Schellhase the 10th overall selection.

The draft was neither televised nor hyped in those days. Schellhase did not walk up on a stage to hug the commissioner or tweet "OMG!"

"The big thing then was that I knew I was going to get drafted, but it certainly was nothing like it is now," Schellhase, 70, told the Tribune in 2015.

"I think someone called me and said I was picked by Chicago. Then I think my (college coach Ray Eddy) may have called me. Then the next day the Bulls called kind of after the fact."

Schellhase said he had no agent to negotiate with Bulls owner Dick Klein. His rookie salary was $12,000 and Bulls players washed their own uniforms. Schellhase figured out recently that today's NBA players make as much in meal money as he did in salary.

"I didn't have a (good) car—I had a '55 Dodge and wound up getting a Chevy, which was probably about $3,000," he said. "But I did need a car and they understood that. I got $12,000, which was more than most college graduates (made) at that time."

As an expansion team, the Bulls were stocked with veterans selected from other teams before Schellhase was drafted.

"It really wasn't a great place for a college guy to go," said Schellhase, who wound up playing just two years in the NBA. "It was different from all the other teams.

"I remember the backcourt was two All-stars: Jerry Sloan and Guy Rodgers. And the forwards, Bob Boozer and Don Kojis, were very good. We wound up with a rookie playing center for us, Erwin Mueller. We had 27 guys at camp and that was out in Naperville at North Central College."

That first Bulls roster also included George Wilson, Jim Washington, Keith Erickson, McCoy McLemore, Gerry Ward, Barry Clemens, Len Chappell and Nate Bowman.

The No. 1 overall pick in 1966 was Michigan's Cazzie Russell, who went to the Knicks. The Pistons, who had coveted Russell but lost a coin flip for the first pick, took Syracuse's Dave Bing at No. 2.

The 1966–67 Bulls played their home games at the International Amphitheatre. They made the playoffs and posted the best first-year record (33-48) for an expansion team in NBA history.

"Some nights there weren't that many people in the Amphitheatre," Schellhase said. The average home attendance was 4,772.

The 6-foot-3 Schellhase, whose 30.5 ppg as a senior at Evansville North High School was Indiana's highest scoring average that season, was unable to showcase his skills during his brief stint with the Bulls. He averaged 2.8 points playing seven minutes per game in 73 games.

"Guys who are 6-4 or 6-5 . . . they are a dime a dozen," he said. "I was a center in high school, a forward in college and tried to play guard in the NBA."

Schellhase has no regrets about his limited Bulls experience.

"I wish it would have worked out, but I went back to school and got my master's and started coaching," he said.

Schellhase became an assistant at Purdue before taking a head coaching position at Moorhead (Minn.) State in 1975. He moved to Indiana State in 1982, where he compiled a record of 37-48 over three seasons before leaving the job to enter an alcoholism treatment center at age 40. He returned to Moorhead State in 1987 and coached there until 1998. During his two stints at Moorhead, Schellhase led the Dragons to a 298-240 record and 13 trips to the NAIA tournament.

He retired from Logansport (Ind.) High School, where he was dean of students and a health and physical education teacher. ●

DAVE SCHELLHASE

- » **Born:** Oct. 14, 1944 in Evansville, Ind.
- » **Height:** 6-3'
- » **Weight:** 205
- » **College:** Purdue University
- » **Years in NBA:** 1966–68
- » **Acquired by Bulls:** May 11, 1966 in 1st round (10th pick overall) of NBA Draft

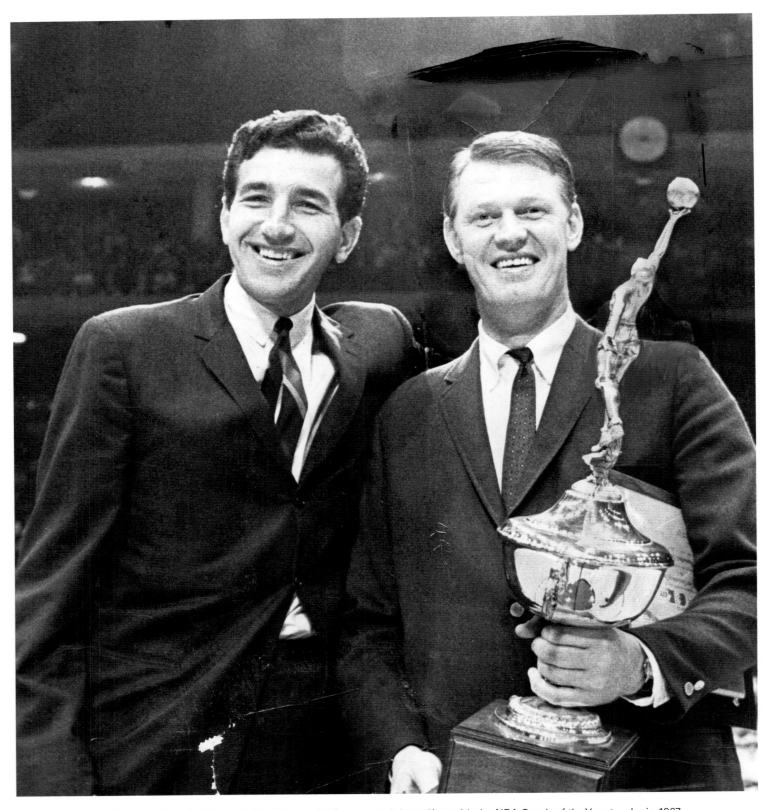

Above: The league's supervisor of referees Dolph Schayes (left) presents Johnny Kerr with the NBA Coach of the Year trophy in 1967.

Opposite: Bulls forward Barry Clemens pulls down a rebound during the first half of a 126-124 overtime loss to the Warriors at Chicago Stadium on Feb. 6, 1968.

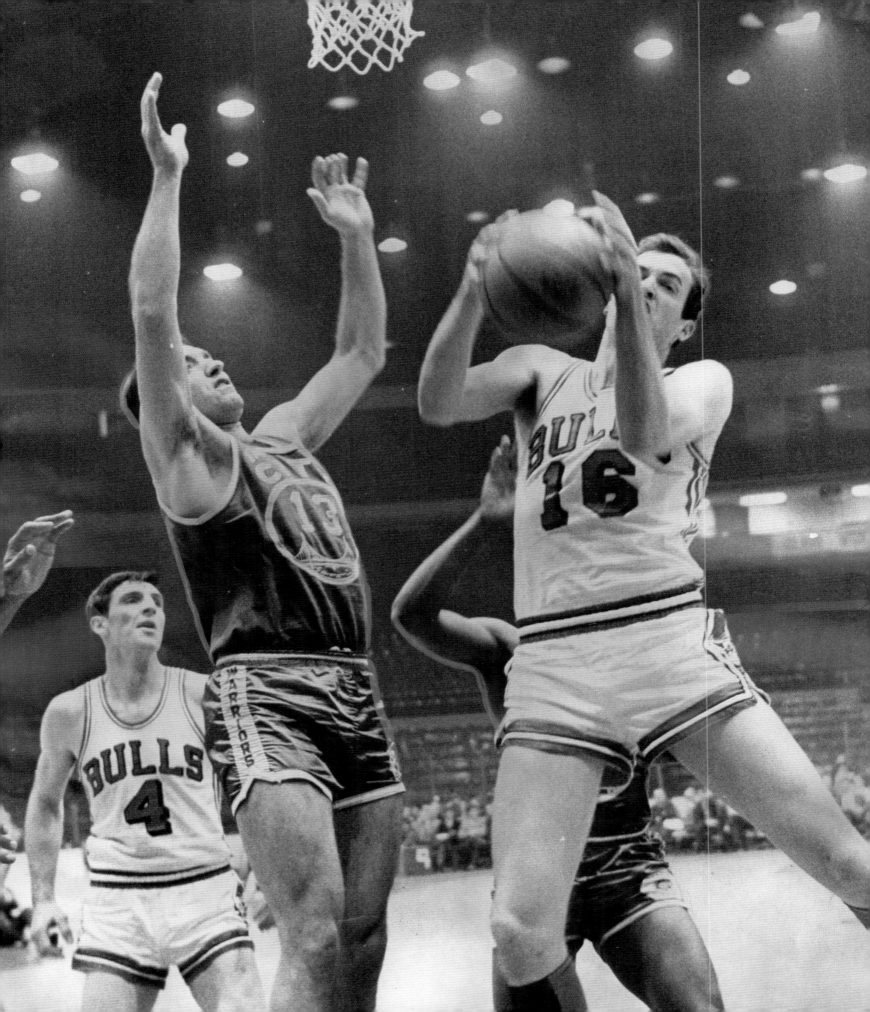

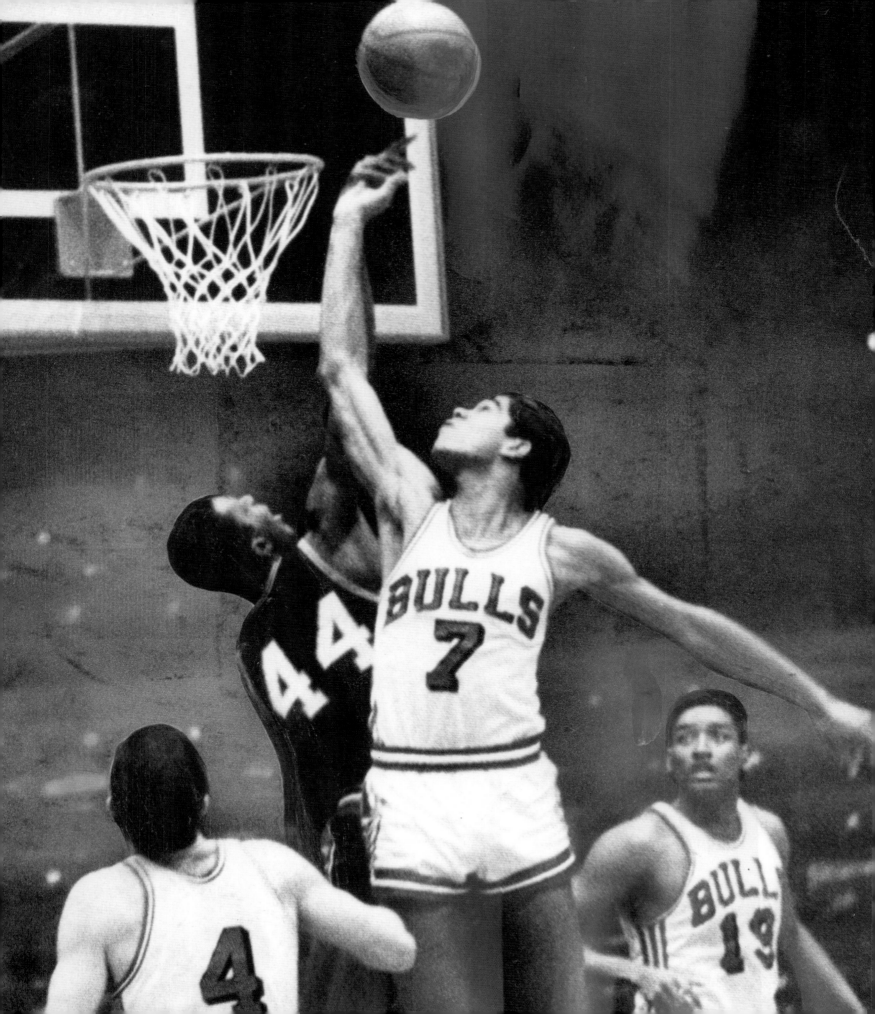

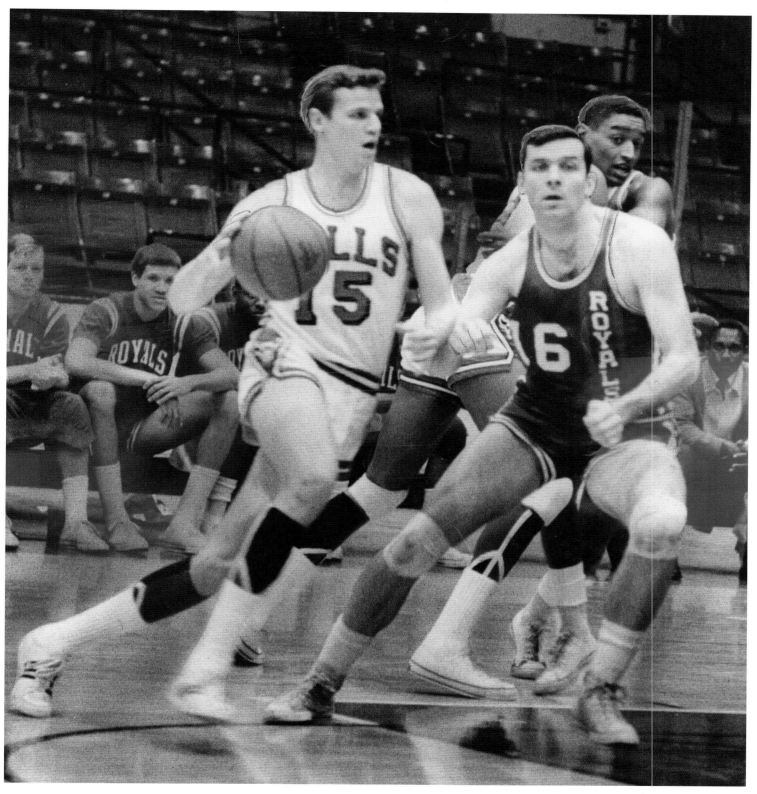

Above: Keith Erickson, shown here dribbling around Cincinnati's Jerry Lucas at the Stadium in 1968, averaged 10 points and 4.9 rebounds in his two seasons with the Bulls.

Opposite: Jim Washington battles Baltimore's Leroy Ellis for a rebound during the Bulls' 113-94 victory over the Bullets at the Stadium on Jan. 3, 1968.

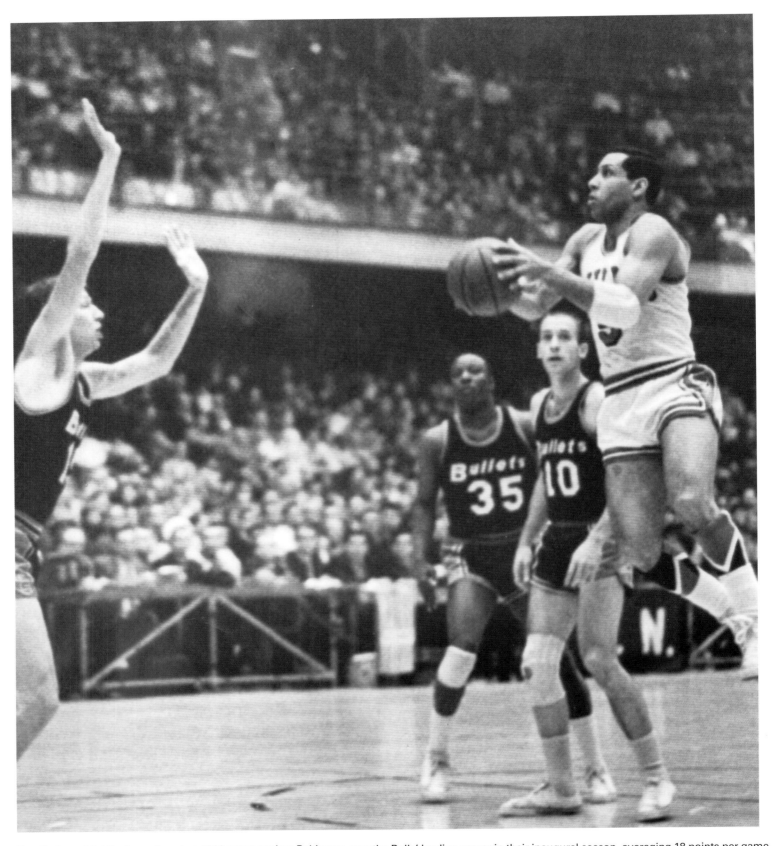

Guy Rodgers (right), shown here in a 1966 game against Baltimore, was the Bulls' leading scorer in their inaugural season, averaging 18 points per game.

Guy Rodgers

'THE GLUE THAT MADE US GO'

He represented one of the best moves the Bulls ever made.

They were the original baby Bulls then, expansion stepchildren of the NBA in 1966 and heading, as rookie coach John Kerr saw it, for disaster.

"We were thinking we'd win maybe 10, 12 games," recalls Kerr.

And that might have been optimistic with the team's expansion list of Jerry Sloan, Nate Bowman, Tom Thacker, John Barnhill, Don Kojis, Len Chappell, Barry Clemens, Gerry Ward, Jim King, Bob Boozer, Jim Washington, Jeff Mullins, Keith Erickson and McCoy McLemore. But on the way to Rockford in the preseason for an exhibition game, Kerr, assistant Al Bianchi and owner Dick Klein stopped at a tollway oasis and agreed to deal King and Mullins for 31-year-old three-time NBA All-Star Guy Rodgers.

> **"We wouldn't have scored many baskets without him."**
>
> —HEAD COACH JOHN KERR

"He became the glue that made us go," said Kerr, whose first-year Bulls remain the only NBA expansion team to make the playoffs as they won 33 games. "We wouldn't have scored many baskets without him."

Rodgers, a crafty 6-foot, left-handed guard much like Lenny Wilkens, led Temple to two NCAA Final Four appearances in the late 1950s and played most of his career for the Philadelphia and San Francisco Warriors. He was an instant success in the NBA, ranking among the league leaders in assists as a rookie in the 1958–59 season and leading the league in assists with 10.4 per game, just ahead of Oscar Robertson, in the 1962–63 season.

Always one of the smallest players in the NBA, Rodgers never saw his lack of size as a disadvantage.

"I was fortunate because my high school coach taught me to run and scramble and also to slow down," Rodgers said.

He played six seasons with the towering Wilt Chamberlain in Philadelphia and San Francisco, but never felt that "the Stilt" had to be the whole show, as some of Chamberlain's detractors did.

"I don't feel I played in Wilt's shadow," Rodgers said in 1966. "He is not selfish like you hear. As a matter of fact, when I tied (Bob) Cousy's assist record, it was Wilt who said the team should help me get it—and they did."

Viewed as being toward the end of his career, the Warriors traded him to the expansion Bulls before the start of the 1966–67 season.

Rodgers went on to have perhaps the best statistical season of his career, averaging 18 points to lead the team and leading the league with a career-high 11.2 assists per game, then the third highest single-season assist total in NBA history. Rodgers and Sloan went on to become All-Stars and help the West team to victory as Rodgers had a game-high eight assists.

But early the following season in the midst of an 0-9 start, Rodgers, in a cost-cutting move, was traded to the Cincinnati Royals for Flynn Robinson and cash. Rodgers was traded to the Milwaukee Bucks the following season and finished his career with the Bucks after the 1969–70 season with career averages of 11.7 points and 7.8 assists.

Rodgers was the kind of veteran ideal for a young, inexperienced team like those Bulls. He was a clever veteran who didn't panic, knew how to set up teammates, finished games and made a big play for himself or someone else under pressure.

"When I'm asked about him and you think of current guys, you might think of Allen Iverson for the way he came at you," Kerr said. "He put you back on your heels and went right by you. He just couldn't shoot as well. But he's a guy who probably should have been headed to the Hall of Fame. Anyone who saw us those first two years, he's the guy they usually want to talk about, the way he took that ball up. He was a real pro."

GUY RODGERS

» **Born:** Sept. 1, 1935 in Philadelphia

» **Height:** 6-0'

» **Weight:** 185

» **College:** Temple University

» **Years in NBA:** 1958–70

» **Acquired by Bulls:** Sept. 7, 1966 from San Francisco Warriors in trade for Jim King and Jeff Mullins

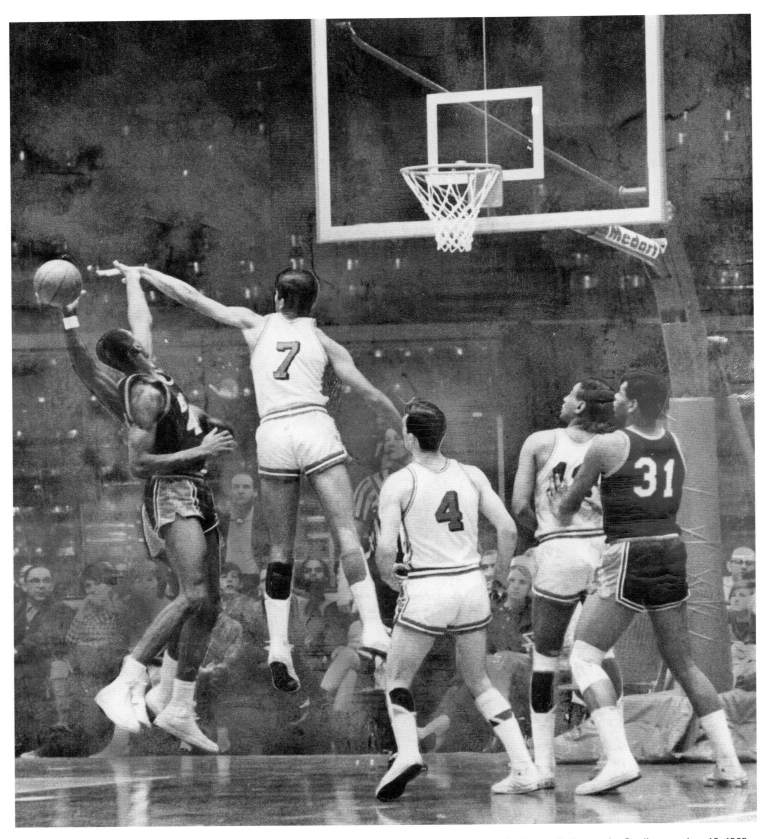

Jim Washington rises up to block a shot during the Bulls' sparsely attended 110-106 victory over the Baltimore Bullets at the Stadium on Jan. 13, 1968.

Johnny Kerr departs after two seasons and is replaced by the relatively unknown Dick Motta, who turns out to be an unlikely savior for the fledgling franchise.

Kerr leaves Bulls with a smile and a quip

'Change the Plays... I Know 'Em All'

April 25, 1968

Johnny Kerr, who always leaves 'em laughing, said goodbye to the Chicago Bulls yesterday the same way he had said hello two seasons ago—with a smile and a quip.

There was a notable lack of hilarity at the outlook for the Bulls, however. Kerr signed a three-year contract Sunday as head coach of the new Phoenix franchise in the National Basketball Association.

Amid a flurry of did-he-jump-or-was-he-pushed speculation, big John strolled into the Bulls' office yesterday to meet the press here for the last time. Nattily attired, as always, in a white sport coat and black turtleneck shirt, Kerr went out gracefully.

The man who was NBA Coach of the Year in 1966–67 for steering the "Cinderella Bulls" into the playoffs in their first season found his position untenable early in the campaign that just ended. The Bulls were artistic and financial failures this time.

For a month or more, Phoenix had been seeking the Bulls' permission to negotiate with Kerr. The green light was given informally on Sunday and Kerr signed with the new team just hours later.

His place will be filled, according to general manager Dick Klein, "with a coach who can win."

Klein, part owner and total operator of the Bulls, became increasingly disenchanted with Kerr's handling of the team after it lost nine in a row at the start of the season.

The big redhead naturally turned to thoughts of employment under less-demanding conditions. He turned down a subsequent offer from Klein to extend his contract for two years and from that point the breach between the two widened rapidly.

Klein said yesterday he had decided after the season not to bring back Kerr as coach next year, though John had one year remaining on a three-year personal services contract. Instead, he offered Kerr a job in the front office.

"I wanted to coach," Kerr said. "So when the offer from Phoenix came, I decided that would be best for me and my family."

"There was a definite conflict between us," Kerr responded to a query at the press conference. Klein said nothing.

Later, while Klein was parrying questions about the identity of the new coach, Kerr popped in again to say farewell. He shook hands all around, though the clasp of hands with Klein had a distinctly formal air about it.

Then he paused at the door to deliver the usual Kerr parting shot.

"Tell them to change the plays," he said. "I know them all."

Motta Bulls' New Pilot

May 28, 1968

The Bulls announced that Dick Motta, 36, had signed a two-year contract as head coach of the National Basketball Association team. As happens so frequently in the NBA, the word had leaked out so appointment of the Weber (Utah) State coach was no surprise.

The appearance of a new face on the Chicago sports scene was overshadowed because it happened on a day one of the great names in sports, George Halas of the Bears, stepped down. Things have been going that way lately for the Bulls.

Motta, a winner as a college coach, is stepping into a difficult situation. He said he has seen only 12 NBA games as a spectator, but added, "If I didn't think I could coach in the NBA, I wouldn't be here."

As successor to the easy-going John (Red) Kerr, Motta served notice that he would run a tighter ship.

"I don't like to be taken advantage of," he responded to a question on his coaching philosophy. "My job is teaching and selling myself to the players. No sport relies so much on teamwork.

"I won't be a rubber-stamp coach," Motta added. "I'm not a good loser and I don't intend to be a loser in the NBA."

Motta's rubber-stamp reference was an admission that he knew of the friction that existed between Kerr and Dick Klein, Bulls general manager. The acrimony resulted in Kerr's recent resignation to become coach of the new Phoenix, Ariz., NBA franchise.

Motta, a native of Medvale, Utah, graduated from Utah State. He compiled a 164-50 record as a college coach.

Dick Motta

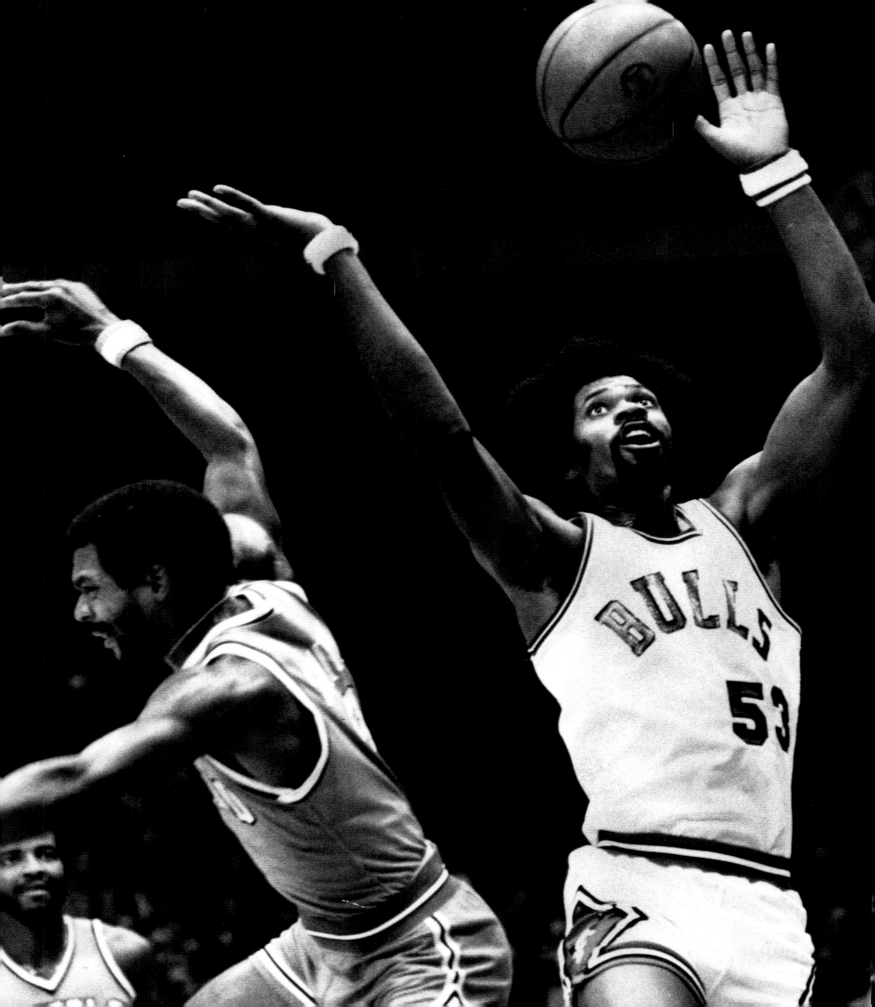

THE
1970s
OFF AND RUNNING

The first golden era in franchise history produced no championships but plenty of highlights and heartbreak. The Bulls averaged 52 victories from 1970–75 and were eliminated by the eventual Western Conference or NBA champion from 1972–75. The tough, hard-playing core of Jerry Sloan, Norm Van Lier, Chet Walker, Bob Love and Tom Boerwinkle resonated with fans and produced multiple All-Star berths for Walker, Love and Van Lier and multiple All-Defensive team honors for Sloan and Van Lier. Motta earned Coach of the Year honors in 1970–71. But eventually, his tyrannical ways led to players staging contract holdouts and Motta got fired after the crash-and-burn, 24-58 season of 1975–76. Under Ed Badger, the Bulls staged the "Miracle on Madison Street," winning 20 of their final 24 games only to be eliminated by eventual NBA champion Portland in the first round of the 1977 playoffs. By this time, the Bulls had acquired Artis Gilmore from the ABA and drafted Scott May in a roster makeover. They started changing coaches with frequency, too, replacing Badger with Larry Costello and then Jerry Sloan. New general manager Rod Thorn drafted Reggie Theus in 1978–79. Perhaps nothing symbolized the what-could-have-been nature to the decade than the 1979 draft. The Bulls lost a coin flip and selected UCLA's David Greenwood with the second pick. The Lakers snagged Magic Johnson with the first.

Opposite: Star center Artis Gilmore (right) joined the Bulls after the American Basketball Association folded and became one of the best big men in team history.

1970s HIGHLIGHTS

July 13, 1973
Bulls demote GM Pat Williams. Head coach Dick Motta takes on additional duties as GM.

Williams 'up', Motta 'in'

April 13, 1974
Bulls win a playoff series for the first time, defeating the Pistons 96-94 in Game 7 at Chicago Stadium.

Eureka! Bulls finally win playoff series

July 25, 1972
After the NBA rejects two other attempts to sell the team, the league approves a deal to sell the Bulls to a group that includes Arthur Wirtz, owner of the Chicago Stadium.

April 15, 1973
Once again, the Bulls reach the seventh game of a first-round playoff series, and once again it's the end of the road as the Lakers win Game 7 95-92 in Los Angeles.

Cliff Ray of Bulls taking rebound away from Detroit's Bob Lanier yesterday during decisive playoff game in Stadium.

April 5, 1970
Bulls are eliminated from playoffs, losing to Atlanta Hawks four games to one.

April 6, 1971
Bulls take Lakers to the limit but lose Game 7 of their first-round playoff series 109-98 in Los Angeles. Bulls win all three home games in series, but lose all four in L.A.

| 1970 | 1971 | 1972 | 1973 | 1974 |

Kareem and Bucks kill Bulls 115-99

Van Lier Back to Bulls

Nov. 9, 1971
Bulls trade center Jim Fox and a second-round pick to Cincinnati for guard Norm Van Lier and a third-round pick.

April 4, 1972
Lakers sweep Bulls out of the playoffs in the first round, four games to none.

April 22, 1974
Milwaukee sweeps the Bulls in the second round, winning Game 4 115-99 at Chicago Stadium.

Chet Nets Record 56

Feb, 6, 1972
Chet Walker sets Bulls record with 56 points in a 119-94 victory over Cincinnati.

April 6, 1975
Bulls finish 47-35, a drop-off from the previous season but good enough to win their first division title.

April 23, 1975
Bulls defeat the Kansas City-Omaha Kings 101-89 to take first-round playoff series four games to two.

May 14, 1975
After taking a 3-2 lead in the Western Conference final against the Golden State Warriors, the Bulls drop Game 7 on the road by the score of 83-79 and are eliminated one win short of reaching their first NBA Finals.

Bulls blow lead, bow out

Aug. 5, 1976
With the first pick in the American Basketball Association dispersal draft, the Bulls select Kentucky Colonels center Artis Gilmore.

April 17, 1977 ······>
The Trail Blazers defeat the Bulls 106-98 in Portland, taking the best-of-three first-round playoff series two games to one.

Bulls run out of time, miracles

June 2, 1978
Despite rumors that assistant coach Jerry Sloan would take over, the Bulls give the head coaching job to Larry Costello, who led Milwaukee to an NBA championship in 1971.

June 9, 1978
With the ninth overall pick, the Bulls draft Reggie Theus, a guard from the University of Nevada-Las Vegas.

April 28, 1979
Bulls name Jerry Sloan head coach.

1975	1976	1977	1978	1979

Feb. 16, 1979
With the Bulls 16 games under the break-even mark at 20-36, Larry Costello is dismissed as head coach and replaced on an interim basis by assistant Scotty Robertson.

May 29, 1976
Dick Motta leaves Bulls to become head coach of Washington Bullets.

June 2, 1976
Bulls name former scout Jerry Krause director of player personnel.

Aug. 25, 1976
Bulls hire Ed Badger as head coach.

Aug. 31, 1976
After just three months on the job, Jerry Krause resigns as director of player personnel.

April 8, 1978
Ed Badger announces that he is leaving the Bulls at the end of the season to become head coach at the University of Cincinnati.

May 12, 1978
Bulls name Rod Thorn general manager. Thorn had been an assistant coach with the New Jersey Nets.

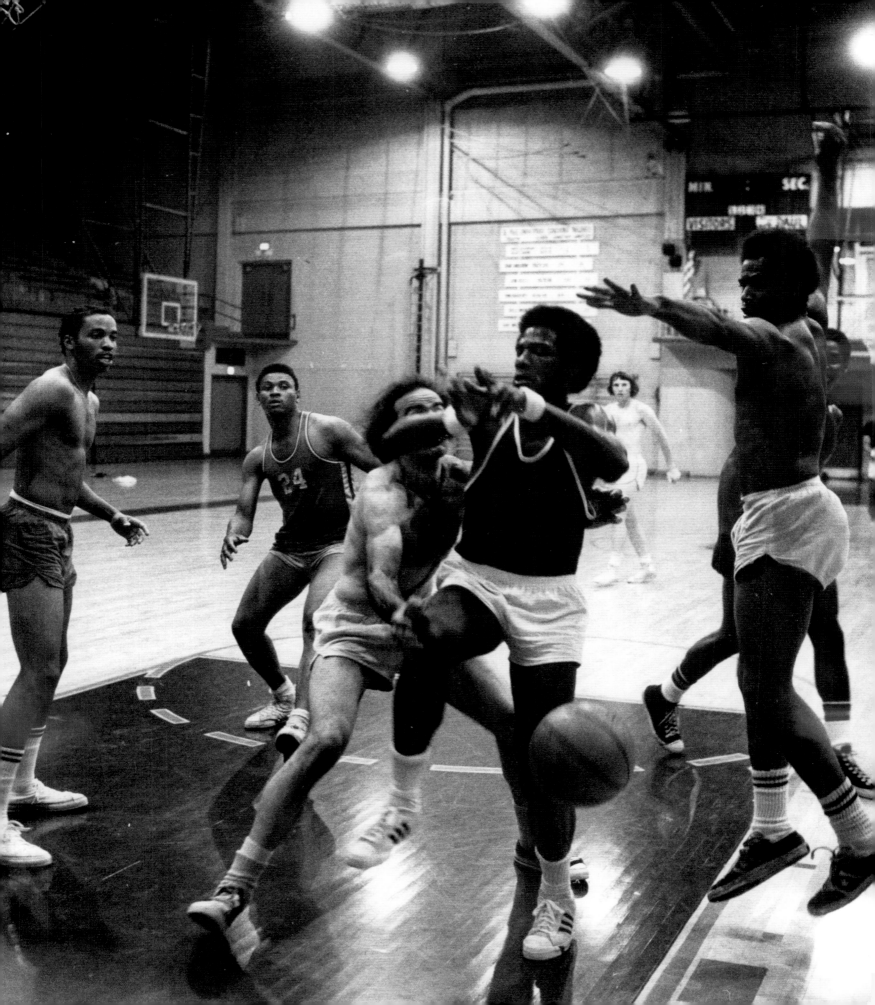

Above: Rookie-camp hopefuls recline against the folded bleachers at DePaul during a workout session in 1970.

Opposite: The Bulls scrimmage at DePaul University in June, 1972.

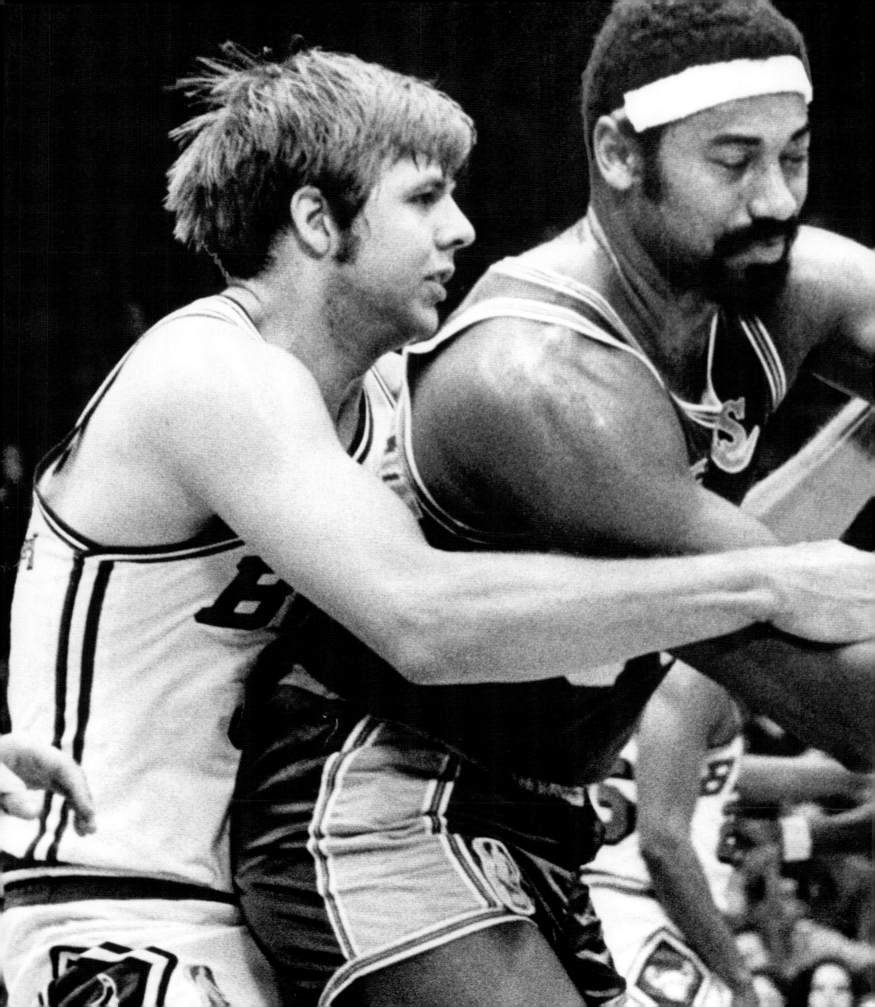

Tom Boerwinkle puts the clamps on the Lakers' Wilt
Chamberlain during Game 6 of the Western Conference
semifinals on April 4, 1971 at the Stadium. The Bulls
won the game 113-99 to even the series but lost Game 7
in Los Angeles.

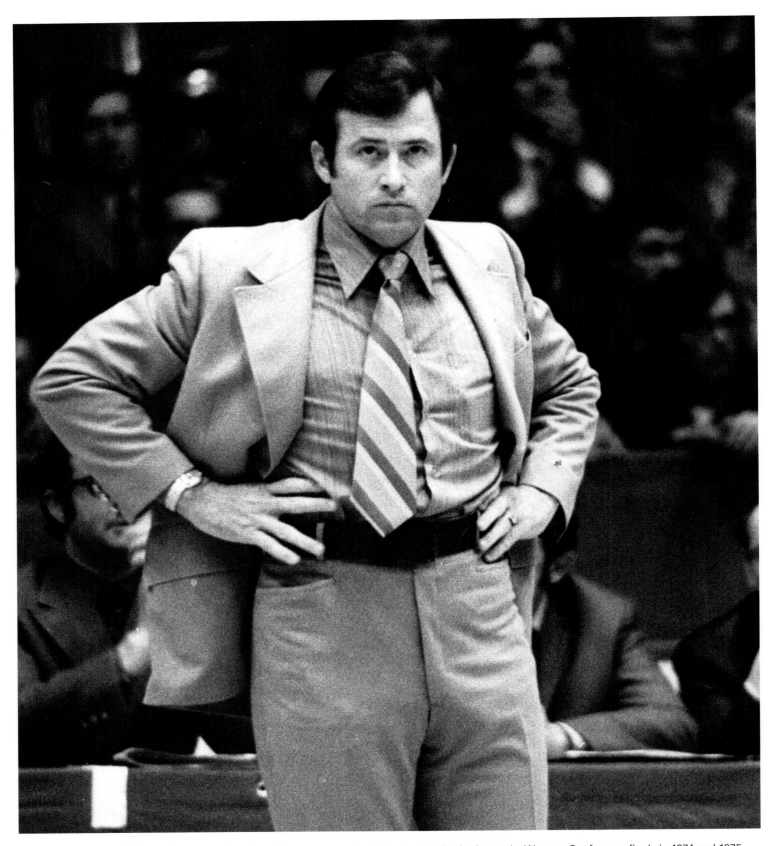

Dick Motta led to the Bulls to six consecutive playoff appearances, including back-to-back trips to the Western Conference finals in 1974 and 1975.

Dick Motta

'I'M NOT A GOOD LOSER'

HEAD COACH

1968–76

"You're trying to destroy my team," said Dick Motta.

The controlled tone didn't disguise the fury in his voice. When the coach of the Chicago Bulls speaks quietly like that, the volcano bubbling under the surface is getting ready to erupt. It was April 1, 1973, and Motta's team had just lost a second straight game to the Lakers in their best-of-seven playoff series. Being down 2-0 means you have to win four of five to survive, a hopeless task in the emotion-charged playoff pit.

Each game is like a season in capsule form. Not even Motta, a man who doesn't give up, could perceive in the smell of defeat which filled the air, the incredible finish yet to be written for this series.

Losing always was and always will be a traumatic experience for Motta, but this time I had provided a target for his frustration. My story in that morning's Chicago Tribune revealed dissension in the front office and, according to Motta, was the reason the Bulls had just been beaten by 15 points.

I realized what was happening; I'd seen it before. Motta reached the top because he's intense, totally involved. Winning is success, losing is failure, and the latter is unacceptable. So when the Bulls dropped important ones like this, Motta's temperament sent him in search of an "explanation," at least until his normal common sense overcame the sting of defeat. Often the referees were the villains. Occasionally it was a writer, and now it was my turn.

We were standing in the visitors' dressing room underneath the Forum in Los Angeles. The place has been described as Jack Kent Cooke's monument to himself, the gaudiest mausoleum outside the gates of Forest Lawn.

Motta was surrounded by Los Angeles writers when I walked into the plush, carpeted room. When Motta saw me, the subject shifted abruptly to the Tribune story in which I had disclosed he was weighing a lucrative offer to coach the Seattle SuperSonics in the 1973–74 season. I had also pointed out that the once-cozy partnership between Motta and Bulls' general manager Pat Williams was in shreds. One or the other would have to go, and I knew enough to predict that Williams couldn't win this power struggle.

Motta insisted this was the worst possible time to speculate about his departure. Personally, I thought that a team halfway to extinction in a seven-game series would be too busy to brood about a story 2,000 miles away.

"You had me going to San Antonio, Utah and Phoenix already," the coach snapped. "You must be awful anxious to get rid of me."

I refrained from pointing out that Motta thought he WAS going to Phoenix until two nights ago when I informed him the Suns had just hired a college coach, John MacLeod. Now time was short for my final edition in Chicago, so I let Motta finish his gripe therapy, asked a few routine questions about the game, and wandered off to talk to the players. I did permit myself the luxury of asking Chet Walker whether my story upset the team as much as Motta claimed it did.

"What story?" asked Walker.

Motta reached the top because he's intense, totally involved. Winning is success, losing is failure, and the latter is unacceptable.

You might conclude from this episode that Motta is (a) irrational and (b) impossible—or at least difficult to work with. But such explosions are the exception to his rules for press relations. He has always (well, almost always) recognized his obligation to talk with the media.

As any fool, including a sportswriter, can see, Dick Motta speaks his mind. Back in the beginning when he arrived in Chicago to coach the struggling Bulls, not all that many people were listening.

Unquestionably, most of the credit for their transformation from losers to winners belongs to Motta, though he didn't have to come here to prove what he could do. A coach with his ability to fit egocentric athletes into a concept of team play would have been discovered sooner or later.

But there comes a time when the main road intersects with a dead end and a man must choose: either confront success or walk away from the challenge.

For Motta, the decision began in 1967 when Bulls general manager Dick Klein arrived in Ogden, Utah, to see a game at Weber State College. The Bulls' boss liked the way the young coach refused to leap at his first pitch.

It would be harder to find more contrasting types than extrovert Klein and introvert Motta. Nevertheless, the salesman who had created the Chicago franchise out of thin (if not hot) air had to sell somebody on being his coach. He'd had enough laughs from John (Red) Kerr, the nice guy who steered the expansion Bulls into the playoffs but was struggling through his second campaign to empty seats.

Klein was impressed by Motta's outlook and dedication. He also figured that the country boy would be easy to handle. Along with a lot of other people, Klein was in for a surprise.

When word leaked out (as it always does in the NBA) of his hiring, Motta was labeled "the unknown coach" amid replays of the Klein-Kerr blowup. He handled himself well at the first grilling, however, fielding hot potatoes like unsubtle hints that his Mormon background might prove to be a handicap with the NBA's majority of black athletes.

"I won't be a rubber-stamp coach," Motta asserted. "I'm not a good loser."

It took Chicago a good while to discover Motta wasn't just another in the procession of rubes who try, fail and quickly vanish. He proved himself in a situation few men could cope with—a domineering boss, a failing franchise, a losing team and an indifferent city.

Until Motta arrived, the pro winners were tough, hard-bitten guys like Red Auerbach and Richie Guerin, survivors of the era when every NBA club had a resident hatchet man. What the rest of us didn't know then was that Motta, under the soft-spoken exterior, was one tough son of a bitch.

Among the traits in his complex personality were desire and stubbornness, plus more than a touch of ruthlessness. All served him well while hacking a path through the NBA jungle. He disliked Chicago at first sight and would have preferred to live elsewhere, but he coached the Bulls for eight seasons and won 50 or

DICK MOTTA

- » **Born:** Sept. 3, 1931 in Midvale, Utah
- » **College:** Utah State University
- » **Years in NBA:** 1968–87, 1989–92, 1994–97
- » **Hired by Bulls:** May 27, 1968

more games four times in a row during that span. The Bulls reached the playoffs six straight times under his direction, making it as far as the Western Conference Finals in 1974–75, finally succumbing to the Golden State Warriors in a memorable seven-game slugfest.

But things started to unravel early in the following season; a nine-game losing streak in November dropped the Bulls to 3-11. They never recovered.

Motta's personality clashed with some of his players, including the usually placid Bob Love—whom Motta once called "the greediest player in the league"—as well as the volatile and fiery Norm Van Lier.

"We've had our differences," Van Lier said in April of '76. "I've said some things about him in the past and I stand by them. At least we talk man to man now. It used to be he'd scream at me like a little kid. I couldn't stand that. I actually felt a little sorry for him this year. He's not used to losing. He's shown more humor this season. I guess he had to."

After the Bulls finished 24-58 in 1975–76, Motta left the Bulls for the Washington Bullets.

Motta would coach another 17 years in the NBA. He won an NBA championship in his second season with the Bullets and reached the Finals again the following year, only to lose to the Seattle SuperSonics. Motta was the first coach of the Dallas Mavericks and also had stints with the Sacramento Kings and the Denver Nuggets. He finished with a career record of 935-1017.

"I learned the hard way in Chicago," Motta said. "My problems came from being the man in the middle, between players who wanted to renegotiate contracts and the ownership, which refused."

The Bulls got off to a quick start in the 1971-72 season and wound up winning 57 regular-season games but were swept by the Lakers in the first round of the playoffs. Here Jerry Sloan (left) and Cliff Ray battle the Suns' Paul Silas for a rebound in a 108-101 Bulls victory at the Stadium on Nov. 2, 1971.

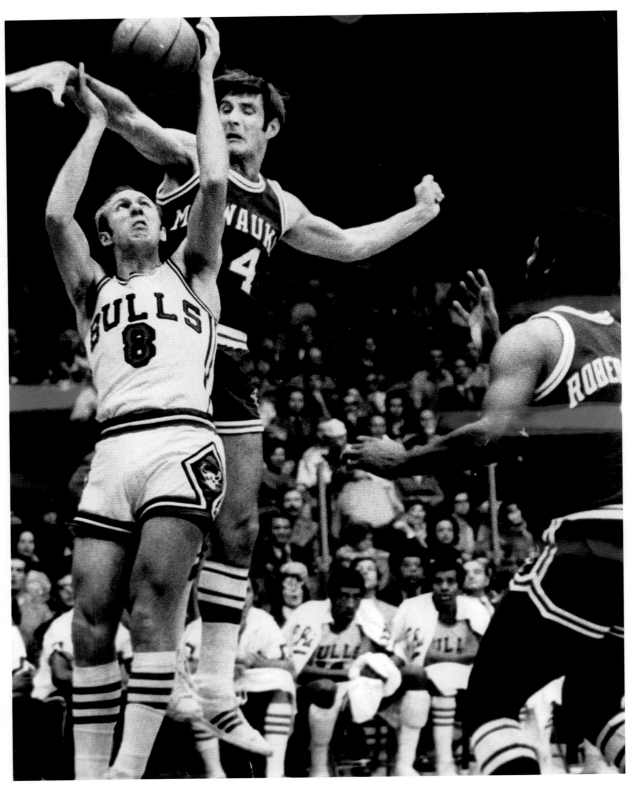

Above: Acquired from Milwaukee with Bob Love in a 1968 trade, Bob Weiss proved to be a valuable and durable guard for the Dick Motta-era Bulls.

Opposite: Dennis Awtrey contends for a rebound against Portland's LaRue Martin during a 109-100 loss to the Trail Blazers at the Stadium on Dec. 19, 1972.

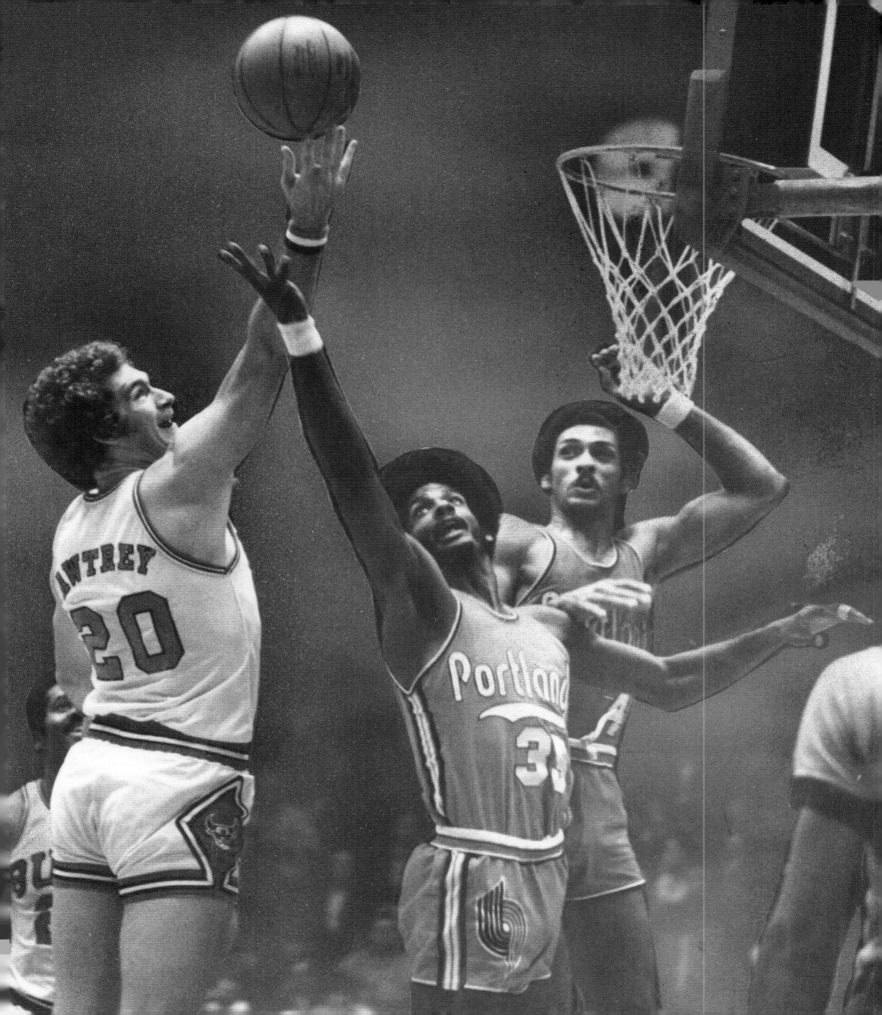

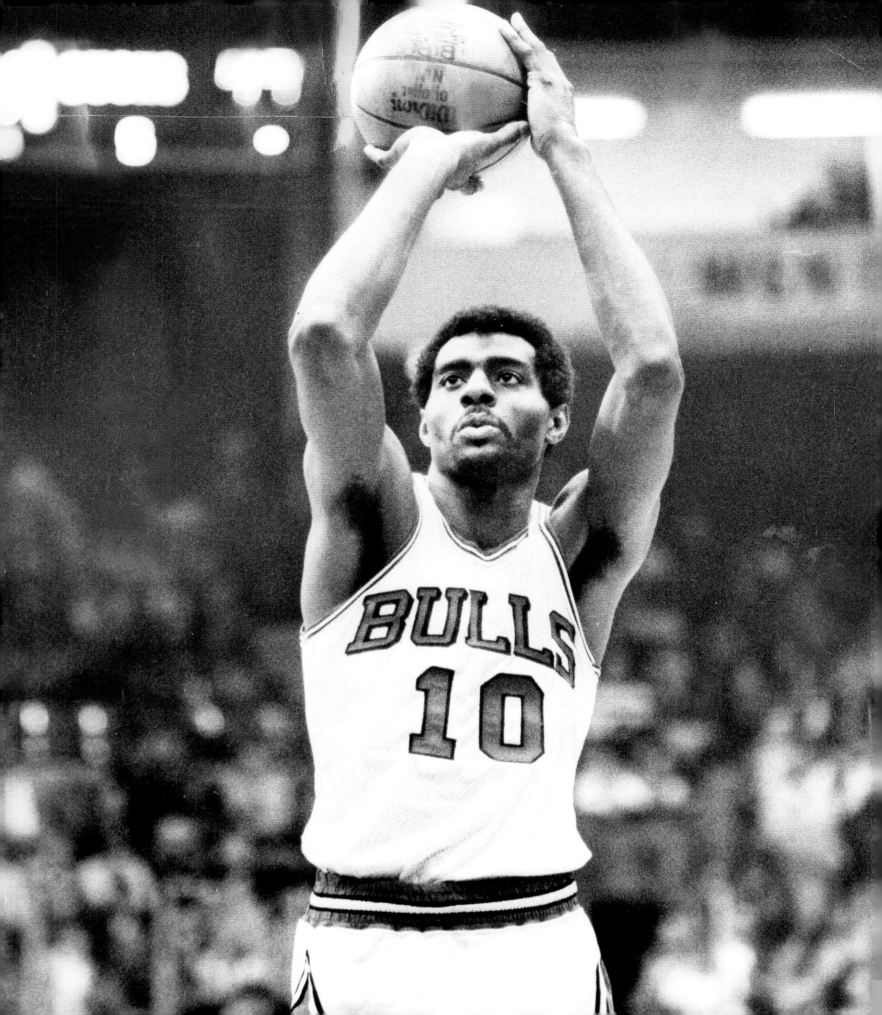

Bob Love

A DECEPTIVE SUPERSTAR

**10 POWER FORWARD/
SMALL FORWARD**

1968–76

This is a Love story.

It's about Bob Love, the poor kid from Bastrop, La., with the severe stutter who saw love everywhere.

The NBA scorned him after he graduated from Southern University in 1965, so he had to go to the old Eastern League for $50 a game and work a part-time job in a hospital. But he believed the NBA eventually would embrace him. And it did.

Bob Love found a home in Chicago in 1968 and went on to lead the Bulls in scoring seven straight seasons while becoming one of the most prolific scorers and feared defenders in the NBA.

He refused to believe that society, so cold in its reaction to his speech impediment that he went from being a basketball star to a department store dishwasher, would not welcome and support him again. And it has.

Love's No. 10 jersey, which he wore during nearly nine wonderful, disappointing and tumultuous seasons in Chicago from 1968 through 1977, hangs from the rafters at the United Center, right up there with the championship banners and all those sad and beautiful memories.

"As I look back and remember all the players who were in the limelight, getting TV interviews and the commercials and all that stuff, you basically don't hear about them," says Love. "It seems like I'm the guy getting the headlines, and back then I was the guy who couldn't even talk.

"It's funny how life comes full circle. But the main thing is, I always wanted to be a nice person and treat people with respect and be treated the same way.

"Mr. (Jerry) Reinsdorf is the greatest guy in the world because he and Steve Schanwald brought me back to the Bulls (as director of community relations), and I can't say thanks enough for that," Love says. "And to Susan Hamilton, my speech therapist, who's put me in a position where I can go out and talk before groups of people every day. I'm overjoyed, really, as I look back on where I came from. It's just unbelievable."

Bob Love's story is remarkable, not only for its long journey to respectability and success, but for his refusal to quit or become embittered by the obstacles he faced. He was raised in a two-bedroom house, one of 14 children in an extended family, and despite his severe stutter, he would be the only one to attend college. "I always felt I had a special something inside of me that told me I had to do a certain thing in life."

He grew up as "Butterbean," a name hung on him by a fellow grammar school student because of his love for the food. He also admired an uncle who had a stuttering problem—so much so that Love acquired the stutter.

"He would take me everywhere with him," Love recalls. "I loved him so much, I guess I wanted to talk like him. Nobody tried to stop me. They thought it was cute. They thought I'd grow out of it. But it kept going."

Love was perhaps the top small-college player of his era, averaging more than 30 points and almost 20 rebounds as a senior. He was a leaper said to rival Julius Erving or Michael Jordan, a player with great defensive instincts and an excellent shot. "I probably would be the No. 1 pick in the draft today," he muses.

But the NBA was just starting to adjust to black players then and was still wary of the small, black colleges. So Love was a fourth-round pick of the Cincinnati Royals at a time when there were nine teams and rookies rarely played.

"I felt I was one of the best forwards there," says Love, who publicly declared he was better than starter Happy Hairston. But he was released to the Eastern League, a CBA-like circuit of small Pennsylvania and New Jersey towns where pay came only when you played and wasn't much. Love worked days in a New Jersey hospital while picking up training to support his degree in nutrition.

He made it back to Cincinnati in 1966, but as a reserve. He averaged only six points per game over two seasons as back surgery reduced him to a floor-bound player. But no setback ever stopped Bob Love.

"Maybe the back surgery was a blessing in disguise," he says, "because I became a smarter player. I worked on my shot day in and day out, and guys never could understand. I'd put the ball at the top of my

Opposite: After two-and-half unremarkable seasons with Cincinnati and Milwaukee, Bob Love blossomed into an All-Star with the Bulls.

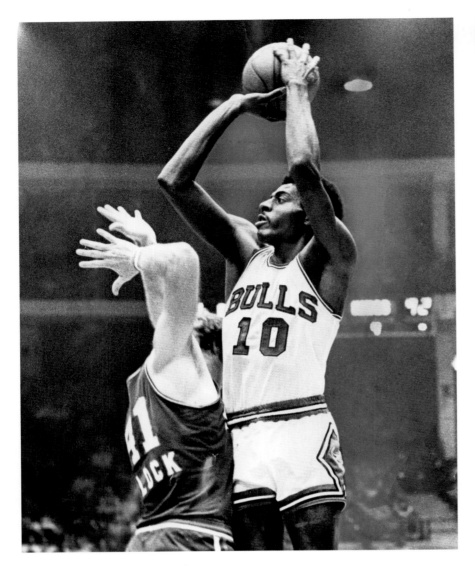

Bob Love led the Bulls in scoring for seven consecutive seasons and was named to the NBA's all-defensive team three times.

BOB LOVE

- » **Born:** Dec. 8, 1942 in Bastrop, La.
- » **Height:** 6-8'
- » **Weight:** 215
- » **College:** Southern University and A&M College
- » **Years in NBA:** 1966–77
- » **Acquired by Bulls:** Nov. 23, 1968 from Milwaukee Bucks with Bob Weiss in trade for Flynn Robinson

head and give a fake. If they jumped, I'd hold the ball, then shoot it. If they didn't, I'd just shoot it. It was as simple as that. I worked on it and worked on it until it was perfected."

Baffled defenders would say he could get that shot off in a phone booth while being guarded by Wilt Chamberlain. But Love didn't get much chance to show it off until Milwaukee, which had acquired him in the expansion draft, traded him to the Bulls with Bob Weiss for Flynn Robinson in 1968.

"In Milwaukee, I was the leading scorer in the exhibitions," he says, "and I remember (teammate) Wayne Embry saying I was going to be one hell of a player for them. But the general manager said, 'Bob can't talk. We don't want a guy like that.' I decided to let my basketball do the talking."

But the Bulls didn't want the 26-year-old bench-warmer, either.

"We got Bob as a throw-in on the Flynn Robinson deal," recalls then-GM Pat Williams, now with the Orlando Magic. "We then got Chet Walker and were trading Bob Boozer for a power forward, Bob Kauffman. But Seattle also wanted Barry Clemens. Dick (Motta) wanted to keep Clemens, and we tried to give them Love. But they wouldn't take him. We reluctantly made the deal."

So Bob Love and his dancing smile stayed in Chicago. And nobody scored more points as a Bull until Michael Jordan eclipsed Love's mark in 1990.

Love averaged 21 points his first full season as a starter in 1969–70, then 25.2, 25.8, 23.1, 21.8 and 22 the next five years. He had back-to-back 49-point games, scored 21 in a quarter against the great Celtics and saved his best for the playoffs, averaging 22.9 points for a team that rarely scored 90.

Despite being a willowy 6 feet 8 inches and 205 pounds, he had to play power forward alongside Walker. Three times, he made the All-Defensive team. "That was my greatest joy. I always felt you could not be a complete player if you didn't play defense."

Love was embroiled in seemingly endless contract disputes and holdouts that eventually caused Motta to blame him for the 1975 playoff loss to Golden State.

"Once he became a good player, we could never keep up financially with what he deserved," Williams said. "He was the Karl Malone of his day. He changed agents every six months."

"Because of my speech problem, people thought I shouldn't fight for my rights and dignity," says Love. "I'd always hear, 'Butter ought to be glad he's in the league.' A lot of people made that mistake about me. I'm a man of enormous pride."

That pride never let Love quit, even after his career came to an abrupt end in 1977, when he was traded by the Bulls and cut by New Jersey and Seattle. He ended up cleaning tables in Nordstrom's basement restaurant in Seattle, promising to be "the best dishwasher and bus boy I could be."

In 1992, the Bulls offered Love a chance to come home as the team's director of community relations.

"What I'm doing now is what I've dreamed about all my life," Love said in 2002. "This never would have happened if I had played the victim in life." 🏀

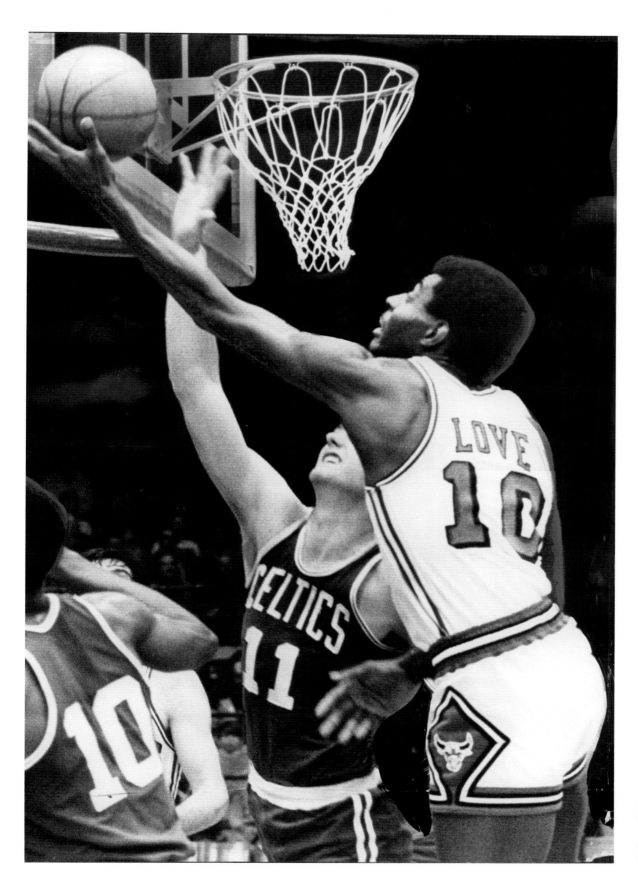

Bulls GM Pat Williams considered Bob Love a "throw-in" piece in the trade that brought Bob Weiss from the Bucks.

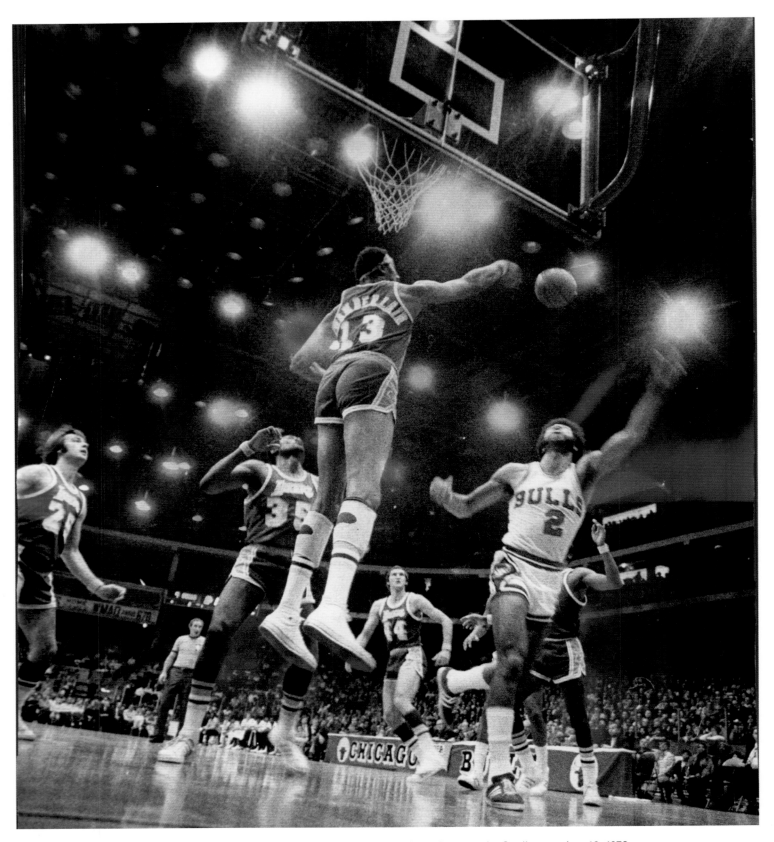

Wilt Chamberlain rejects a shot by the Bulls' Norm Van Lier during a 109-97 Lakers victory at the Stadium on Jan. 12, 1973.

Above: The core of the 1970s Bulls consisted of (from left) Norm Van Lier, Chet Walker, Jerry Sloan and Bob Love, shown here at a 1973 practice session.

Right: The Bulls' braintrust—from left, business manager Johnny Kerr, assistant coach Ed Badger and head coach Dick Motta—is captured in full hand-on-chin mode during the 1974 draft. The Bulls drafted Marquette University star Maurice Lucas with the 14th pick of the first round that year, but Lucas chose to sign with the St. Louis Spirits of the rival ABA.

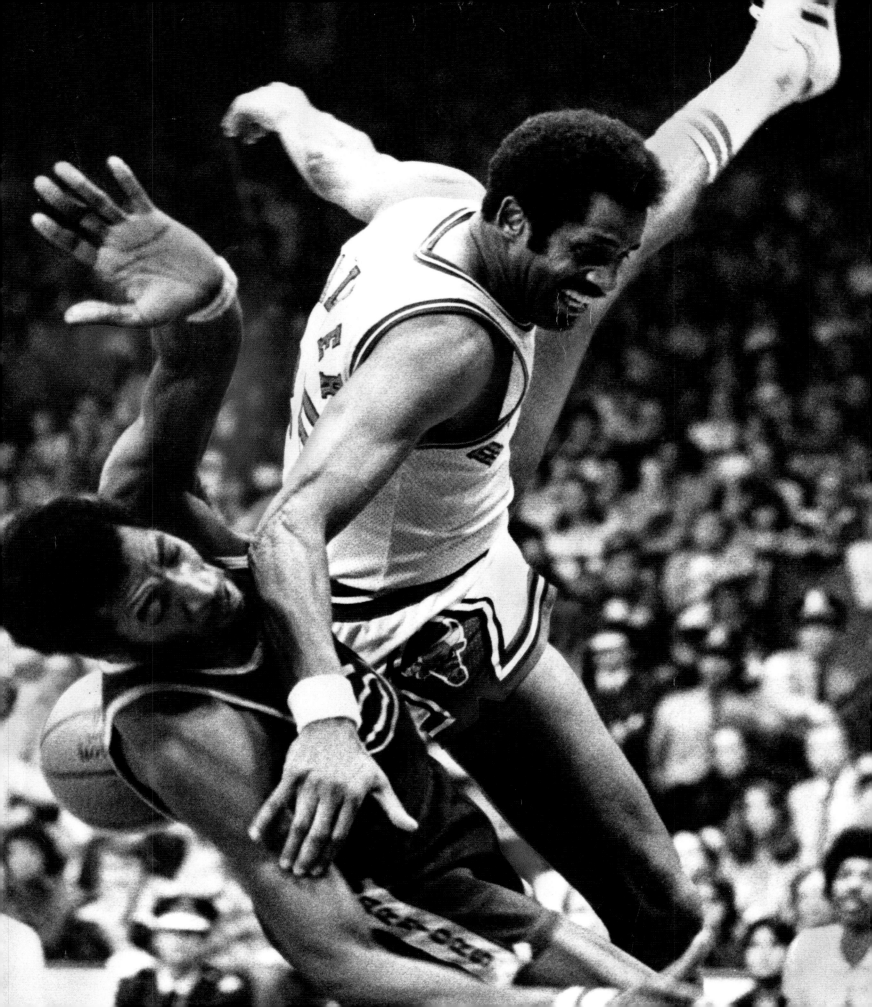

Chet Walker

LONG TIME COMING

25 SMALL FORWARD

1969–75

A seagull was gliding effortlessly above the dozens of boats splashed across this inlet near the Pacific Ocean, and Chet Walker sat back for a moment in reflection. The harsh screech of a gull seemed to jolt him back, perhaps to the days when Walker's subtle grace and meticulous moves—a head feint, a shoulder twitch, some where-did-he-go deception—led to a big basket that would ignite the crowd at Chicago Stadium or Philadelphia Civic Center or Bradley's Robertson Fieldhouse.

"I never thought I'd be saying guys are making too much money," Walker said, and it's difficult for him to suggest that even now given his history as a labor activist. "But you hear of these guys rejecting $10 million a year, it's absurd. You can't believe it.

"I don't have cable, so I don't watch much NBA. But I watch the Lakers. I don't understand these owners, how they evaluate talent. How do you pay Kwame Brown $9 million? Amazing. And these guys think they're making this money because they're great players."

Actually, they're making it in large part because of guys like Walker, who was one of the so-called NBA 14, the group of players that successfully brought on the modern NBA era with the first free agency. Many, like Walker, suffered for it. His career ended prematurely even though he averaged almost 20 points per game his final season for the Bulls in 1974–75.

Like a jet plummeting to Earth, it was a sudden flameout for the career of the 6-foot-7-inch Chet "the Jet" Walker, a skillful ironman who missed an average of two games per season in a 13-year career and was an All-Star four of his last six NBA seasons and seven times in all.

After the lawsuits were settled, no team would sign Walker, and he retired at 35 with career averages of 18.2 points and seven rebounds and the only 50-point game in Bulls history until Michael Jordan came along.

The original suit was filed in Oscar Robertson's name, and despite his stature in the game, Robertson was not allowed to do television work after he retired while the suit was pending, and he never could land a coaching job or an executive position.

Walker can relate.

His gentle demeanor belies a fierce competitiveness that was on display during Michigan high school battles with Dave DeBusschere and Missouri Valley Conference college wars with Robertson that still stir basketball memories.

Walker came to the NBA with the Syracuse Nationals, soon to become the Philadelphia 76ers, in 1962, part of the first wave of great black players who remade the pro game, disrupting the quota system ("play three blacks at home, four on the road and five if you want to win") and rescuing the league from its own ignorance.

Walker was no stranger to racism growing up in rural Mississippi, where he recalled having to call white children "sir." He was the youngest of 10 children whose mother took the family to Benton Harbor, Mich., to escape frequent beatings by Chet's father.

Walker was drawn to the story of Mary Thomas' struggles on Chicago's angry West Side partly because of the similar inner strength of his own mother, Regenia, who never allowed despair to overtake her family.

It was a golden, somewhat naive era for basketball, and Walker was in the middle of it, playing with Wilt Chamberlain in the great rivalries and showdowns with Bill Russell and the Boston Celtics, playing for what some regard as the NBA's best team ever, the 76ers of 1966–67, who were a then-NBA-best 68-13 and halted Boston's streak of eight consecutive titles.

"We didn't realize how good we were," Walker recalled of the team that started 46-4 at a time when the league record for victories was 60. "We could have lost maybe five, six games, but we went out on some road trips and goofed around."

Walker was known as something of a ladies' man in those days, running with Chamberlain, whose fondness for female companionship was legendary. He misses his friend, who died of a heart ailment in 1999.

"Wilt always had that condition," Walker said. "He took medication all the time. He was always afraid of something. He would never go to sleep, maybe two or three hours a day. I think he was afraid he might die. When he died, it was in his sleep.

Opposite: The acquisition of Chet Walker (right), who had won an NBA title with the 76ers, gave the Bulls a proven veteran who was a prolific scorer as well as a stalwart defender.

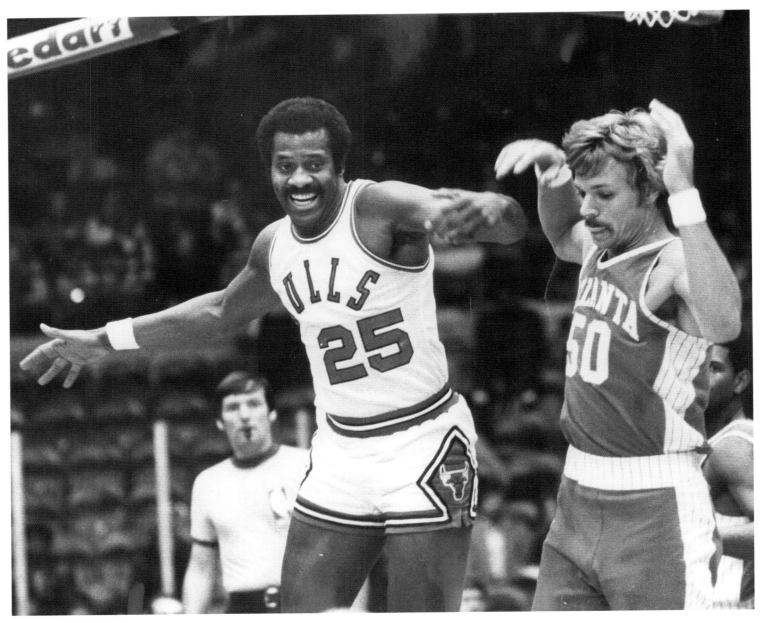

Chet Walker was a four-time All-Star with the Bulls and averaged 20.6 points and 7.1 rebounds per game in his six seasons in Chicago.

"Can you imagine what a show Wilt and Russell would be today?" Walker asked with a knowing laugh. "We'd play 12 times. They beat us the game [John] Havlicek stole the ball (the pass was intended for Walker because Chamberlain didn't want it—he was a notoriously poor free-throw shooter). Next year we come back and beat them. The next year we're up on them 3-1 and Martin Luther King was assassinated and they come back and beat us at home in Game 7. Wilt doesn't take a shot in the second half of the last game. I never knew why."

Walker smiled as memories of Chamberlain came flooding back.

"Wilt never did want to practice. He and [76ers coach Alex Hannum] would fight all the time. He didn't like to run plays. He'd think too much. Finally Alex would say, 'Forget it and just play.'"

Chamberlain soon would pack up and leave for Los Angeles as there wasn't much beach volleyball in Philadelphia. Walker was traded to the Bulls in 1969 for the supposedly more athletic Jimmy Washington as the great Sixers team was broken up gradually.

Still unshakably poised with the ball and uncannily crafty with one-on-one moves, Walker was the leading scorer that first season as the Bulls became one of the toughest teams in the league, averaging 52

CHET WALKER

» **Born:** Feb. 22, 1940 in Bethlehem, Miss.

» **Height:** 6-6'

» **Weight:** 212

» **College:** Bradley University

» **Years in NBA:** 1962–75

» **Acquired by Bulls:** Sept. 2, 1969 from Philadelphia 76ers with Shaler Halimon in trade for Bob Kauffman and Jim Washington

victories in a five-year run. But also perhaps the most snakebit—they never did make a Finals appearance.

Walker was a renowned clutch performer who typically took the last shot for his teams. His moves seemed simple, though rarely defendable. His game was like unappreciated artwork, a symphony of simplicity.

Off the court, Walker was viewed as somewhat aloof and private, but he was a fighter against injustice, which prompted him to take a leading role in the historic NBA labor changes. The league was more of a sideshow in its early days, overshadowed by sports like boxing and horse racing, not to mention baseball and football. It wasn't uncommon for players to leave for better paying jobs in insurance or accounting.

A **players union** was formed in 1954 with Celtics great Bob Cousy as president, but membership was sparse as many players balked at paying the $10 annual dues. The union finally flexed its muscles in 1964 when players threatened to boycott the All-Star Game after owners balked at funding a pension plan.

Walker made his first All-Star team that year.

"I remember owners were banging on the door," he said. "Elgin Baylor and Jerry West were being threatened with their careers—they'd never play again. We wouldn't come out until they agreed to talk. Finally, the commissioner promised he'd discuss a pension plan."

The ABA came along in 1967. Three years later NBA owners initiated merger talks to halt the costly bidding war for players, but the players union, now led by Robertson and backed by Walker and fellow members of "the NBA 14," filed suit to block a merger.

It finally was agreed to in 1976, with provisions that allowed for free agency and effectively began the NBA's economic renaissance, though not necessarily for Robertson, Walker and their fellow pioneers: Bill Bradley, Joe Caldwell, Archie Clark, Mel Counts, John Havlicek, Don Kojis, Jon McGlocklin, McCoy McLemore, Tom Meschery, Jeff Mullins, Wes Unseld and Dick Van Arsdale.

With free agency initially delayed, Walker was in no position to wait at age 35. So he filed his own suit, temporarily blocking the settlement, and eventually settling. And suddenly offers dried up. He felt ensnared in the thickets of an ugly past and small-minded men.

"I think I was blacklisted," Walker said matter-of-factly.

There's not the slightest hint of rancor in his voice, which still carries musical traces of his Southern heritage. But he's deeply hurt by an ongoing snub from the Basketball Hall of Fame.

"I wouldn't come back to the Bulls—I couldn't play for [Dick] Motta," Walker said. "I always felt if we had a coach we'd have won two championships for sure with that team.

"I thought I had a deal in Milwaukee, but I couldn't get one anywhere. I was basically forced out. It was like the end of the story."

So Walker moved to California to begin a new chapter, a good one, he said with a smile.

"The point was the lawsuit changed the whole structure of the NBA," Walker said. "The players started making more money, so the coaches made more money. It took away all the power from the owners. The Robertson suit made possible all the money that's made now. Larry Fleisher (the players' attorney) never got the credit he deserved.

"Nobody talks about what those players did. I wonder if guys even know who we were. It all started with 14 guys. It just seems to be something guys should know." 🏀

In 1975, the Bulls came within a win of reaching the NBA Finals for the first time in franchise history, but squandered a 3-2 series lead and were beaten in seven games by the Blazers.

The one that got

Norm Van Lier, Jerry Sloan and Nate Thurmond found themselves together on the Chicago Stadium floor as members of the West team in the "Legends" All-Star game.

They cavorted about some, trying not to embarrass themselves ("I don't know how safe the people in the front row will be," says Sloan. "I'm so awkward now I'll probably run over somebody.") and thinking they might even get to shoot the ball if Rick Barry and Doug Collins were not in the game.

Yet the moment had to feel somewhat bittersweet for Van Lier, Sloan and Thurmond, too, because it carried with it memories of the May Sunday in 1975, the last time they played together on this court, when their Bulls team squandered a chance to become champions of the National Basketball Association.

That loss and the subsequent one on the road to the Golden State Warriors after the Bulls had taken a 3-2 lead in the series marked more than a missed opportunity since the Warriors went on to sweep the Washington Bullets for the NBA title.

It represented the end of an era for that team, which had averaged 52 wins a season for the prior five years. The following season, the Bulls would fall to 24-58, coach Dick Motta would leave and only twice in the next 11 years would the Bulls even have a winning record. They would never win as many games as any of those teams.

"We felt that was our year," recalled Thurmond, who went on to become a Warriors executive. "After that, you could see things unraveling."

It started right after that seventh-game loss in Oakland, where the Bulls blew a 14-point lead. Motta blasted Van Lier and Bob Love, saying he wanted to get rid of them and suggesting they not get their full playoff shares because they were early-season contract holdouts.

"Whenever something went wrong, Motta would find someone to blame," said Van Lier, now a West Coast automobile dealer. "He wouldn't accept blame too often. It never bothered me. But I thought they broke that team up too quickly.

"The Bullets stayed together and they finally won. They should have gotten (Chet) Walker signed (he retired after that season) and they should have kept Thurmond (he was traded early the next season). Then they got rid of Love (for a second-round draft pick). I think we would have been back."

Whether they would have been back no one will ever know. What is clear is the way that team was disbanded produced the decade of dearth for Chicago pro basketball fans.

"They allowed guys to retire or be traded without getting anything for them," observed Johnny Kerr, then the team's business manager. "You can't replace these type of players with second- and third-round draft picks."

Yet that was the essence of the best pro basketball team Chicago, up to that point, had ever claimed.

"I was an expansion player from Baltimore," said Sloan. "They told me I'd probably never play in the NBA. Van Lier had been drafted by the Bulls (in the third round in 1969) and traded to Cincinnati. But they (the Royals) had Tiny (Archibald) and needed a big guy, so we gave them Jim Fox for Van Lier (in 1971). That's when the team really started making strides."

"I felt we were the best defensive backcourt ever to play the game, bar none," said Van Lier.

Love, who had been cut by the Royals and had played in the Eastern League, came with Bob Weiss from Milwaukee for Flynn Robinson. Walker came from Philadelphia, where new coach Jack Ramsay thought he was too slow and too old, for Jim Washington. And then what seemed like the final piece: Thurmond. "There was the feeling that if we had the big center we could compete with Wilt (Chamberlain) and (Kareem Abdul-) Jabbar, who we had to get past in the Western Conference in those days," says Van Lier.

Despite winning 51, 57, 51 and 54 games in the four previous seasons, the Bulls could never finish ahead of the Bucks with Abdul-Jabbar or beat the Lakers with Wilt in the playoffs. But in the 1974–75 season, Wilt had retired, Abdul-Jabbar was hurt and the Bucks missed the playoffs. The Bulls won their first division title that season.

And now they had the big center in Thurmond, who blocked 12 shots in his Bulls debut to go along with 22 points and 14 rebounds, even if they didn't call it a triple-double in those days.

But it would be a disappointing year for Thurmond, not only because the team that traded him after he spent 11 seasons with them ended up winning the title, but because he never could make the contributions that were expected of him.

"I still feel he was not used the way he should have been," said Van Lier. "He was not a passing center like

away

(who he was traded for, Clifford) Ray or (Tom) Boerwinkle. But he had to adjust to our system, and there wasn't time."

"I figured they'd change the offense a little bit," said Thurmond.

"Motta liked the forward scoring low. I thought I'd get more shots, but that wasn't the case. I tried to adjust. But I wasn't a great passer. And we really didn't get the team together until after the season started."

That was because of the Van Lier and Love holdouts.

"If they had paid me what I deserved, I would have been around," said Van Lier, still bitter about the negotiations.

The team struggled early with Leon Benbow playing for Van Lier and Matt Guokas playing for Love. But after Van Lier returned in November and Love in December, the team won 22 of 27 through the end of February on the way to 47 wins and the division title. But the holdouts may have played a part in the eventual defeat.

"We dropped below 50 wins that year," recalled Sloan, "and with a few more wins we could have had homecourt advantage for that seventh game."

But it didn't seem like a seventh game would be necessary.

The Bulls were a team of overachievers, players rejected by other teams seeking to prove their worth. They fit well into Motta's system and developed a fearsome reputation for their tough defense, often called cheap and dirty around the league.

"We heard everything," said Sloan. "That's what happens when you play hard. We didn't give an inch because we knew we were playing against people who were more highly regarded and we had to play hard all the time to have a chance to win. We fought for everything we got."

The Bulls eliminated Kansas City, coached by Motta protege Phil Johnson, in six games and were ready for Golden State, whom they'd defeated three of four times during the season. Thurmond and Boerwinkle had dominated Ray and George Johnson, and Love and Walker handled Barry and Keith Wilkes.

The Bulls won two of the first three, but then lost Game 4 after holding a 19-point lead. And that was producing a disturbing pattern for Chicago. The Warriors substituted freely and were wearing down the Bulls, who got little from their bench.

GAME 1
Warriors, Barry handle Bulls 107-89

GAME 2
Bulls even series with 90-89 triumph

GAME 3
Bulls tame Warriors, lead series 2-1

GAME 4
Bulls blow it! Warriors knot series

GAME 5
Bulls triumph 89-79

GAME 6
Warriors deny Bulls 86-72

GAME 7
Bulls blow lead, bow out

"It just seemed like they were putting new people out there all the time," said Sloan.

The Bulls won Game 5, holding Golden State to just 79 points, and went back to Chicago needing just one win to earn the right to play the Bullets, who had started out in Chicago as the Packers/Zephyrs.

Almost 20,000 packed the Stadium May 11, 1975, to celebrate a title. And the Bulls jumped ahead by 10 points early. But Barry kept the Warriors close with uncanny shooting and late-season pickup Bill Bridges contributed key baskets.

"Bridges had been retired when they picked him up," said Thurmond, who was backing up Boerwinkle in the playoffs, "and he was making shots that he never made in his prime. He killed us."

The Bulls scored just 72 points and lost by 14, then went back to Oakland, where they lost by 4 after blowing a 14-point lead.

"People said we were too old," said Sloan, "but they just wore us down. The amount of minutes we played and as hard as we played them, we just couldn't hang with them (Golden State's reserves outscored Chicago's 26-3 in the seventh game). We played as hard as anyone can play."

Which they all felt would be enough.

"It was all in our favor," Van Lier lamented. "We had it." 🏀

Norm Van Lier

STORMIN' NORMAN: A FIGHTER AT HEART

23.2 POINT GUARD/ SHOOTING GUARD

1969, 1971–78

Being an outsider always suited Norm Van Lier. It fit his personality like a floor burn, made him hungry, caused him to narrow his eyes.

It informed almost everything he did, from his days as a player to his later work as a radio and TV personality.

His edges were hard, his elbows were hard and his life was, at times, hard.

He was hard to get around if you had the basketball. He was hard to figure sometimes. And his hardheadedness was legendary.

You didn't want to be around Van Lier when there was a loose ball.

He wasn't a superstar. He was a presence. He was the checkpoint you had to get past. He had to be accounted for. As a player, he demanded that.

He played his college ball at St. Francis in Pennsylvania because no big-time basketball schools came calling for his services. That's how it was for him, and that's how he ended up trying to prove to the world how wrong it was.

If you're a Chicagoan of a certain vintage, whenever you think of Van Lier, you think of Jerry Sloan. They were cut from the same rock. The Bulls drafted Van Lier in 1969 and traded him to the Cincinnati Royals. That led to a confrontation between the two players.

"We were playing an exhibition game against [the] Bulls, I think on the campus of Illinois State," Van Lier told the Washington Post. "Jerry and I got to pushing and shoving each other and then fighting. . . . Well, play continued at the other end, and Jerry and I kept going at it.

"The rest of the guys looked up and said, 'Where the hell are Norm and Jerry?' We had rolled right out of the gym into the halls of the arena. I think we knocked over a popcorn maker."

The Bulls later wanted to reacquire Van Lier, but before they did, they asked Sloan whether he would be able to coexist with the scrappy point guard.

Sloan said that any guy who fought like Van Lier could be his teammate.

Opponents would have rather had non-elective surgery than face Van Lier. He often was assigned to the other team's best guard and he usually made life hell for him.

But his offensive game tends to get lost in the discussions about his grit. He averaged 11.8 points, 7 assists and 4.8 rebounds per game. That would get him about $8 million a year in the NBA today.

Longtime teammate Bob Love recalled an incident when Van Lier retaliated for a hard foul against one of the Bulls by challenging Portland's Sidney Wicks.

"He was a fighter who wasn't afraid of anybody," Love said. "Sidney was 6-9, 240. Norm was 6-1, 165. Norm picked up a chair and ran Wicks all around the court. He said, 'Butter, if I had hit him, I would've cut him down to my size.'"

NBA Senior Vice President Brian McIntyre was at that game and laughingly recalled Bulls coach Dick Motta saying, "I knew when Norm went for the chair, he wasn't going to sit on it."

Van Lier was born and grew up in Midland, Pa., a town of 6,000 in an area of coal mines, steel mills and football players. Mike Ditka, Tony Dorsett, Joe Montana and Joe Namath came from nearby towns.

In high school, Van Lier excelled in sports. He was a guard on a basketball team that lost two regular-season games in three years and won the state championship when he was a senior.

"I never had anyone who competed harder," said Hank Kuzma, his high school coach. "He was like a coach on the floor, he never second-guessed me and he sacrificed his statistics for the good of the team."

"I followed all his games," said Van Lier's mother, Helen. "Once when we were playing Monaca, one of their players was beating up on Norm, and I ran on the court and started hitting him with my umbrella. I hit the policeman that came out too. The picture made all the papers. Ohhh, I was ashamed to go out the door the next day."

She laughed.

"We all looked for Norm to be a preacher because he was such a leader and always tried to teach the kids the right way," she said. "I was the mouth of the family, and I'm afraid Norm takes after me too much, but his dad's guidance meant a lot."

"He believed that every moment you were wearing that Chicago Bulls uniform, you had to leave it all on the court."

—MARK SCHANOWSKI

Opposite: Originally drafted by the Bulls in 1969, Norm Van Lier was traded to Cincinnati before his rookie season and reacquired two years later.

> **"[He] never took a night off. He came to play every game . . . [and] as a one-on-one defender, he was the best. He would eat you up."**
>
> —BOB LOVE

NORM VAN LIER

» **Born:** April 1, 1947 in East Liverpool, Ohio

» **Height:** 6-1'

» **Weight:** 173

» **College:** Saint Francis University

» **Years in NBA:** 1969–79

» **Acquired by Bulls:** April 7, 1969 in 3rd round (34th overall) in NBA Draft; traded with Dave Newmark to Cincinnati Royals for Walt Wesley on Oct. 12, 1969; reacquired by Bulls on Nov. 9, 1971 along with a 3rd round draft pick from Cincinnati in trade for Jim Fox and a 2nd round draft pick

Van Lier's father, Norman Jr., was the son of a Baptist preacher and worked for 40 years in the Crucible Steel Mill, Midland's major employer.

"My husband taught Norm what it is to be a man," Helen said. "It's more than having babies. It's being faithful and taking responsibility and supporting the family."

In football, Van Lier was a quarterback and defensive back recruited by powerhouses such as Nebraska, Southern Cal and, briefly, by Alabama.

"The guy from Alabama saw my name—Norman Allen Van Lier III—and figured I was white," Van Lier said. "Our family is descended from Dutch slave traders and their African slaves, but he must have thought he had another Namath. You should have seen his face when he saw me."

At his mother's urging, Van Lier said no to football, then turned down a $25,000 bonus from the St. Louis Cardinals to play baseball, his favorite sport, because it would mean starting in the segregated South.

His choice was basketball at tiny St. Francis College in Loretto, Pa., population 2,000, which is where Bulls scout Jerry Krause spotted him. He was a standout on a good team, graduated with a B average in history and headed for acclaim and a beginning salary of $17,500 in the NBA.

The Bulls took Van Lier in the third round of the 1969 draft, the 34th pick overall, but traded him to Cincinnati for center Walt Wesley. In 1970–71, his second season, he led the NBA in assists with 10.1 per game.

"A year later, Wesley goes to Cleveland in the expansion draft and Van Lier becomes a significant player in Cincinnati, and I have to pick up the paper every day and see that," recalled Pat Williams, the Bulls' general manager at the time.

The Royals had drafted Nate Archibald in 1970, giving them two undersized guards. Needing a center, they sent Van Lier back to the Bulls for Jim Fox.

"And suddenly, we had the most ferocious guard line in the history of the NBA," Williams said. "Norm and Jerry Sloan were not the most talented guard line, but they led the league in charges, floor burns and diving into the stands for loose balls. Old-time basketball fans in Chicago will never forget the intensity and passion and fervor they brought every night."

Sloan always spoke fondly of his backcourt mate.

"It was a pleasure playing with Norm; he was a terrific competitor," he said. "We practiced hard every day, and he was not afraid to tell a guy to practice hard—'That's the way we do it here.'"

Love said Van Lier "never took a night off. He came to play every game . . . [and] as a one-on-one defender, he was the best. He would eat you up.

"We fed off of Norm. I would call him the 'Little Rat' because that basketball was like a piece of cheese for Norm."

"The only real bad, bad year we had was '75–'76," he said. "We won 24 games (of 82, the Bulls' lowest point, until the Tim Floyd era). Most of the guys (the key players in four straight 50-win seasons) were gone."

The next year, however, with Van Lier heading an all-new cast, the Bulls were again a top team, winning 20 of their final 24 games and dropping a stomach-knotting three-game playoff series to the Portland Trail Blazers, who went on to win the title.

"I'll never forget the second game, which was the only one in Chicago," he said. "We won, 107-104, and I've never heard noise like that—ever. We played in the old Chicago Stadium then, and you didn't get the corporate crowd you do now at the United Center that goes clap-clap-clap."

He illustrated by looking bored and applauding listlessly.

"That was an arena!" he said. "You had a working-class crowd that knew basketball. I remember looking up during games and seeing that big cloud of cigarette smoke coming down from the balconies."

After a final season with the Milwaukee Bucks in 1979, Van Lier retired as a three-time All-Star. He was named to the first or second All-Defensive team eight times and had totals of 8,770 points and 5,217 assists.

As can be the case for other pro athletes, Van Lier faced his most daunting challenges when his playing days were over.

The biggest disappointment was that the coaching jobs he sought were not there. "I think part of it was racial," he said. "I was a black man who spoke my mind and wore an Afro and a beard. That made you a 'militant' in those days. I had stopped the painkillers, but the people in management may have held it against me. I was very bitter."

Van Lier tried a number of things. He worked for ESPN radio, sold luxury cars in Los Angeles (Wayne

Once Norm Van Lier was paired with Jerry Sloan "we had the most ferocious guard line in the history of the NBA," said Bulls GM Pat Williams.

Gretzky's wife bought a blue Bentley from him), coached for 15 games in the Continental Basketball Association and participated in a youth program for the Center for the Study of Sport in Society in Boston.

He and his second wife, Susan, whom he married in 1980, and her two young daughters, whom he adopted, lived for four years in the Seattle area and then moved to Los Angeles.

They met in 1977 when she was a flight attendant on a Bulls flight to Cleveland. "It was love at first sight for me," Susan said. "I'd grown up in Minneapolis and never dated anyone from another race, but all the barriers evaporated when I met Norm."

She didn't realize he was a basketball player. "I knew nothing about the Bulls, and I assumed he was the team manager. He seemed so small. When he finally told me he played, I felt sorry for him. I was sure he must have sat on the bench. It took me years to understand he was a great player. He never let on."

In 1992, as the Bulls began to be a national phenomenon, Van Lier was hired by SportsChannel, the forerunner of Fox Sports Chicago, to join its expanding coverage.

Van Lier said a talk in 1989 with his father finally helped him to rid himself of his resentments about not having been given a chance to coach in the NBA. "It

was just before he died, and after that, positive things began to happen," he said.

In 1994, the Reader's Ben Joravsky described Van Lier as "the freshest, most original voice in local sports programming."

"When they offered me the job, I said I'd call it as I see it," Van Lier said. "When I see bad basketball, I'll say so."

To some viewers, Van Lier seemed abrasively self-confident in his assessments.

"I'm comfortable on TV because I'm talking about a game I played and know about," Van Lier said. "Not everybody likes to agree with me, but I think it's because people don't want to hear the truth."

It seems unlikely that his basketball philosophy ruffled many sensibilities, except for those who might have found his old-school standards somewhat extreme. He condemned trash talk and taunting by players, despised self-congratulatory behavior, demanded full effort, extolled discipline and teamwork and always came down hard on the Bulls for indulging Dennis Rodman. He didn't have any use for players who weren't hustling. You stepped on the court, you played hard. That was a given. Being an outsider allowed him to look at the Bulls with a more discerning eye than other former members of the organization

Norm Van Lier lines up next to Milwaukee's Kareem Abdul-Jabbar late in Game 4 of the Western Conference final in 1974. The Bucks swept the Bulls and advanced to the NBA Finals.

Small in stature but large in spirit: Norm Van Lier was fearless on and off the court, an attribute that endeared him to fans and made him a popular TV analyst after his playing days.

did. He was blunt, and he cared. It could be a wonderful, devastating combination on the air.

It didn't matter if you played in his era or the current one. If you played with fire, he saw it. If you didn't, God help you.

"He believed that every moment you were wearing that Chicago Bulls uniform, you had to leave it all on the court," said Mark Schanowski, who was Van Lier's colleague on Comcast SportsNet's Bulls telecasts. "He couldn't accept some of today's privileged athletes who felt they could coast."

Schanowski remembered Van Lier challenging James Posey to a fight after the then-Miami Heat forward delivered a cheap shot to Bulls guard Kirk Hinrich during the 2006 playoffs.

"Norm was offended. He said, 'Posey, I'll meet you outside the locker room and kick your ass,'" Schanowski said. "Norm always felt he represented the Bulls, and if he saw something that was not right, he was going to call the guy out."

"Norm loved Chicago," said former Bull Mickey Johnson. "He loved the Chicago Bulls. He expressed that during the TV shows. . . . If you look for an analogy of what a 'bull' is and Norm, it would be synonymous:

fiery, rugged, ready to go and take on anybody."

After Van Lier's death in 2009, Bulls owner Jerry Reinsdorf praised him as "one of the all-time greats ever to put on a Chicago Bulls uniform."

But Van Lier did not always feel appreciated by the Bulls.

"One thing that bothered Norm, and he talked about it all the time, was that his number wasn't hanging up in the rafters," said former Bull and Comcast SportsNet analyst Kendall Gill. "I wish the Bulls had done that before he passed on.

"That tormented his soul. When you put your heart and soul into a franchise like Norm did . . . that means something that somebody gives you recognition for that. And that's all he was looking for. And I think if he had known his number was going to be retired, it would have taken so many demons away from him."

"I've been blessed," Van Lier said late in his life. "Sometimes I go home and think, Is this a dream? The Bulls are champions in six of the last eight years, and I'm a part of it. And sometimes I also think about how amazing it is that I played this game. It blows my mind. It really does." 🏀

Jerry Krause's tumultuous first stint as Bulls' player personnel director lasted less than three months.

In Bulls' Pen: Krause tabbed player personnel director

June 2, 1976

PHOENIX – The Bulls have picked Jerry Krause as director of player personnel, the Tribune learned Tuesday night. Krause will leave Raleigh, N.C., where he is attending the U.S. Olympic basketball trials, to fly to Chicago for the announcement Wednesday.

The Bulls, in the midst of a complete shakeup since coach Dick Motta left to take over the Washington Bullets last week, now have a new front office team, with Krause joining general manager Jon Kovler. They still have to name a coach to succeed Motta.

A veteran NBA and major league baseball scout, Krause, 38, worked for the Bulls in that capacity when they joined the league in 1966. He left in 1971 after bitter disputes with Motta, shifting to the Phoenix Suns and then to the Philadelphia 76ers under general manager Pat Williams, his former boss with the Bulls.

Jerry Colangelo, the Suns' general manager, confirmed Tuesday night that the Bulls had asked him for a recommendation on Krause.

"I told them Jerry is loyal and a hard worker," Colangelo said. "He's been around the NBA and he knows basketball. Jerry's made mistakes, like all of us, but that organization needs some loyalty.

"It's been lacking in that area for a long time. Besides, they're really at a loss in the decision-making process.

"I told them they'd get their money's worth out of Krause."

Bulls set to sign Badger

Aug. 17, 1976

When the Bulls call a Thursday press conference to announce Ed Badger's hiring, the new coach will get what he wanted—a three-year contract, plus the ability to hire Gene "Bumper" Tormohlen of the Atlanta Hawks as his assistant and scout, an informed source told the Tribune on Monday. Badger also will have "full authority" to make trades and other player decisions, the source added.

That indicates Jerry Krause, the Bulls' director of player personnel, will play second fiddle in the new setup. Neither Badger nor managing partner Jonathan Kovler is enthusiastic about Krause, although one of the owners, Lester Crown, strongly supports him.

Both Arthur Wirtz and his son, Bill, would have preferred DePaul's Ray Meyer to take the Bulls' reins for one year, with Jerry Sloan as assistant coach, then turn the job over to Sloan. After that deal collapsed, they offered Badger a one-year coaching contract, with the provision that Sloan become his assistant.

Badger refused and when the Bulls were rejected by other candidates, they had to meet his terms. The combined salary package—in the neighborhood of $50,000 yearly for Badger and $30,000 for Tormohlen—is roughly what Dick Motta got by himself before quitting to coach the Washington Bullets.

Badger had been coaching the Bulls' summer league team in California and said he knew "a week ago" that the job was his.

Krause quits; rift with Badger?

Sept. 1, 1976

Jerry Krause's stormy three-month term as Bulls director of player personnel ended Tuesday over apparent policy disagreements with new coach Ed Badger.

Krause said he quit for "personal reasons" and was pursuing an opportunity with another NBA club. His only elaboration was that, "I felt that I wouldn't be able to work effectively under the present conditions."

Bulls executives could not be reached for comment on whether the 38-year-old Krause stepped down on his own or was forced to resign.

Informed sources say Krause's growing frustration with the restrictions on his job "came to a head" when he met with Badger in Los Angeles last week. Badger was coaching a Bulls team in the California Summer League.

Their discussions were awkward to begin with because Badger knew that he was not Krause's choice to fill the head coaching vacancy. Krause reportedly had recommended a couple of college coaches to the Bulls' executive committee.

Then, according to a source, Krause and Badger had "many differences of opinion on how things should be run." In the end, Badger had the greater authority. And it is believed that some of the duties he had outlined for his still-to-be-named assistant coach conflicted with Krause's role—presumably in the scouting area.

Krause assumed he would be the primary basketball advisor to the executive committee, but he wound up with pretty much of a non-job.

He also felt his conversations with DePaul's Ray Meyer about the head coaching position as well as alleged trade proposals that Krause denied making, produced adverse publicity that hurt him with Bulls management. He insisted that he "never offered" Meyer the coaching job.

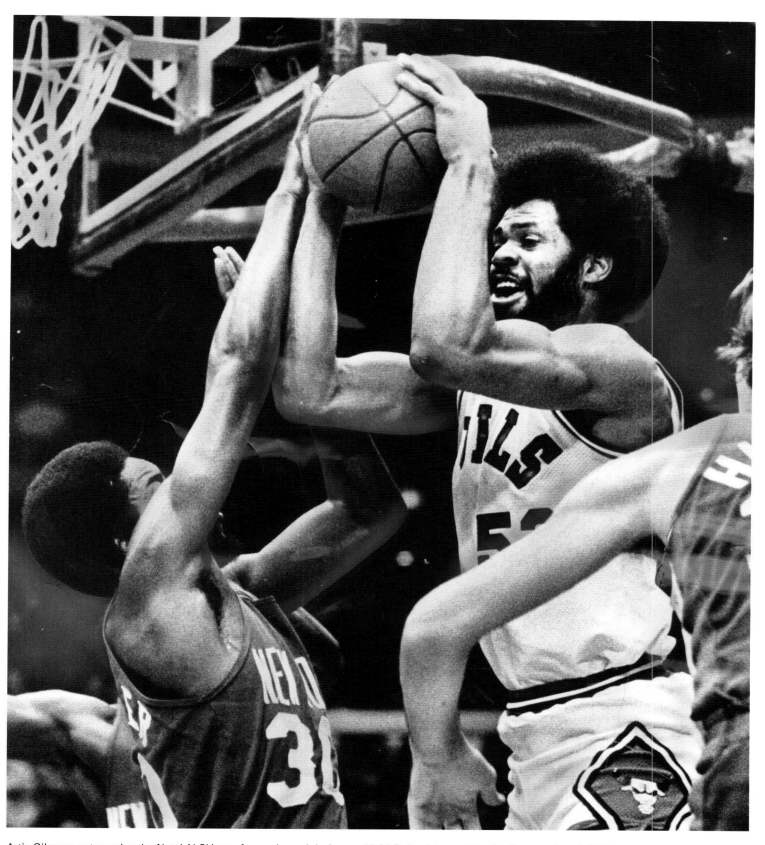

Artis Gilmore outmuscles the Nets' Al Skinner for a rebound during an 88-80 Bulls victory at the Stadium on Jan. 4, 1977.

The '76–'77 Bulls rode a late-season hot streak into the playoffs, but they were thwarted once again by the Blazers.

Blazing their own trail

No one saw the Bulls coming in 1976, especially after an early 13-game losing streak dropped them to 2-14. But what appeared to be a lost season took a dramatic turnaround in late February when they rallied to win 20 of their final 24 games to make the playoffs. The unlikely run set up a thrilling three-game playoff series with Portland.

This was a Bulls team in transition. The perennial contenders during the early '70s faded after their 1975 playoff loss to Golden State. Chet Walker and Jerry Sloan retired and Bob Love was on his way out. The Bulls went 24-58 in 1975–76 in what turned out to be coach Dick Motta's last season.

Guard Norm Van Lier was the lone mainstay as the Bulls began to retool under new coach Ed Badger. The Bulls added top draft pick Scott May to pair with forward Mickey Johnson. But the biggest addition was an ABA pickup who gave the Bulls their first real scoring presence in the middle—center Artis Gilmore.

After losing to Portland on Feb. 18, the Bulls stood at 24-34. Then just when it seemed hopeless, the Bulls caught fire.

Gilmore started to assert himself and guard Wilbur Holland gave the Bulls an outside game. Chicago fans also went along for the ride. A crowd of 21,652 jammed the Stadium to watch the Bulls beat Houston 113-109 in the regular-season home finale.

"We clicked at the end of the season," said Van Lier. "We had that chemistry similar to this year's team. We caught fire and we had a confidence level beyond compare. The fans stuck in there, and Artis played to where he needed to be to carry us."

Finishing the season 44-38, the Bulls looked forward to their playoff encounter with Bill Walton and the Trail Blazers.

Portland took the opener of the best-of-three series with a convincing 96-83 victory, thanks in part to the sharpshooting of Maurice Lucas, the muscular 6-9 forward from Marquette who riddled the Bulls with 11 straight baskets at one point. He finished Game 1 with 29 points on 14-for-17 shooting.

Game 2, though, was a different story. Playing in front of a packed Chicago Stadium that was as loud as it ever had been, including during the Michael Jordan era, the teams engaged in a physical battle that erupted into a full-blown brawl with six seconds left in the first half. After some two-way contact on their way down the floor, Portland's Herm Gilliam kicked at the Bulls' Wilbur Holland, prompting Bulls assistant coach Gene Tormohlen to spring off the bench and clutch Gilliam's throat with both hands.

Lucas quickly came to his teammate's aid and threw a couple of punches at Tormohlen. The result: Gilliam was ejected for a flagrant foul. Lucas received a technical foul for punching. Holland hit all three free throws. Tormohlen sat back down on the bench.

The Bulls led 105-93 late, but the Blazers chopped that lead down to a single point before Holland sealed it with two free throws in the game's final seconds, giving the Bulls a thrilling 107-104 victory.

Then it was back to Portland for the pivotal Game 3. The Trail Blazers couldn't close out the Bulls. Trailing by 15 points in the fourth quarter, the Bulls made one last run. A Jack Marin jumper pulled the Bulls to within 100-98 with 35 seconds left.

It looked good for the Bulls as Portland starters Walton, Maurice Lucas and Dave Twardzik had fouled out. But Trail Blazers guard Lionel Hollins saved the day when he hit a 25-footer with 15 seconds left. Portland took the series with a 106-98 victory.

"Those Bulls are one tough team," said Portland coach Jack Ramsay. "The way things were for them the last time we met in the regular season, it's remarkable they made the playoffs. But the way they put out today shows how they did it."

"I'm proud of my team," said Bulls coach Ed Badger. "I think possibly the two best teams in the NBA played out there."

The Trail Blazers went on to win the NBA title, beating Philadelphia and Julius Erving in the Finals. The Bulls, meanwhile, failed to carry over the end of the season magic, as they went 40-42 in 1977–78.

GAME 1 ··

Blazers grind down Bulls

GAME 2 ··

Bull-Blazer brawl moves to final act

GAME 3 ··

Bulls run out of time, miracles

Veteran center Tom Boerwinkle, shown here launching a hook shot against the Jazz on Nov. 29, 1977 at the Stadium, played his entire 10-year NBA career with the Bulls.

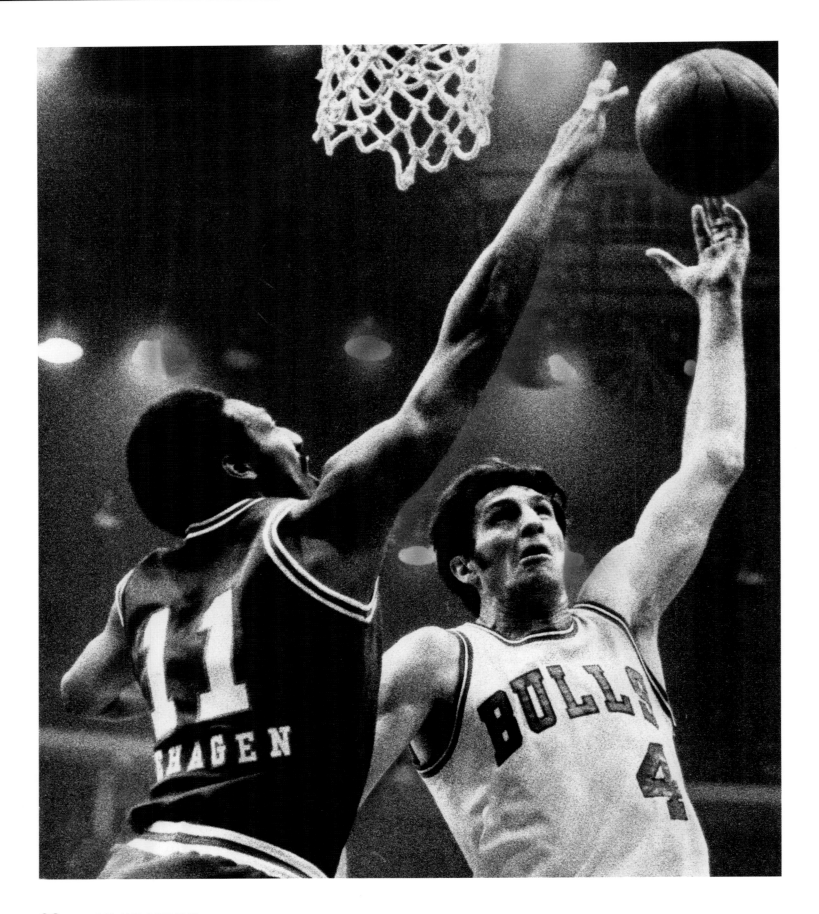

Jerry Sloan

TRUE GRIT

**4 SHOOTING
GUARD/
SMALL FORWARD**
1966—1976

HEAD COACH
1977—82

Jerry Sloan likes to say he's lucky.
Because:

- He's been able to work his entire adult life in basketball.
- He had great players with the Utah Jazz and coached the team to back-to-back NBA Finals.
- He got a second chance to coach after being dumped after less than three seasons with the Bulls in the early 1980s.
- Even though he had little athletic ability and no reputation, he was picked up by the Bulls in the expansion draft. "I was put on an expansion list," he said. "That means they don't want you."

Sloan then made two All-Star teams, was named an all-league defensive player six times in seven seasons and became the first Bull to have his number retired.

But that is just some of Sloan's so-called luck, which is more the result of hard work than happenstance.

The day Sloan got luckiest was the saddest day of his life.

Because he was supposed to be a passenger on the DC-3 airplane carrying the Evansville basketball team that crashed Dec. 13, 1977, killing all aboard.

"My college coach told me when I got through playing in the pros, I'd be a coach," recalls Sloan. "He had more foresight than I did. He said he wanted me to come back and take his job. I was a sophomore who never played, so I didn't think much about that."

But Sloan threw his 6-foot-5-inch, 195-pound body into the NBA like few players, a lean package of the desperation that comes from expecting to be released every day and the determination of someone who refuses to allow it to happen.

He once got called for a technical foul during warmups.

Players didn't dribble behind their backs against Sloan. If they did, he'd knock them down.

"Don't embarrass me with that kind of stuff," he'd say.

Sloan's only problem when he was hired to coach the Bulls in 1979 was that he demanded the same of the players as he did of himself.

Few could respond.

When he was 33, Sloan dragged himself as far as he could on bad knees through his 11th NBA season in 1975–76 and then retired.

And even though Sloan, a reserved man known for his hard stare and straightforward manner, traveled for a decade around the NBA, he never left Downstate McLeansboro and Evansville.

He's still more comfortable in corduroy than silk. This was no "Air" or "Glide" or "Dream." Just Jerry.

"I'm not a high-profile person," says Sloan. "I'm a farmer. In the off-season, I've always been a farmer. I never worried about not getting another job. I can do anything. I can work."

Sloan left the NBA in 1976 for what he thought would be for good. He took an assistant's job at Evansville and was to be named head coach the next season.

That was early in 1977. But that changed. Ed Badger replaced Dick Motta and offered Sloan a job as an assistant.

Sloan accepted after about a week back in Evansville.

Early that next season, 36 players, staff, coaches, student managers, media, cheerleaders, fans from the school and aircraft personnel died when the twin-engine charter prop plane bound for Nashville for a game with Middle Tennessee State crashed and burned shortly after takeoff in rain and fog.

"I'm reminded of it," Sloan says while grudgingly reminiscing. "It's sad. Just a sad thing to think about."

Jerry Sloan is a man of few words.

And fewer expectations.

"Even when I played, I said I was happy just to be here," Sloan said. "It's a day-to-day thing for everyone. As a player, I knew I could break a leg as soon as I walk on the floor. And I could get fired anytime. I've seen it happen. You have a problem with a guy and he doesn't want to play for you or you have a problem with the owner and bang, it's over for you just like that.

"It makes you compete harder. I guess that's always been a motivating factor for me."

Opposite: Jerry Sloan averaged 14.7 points and 7.4 rebounds per game in his 10 seasons with the Bulls. He also served as the team's head coach for two-plus seasons.

"I was so enthralled with (basketball) it was almost a sickness"

—JERRY SLOAN

Coaches never knew what motivated Sloan, because if they did they'd use it for all their players.

No one in the NBA may have given as much of himself as often. "He was a madman," says Motta with admiration. "Highest threshold of pain I've ever seen in an athlete."

"Jerry would not play dirty or take a cheap shot at anybody," said his former teammate Tom Boerwinkle. "The guys he guards know what to expect from him and they're ready for it. When we scrimmage and he knocks the ball away from me, I feel like killing him."

Sloan came out of Gobblers Knob, an oilfields crossroad 16 miles from tiny McLeansboro, Ill. His father died when Jerry was 4, so he had to look elsewhere for an image of masculinity. Part of it was supplied by his McLeansboro High School coach Gene Haile.

"I was a cocky, smart-alecky kid—thought I knew everything," Sloan recalled. "The coach made us run track and I detested it. Looking back, it's the best thing that could have happened."

As a high school freshman in 1956, Sloan stood 5 feet 6 inches. He grew eight inches the next year and from then on, basketball played an increasingly important role in his life.

Sloan was an All-State guard in 1960 and the object of an intensive recruiting campaign by college body snatchers.

"Lots of them were after me. There were coaches at my house all the time," Sloan said. "I remember one showing up at 1:30 in the morning. He got lost on the lease roads in the oil fields."

Sloan enrolled at Illinois, a decision he regretted almost instantly. The huge Illini campus overwhelmed the country boy.

"It was a mistake on my part," he said. "I left school and told them I'd never go back. Then I got a job on an oil rig."

Eventually, he wound up at Evansville, a small college 60 miles from McLeansboro, where he led his team to an undefeated season and an NCAA Division II title.

He was drafted by the Baltimore Bullets, formerly the Chicago Zephyrs, but after one season, Sloan was left available in the expansion draft and selected by the Bulls.

Paired with another small-college product in Motta,

Sloan, along with fiery back-court teammate Norm Van Lier, was unleashed on the NBA and the Bulls became one of the top teams of the 1970s.

In his first book, "Maverick," written in 1975, Phil Jackson wrote: "I greatly admire the type of game the Chicago Bulls play. Their defense is predicated on controlling the court and forcing their opponents to change their offense. Chicago stops the ball from moving by taking away the passing lanes. . . . Both Jerry Sloan and Norm Van Lier are super. Sloan is a good shooter whose hard-nosed defense is legendary. The only trouble with Chicago's back court is they're both very volatile individuals. I believe the Bulls will always have trouble winning a championship with two guards who can get upset so easily."

But that passion and lust for success was what enabled a lesser talent such as Sloan to become an All-Star.

"I was so enthralled with (basketball) it was almost a sickness," Sloan said. "Coach Motta always said I needed something outside basketball to get away to. So I go back to my farm. I do a lot of work there. It's therapeutic."

Sloan especially needed that after his short tenure as coach of the Bulls.

The Bulls named Sloan the sixth head coach in team history on April 28, 1979. At the time, he was the second-youngest head coach in the NBA (a year older than Philadelphia's Billy Cunningham). Through no fault of his own, his debut was less than a dazzler, as Chicago lost 15 of its first 20 games. Supporters pointed out, however, that several losses were decided in the final minute or two, and that the team had faced a brutal opening schedule, with 8 of its first 11 games having been on the road, mostly on the West Coast. The team finished 34-48 and missed the playoffs.

In his second season, Sloan drove the team to its first playoff appearance in four years, and a first-round upset of the Knicks. But 51 games into the 1981–82 season, with the Bulls' record at a dismal 19-32, Sloan was out.

"I had my feelings hurt," Sloan said. "In my opinion, it wasn't fair. But I also understood. It was very simple what happened. I couldn't get rid of (Larry) Kenon. I knew I was going to get fired if I kept him on the floor."

Over Sloan's objections, the Bulls had signed free-agent Kenon, a high scorer with the free-wheeling

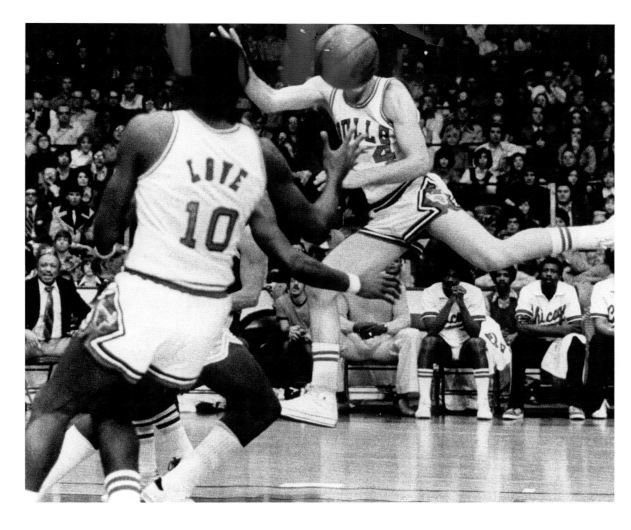

Jerry Sloan, shown here with his face obscured by the basketball, finally reached the NBA Finals as head coach of the Utah Jazz—but was beaten two years in a row by Phil Jackson's Bulls.

JERRY SLOAN

» **Born:** March 28, 1942 in McLeansboro, Ill.

» **Height:** 6-5'

» **Weight:** 195

» **College:** University of Evansville

» **Years in NBA:** 1965–76 as player, 1977–82 and 1988–2011 as head coach

» **Acquired by Bulls:** May 1, 1966 from Baltimore Bullets in NBA expansion draft

Spurs of the late 1970s. Sloan fought unsuccessfully for Bernard King, who went on to several All-Star seasons. Sloan benched Kenon during that playoff run, and when the Bulls opened the next exhibition season 4-0 and then lost four straight when Kenon returned, Sloan said he saw his fate.

Of course, Sloan once tried to kill Kenon with a chair in the locker room.

"I had a lot more player in me then," he said.

Within a year of Sloan's firing, Kenon was traded twice and out of the NBA.

In 1984, Sloan signed on with the Jazz as an assistant and four years later replaced Frank Layden. The franchise then went on its greatest run, reaching the NBA Finals in back-to-back seasons only to get beaten both times by the Bulls.

Sloan's Jazz teams were criticized for being boring, with John Stockton and Karl Malone running the same high screen-and-roll play, slowing the game down, playing Eastern Conference-style defense.

Their players, including Stockton and Adam Keefe, were accused of being the dirtiest in the NBA. The Jazz frustrated people. Just as Sloan always did.

Players and other coaches wondered, as they did then about Sloan, how that amount of athletic talent could win as often as the Jazz did.

"Jerry doesn't get the credit he deserves because he doesn't seek it," said longtime friend and assistant Phil Johnson. "He coaches the way he played—a good, hard effort and leaving everything on the floor."

"If you get into this business for recognition," Sloan said, "you're going to get your feelings hurt."

Sloan goes through life giving it a hard pick.

His players didn't get rested, even in meaningless games.

"They pay you to play," Sloan said. "Taking players out of the lineup is bad for basketball. You think a guy working 8 to 5 every day is going to care if players making $3 million a year want to rest? It's ridiculous."

And don't give Sloan any of that fancy motivation stuff about dealing with modern-day players.

"To me, motivation is the most overused word in sports," Sloan said. "You've got to have good players who want to work hard. I can't come up with 82 scenarios to get a guy out of his seat. He has to have it within himself." 🏀

Bulls coaches in the late '70s were like 'L' trains—they came and went frequently and never stopped for long.

Badger says he's quitting Bulls job

April 8, 1978

Ed Badger says he is quitting the Bulls to become head basketball coach at the University of Cincinnati.

Jerry Sloan, now a Bulls assistant coach, then will be offered the head spot with the National Basketball Association team, sources report. Other sources in Cincinnati confirmed that Badger was the man who'd been offered a five-year, $250,000 contract as head coach of the Bearcats.

"Arthur Wirtz is the only Bulls owner I talk to," Badger said, admitting the report was true. "We discussed the situation, and if they'll let me out of my contract, it (Cincinnati) is too good an opportunity to turn down.

"There's been so much speculation the last month or so, it would be impossible for me to do a good job here anymore."

The bombshell overshadowed the Bulls' 113-103 loss to Buffalo Friday in their final Stadium game of the season. Badger will coach then one more time Sunday in Atlanta, then Sloan, the only member of the 1966–67 expansion team still connected with the Bulls, is expected to get a long-term contract as head coach.

"Ed knows he can come back for the final year of his contract next season," a source said, "but if they didn't get off to a fast start, he'd get fired right away. There has to be a scapegoat, either (Bulls managing partner) Jon Kovler or Ed, and Badger knows damn well who it would be."

Wirtz visited Badger in the Bulls dressing room after Friday night's game. Wirtz reportedly favors releasing the coach from his contract, but Kovler is against it. When such confrontations occur, Wirtz's view usually prevails.

A major factor in Badger's growing disillusionment with the Bulls job was his inability to get the players he felt were necessary to strengthen the bench. When the Bulls signed Cazzie Russell at midseason, Badger privately grumbled that the veteran was not what his team needed.

The coach signed a three-year contract to replace Dick Motta in 1976 and was under constant pressure from the outset when the Bulls got off to a bad start, losing 13 straight games early in the season. Artis Gilmore sparked a blistering finish that put the Bulls in the playoffs and probably saved Badger's job.

Bulls settle on Costello as coach

June 2, 1978

SEATTLE – Larry Costello will coach the Bulls in 1978–79. He spent Thursday in Chicago negotiating the contract which the Bulls executive committee is expected to ratify Friday and make public shortly thereafter.

Jerry Sloan, who served as an assistant to Ed Badger last season, was passed over, apparently because he has no experience as a head coach.

"Larry wanted it desperately," said the Philadelphia 76ers' Pat Williams, who was the Bulls' general manager when Sloan was the Bulls' ace defensive guard. "He's a diligent, hard-working guy. I understand the choice came down to those two, and Costello's experience was the decisive factor."

Costello led Milwaukee to the NBA championship in 1971, the high point of eight full seasons with the Bucks.

"I'm convinced Jerry will become a good NBA head coach," Williams said. "It's probably better for him to make a fresh start somewhere else without all those Chicago memories on his back."

The Bulls still have the problem of what to do with Sloan, the only survivor of the 1966–67 expansion team and still the most popular figure in franchise history. One NBA source expects them to try to convince Costello that Sloan should finish out the year left on his contract as a Bulls assistant coach.

"It's not a bad idea," the source said. "Jerry and Larry could learn a lot from each other. I think the Bulls' owners told (GM Rod) Thorn to find somebody else besides Sloan because they didn't like the conditions he was seeking.

"He wanted control over trades and draft choices, the way it used to be for Dick Motta. The owners don't want the coach to have that kind of power."

Costello out, Robertson in—temporarily

Feb. 17, 1979

Larry Costello must have known it was coming. In fact, you might say he asked for it.

The beleaguered coach of the Bulls asked his bosses Friday morning for a clarification of his job status. Before the day was out, he was "clarified" right out of a job.

At a press conference before the Bulls took the court against the New York Knicks Friday night in the Stadium, general manager Rod Thorn announced the Bulls had fired the man he had hired only last June.

Scotty Robertson, one of Costello's assistants, was named to succeed him on an interim basis.

"A search will begin immediately for a permanent head coach," Thorn said, adding that the choice could be announced before the end of the present season. He refused to pinpoint candidates but said he had several in mind.

Thorn declined to say whether former Bull Jerry Sloan, currently drawing a paycheck as an assistant coach, was the likely choice.

"I don't want to bring anyone's name into it right now," Thorn said. "It's not fair to Jerry Sloan or anyone else."

"After hearing on TV and reading in the media that he was going to be fired, Larry was looking for a vote of confidence. That just wasn't forthcoming." —GM ROD THORN

Thorn, flanked by Robertson and managing partner Jonathan Kovler, said the decision came to a head when Costello called him Friday.

"After hearing on TV and reading in the media that he was going to be fired, Larry was looking for a vote of confidence," Thorn said. "That just wasn't forthcoming."

Costello's biggest sin, other than his 20-36 record as coach, was his tendency to tell the truth about his players.

"Sometimes I wonder why I talk to reporters," Costello told the Tribune. "It's tough to talk after a game without mentioning the name of a player someplace along the line. A writer can twist the quote any way he wants to. You're better off if you keep your mouth shut."

Sloan signs 3-year deal to coach Bulls

April 29, 1979

Jerry Sloan signed a three-year contract Saturday morning to be the next head coach of the Bulls.

Then he went into hiding, under orders from the team not to emerge until a press conference Monday in owner Arthur Wirtz's skyscraper office on the lakefront.

Spotted on Michigan Avenue just after signing, the new coach said only: "I'm really elated at getting the job."

The Bulls made a brief announcement Saturday that Sloan, the most popular figure in their 13 National Basketball Association seasons, would succeed Larry Costello, fired Feb. 15. They refused to confirm the length of the contract or a report that the new coach would be paid $100,000 a year.

"I believe Jerry got three years, time enough to build his kind of team," said a source close to the situation. "The main thing was a degree of control over personnel matters, and I'm sure Jerry wouldn't have

signed unless he was satisfied on that point."

General manager Rod Thorn, under fire after his personal choice, Costello, flopped last season, tried to hire other college and pro coaches before turning to Sloan this time. Thorn insisted that no hard feelings remained between him and Sloan.

"My recommendation for Jerry had to be accepted by the owners, but I take credit for it," Thorn said. "There wasn't one certain thing that made up my mind, just the whole aura of Jerry Sloan.

"He's a classy, honest, hard-working man. We've talked a lot in the last few days, and I'm certain he can turn the Bulls back into a hustling, winning team."

Failing to adjust to Costello's complicated patterns last season, the Bulls became a sluggish team. While they were fading from the NBA playoff picture, Stadium attendance dropped almost 4,000 per game and the fans grew increasingly restive at the Bulls' lackadaisical performance.

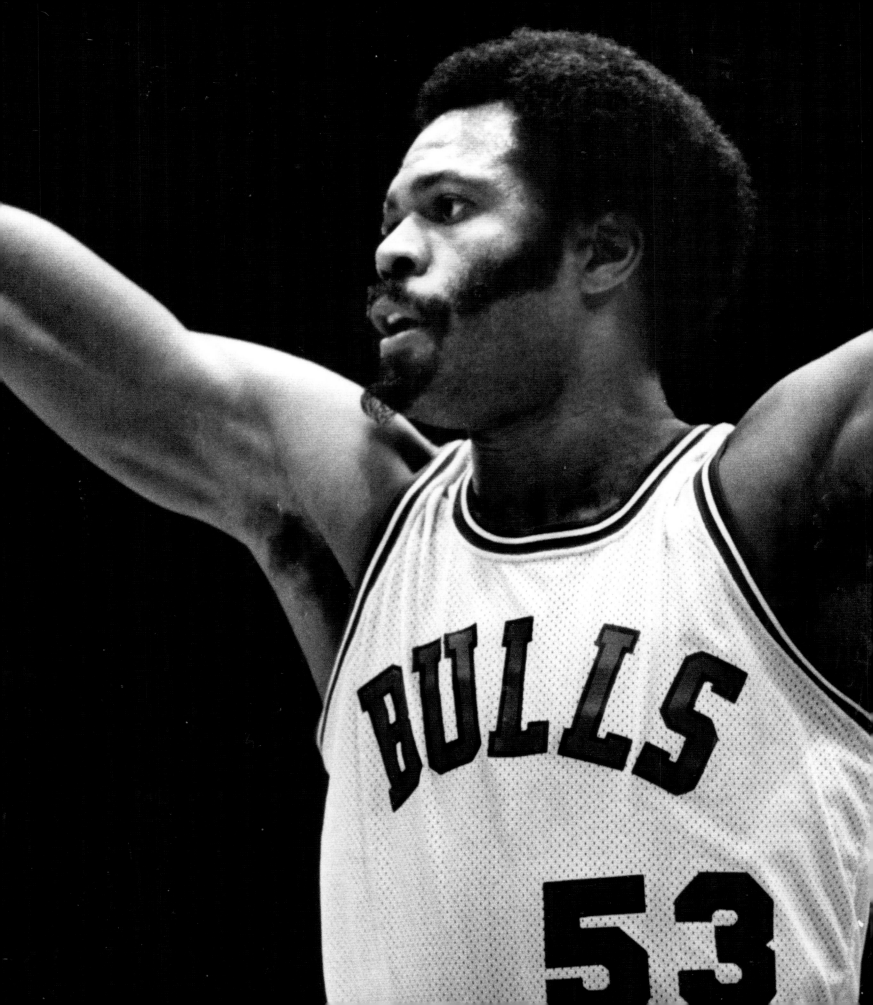

Artis Gilmore
THE "A-TRAIN"

53 CENTER
1976–82, 1987

When **Artis Gilmore** was an All-American center at Jacksonville University in 1970, slick nicknames were almost as abundant as campus protest marches. Athletic dorms were stuffed with basketball-playing jocks labeled "Big E" or "Dave the Rave" or "Earl the Pearl." Mountains of publicists labored to produce such molehills in hopes of spawning eye-catching headlines. Maybe it was another symptom of a decade of American malaise, but for whatever reason the practice went into a welcome decline.

Things being what they were at the time, it's a wonder such a tag wasn't slapped on Gilmore until after his college days. The national spotlight shone on the big kid from little Chipley, Fla., when he led Jacksonville to the 1970 NCAA tournament's final game against UCLA. He has been blinking in that glare, more or less uncomfortably, ever since.

Despite that, Gilmore was more of a mystery to Chicago fans when the Bulls landed him in 1976 after his five seasons of semi-obscurity in the American Basketball Association. The Kentucky Colonels had won the bidding war for Gilmore with a 10-year contract worth some $2.5 million. But the Colonels didn't play in the National Basketball Association, where a network television contract made the stars household names. So when crafty Pat Williams, then the Bulls' general manager, drafted Gilmore in 1971 (figuring to grab him when the ABA folded), the towering center became a man of mystery around here.

All the fans knew was that the Bulls didn't have an overpowering pivotman and Gilmore was piling up impressive statistics in that other league. Putting him in a Chicago uniform would assure the Bulls of a long-awaited NBA championship, or so went the tempting delusion.

Such fantasies eventually had a collision with reality. Artis Gilmore, bearing a string of 420 consecutive games played, perennial "all-everything" status, one ABA championship and a $1.1 million price tag, arrived here officially on Aug. 18, 1976. Some stunning backstage diplomacy by NBA commissioner Larry O'Brien had resulted in a pro basketball merger. Four of the six ABA clubs were taken prisoner in the raid, while Kentucky and Utah folded.

Gilmore and his agent, Chicago lawyer Herb Rudoy, thought that gave the big man automatic freedom to shop for a fat contract anywhere they pleased in the NBA.

"As it turned out, I had no choice at all," Gilmore said. "It was Chicago or no more pro ball. First of all, I would have chosen a warmer climate. San Antonio needed a center at the time, or maybe it would have been Golden State, with the New York Knicks as a third choice."

But as Bill Wirtz of the Bulls admitted, "We didn't back the merger to lose Gilmore." The allegedly 7-foot-2 center was dumped into a jury-rigged "dispersal draft" of ABA talent, and his destination was as predictable as the outcome of a Chicago election. Allegedly 7-foot-2? That's right. Some opponents insist he's at least two inches taller, but even Gilmore says he doesn't know for sure.

"The last time I was officially measured was in high school, and they said I was 6-foot-8½," Artis recalled. "I kept growing, but the 7-2 just happened after I stood next to a guy who was 6-2 and he told me, 'You're at least a foot taller.'"

And that's how legends are created. Chicago fans' expectations that Gilmore would carry the Bulls to an 82-0 record in the 1976–77 season were formed just as scientifically. The big guy had too many obstacles to overcome. The way things turned out, he was almost ridden out of town on a lengthy rail before finding himself.

When the Bulls opened the 1976–77 season with a 13-game losing streak, shock waves traveled through the league. Coach Ed Badger and owner Arthur Wirtz were dumbfounded as well, though their reaction was mild compared to the criticism from the Chicago media and Stadium ticket buyers.

Naturally, Gilmore was the focus of their wrath. He was a gigantic turkey, the more vocal critics insisted, a $1.1 million lemon. There was even an astonishing proposal to trade the same man who'd been hailed as a conquering hero a few months before.

Opposite: The Bulls finally landed the big man they had long sought when they acquired Artis Gilmore in 1976, but his tenure in Chicago ended without a title.

ARTIS GILMORE

- **Born:** Sept. 21, 1949 in Chipley, Fla.
- **Height:** 7-2'
- **Weight:** 240
- **College:** Jacksonville University
- **Years in NBA/ABA:** 1971–88
- **Acquired by Bulls:** Aug. 5, 1975 from Kentucky Colonels in ABA dispersal draft; reacquired June 22, 1987 from San Antonio Spurs in trade for 2nd round draft pick

Such things are predictable in the win-or-else world of professional sport, but Gilmore had never been subjected to such pressures before. The gentle giant was struggling to live in what he perceived as a cold, hostile city and adjust his own game to the Chicago system, which calls for the offense to wheel around the center. He almost gave up in despair after being pelted by verbal brickbats.

"It was about the time when that fellow Gary Gilmore was being executed out west, and I heard some talk about 'the Gilmore that's killing the Bulls,'" he said. "It seemed terribly unfair to me, almost like I was being executed by the Chicago media.

"I knew it was a matter of time until we got it together. Even so, there were occasions when I was very unhappy. I thought about going to the organization and telling them I wanted to leave. If I was hurting the team, it would have been better to trade me, but not at any time did I discuss it with Mr. Wirtz or anybody else. I decided that would be a cop-out, even though I wasn't fitting into the system and there were a dozen different reasons for me to go elsewhere.

"I felt I was a big enough man to overcome all that. The turnaround was going to happen, and I knew the rest of the Bulls would follow suit and perform as well once I got untracked. The most any team I played for had lost was three or four games in a row, so the 13-game streak was a real jolt.

"I put enough pressure on myself if I'm not doing the things I feel I'm really capable of. I didn't need all that criticism to add to the burden.

"One man can't turn a team around by himself. We had five men out there who'd never played together. The only time you can get away with that is in an All-Star game. It wasn't until we got Wilbur Holland to start at guard and John Mengelt to strengthen the bench that things started to blend in. Gradually our combinations got organized and worked together, something that usually takes years. We were fortunate to do it in such a short period."

Counted out of the playoffs with a 24-34 record on Feb. 18, the Bulls staged one of the most remarkable stretch rushes in sports history. They won 20 of their last 24 games to finish 44-38 and earn the Western Conference wild-card berth. During that span, Gilmore was the best all-around center in the NBA, scoring, rebounding, blocking shots and emerging as a defensive intimidator.

It didn't take the fans long to forget the bad start, and they began packing the Chicago Stadium in record numbers. Portland's Bill Walton said after the Trail Blazers had won the NBA title that he'd never seen a wilder crowd than the 22,000 or so who defied the fire laws to cram into the place for the April 15 playoff game, in which the Bulls beat the Blazers.

"The fans were a motivating factor, and we all felt the enthusiasm," said Gilmore of that magical spell when the Bulls redeemed themselves. "It increased the tempo of both teams by 25 percent or maybe more. We were anxious to go out and perform, give them what they had paid to see."

Playing basketball in front of sellout crowds didn't seem likely for a boy born in a peaceful little town called Chipley (population 5,000) in Florida's panhandle.

"Basketball isn't important around there," Gilmore recalled. "Eventually, it gave me a chance to get away from a small town that was very boring at times, and from a crowded house with five brothers and two sisters. There was no regular job for my father, and he did whatever odds and ends he could to help provide. It was difficult to find money for all the things kids needed in school, like pencils, paper, notebooks, shoes, clothing and food.

"Many times I went to our consolidated school in Washington County without breakfast, but later there was a school-lunch-and-work program that helped. It was just a five-minute walk from home, and I was growing so fast it was hard to keep me in shoes.

"We turned out all right, though, and I have to credit my father, Otis, and my mother, Mattie, for that. They had limited education, but they had been taught

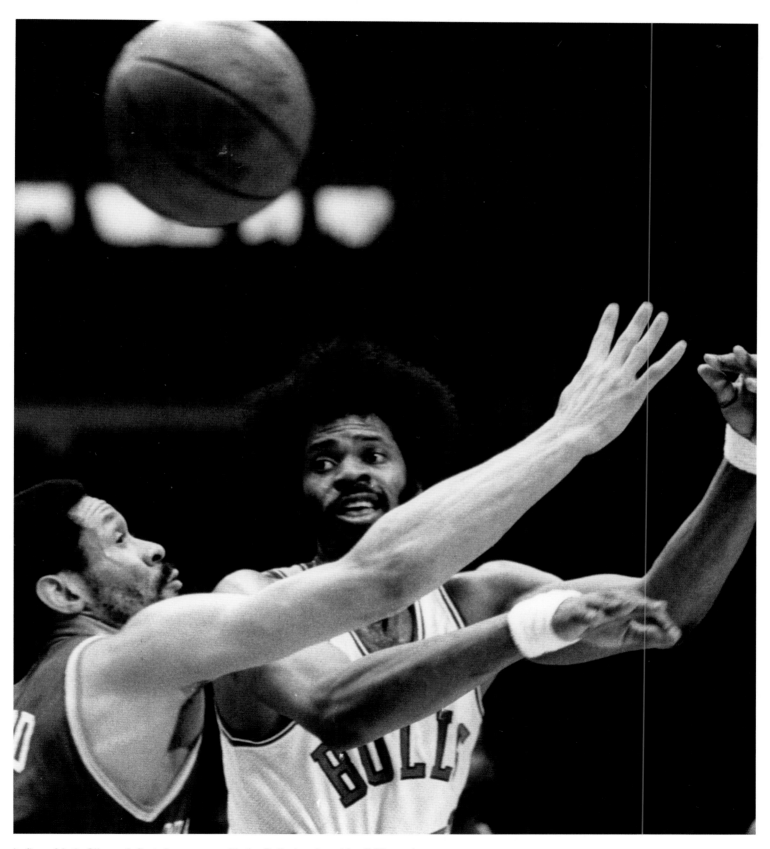

In five of Artis Gilmore's first six seasons with the Bulls, he played in all 82 regular-season games.

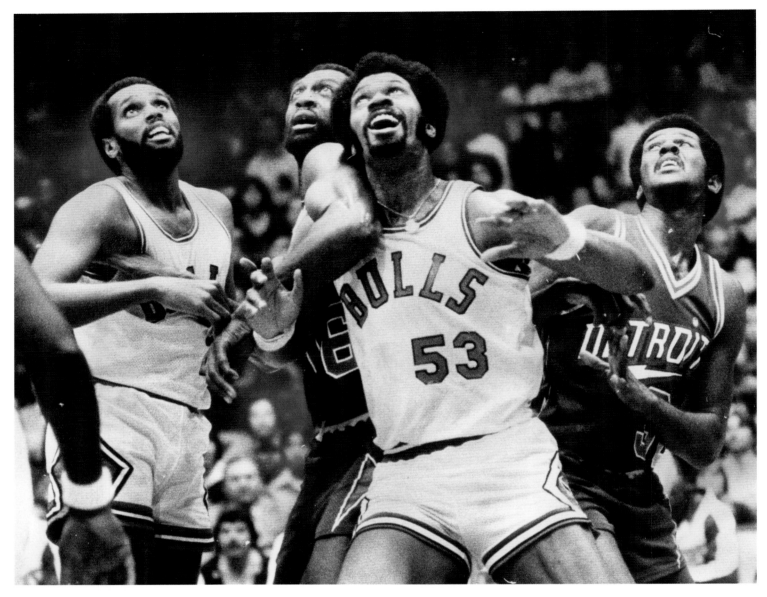

In a matchup of future Hall-of-Fame centers, Artis Gilmore jostles for position with Detroit's Bob Lanier.

there was one way to live—the right way—and they instilled it into us.

"Even if I hadn't been an athlete, I would have moved from Chipley eventually, probably to New York, where two of my brothers live. I spent some time there in high school and worked as a dishwasher at Mr. D's restaurant on Long Island. It was a very busy place on weekends.

"My senior year in high school was in Dothan, Ala., and that's where I really got into basketball. I was third-team All-American behind players like Howard Porter and Jim McDaniels, so the offers started coming from colleges all over the country.

"Some of them offered a lot more than a basketball scholarship. Because I didn't have a strong academic background, I went to Gardner-Webb Junior College (Boiling Springs, N.C.) first. That was another very small place back in 1968, and there weren't many black girls in school.

"I was introduced to Enola Gay Maddox by her cousin, who was in school with me. She was named for the plane that dropped the atomic bomb on Japan because her mother watched a movie about it when she was pregnant."

Enola Gay and Artis were eventually married and had two daughters.

"We were expecting a son the second time, and I was thinking seriously of naming him Dorian, for Dorian Gray," Gilmore said. "I wouldn't want him to be handicapped with the name Artis. That would

mean tremendous pressure on him all through life to play basketball and be like his father. It's happened to many sons, like Jackie Robinson Jr."

When the time came to transfer to a basketball power, Gilmore didn't have to think twice. Jacksonville was the natural choice, Artis said. It was close to home, close enough that his father could make the drive to see him play.

Jacksonville and Gilmore were good for each other in his two years of stardom. The nationally ranked Dolphins also boasted such luminaries as 7-foot Pembrook Burrows and "Sexy Rexy" Morgan, although Gilmore was the only genuine pro prospect.

But the ABA and NBA were already locked in a fight, a war which was definitely not hell for the college seniors who gleefully sifted ridiculous offers. Bids of a million dollars became openers for first-round draft choices, with a horde of agents scrambling to cut themselves in on the bonanza.

Nobody will ever know how much unsuspecting rookies were swindled out of by con artists. Gilmore recalls a lot of fast talkers "telling about the things they could do for me as my agent." He selected Rudoy because the Chicago lawyer wangled a million-dollar deal for Gilmore's teammate Morgan, a total NBA bust with the Boston Celtics.

There never was serious doubt about Gilmore's talent, however, so the ABA happily tossed more than $2.5 million into the pot to get him. He earned it by winning both Rookie of the Year and Most Valuable Player awards in his first ABA campaign.

But the leap to the NBA proved to be a bigger hurdle than he expected.

"The Chicago system was quite an adjustment for me, especially playing about half the time on offense at the high post," Gilmore said. "It's difficult to set picks there, because I was used to operating from the low post."

The relocation posed other challenges. Gilmore recalled his painful "welcome" to Chicago, when he was denied admittance to the BBC, a Rush Street disco.

"In a city this size, I didn't expect it," he said. "It was a shocking experience."

Despite Gilmore's presence in the pivot, the Bulls underachieved during his six years with the team. They made the playoffs only twice in that span, never making it past the second round.

Prior to the 1978–79 season, Gilmore signed a so-called "lifetime" $4.5 million contract with the Bulls, with payments spread over the next 25 years. But after that season he was already talking about a trade, saying it "would be in the best interest of Chicago basketball, because we have far to go."

Finally, in June of 1982, he was dealt to the San Antonio Spurs—the warm-weather location he had always sought, and a place where he had considerable business interests, including a dozen apartment complexes and a racquetball club, according to his attorney—for Dave Corzine, Mark Olberding and cash.

"Artis had asked to be traded," then-GM Rod Thorn said, not as an ultimatum but "just to recharge his battery. We have felt for some time that the chemistry has not been right on the Bulls. The major factor in the decision, in addition to Artis asking to be traded, was his age."

Gilmore had just returned from China, where he was playing for a touring NBA All-Star team, when the trade was finalized.

"I regret that I am going to leave Chicago. On the trip, I talked to (Kareem Abdul-) Jabbar and he had impressive things to say about (newly hired Bulls coach Paul) Westhead. I even talked briefly to Westhead on the phone. The Bulls made a very wise decision in getting a new coach.

"I don't want to leave Chicago with a bitter taste, but it was a very slow process here. I don't ever want to be tagged as a loser."

Gilmore played five seasons in San Antonio, reaching the playoffs three times but only advancing past the first round once. He was traded back to the Bulls in 1987.

"Now I'm getting the chance to play with a Michael Jordan," Gilmore said upon returning to Chicago. "I want to set an example for the young guys by convincing them you have to shake off the little aches and pains. In the NBA, winners show up ready to play every night."

Gilmore was 38 when the 1987–88 season opened, slotted into a backup role behind Corzine, the player for whom he was once traded. With his creaky knees, Gilmore was only a shadow of the once-dominant "A-Train." The Bulls waived him two months into the season.

He signed on with the Celtics as a backup for Robert Parish and appeared in 14 playoff games, coming within two victories of reaching his first NBA Finals. 🏀

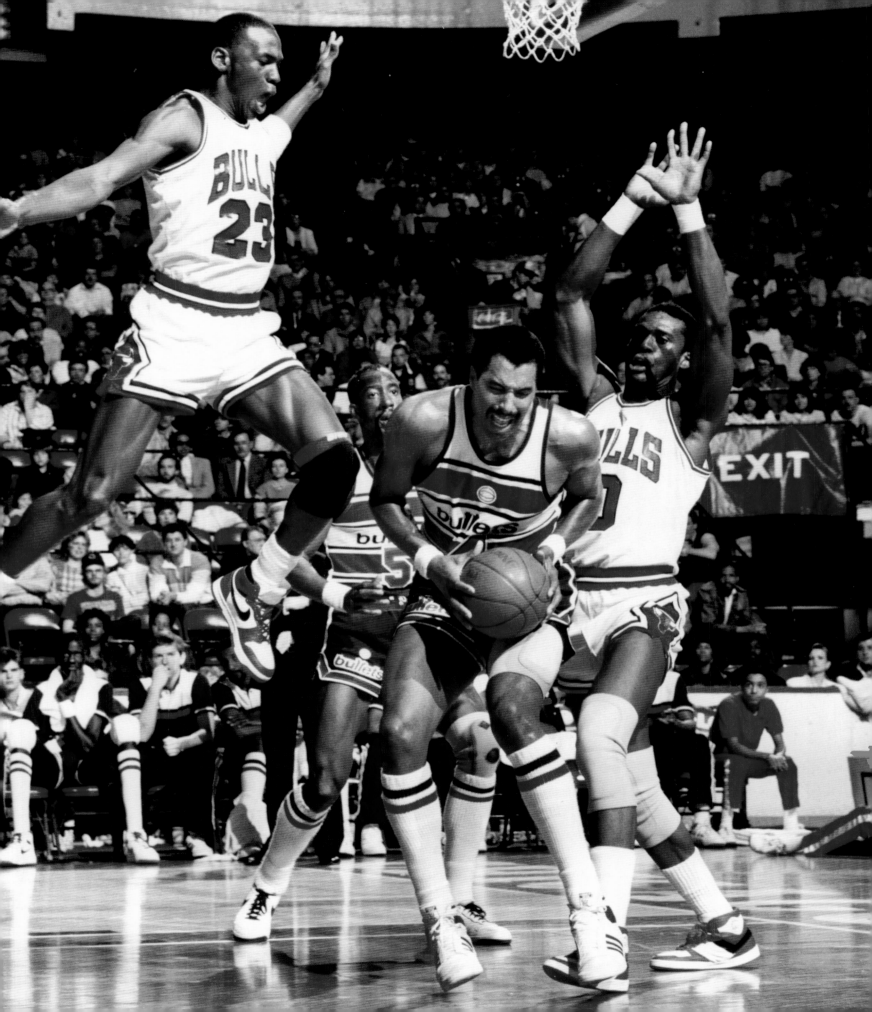

THE

1980s
GROWING PAINS

The decade opened promisingly enough with the Bulls moving to the Eastern Conference, Reggie Theus and Artis Gilmore landing in the All-Star Game and a first-round playoff victory over the Knicks before a second-round sweep to the eventual NBA champion Celtics. But Jerry Sloan got fired the next season and another revolving door of coaches produced Paul Westhead, Kevin Loughery and Stan Albeck over a mere four seasons. Jerry Krause succeeded Rod Thorn as general manager but not before Thorn drafted Michael Jordan with the third overall pick in 1984. Jordan started the All-Star Game and won Rookie of the Year honors to set the scene for his once-in-a-generation career. Despite no coaching experience, Doug Collins got hired by Krause in 1986 and the franchise's steady climb to immortality began. Krause added Scottie Pippen and Horace Grant in the same 1987 draft. Jordan won the first of his five MVP awards in 1988 as the Bulls began knocking on the Pistons' playoff door. Following the conference finals loss to the Pistons in 1989, Krause shockingly fired Collins and replaced him with Phil Jackson. The decade closed with a second straight conference finals loss to the Pistons as Pippen suffered an infamous migraine headache in the Game 7 loss.

Opposite: Soaring even when playing defense, Michael Jordan gets between Washington's Cliff Robinson and the basket during the Bulls' 105-103 victory over the Bullets on April 11, 1986 at the Stadium.

1980s

HIGHLIGHTS

The Milwaukee Bucks' Terry Cummings meets an obstacle named Orlando Woolridge in the Bulls' 105-97 loss Friday night. Cummings finished with 29 points.

June 29, 1982
With the seventh pick in the first round of the NBA draft, the Bulls select Quintin Dailey, a guard from the University of San Francisco.

Quintin Dailey a Bull

June 19, 1984
With the third overall pick in the NBA draft, the Bulls select North Carolina guard Michael Jordan, the reigning NCAA player of the year.

Jordan feels Bullish

February, 1980
NBA realigns; Bulls move to Central Division of the Eastern Conference.

Feb. 17, 1982
Jerry Sloan dismissed as head coach; GM Rod Thorn takes over behind the bench.

1980 — **1981** — **1982** — **1983** — **1984**

June 23, 1982
Bulls name Paul Westhead head coach.

May 10, 1983
Bulls fire Paul Westhead.

July 7, 1983
Bulls hire Kevin Loughery as head coach. Loughery had previously coached the 76ers, Nets and Hawks.

April 3, 1981
Bulls defeat Knicks 115-114 in OT to take their best-of-three first-round playoff series two games to none.

April 12, 1981
Celtics sweep Bulls out of the playoffs, closing out the series with a 109-103 victory in Game 4.

82 GROWING PAINS

April 26, 1985
Bucks beat Bulls 105-97 in Game 4 at Chicago Stadium, winning the first-round playoff series three games to one.

May 16, 1985
Michael Jordan named NBA Rookie of the Year.

June 17, 1985
Bulls name Stan Albeck head coach. Albeck had previously coached the Cavaliers, Spurs and Nets.

Oct. 18, 1985
Quintin Dailey leaves team to enter drug rehabilitation center in California.

April 20, 1986
Jordan sets an NBA playoff record by scoring 63 points in a 135-131 double-overtime loss to the Celtics in Game 2 of a first-round series.

April 22, 1986
Celtics sweep series, winning Game 3 122-104 in Chicago.

April 28, 1987
Boston sweeps Bulls out of the playoffs, taking Game 3 in Chicago 105-94.

June 22, 1987
In a draft day deal, the Bulls acquire Scottie Pippen, a forward from the University of Central Arkansas whom the Sonics had selected at No. 5. With the 10th pick, the Bulls draft power forward Horace Grant from Clemson.

May 7, 1989
Thanks to what later would be known as "The Shot," the Bulls upset Cleveland on a last-second jumper by Michael Jordan over the outstretched hand of Cavs guard Craig Ehlo.

Just incredible, Michael

June 2, 1989
After taking a 2-1 series lead over Detroit, the Bulls drop three straight and are eliminated from the playoffs with a 103-94 loss at the Stadium in Game 6.

Pistons end Bulls' joyride

1985 **1986** **1987** **1988** **1989**

May 28, 1985
Bulls fire head coach Kevin Loughery.

May 19, 1986
Bulls fire head coach Stan Albeck, name Doug Collins as his replacement.

May 8, 1988
Bulls defeat Cleveland 107-101 to take first-round playoff series three games to two.

May 18, 1988
Pistons eliminate Bulls four games to one with a 102-95 victory in Game 5 of their second-round series.

July 10, 1989
After the firing of head coach Doug Collins, Bulls promote assistant Phil Jackson to head coach.

Krause signals new Bull era

March 26, 1985
Bulls fire GM Rod Thorn, name Jerry Krause as his replacement.

March, 1985
Jerry Reinsdorf gains controlling interest in the franchise and becomes the team's principal owner.

June 27, 1988
Bulls trade Charles Oakley to the Knicks for center Bill Cartwright in a deal that also includes an exchange of draft picks.

Reggie Theus

RUN-AND-GUN REGGIE

24 SHOOTING
GUARD/
POINT GUARD

1978–84

Though he's from Inglewood, a Los Angeles suburb, it's so close to Tinseltown that boyishly handsome Reggie Theus could be mistaken for a movie star.

Theus was listed as a guard, something of a misnomer. Actually, he was a 6-foot-6 entertainer. The Bulls' first-round draft choice in 1978 had the size, speed and skills to become an All-Star in the NBA. What really set him apart, however, was the same quality possessed by That Other Reggie in baseball—charisma.

When Theus stormed downcourt in the Stadium, Bulls fans came out of their seats and their lethargy, venting their emotions with an eerie bellow that bounced off the frozen snowbanks surrounding the West Side playpen:

"REG-gie! REG-gie! REG-gie!"

"When I hear that, I want the ball badly," confessed the object of all this adulation during a 1979 interview. "If I'm into my own game, I can get everybody else going, too. It's tough for a rookie to come into a new situation and to be that kind of player.

"You know veterans, and rightfully so, aren't going to turn over control of the floor just like that. It's hard to accept, but I understand.

"I know I can take the ball and get a good shot anytime I want, or set one up for somebody else. That's the way it was for me in high school and college. The Bulls don't want it to be that way here. I'm aware of that. The fans appreciate what I'm capable of doing, and at some point in every game I can give them a bit of what they're looking for.

"They go home and say, 'Maybe the Bulls lost and we didn't get our money's worth, but at least we saw Reggie make one helluva move.' That's not being arrogant, just being honest and analyzing my game. I can turn myself on as well as everybody else and I do it quite often. That's what I enjoy: making a basketball game fun."

Some basketball purists would nominate Theus for the Hot Dog Trophy, a bronzed Oscar Mayer wiener, if they heard him expounding such heresy. They'd be just as wrong as the Bulls were when they shackled Theus in a futile attempt to make him something he wasn't—a controlled, disciplined, dull player.

Even if the Bulls had been winning when he first joined the team, Reggie's instant rapport with the fans would have evoked a certain amount of resentment among less-spectacular teammates. Because the team faded rapidly from the playoff picture in his first two seasons, his razzle-dazzle passes and one-on-one forays made the quick guard a convenient scapegoat.

That's not precisely what Theus expected when he dropped out of the University of Nevada-Las Vegas after his junior year to be eligible for the 1978 NBA draft under the hardship rule. The Bulls made him the ninth player chosen and signed him to a four-year, no-cut contract with a bonus up front and salary escalating to $150,000 in the final season.

Theus joined a team that was lacking on both ends of the court; they struggled to score and struggled to get stops. Norm Van Lier was the playmaker in those balmy days before the freshman general manager, Rod Thorn, made an even balmier decision to unload Van Lier without signing an adequate replacement.

The Bulls were doomed from that moment, and much of the ballhandling burden fell on Theus, preventing him from developing other skills, like finding his man on defense. The eager rookie responded with a trick bag full of hit-and-missile passes designed to produce easy Bulls baskets.

Unfortunately, some of these identified flying objects struck teammates in difficult places—on the hands—and others ricocheted in all directions. It soon became apparent that Reggie's reflexes were a split-second faster than most. Early on, that created more problems than it solved.

Not for the fans, though. They voted with their tonsils and whenever Tommy Edwards said "Thee-us!" over the Stadium public address system, they cheered. When Edwards said that the Bulls were coached by Larry Costello, they booed. A key to understanding Reggie Theus is that he felt uncomfortable, almost apologetic, about the boos.

Opposite: Even when the team was struggling, Reggie Theus gave Bulls fans something to cheer about. "That's what I enjoy," Theus said, "making a basketball game fun."

> ## "They go home and say, 'Maybe the Bulls lost and we didn't get our money's worth, but at least we saw Reggie make one helluva move.'"
>
> —REGGIE THEUS

REGGIE THEUS

» **Born:** Oct. 13, 1957 in Inglewood, Calif.

» **Height:** 6-7'

» **Weight:** 190

» **College:** University of Nevada-Las Vegas

» **Years in NBA:** 1978–91

» **Acquired by Bulls:** June 9, 1978 in 1st round (9th overall) in NBA Draft

"I really never try to show off," Theus said in 1979. "What happens is just my reaction to the defense. If I make a move and my man gets in the way, I gotta do something else.

"That's why Coach Costello gets mad at me sometimes. I have no excuses. He's telling me to do one thing and I want to do it, but none of my passes or (behind-the-back) ballhandling things are programmed.

"Larry puts a lot of the blame on the Bulls guards. We don't run the offense, we don't guard anybody. He's pretty rough on us at times. I think he'd like me to be an image of himself out there. You know: straight quarterback, nothing that isn't in the book. I have a lot of respect for him and Scotty (Bulls assistant coach Robertson), and there are certain things a rookie has to put up with, like yelling at me to get through to somebody else.

"But if I did exactly what the coach wanted, I wouldn't be myself. A player has to work hard, and he also has to be happy. I don't believe in sacrificing your mind."

"Reggie's a good kid, a hard-working kid," Costello said. "He's just got to learn that in this league you can't go dribbling through a crowd with your head down. He doesn't look for the open man or the trailer on the fast break.

"I know we've had to use Theus a lot at point guard. That's not his best role, but he has to get his game under control and stop worrying about pleasing the fans with those turnaround shots and that kind of stuff.

"All that wild dribbling and running around does is turn the ball over. Reggie knows and all our guards know if the break's there I want them to take it. If not, pull up and run the play. It's that simple."

Costello didn't last a full season as Bulls coach. Theus seemed to thrive under Jerry Sloan, but Sloan's tenure ended after two-and-a-half seasons. Paul Westhead's fast-paced style seemed built for a player like Theus, but Westhead's lone season at the helm produced a woeful 28-54 record. Kevin Loughery followed and he never seemed to appreciate Theus' game.

In Theus' first five seasons with the Bulls, he never missed a game and averaged close to 20 points and made two All-Star teams. But by the middle of the 1983–84 season, he found himself benched and basically unwanted by Loughery. On Feb. 15, 1984, the Bulls traded the popular guard to the Kansas City Kings for center Steve Johnson and a pair of draft picks.

"Kevin had a fixed idea about me before he took over the Bulls," Theus said. "He never knew me as a person or a player. I'm just glad I had the strength not to let all his petty harassment break me. . . . I wouldn't have survived it without support from the fans in Chicago. I doubt I'll ever find better ones, but I'm optimistic about playing in Kansas City and doing the things I can do on the court again."

The trade was seen by some observers as an attempt to remove the Theus burr from Loughery's saddle, even though the coach had put it there himself.

"It was obvious a deal had to be made," Thorn said, "and we needed some help at center."

Johnson turned out to be a serviceable, journeyman center with a propensity for getting into foul trouble. After just a season and a half, the Bulls traded him to San Antonio in June of 1985 for guard Gene "Tinkerbell" Banks.

Theus had a few good seasons with the Kings before getting dealt to the Atlanta Hawks in 1988. A year later, Orlando chose him in the expansion draft. He played a year for the Magic, then was traded to New Jersey in 1990. His lone season with that 26-56 Nets squad was his last in the NBA.

On the day he retired after 13 seasons, Theus was among the NBA's top 25 scorers of all time with 19,105 points, and he ranked 11th on the assist list with 6,453.

Theus went on to play professionally in Italy, did some broadcasting work and later became a coach. He broke in as an assistant under Rick Pitino in Louisville before getting the head coaching job at New Mexico State. He left Las Cruces for the NBA, compiling a 44-62 record over two seasons as head coach of the Sacramento Kings. After Sacramento, he was an assistant with the Minnesota Timberwolves before returning to the college ranks as head coach at Cal-State Northridge.

Looking back on his career, Theus acknowledged that there were some good times in Chicago.

"If you're 19 years old and you're living two blocks from Rush Street, life is good," he said.

A few times were not as good.

"In five years, I think I had six coaches," Theus said. "It was a revolving door. One thing I do remember being very unjust was the way they fired Jerry

Reggie Theus was a two-time NBA All-Star with the Bulls and averaged 18.8 points per game in his six seasons in Chicago.

Sloan so prematurely. He hadn't been a coach for that long. Everybody knew he had the potential to be a great NBA coach."

Theus was disappointed that his feud with Lough-ery became part of his legacy in Chicago.

"I was in Chicago for 5½ tremendous years and had two bad months," Theus said. "I would hate for a lasting impression to exist that those two months were a big deal because my Bulls years were some of the absolute best times of my life." 🏀

The Bulls were hardly the picture of stability during Reggie Theus' years with the team. "In five years, I think I had six coaches," Theus said. "It was a revolving door." Here, he and his teammates get instruction from general manager and interim head coach Rod Thorn during a game in February, 1982.

Hard-nosed defense gave way to fast-paced offense after Jerry Sloan was replaced by Paul Westhead.

Sloan's out, Thorn's in

Feb. 18, 1982

EAST RUTHERFORD, N.J. – Saying he wants to change the philosophy of the Bulls, general manager Rod Thorn fired coach Jerry Sloan Wednesday. Thorn will assume the coaching responsibilities until the end of the season, even though assistant coach Phil Johnson directed the club Wednesday in a 115-105 loss to the New Jersey Nets.

Thorn said it had become a question of trading a lot of players or changing the coach. "You just can't change the whole bunch of players unless you're ready to start all over again and rebuild," Thorn said.

"What they were telling me is that I failed to get the Bulls to play up to their potential," said Sloan, who had a 19-32 record this season after leading the team to a 45-37 record and a playoff berth last year. "It was not unexpected; it was the way things were going. We should have been a very competitive team, and we weren't.

"Any time you don't succeed, there's disappoint-ment, but I'm not going to try to hurt somebody by pointing fingers and naming names. Downgrading the organization is not a professional approach. I'm an ex-coach, and I don't want to make it any tougher for the next guy."

The Bulls lost 9 of their last 10 games under Sloan and were next to last in the National Basketball Association's Central Division.

"Candidly speaking, most of the people within the league structure that I have talked to feel we have above-average talent," said Thorn. "Last year, we had the right chemistry. This year it just hasn't been the same. Some people have commented around the league that we don't have the right mix.

"All the coaches we've had here in the past—Ed Badger, Larry Costello, Dick Motta and Sloan—have had basically the same philosophy, but we don't have the same type of players anymore."

Bulls will run—and run— Westhead vows

June 29, 1982

"This team is at a crossroads situation. But we have the players here to help win games."
—Paul Westhead

More fast breaks, more unselfish players and a more cooperative, winning spirit were a few of the campaign promises made by Paul Westhead when he was introduced as the new head coach of the Bulls.

Westhead signed a four-year, escalating contract, the longest and most lucrative in the club's 16-year history. Details of the contract were not revealed, but the salary was estimated to start at $150,000 per year and increase in increments of $25,000 each year.

He had two years remaining on his Lakers contract ($275,000 a year, including bonuses), but the two parties settled that arrangement separately from the Bulls agreement.

Even though Pat Riley took over the Lakers' head coaching position in November of 1981, Westhead earned a $50,000 bonus when Los Angeles won the NBA championship in 1982. Pressed for details during his introductory press conference in Chicago, Westhead would not say whether any such incentive clauses were included his Bulls contract.

"The real perk you get here is to get things going well for the Bulls," he said.

"We feel very fortunate to get a coach with Paul's credentials," said Bulls general manager Rod Thorn, referring to Westhead's .691 winning percentage (112-50 record) and the NBA title his Lakers won in 1980. "He's been a winner at every level," Thorn said. "We look forward to a long and successful relationship."

Although Westhead was fired just 11 games into the 1981–82 season when star guard Magic Johnson complained that the team's offense was too structured, Westhead vowed to play a wide-open style in Chicago.

"I would like to go on record as being a fast-break-oriented, running coach. We're going to run relentlessly. I don't think there's any question that in my 2½ years in Los Angeles, I was directly responsible for fashioning the fast-break offense that was so successful for that franchise."

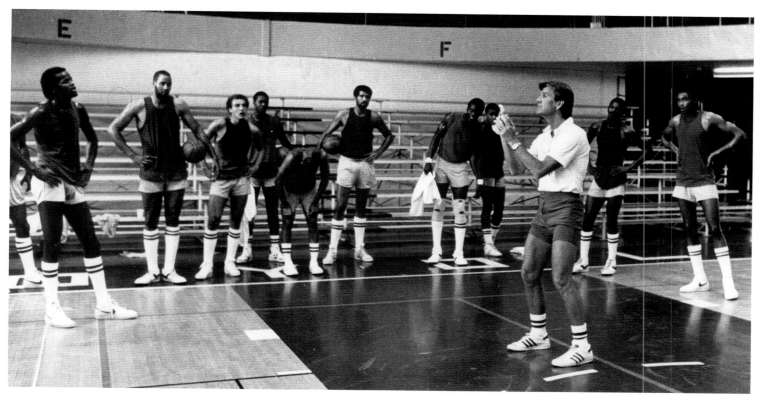

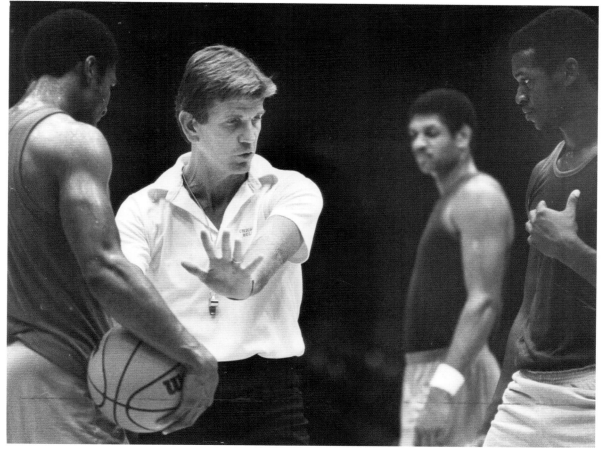

Above: Newly appointed head coach Paul Westhead directs his charges during a rookie/free-agent mini-camp in July, 1982.

Left: Paul Westhead conducts a preseason workout in with players (from left) Ronnie Lester, James Wilkes and Tyrone Adams in October, 1982. Only Lester would wind up making the Bulls roster.

Choosing to overlook the baggage that accompanied Quintin Dailey, the Bulls made him their No. 1 pick in 1982.

Troubled past, uncertain future

July 1, 1982

Quintin Dailey, the Bulls' No. 1 choice in the National Basketball Association draft, said he feels no remorse for assaulting a female University of San Francisco nursing student in December of 1981.

"Basically, nobody heard my side of the story when it happened," said the 6-foot-3 All-America guard. "And I really don't want to get into it now. I have forgotten about the episode. When you've got other, greater things ahead of you, I can put it behind me. Right now, it's forgotten."

Asked if he ever thought about the female student he assaulted, Dailey replied: "No, not really. Basically, I don't.

"People who tend to live life in history don't get the most out of it. What happened . . . it's all part of life. Mine was more publicized. I have to live with it."

Flanked by head coach Paul Westhead and general manager Rod Thorn at a Chicago press conference, Dailey talked casually to reporters about the incident that has evoked nationwide reaction, an incident that at first resulted in a charge of sexual assault and was later reduced to aggravated assault as part of a plea bargain.

Dailey, nicknamed "Q," left USF after his junior year. He was a communications major, and said if he were reporting his case, "I'd ask the sane questions. People are curious about public figures."

Pressed further to explain his side of the story, Dailey said: "If you look deep into it, he (Dailey's lawyer George Walker) can give you more details." But Dailey refused numerous opportunities to offer a reason or motive or public apology for his criminal action, opting instead to respond by saying such things as: "There are a lot of things you have to do because you have to." And "Everybody has their little problems and big problems."

The 21-year-old athlete said the death of both his parents when he was in high school had a profound effect on his outlook on life.

"I'm a survivor," he said. "My parents died when I was about 16 or 17. It's not fun when you graduate from high school and there's no one there to see you. When you have a big game and there's no one there to share it with . . ."

Dailey, who was raised by an aunt in Baltimore, said he had the same feeling after assaulting the female nursing student that he had after his parents died.

"Both times, it was out of my control. I had no control at all. I was into myself."

Thorn said he expected the widespread public reaction to the selection of Dailey. "I think that after what has transpired over the past couple months, we anticipated some people questioning what we have done. But we have checked extensively into Quintin's background. Everyone had extremely positive things to say about him."

"If you're a superstar, people are going to think what they want to think anyway," said Dailey, who dates Reggie Jackson's niece. "He (Jackson) has given me a lot of moral support. But basically, it's my life. My friends are behind me."

He later described his closest friends as his college coach (Pete Barry) and before that his high school coach (Ray Mullis). "Now, Mr. Westhead will be my closest friend."

While Dailey is eager to put the incident behind him, he acknowledges that many other people will never let him forget it. He knows, for example, that endorsements probably won't be coming his way if he becomes a star with the Bulls.

"A lot of times they will shade away from you because of this sort of thing. I'm willing to accept that. I don't really blame them."

"A lot of times they will shade away from you because of this sort of thing. I'm willing to accept that. I don't really blame them."

—DAILEY

Opposite: Quintin Dailey, shown here guarding San Antonio's Johnny Moore during a 1982 preseason game, was the Bulls' first-round pick and seventh player chosen overall in the 1982 draft.

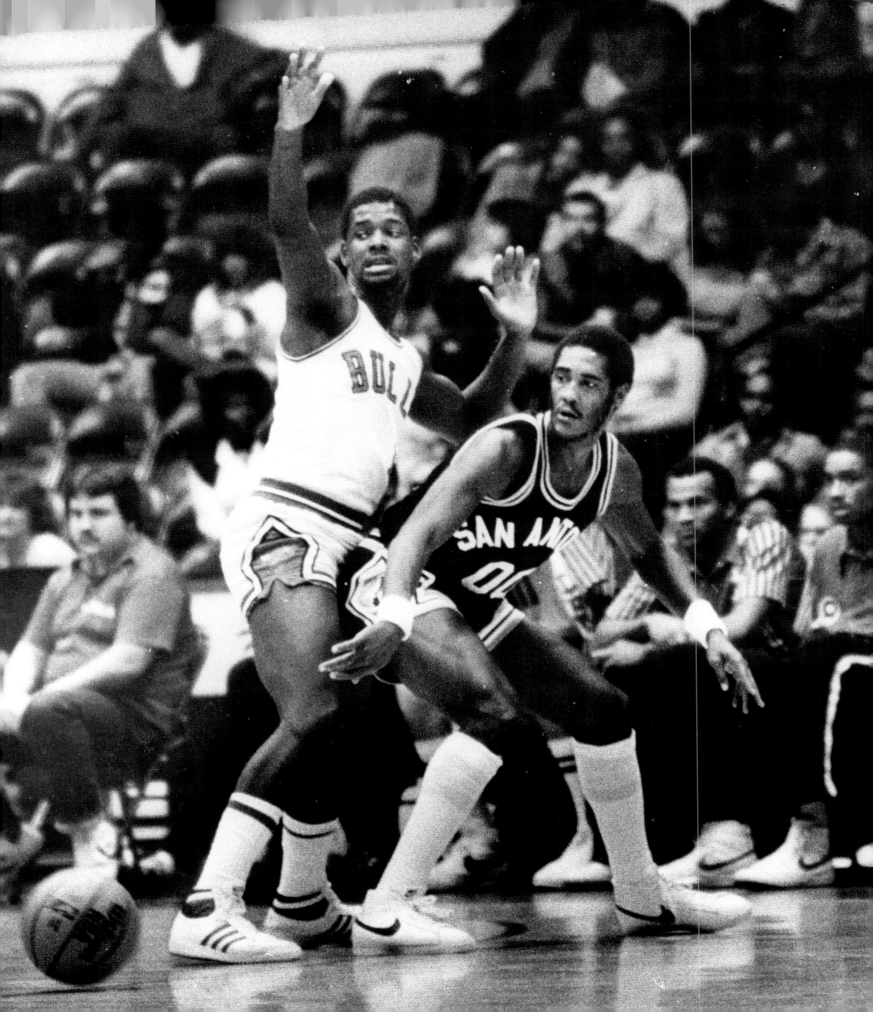

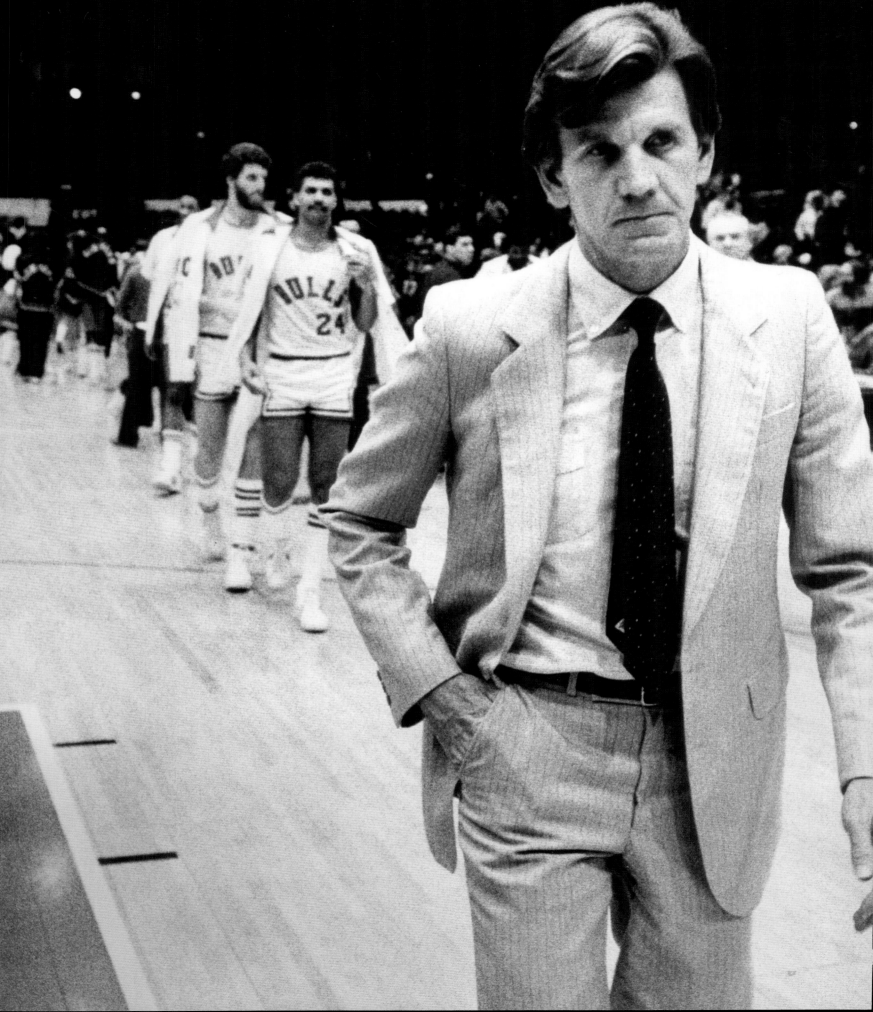

Paul Westhead

A FAST BREAK-UP

HEAD COACH

1982–83

Paul Westhead came to Chicago in the summer of 1982 accompanied by high hopes and much fanfare.

He was a coach who had won a championship in his first year with the Lakers, employing a fast-paced, run-and-gun offense that averaged 115 points per game. He won 54 games in his second season, but the Lakers couldn't survive their first-round best-of-three series with the Houston Rockets.

Then, 11 games into the 1981–82 season, with the Lakers' record at 7-4, Westhead was fired. The axing came a day after star guard Magic Johnson complained that he was unhappy with Westhead's "patterned" style of play.

"The ultimate irony is that it looked like I was run out of town because we weren't a running team," Westhead recalled. "I remember meeting with (owner) Jerry Buss. I wasn't argumentative, pleading, I took it like, 'It's your deal.' The only thing I voiced a disclaimer on—I said fire me for whatever reasons, but it would be an incredible mistake if that's the reason. I've never had a practice or a game plan where running wasn't the prime mover."

Westhead left L.A. running and never slowed down. He embarked on a coaching odyssey that took him next to Chicago, a pit stop on what would become a peripatetic career.

A year after the abrupt dismissal in Los Angeles, Westhead was hired to make a contender of a Bulls club that finished fifth in the Central Division with a 34-48 record in 1981–82.

"We feel very fortunate to get a coach with Paul's credentials," said Bulls general manager Rod Thorn. "He's been a winner at every level. We look forward to a long and successful relationship."

It would be neither long nor successful.

"This team is at a crossroads situation," Westhead said at his introductory press conference. "But we have the players here to help win games."

Westhead then ran down a list of observations he had about his style and his new team:

- "I want my team to be prepared to run and run and run."

- "The players can't be concerned about personalities and little things on the court. We must cooperate to win."
- "I don't have a real tolerance for people who don't care out on the court."
- "In my evaluation of this team, what the team needs is some good outside shooting. (Recently drafted rookie guard) Quintin Dailey represents the talent this team needs. He's a great offensive player. He says to your team, 'You need a basket? I'll get you one.'"
- "I don't think there is any incongruity in having a good running team and a great post-up center (such as Artis Gilmore). That could be the best team. I'm an up-tempo coach and I expect to win."
- "There's no question that this team centers around the biggest shoulders of all (Gilmore's), but that's not good enough to be a successful team."
- "I want to make this club a player-oriented team . . . I hope this coming season. (The four-year contract) indicates that I have been given the opportunity to turn this into a winning program."

Bulls managing partner Jonathan Kovler said, "We (the executive committee) gave Rod instructions to get the best coach possible. Price was no object. We're going to do whatever is in our power to win."

While the Bulls squad Westhead inherited was not as talented a club as the Lakers, he believed that his teaching skills would be no more in demand in Chicago than in Los Angeles.

"Coaching, if you do it effectively, is basically the same at the bottom of the rung, middle of the rung or top of the rung," Westhead said. "I think the Bulls will be responsive to my teaching. I'll do my best to win more than 34 games. It is very much undervalued, the coaching that goes on in the NBA."

Then the former English literature professor harkened back to Carl Sandburg's line.

"Chicago, as Sandburg so aptly put it, is the city of big shoulders. We would like to be a team of big shoulders. Today is the start of building some strong shoulders for the Bulls.

"If I were writing a book about myself," Westhead

Opposite: Paul Westhead walks off the Stadium floor after the final game of the 1982-83 season, a 120-103 loss to the Knicks that left the Bulls with a 28-54 record.

Known as an offensive innovator, Paul Westhead won an NBA title with the Lakers and later had success as a college coach at Loyola Marymount.

added, "I'd call this chapter 'Challenge and Opportunity.'"

When he was asked when Bulls fans might expect a championship-caliber team, Westhead said, joshingly: "I hope it's before the World's Fair (1992)."

That prediction would turn out to be remarkably accurate, but Westhead would not be around to see it come true.

Westhead was true to his vow: His Bulls came out running. They broke the 100-point mark in each of their first 15 games. Unfortunately they got outscored in nine of them. Westhead's Bulls lost all seven games on a disastrous road trip in late November–early December that dropped their record to 6-13. Among those 13 losses were games in which the Bulls scored 144 points (the Pistons scored 152) and 132 points (the Kings scored 143).

Thorn and Westhead clashed over the construction of the roster. The coach pushed for big changes, but the GM insisted the team's talent was better than its record indicated.

"Our team is better than it has played," said Thorn when the Bulls' mark stood at a ghastly 17-33.

Westhead saw it differently.

"Never once did I think it was sufficient," the coach said. "Trades are one avenue that helps. We should be willing to do anything at this time to improve our situation."

"Paul and I talk about things," said Thorn. "It would be nice to say we can get this guy or that guy. . . . There's always a possibility, but I don't foresee any trades."

Asked about his apparently strained relationship with Thorn, Westhead said: "In my mind, it's not really pertinent whether we're in total agreement or disagreement. I'm matching opinions with him. I just want to create a better winning posture.

"It was my feeling when I took this job that everyone involved with this organization was anxious to improve the team. I had the feeling there would be a forward movement of players."

The two men seemed to agree on the type of players they needed, but not on the price they'd need to pay to get them.

"If we were to make a trade," Thorn said, "a young center or a high-scoring forward would be what we want. But we would have to give up one of our big people—(Orlando) Woolridge, (Mark) Olberding or (David) Greenwood. Those are the players—besides (Reggie) Theus or (Dave) Corzine—who have the most value. I haven't gotten any offers for Theus lately."

"Since the summer, when I took the job," said Westhead, "I felt a major priority would be the acquisition of a quality small forward, particularly being in the Eastern Conference. We need a player to keep up with the (Kelly) Tripuckas and (Julius) Ervings. I would rather make one major move instead of three or four ancillary moves to patch things up. We need help at center. There have been nights when Dave Corzine has done a very fine job, and there have been nights when he could have used some help. We need a steady backup center.

"We also could use a steady lead guard. There has not been a clear identification of the quarterback-type guard we have been searching for. But small forward is the biggest need.

"Bringing in a high-quality player can do wonders."

The big deal never came to pass, the Bulls continued to flounder, and the rift between Thorn and Westhead widened.

On May 11, 1983, less than a month after the Bulls closed the books on a miserable 28-54 season, Westhead was fired.

"What I had to assess at the end of the season was whether the situation was going to get better or not," said Thorn. "I didn't talk to any of the players. It was my decision."

Some Bulls players expressed surprise at the firing, but guard Ronnie Lester was not shocked.

"You kind of feel sorry to see a coach go, but we had a pitiful season," said Lester, who lost his starting job to Dailey in December. "It got so bad during the season that I thought about asking to be traded. . . . He (Westhead) never said anything to us after a game—win or lose."

"I didn't think he would get fired," Theus said. "How many coaches get fired after just one year? This is a difficult team to turn around in a year. Usually they give a coach a year and a half. You can point the finger at everyone from the top of the Bulls' management to the lowliest player for our problems."

Westhead's agent Richie Phillips, not surprisingly, had his finger pointed at the top of the organization chart.

"Paul works very hard and is committed to excellence and feels the Bulls' management does not share that commitment," he said. "It's impossible to take a team like Chicago and turn it into a contender in a year. He feels he came into a situation which had been traditionally a bad situation. Paul feels under the circumstances he did the very best he could possibly do."

"It was a done deal before I started," Westhead said of his time in Chicago. "I was one in a string of coaches given a team that had little or no chance to do better than it did a year before, and there wasn't a commitment to changing it. You can do it quick with a lot of money, or slow, but if you don't do one or the other, you're on a collision course. I was on a collision course from the start."

After leaving the Bulls, Westhead found success at the college level, coaching Loyola Marymount to a 105-48 record in five seasons. Westhead made the small school into a national power, qualifying for the NCAA Tournament three years in a row from 1988–1990. In 1990, the Lions set an NCAA record with an average of 130 points per game and advanced to the Elite Eight, where they were beaten by the eventual champion Runnin' Rebels of UNLV.

Westhead's offense, when it worked, was a joy to watch. And it was a joy to run, at least according to some players. "It takes the fat out of basketball," said Bo Kimble, who played guard for Westhead at Loyola Marymount. "It's the way the game should be played."

In 1990, Westhead got another crack at an NBA head coaching job, taking over a Denver Nuggets team that was coming off a 43-39 season and nine straight playoff appearances under Doug Moe. Westhead picked up where he left off, instituting his run-and-gun-and-run-some-more offense in Denver.

"I am a fast-paced coach," he told the Orlando Sentinel. "No, I stand corrected. I am the fastest-paced

coach. And I will accept any and all criticisms because of that. This is what I do. The people who hired me know that. They didn't ask me to walk the ball up the court. Everybody in the league runs basically the same stuff, everybody plays the same game of 'Monopoly.' Well, I'm going to try to play 'Parcheesi.'

"I can only say that this, for better or for worse, is a very, very special way of playing," Westhead said of his frenetic style. "When it's good, it's very good. When it's bad, it's very bad. Am I prepared to follow the very good and lead that quest and work my team, work my scheme toward that? Absolutely."

In his two seasons in Denver, the Nuggets went 20-62 and 24-58 before he was fired.

"That," Westhead said of his Denver experience, "was just another reminder you have to have good players to win. As good as, if not better than, your opponents."

He took a job as head coach at George Mason University in 1993, in hopes of replicating the success he had found at Loyola Marymount. In Westhead's vision, the 45-second shot clock used in college ball back then was, in his view, a "four-to-five second clock." George Mason went 38-70 in his four seasons there.

After stints as an NBA assistant in Golden State and Orlando, Westhead was named head coach of the WNBA's Phoenix Mercury in 2006 and led them to a title, making him the first coach to win NBA and WNBA championships. He returned to the NBA in 2007 as an assistant with the Oklahoma City Thunder, but left in 2009 to become head coach of the University of Oregon women's team.

Wherever he went, his go-go-go philosophy of basketball went with him.

Westhead traced his fascination with speed back to his early days as a coach at LaSalle in Philadelphia. In 1975, a coach named Sonny Allen used a hurry-up, run-and-shoot offense to guide Old Dominion to a Division II title. Later, at a clinic, Westhead's interest was piqued further while listening to Allen describe his system's basic principles.

The student afterward asked the lecturer to expand on the subject, and when Allen told him there was nothing more to it, Westhead asked, "If it's so easy, why doesn't everybody do it?"

"Because," said Allen, "you have to be a little bit crazy to do it."

"And I am," admitted Westhead, "a little bit crazy."

PAUL WESTHEAD

» **Born:** Feb. 21, 1939 in Philadelphia

» **College:** St. Joseph's University

» **Years in NBA:** 1979–83, 1990–92

» **Hired by Bulls:** June 23, 1982

The Bulls would have preferred to draft a big man, but the best ones were off the board, so they settled on a shooting guard from North Carolina instead.

Apologetic Bulls 'stuck' with Jordan

June 20, 1984

The Chicago Bulls send their regrets. They ask forgiveness. Please understand. They really wanted to do better in the draft than the best college basketball player in America, but they couldn't.

They got stuck with Michael Jordan of North Carolina, maybe the greatest natural basketball talent, inch for inch, in this young decade. Nothing they could do. They want you to know that.

They tried to avoid Jordan, tried hard. But nobody wanted to trade with them, swap some big fossil of a center for the third pick in the draft. It was like they were under quarantine or something. So, they were forced to do the intelligent thing Tuesday.

They had to take Jordan, even though he is already famous, has had quality coaching, is not a social disgrace and may likely become the next Julius Erving before the old one is in the Hall of Fame.

It was a hard choice.

"We wish he were seven feet, but he isn't," said Bulls general manager Rod Thorn.

Sigh.

"There just wasn't a center available," said Thorn. "What can you do?"

Counting your blessings doesn't seem inappropriate.

"He's only 6-5," said Thorn, who must use a different yardstick than Dean Smith, the Carolina coach. Down where the tobacco grows, Jordan has always been 6-6, not that one inch ever stopped Jordan from crashing the boards, hitting from the outside or playing substantially above sea level. By the time he gets to Chicago, or when negotiations for his wages get sticky, Jordan may be the size of a jockey.

"We've taken a step in the right direction," said Thorn. "Jordan isn't going to turn this franchise around. I wouldn't ask him to. I wouldn't put that kind of pressure on him."

The patient Bulls faithful will. There were as many civilians in the Conrad Hilton ballroom watching the draft on television as there have been at some Bulls games. Anticipation will draw a bigger crowd than reality. After the selection of centers Hakeem Olajuwon by Houston and Sam Bowie by Portland, there was a suspicious delay as the Bulls prepared for their turn. Would the Bulls be stupid again? The crowd began chanting "Jordan! Jordan!" loudly enough for the Bulls' management to hear two floors above, not that anyone was listening.

The announcement was cheered with enthusiasm and relief. The public got what it wanted, if not the Bulls.

"He's a very good offensive player," said Thorn. "But not an overpowering offensive player."

Translation: Fans, don't expect miracles. Jordan, don't expect a million dollars.

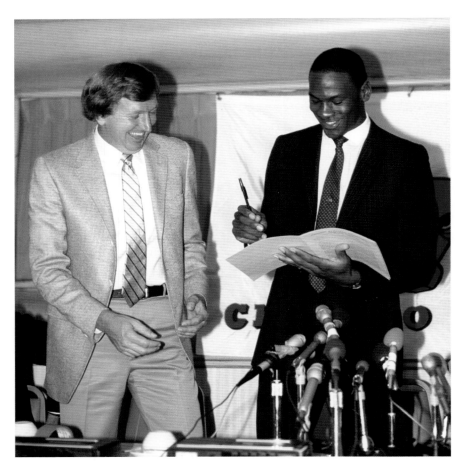

General manager Rod Thorn smiles broadly as Michael Jordan signs his first contract with the Bulls on Sept. 12, 1984.

Opposite: With his signature tongue-wag already in place, rookie Michael Jordan works against San Antonio's Mike Mitchell during the Bulls' 120-117 victory over the Spurs on April 13, 1984 at the Stadium. Jordan scored 45 in the game and the Bulls improved to 7-2 on the season.

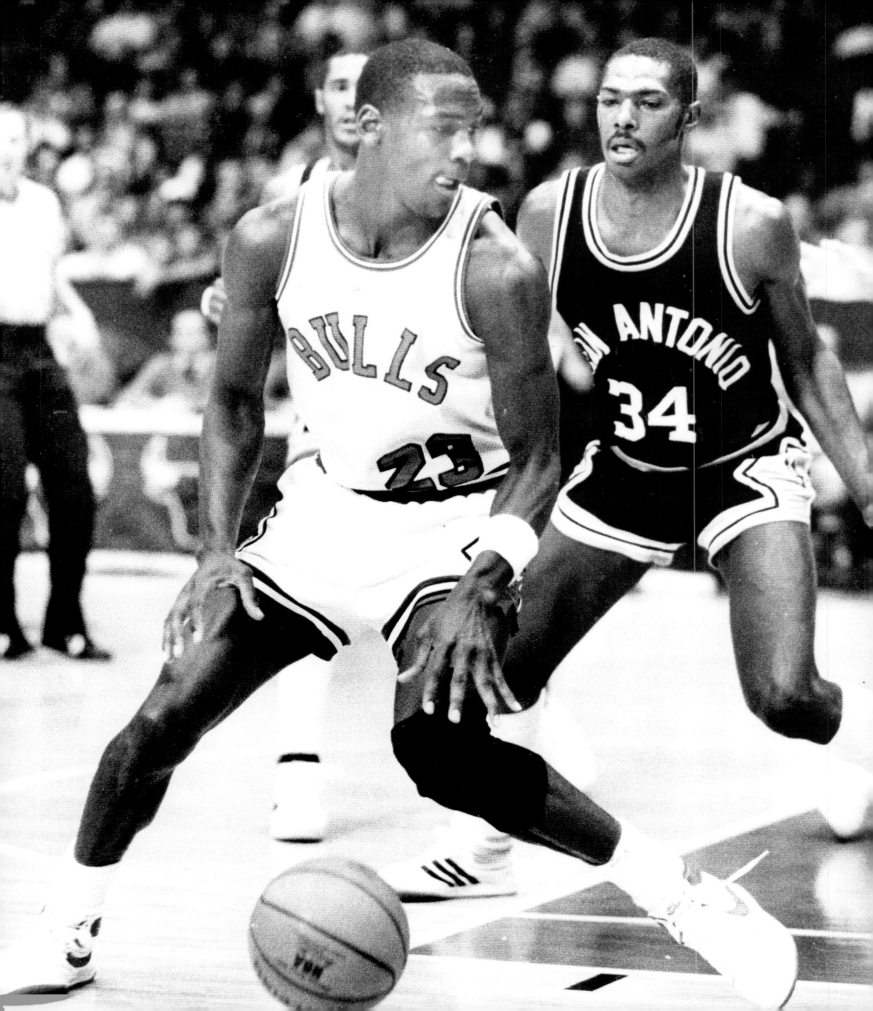

Turnover at the top continued when Jerry Reinsdorf took over as principal owner and Jerry Krause returned to the front office.

Kovler bows out as a Bulls' owner

March 13, 1985

A dream that Jonathan Kovler lived for 13 years came to an end Tuesday when the Bulls' former managing partner sold his seven percent interest to new owner Jerry Reinsdorf, who now has 63 percent.

"It's an emotional thing," said Kovler, 38, who was in charge of the team's day-to-day operations until White Sox chairman Reinsdorf gained controlling interest in the franchise Monday. "Over one-third of my life has been spent with the Bulls. I still remember the day in March of 1972 when Arthur Morse called me and asked if I wanted to buy stock in the Bulls. It was like a dream come true for me as a 25-year-old kid."

Some people in the Bulls organization are relieved to see Kovler go. They blame him for the team's dismal fortunes in recent years. A source close to the team said Kovler vetoed trades that would have brought Terry Cummings and Rodney McCray to the Bulls.

Kovler did not deny blocking the trades, but said nobody knew the complete story behind his actions. He refused to elaborate, but said he realizes he makes a convenient scapegoat for those trying to cover for themselves.

Reinsdorf, who will hold a press conference Wednesday to announce any changes in the organization, said: "I did a lot of investigating before buying the team, and in my opinion, whatever the problems were, they cannot be attributed to Jonathan."

Thorn is out as Bulls' GM

March 26, 1985

Rod Thorn, 43, general manager of the Bulls since 1978, has been dismissed by new owner Jerry Reinsdorf, and former Bulls scout and personnel director Jerry Krause will be named to replace him at a 10 a.m. press conference Tuesday.

"I'm tremendously shocked and disappointed," Bulls coach Kevin Loughery said about the firing of Thorn, who hired him before last season and whose dismissal puts his own status in doubt. "He is a good basketball man and a class individual. I talked to Rod earlier this evening and he is very disappointed. I'm sure Rod was tremendously shocked.

"I'm shocked it would happen at this time, when we're driving for a playoff spot. I can't worry about my job being next. When you enter into this business, you have to realize coaching is a very precarious position.

"Jerry Reinsdorf has made two major moves already, with (the removal of managing partner Jon) Kovler and Thorn. How much more serious about changes can you get?"

In Thorn's first six years in Chicago, the Bulls qualified for the playoffs only once—in the '80–'81 season, Jerry Sloan's second as coach. Sloan was one of six people—Larry Costello, Scotty Robertson, Sloan, Paul Westhead, Thorn himself, and Loughery—who coached the team during those years.

Krause is no stranger to the Bulls' operation. He was on the scene almost from the franchise's inception in 1966, brought into the organization from the Baltimore Bullets by team president Dick Klein. Krause was appointed Bulls player personnel director in 1976, but he was on the job only three months.

Krause signals new Bulls era

March 27, 1985

Jerry Krause is in, Rod Thorn is out and Kevin Loughery is somewhere in between.

That is the state of the Bulls' leadership after owner Jerry Reinsdorf announced the firing of general manager Thorn and the signing of Krause to a three-year contract as vice president of basketball operations at a press conference Tuesday.

Krause, 45, had a three-month term as the Bulls' player personnel director in 1976. He allegedly offered former De Paul coach Ray Meyer the Bulls' head coaching job that same year, then denied having offered him the position. The controversy that ensued was the beginning of Krause's downfall. Team president Dick Klein brought him into the franchise as a scout in 1966 and he remained until 1971. For the last six years he has been a scout for the White Sox, including the last four under board chairman Reinsdorf and president Eddie Einhorn.

> **"[Krause] said I was being fired because of a difference in philosophy. I don't know what that means."**
> —LOUGHERY

Bulls' coaching search is on

May 29, 1986

In what is becoming their annual rite of spring, the Bulls Tuesday fired Kevin Loughery and began a search for their eighth coach in eight years. Among the possible choices are Stan Albeck, now with the New Jersey Nets, and Phil Jackson, the Continental Basketball League Coach of the Year.

Jerry Krause, the club's new vice president of operations, lowered the expected boom on Loughery in a 6:30 a.m. phone conversation.

"You don't take Step B until you take Step A," Krause said. "Step A was arrived at this weekend. Now I'll go about taking Step B."

"It was a bizarre season, to say the least," said Loughery, who expressed gratitude that he hadn't bought a larger house in the Chicago area. "When Rod Thorn was let go, everything could have fallen apart, with 10 games left in the season. It's a credit to the players that they didn't come apart."

After a meeting in late May with Krause and Reinsdorf, it was becoming clear that Loughery was on his way out. On Tuesday, he was officially unemployed.

"Krause said it was a tough call to make but that he would be bringing in another guy," Loughery said. "He said I was being fired because of a difference in philosophy. I don't know what that means.

"I look back at the day Jerry was hired, and I was sure I wasn't going to be around much longer."

"I wanted to hire a man whose philosophies about the game are more similar to mine," Krause said when the move was finally announced. He didn't elaborate, saying he didn't want an applicant to "come in and say what I expect to hear. I want to prevent others from knowing my philosophy. It's better to sit back and wait and not talk about my philosophy."

"This is the first time I've been fired," Loughery said. "I'm sad about it, but I'm not going to go out and blow my brains out. I came in with the team and the organization floundering and we made the playoffs and doubled the attendance. There was some definite progress made.

"I knew all along, no matter how the Bulls did in the playoffs, I wouldn't be around. Now I have no idea what I'll do. Up to this point, I wasn't able to talk to anyone and nobody could talk to me about another job. I asked them why it was taking so long, but I didn't get an answer. They have such a veil of secrecy.

"I have no bitter feelings toward the organization. I wish them luck. I've talked with Reinsdorf and Krause, and Reinsdorf is a real nice man."

Albeck gets a warm welcome

June 18, 1986

Stan Albeck made his Chicago debut Monday, and Dave Corzine was there to welcome him.

The 54-year-old former New Jersey Nets coach agreed to a three-year contract, becoming the Bulls' eighth head coach in the last eight years. Terms were not announced, but it has been reported that he would get about $900,000 over three years. Albeck was making $250,000 a year with the Nets.

Announcement that Albeck, a native of Chenoa, Ill., had signed was made at a press conference in the One Magnificent Mile building, and Corzine, who had flourished while playing for him in San Antonio, was all smiles.

"I'm double-parked outside, but I had to stop by and say hello," said Corzine, who had been downtown for a luncheon.

"You're dressing a lot better than when I last saw you," Albeck said, admiring Corzine's rare impersonation of a model from Gentleman's Quarterly.

"Nah," Corzine replied with a laugh. "I've only worn this suit to two funerals and now this, your grand opening."

That brief encounter illustrated why the Bulls made

Albeck one of the highest-paid coaches in the National Basketball Association. Along with his .563 winning percentage, Albeck has a rapport with centers. The best years of Corzine's NBA life were the three he spent with Albeck in Texas.

Albeck has some definite ideas on how to compensate for the Bulls' weakness in the middle, even if the team fails to select a center in Tuesday's college draft.

"That doesn't scare me," Albeck said about the Bulls No. 1 drawback last year. "Dave Corzine is a much better player than he showed last season. He can shoot and do certain things. Jawann Oldham can block shots and rebound. I had the same situation in San Antonio with Corzine and George Johnson. We won three Midwest Division titles, and one year we won 53 games and lost to the Los Angeles Lakers for the Western Conference title."

Albeck realizes that whatever success the Bulls have in the pivot will come from within.

"As long as Michael Jordan is around, the Bulls will never finish in the lottery and have a chance for a great college center," he said.

Rod Thorn

THE MAN WHO DRAFTED MICHAEL JORDAN

GENERAL MANAGER

1978–85

HEAD COACH

1982

When he took the job as Bulls' general manager in 1978, Rod Thorn did not think it would take him long to get the team on the right track. After a few weeks on the job, the 36-year-old Thorn wondered if he had misjudged the situation.

"From a distance it looked like the Bulls were a team that just wasn't playing to its potential," Thorn said. "You figured a team that had Artis Gilmore had to be better than their record. When I got here, I found they weren't very good. They didn't have enough good players. The bench was weak, the starting lineup wasn't very strong. Everyone but Artis was playing out of position."

Basketball has been described as a chess game with soul. Thorn figured he pretty well knew all the moves; he just didn't have all the pieces. He spent years collecting more. His prize piece was Michael Jordan, whom he drafted in 1984. But Thorn didn't last long enough to see Jordan lead the Bulls to the promised land, partly because he made an ill-advised gamble on another draft pick, Quintin Dailey, who was selected with the seventh overall pick in 1982. Thorn was fired in March of 1985 and replaced by Jerry Krause.

In Thorn's six years as GM, the Bulls made the playoffs only once—in the 1980–81 season, Jerry Sloan's second as head coach. Sloan was one of six people—Larry Costello, Scotty Robertson, Sloan, Paul Westhead, Thorn himself and Kevin Loughery—who coached the team during those years.

Thorn was a great basketball player before his knees betrayed him and went bad. He was a high school All-America in Princeton, W. Va. He was a college All-American at the University of West Virginia. He played in the NBA for seven years and four teams—the Baltimore Bullets, the Detroit Pistons, the St. Louis Hawks and the Seattle SuperSonics.

After using guile and style—sometimes they are commodities more important than speed and jumping ability—to last as an NBA player, Thorn turned to coaching. He did apprentice work as an assistant to Lenny Wilkens in Seattle and to Loughery with the New York Nets. In 1975, he went for it all. He signed on as coach of the Spirits of St. Louis of the American Basketball Association. There, he learned patience. There, his star was a fellow named Marvin Barnes.

"Marvin was amazing," Thorn said. "Like other teams, we had fines. If you were late for practice or a meeting, it cost you $2 a minute. If you missed a practice, it cost you $300. If you missed a plane, it cost $250 plus plane fare. When I was there, Marvin was fined in excess of $10,000. I mean, he was always late or missing something. But he could play. The season before I got there, he missed a plane from New York to Virginia. He chartered a plane for $2,500, got to the arena as they were playing the National Anthem, got in the game with five minutes left in the first quarter, and scored 45 points.

"When I was coaching him, I was always having long, serious discussions with Marvin. After the third one, I realized they were always after he did something wrong. One night in Utah, he scored 25 points and got 20 rebounds, and I decided to have a talk with him after he did something good. I told him that as a great player, as a leader on the team, he had a responsibility to the organization, the league and himself. He said, 'Coach, I finally see what you're talking about. I won't miss a practice. I'll be on time. We'll win it all.' The next morning, he missed the plane to Denver. He was incredible."

After 47 games and 20 victories of dealing with Marvin, Thorn was fired by the Spirits, and he returned to New York to work with Loughery. He stayed there until the Bulls beckoned in the spring of 1978.

The first thing he did was hire Costello as coach. The second thing he did was draft Reggie Theus in the first round. The third thing he did was fire Costello as coach. The fourth thing he did was suffer through a 31-51 season. The fifth thing he did was hire Jerry Sloan as coach. The sixth thing he did was draft David Greenwood in the first round. The seventh, eighth and

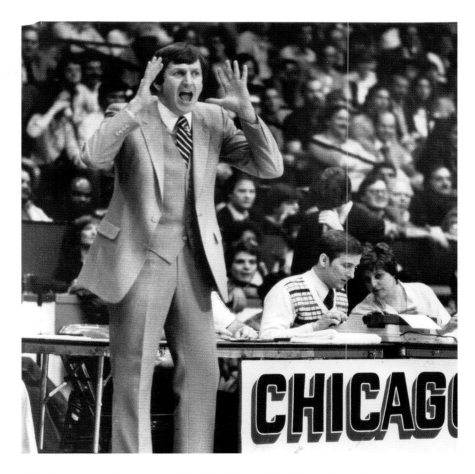

ninth things he did were sign free agents named Coby Dietrick, Ricky Sobers and Dwight Jones. The 10th thing he did was watch Artis Gilmore get injured and Delmar Beshore play. The 11th thing he did was suffer through a 30-52 season.

That was enough suffering. Thereafter, Thorn put the finishing touches on a team that seemed destined to make the playoffs and thrive for seasons to come. On draft day in 1980, he traded Kelvin Ransey for Ronnie Lester and a first-round pick in 1981. He signed Larry Kenon as a free agent. When Lester came up lame, he started shopping around for another guard. He offered two second-round draft choices to Denver for Bobby Wilkerson. Denver wanted a first-rounder. Thorn demurred. Ten days later, Denver kicked Wilkerson out of training camp and Thorn bought his contract for roughly the price of a full-size American automobile. He signed Sam Worthen and coaxed Sobers into staying in Chicago.

The result was a 45-37 finish in 1980–81 and a playoff appearance. The Bulls took their first-round series two games to none over the Knicks, but were swept by the Celtics in round two, four games to none. It would be the only postseason run in Thorn's six-year reign.

The Bulls followed their playoff season by going 34-48 in 1981–82, a year in which Thorn took over as coach for the final 30 games of the season. (The Bulls were 15-15 during that span.) Things got worse in 1982–83 under Westhead when the record dropped to 28-54, and worse yet in '83–'84 under Loughery, when it fell to 27-55. At least that record resulted in the No. 3 overall pick, which Thorn used to select Jordan.

Shortly before he was fired in 1985, Thorn admitted that he had made a mistake by drafting and defending the troubled Dailey, who had been accused of sexual assault while in college and then battled substance abuse during his short time in the NBA. Dailey was often late to practices and sometimes failed to show up at all.

"I've been his champion," Thorn said. "I thought that when he got here, he got a bad deal because he failed a press conference. But since he's been with this organization, Quintin has been treated as well as any player ever has been. And there has been a lack of reciprocity on his part."

Thorn cited a game that typified Dailey's attitude.

"We'd been having some rough times and we win a game we needed to win (a 109-104 decision over the Knicks on March 1, 1985 that pulled the Bulls within four games of .500), so what does Quintin do? He storms out of here without talking to anybody because he didn't get as many minutes (19) as he wants.

"I shouldn't take it personally, but I do."

Some of Dailey's defenders say his problems with the Bulls stemmed from a dismal relationship with Loughery, his coach. But Thorn didn't buy it.

"Kevin is the logical guy for Quintin to use (as an excuse), isn't he?" Thorn said, answering his own question. "It's always somebody. It's Westhead. Or it's (teammates) Reggie Theus or Michael Jordan. Who was it last year?

"If it were another coach, like (then-Lakers coach) Pat Riley or (Philadelphia's) Billy Cunningham, it would be the same.

"I mean, who is Quintin Dailey?"

As it turned out, he was the person who helped bring down the curtain on Rod Thorn's run with the Bulls. 🏀

General manager Rod Thorn named himself head coach for the final 30 games of the 1981-82 season.

Left: Orlando Woolridge played the first five seasons of his 13-year NBA career with the Bulls. He later played for the Nets, Lakers, Nuggets, Pistons, Bucks and 76ers.

Opposite: Orlando Woolridge elevates during a Dec. 12, 1985 game against the Sixers. Woolridge was the Bulls' first-round pick and sixth player chosen overall in the 1981 draft.

A battle over when Michael Jordan would be ready to play after breaking his foot created a rift between the young star and Bulls management.

Air Jordan down with injured foot

Oct. 31, 1985

LOS ANGELES – Michael Jordan walked on crutches slowly up and down the sideline at practice, his left foot wrapped in a protective brace.

The Bulls are about to play their first game in more than a season without The Franchise.

Jordan jammed two bones in his foot just before halftime of a 111-105 victory over Golden State. He sat out the second half.

Jordan said his chances of playing in the next game against the Los Angeles Clippers were "less than 50 percent."

This comes from an athlete who hadn't missed a game throughout high school, college and his short NBA career. Several times last year, Jordan played in pain. Now simply walking seemed to be an accomplishment for a young man who normally flies.

"It's improved because I can put a little pressure on it," Jordan said. "If I can walk without crutches, I'll try playing. But I don't know what good I am. There is always a chance I could reinjure it."

Jordan's injury could have left the Bulls in a huge jam if not for the recent arrival of George "the Iceman" Gervin from San Antonio, and the addition of another ex-Spur, guard John Paxson, a free agent who signed an offer sheet. The Bulls gave San Antonio $200,000 not to match the offer. Coach Stan Albeck said Gervin would start alongside Kyle Macy in the backcourt on Thursday.

Jordan rails at Reinsdorf, Krause

April 3, 1986

INDIANAPOLIS – Michael Jordan erupted after practice, angrily criticizing management because of the way it has treated him during his comeback from a broken left foot.

Jordan said he was getting "jerked" around "big-time" by owner Jerry Reinsdorf and vice president of operations Jerry Krause because of their policy of limiting Jordan's playing time. He also said he feels the team is limiting his time to lose enough games to become part of the NBA's college draft lottery, a charge the Bulls deny.

"This is total bull," said Jordan of his playing time. "They have been leading me on the whole time. They never had any thought about letting me play a full game.

"I talked to Dr. Hefferon (team physician Dr. John Hefferon) today and he told me the X-rays showed enough improvement that I could go play a whole game. If Krause said anything else, he was lying. It's not a medical decision anymore, it's all business."

Jordan has been playing about 12 minutes a game since his return, and the plan is to increase his court time by a minute or two per game. But he won't be going full tilt until next season.

The Bulls trail Cleveland by 2 ½ games in the fight for the last Eastern Conference playoff spot with six games left.

"Michael saying this kind of stuff doesn't bother me," Reinsdorf said. "He is such a good competitor and he is frustrated. I will be angry with him if he continues to say these things after I've talked to him. Then I'll be perturbed. I let him talk me into playing him, but the line has been drawn as far as playing time. He is not going to make this decision."

"Michael won't play a full game until all three doctors say it's okay," Krause said. "Even if Dr. Hefferon said that, well, Dr. Hefferon is our team physician and he is a fine doctor, but he isn't a specialist in that area."

According to Krause, one specialist—Dr. John Bergfeld of Cleveland—said it was "unreasonable" to let Jordan play, and the other—Dr. Stanley James of Eugene, Ore.—said the Bulls would be "crazy" to bring him back.

Jordan said that he suspects the Bulls are limiting his time to lose enough games to qualify for the draft lottery. He says he doesn't want to be associated with an organization that tries to improve itself by losing.

"Losing games on purpose reflects what type of person you really are," Jordan said. "No one should ever try to lose to get something better."

How far can Jordan push Reinsdorf and Krause before they tell him they've had enough?

"I think Michael has enough sense not to let it get to that point," Krause said. "Jerry Reinsdorf is running the franchise. No one player is bigger than the franchise, no matter who he is."

A 63-point game against the Celtics offered a glimpse of greatness to come from Michael Jordan.

'My God! That's incredible!'

April 21, 1986

BOSTON – Wow!

"He got how many?" asked Orlando Woolridge. "Let me see that stat sheet."

Woolridge snatched the final box score from Charles Oakley. "That's a mistake," Woolridge said.

Woolridge stared at the blue and white mimeographed sheet.

Right there under the accounting of mortal Bulls—Woolridge 24, Oakley 10, Corzine 8, Macy 7, Green 7, Banks 8, Paxson 4—it screamed like a birthmark on a beauty queen.

63.

63 points.

"My God!" Woolridge gasped. "That's incredible!"

No, that's Michael Jordan.

You can call him "incredible," and it still sounds like an insult. "Amazing" is a marquee lie. "Unbelievable" begs for laughs. "Astounding" is the fourth cup from the same tea bag. Weak, much too weak.

Jordan is his own adjective, maybe his own language, and foreign to anyone who has watched the game of basketball played by mere humans. Or those who have played it themselves.

"Awesome," said K.C. Jones, the Boston Celtics' coach.

Nice try, coach. Now call Baryshnikov limber. Pavarotti loud. Woody Allen clever.

This was a record, if as disposable as was the old one, 61 points in a playoff game by Elgin Baylor, in 1962, same place, different Celtics.

"Elgin was before my time," Jordan said.

Wasn't everything?

If Baylor's record stood for 24 years, Jordan's may stand for 54. Hours, or as long as it takes Jordan to get on the floor against the Celtics again, this time at Chicago Stadium. Arrive early and bring extra breath.

"This has to be the greatest individual performance in playoff history," said Bulls coach Stan Albeck. "Against the Celtics. In Boston Garden. With 15 championship banners hanging over his head, against the team everybody picks to win. This guy puts in this type of performance. It has to rank way up there."

Albeck won't start many arguments that way. Even in Boston.

"There's no telling what he might have done in another five minutes," said Celtic center Robert Parish, "He might have had 90."

Yes, there is that one, tiny qualifier for Jordan's glorious afternoon. It did take two overtimes, an extra 10 minutes. Without that, Jordan only would have had 54, which is like saying if Secretariat hadn't had to go that extra quarter of a mile he would only have won the Belmont by 20.

"I'd give back all the points if we could have won the game," Jordan said.

That, too. The Bulls lost 135-131. That can't be minimized. The Bulls lost because... well, because they are the Bulls. And the Celtics won because they are who they are.

The Celtics won because an obscure gym rat named Jerry Sichting came off the bench to be invaluable, and because Jordan missed what would have been the game winner from 15 feet at the end of the first overtime.

"That's what usually happens," said Larry Bird, who missed an easy one himself with 12 seconds to go in regulation time. "You make all the tough ones and you miss an itty-bitty, open shot."

"I'll remember that shot longer than my points," Jordan said. "Missing that shot. It was the shot we wanted. I felt good about it. It just didn't fall."

Jordan did make two free throws with no time left after a foul by Kevin McHale to send the game into overtime.

"I was surprised I got that call," Jordan said. "It was a foul, but they usually don't call those at the end of a game."

It was game that should not have ended. This was one of those special moments in sports to be lingered over and savored.

To have Bird, widely revered as the best player in the game, in his prime, surrounded by competence, and Jordan, young and hungry, working with few tools but his own, making the improbable into the possible, made delicious drama.

Take your choice. Do you prefer it as it is or as it will be?

And on this day, the rest of the Bulls were nearly as dependable as Jordan. The example should not be dismissed as an accident but studied as an inspiration.

"I didn't score all those points by myself," Jordan said.

Much more was gained than lost for the Bulls, no matter that the world is one game away from not seeing Jordan again for a long empty summer.

Always a scout at heart, Jerry Krause had been keeping an eye on Doug Collins as a potential head coach. "I'm willing to say it—this is my man."

Bulls pull plug on Albeck

May 20, 1986

The Bulls, as expected, fired coach Stan Albeck, paving the way for the hiring of Doug Collins.

Bulls' owner Jerry Reinsdorf issued a statement announcing Albeck's firing. A short while later, Albeck fired back.

"It's not fair," said Albeck, who led the Bulls into the playoffs with a 30-52 record despite losing superstar Michael Jordan for 64 games. "I think it was completely uncalled for, but I'm probably biased. With the number of injuries we had—well, it was an absolute bizarre year."

"First of all, let me say there is no question he is a competent NBA coach," Reinsdorf said. "When we first got together, I thought we had a common understanding of how the game should be played. It's obvious his concept is not the same as mine. That's not to say I'm right. But I bought this team because I want to see basketball played a certain way. And I want to try it.

"I blame myself totally for the lack of understanding. I couldn't tell Stan to change his coaching style that has been so successful. My mistake was in not ascertaining this difference in the beginning."

Albeck charged that the dismissal was handled without "any sense of dignity, any sense of respect or sensitivity."

"It's the first time I've ever been fired," he said. "I came here with the greatest of expectations, and now I feel shortchanged because I never had a full deck to play with. . . . not to have the opportunity to come back and continue what we started, that's what's disappointing. . . . I'm stunned and shocked. I'd programmed us for 40 to 50 wins next year."

Bulls sign Collins for 2 years

May 23, 1986

Doug Collins became the Bulls' ninth coach in the last 10 years Thursday night when he signed a contract that is believed to guarantee him two years at about $225,000 a year with an option the Bulls can exercise for a third year. Collins replaces Stan Albeck, who was fired Monday.

Collins, 34, will be officially named the new coach Friday at an 11 a.m. press conference in the Bulls' office complex at One Magnificent Mile. Collins comes to the Bulls after coaching one season as a volunteer assistant at Pennsylvania and two years as an assistant coach at Arizona State. He has been an analyst the last four years for CBS-TV.

Despite his lack of experience, Collins is highly regarded among National Basketball Association executives. San Antonio Spurs owner Angelo Drossos was interested in him as a head coach, and last year Collins turned down overtures from the Philadelphia 76ers and the Bulls for assistant coaching positions.

"I was impressed with his concept of how the game should be played," Bulls' owner Jerry Reinsdorf said. "Without telling him what I believe in, he agreed with my ideas—movement without the ball, not so much isolation or one-on-one play and tenacious defense.

"He is always talking to coaches, both college and pro, and picking their brains. He is a very bright person.

"I was reluctant, originally, to make a change. Even though I knew I had made a mistake (in hiring Stan Albeck), I didn't want to make a second mistake. The safest thing was to bring Stan back, and with Michael healthy we'd win 40 games and everyone would be happy. I went into my meeting with Doug thinking, 'Let's not do anything.'

"Then I met with him and became enamored with him. It was his total personality and feel for the game. I found out he relates very well to the players. There are no guarantees, but I have a very, very strong feeling we have the right guy."

Collins has actually been a pet project for vice president of operations Jerry Krause for quite some time. Last summer, Krause approached Collins with an offer to work as an assistant coach under Albeck, but the Bulls couldn't match the money CBS was paying their rising star.

"It's been pretty much my baby," Krause said. "I'm willing to say it—this is my man. I've known Doug for a long time. You have to have the courage of your convictions."

The camera captures a bird's-eye view of Chicago Stadium during the 1988 NBA All-Star Game, won by the East 138-133. Michael Jordan scored 40 points in 29 minutes and was named the game's Most Valuable Player.

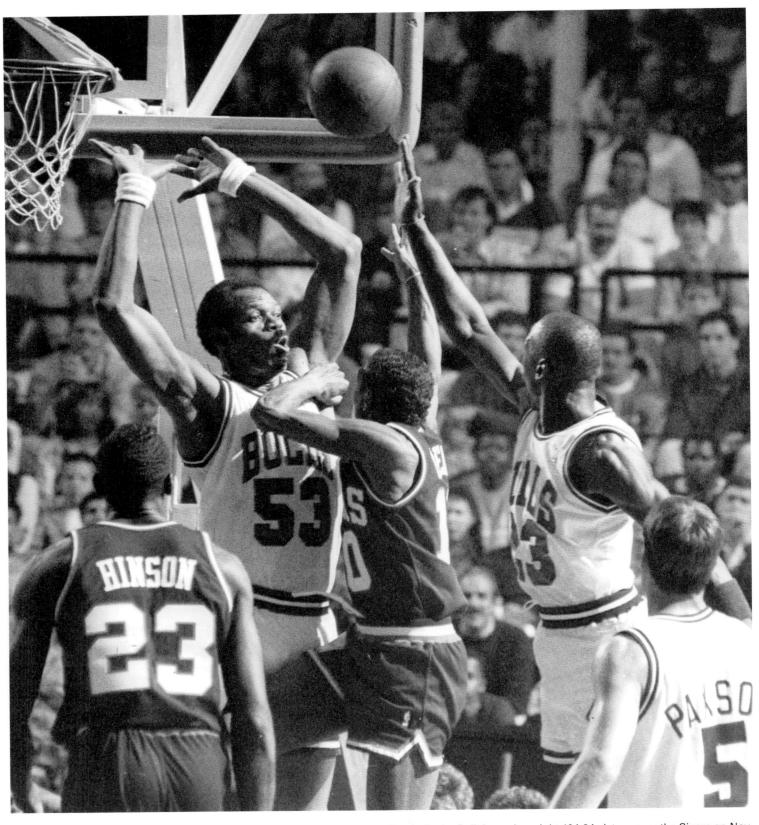

Artis Gilmore (53) and Michael Jordan converge on Philadelphia's Maurice Cheeks in the Bulls' opening-night 104-94 victory over the Sixers on Nov. 7, 1987 at the Stadium. After five years in San Antonio, Gilmore returned for a second stint with the Bulls, but was waived at midseason.

The price was high, but the Bulls finally got their man in the middle.

Bulls deal Oakley to Knicks for Cartwright

The Bulls may have finally solved their biggest weakness Monday when they acquired New York Knicks center Bill Cartwright in exchange for power forward Charles Oakley.

In addition, the Bulls and Knicks traded first- and third-round draft picks. That gives the Bulls the No. 11 pick in the first round of Tuesday's National Basketball Association college draft. The Knicks will now select 19th.

The Bulls have gone without a force in the middle since the 1981–82 season, when Artis Gilmore was in his prime. Cartwright, who will turn 31 on July 30, gives the Bulls a 7-foot-1-inch, 245-pound proven inside scorer.

But there is a catch. Cartwright just completed his first full season since 1983–84. He has fractured a bone in his right foot three times and has undergone surgery twice.

"We tested the right foot and it is stronger than it has ever been," Bulls operations chief Jerry Krause said. "We gave him a thorough physical, took X-rays and he is completely healthy."

Cartwright has not experienced any problems since a bone graft Feb. 6, 1986. Last season, he averaged 11.1 points and 4.7 rebounds in 20.4 minutes, sharing the center spot with Patrick Ewing. Oakley was second in the NBA in rebounding average at 13 a game along with 12.4 points. Cartwright shot 54.4 percent from the floor to Oakley's 48.3.

Cartwright suffered a stress fracture in October, 1984, and refractured it that Nov. 9. He underwent surgery Dec. 19 and sat out the rest of the season. He fractured the fifth metatarsal bone on Oct. 4, 1985, and the surgery the following February was supposed to have finally corrected his problems.

"You hate to give up the top rebounder in the league," Bulls coach Doug Collins said of Oakley, whose total of 1,066 rebounds was unsurpassed last season. "He gives you a dimension you need with his rebounding and his physical toughness. But in order for us to keep up with teams like Detroit, Cleveland and Atlanta in the Central Division, we needed a post-up center. We feel Horace Grant is ready to step in and take over at power forward."

By upgrading themselves to No. 11 in the first round, the Bulls could fill another need. If they want an insurance policy for Cartwright, Vanderbilt's 7-foot center Will Perdue could be available. If they opt for a scoring forward, Oklahoma's 6-8 Harvey Grant—Horace's twin brother—and Missouri's 6-7 Derrick Chievous will be there.

If they're still uncertain about Sam Vincent at point guard, Michigan's Gary Grant could be chosen. If they want a backup power forward, they could select Seton Hall's 6-9 Mark Bryant.

There's more. The Milwaukee Bucks are offering the Bulls their first-round pick, the 13th overall, for Brad Sellers. According to one Bucks' coach, "There's an offer on the table, but we don't have a deal yet."

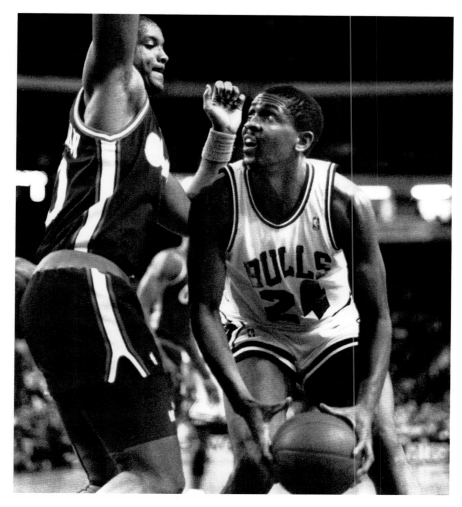

Bill Cartwright gave the Bulls veteran leadership and a reliable low-post scoring option.

'The Shot' stunned the crowd in Cleveland and cemented Michael Jordan's reputation as one of the game's great clutch players.

Sunday silencer

May 8, 1989

RICHFIELD, Ohio – One assumes that Michael Jordan has not finished reinventing himself, that one day there will be another shot more dramatic than the one he made to beat Cleveland Sunday, that in a career already festooned by Olympic gold medals and NCAA-winning shots and limitless applause, there is still more to come.

Just maybe, for as long as anyone will watch, Jordan can do the impossible and the expected at the same time. He will be Michael Jordan only as long as he can.

One day, with the help of "dross," as one Cleveland columnist characterized Jordan's teammates, he may get his NBA championship and not merely a pardon from the first round to the second round of the playoffs.

There are yet greater goals and more breathless moments to imagine.

But for now, on this day, after Jordan had hit the lowest point in his basketball life, with the digital score clock in Richfield Coliseum digesting itself and the Bulls' season to zero, a meager little double-pump, 15-foot jump shot—the length of a free throw—will do just fine, thank you.

"My most memorable shot ever," said Jordan, who is, after all, the curator of many treasures.

Better than the medal moment in the Olympics?

"We were expected to win, and the Russians weren't there," Jordan said.

Better than the jump shot that beat Georgetown and won the NCAA for North Carolina when he was a sophomore?

"I was unknown and a kid," Jordan said. "I couldn't appreciate it."

Better than scoring titles and All-Star approval and MVP votes?

"The best," Jordan said.

It was a shot not unlike the one he missed Friday at the buzzer that would have made Sunday's Game 5 unnecessary. It was a shot made only slightly difficult by the hand of Craig Ehlo, which caused the double pump. It was a shot without Jordan's signature gymnastics, without his soaring majesty.

It was a shot Jordan will make again without turning heads, never mind the entire body of Doug Collins, who catapulted himself into delirium when it went in.

Or even Jordan himself, who danced and punched the air with his fists and scolded the Cleveland fans for their loud and persistent rancor.

"That's uncharacteristic of me," Jordan said, "but they had been on me all day. Yelling 'choke' and telling me to get a tee time."

Jordan had missed a late free throw in Game 4 on Friday. He had predicted a Chicago win in four games. In Cleveland's house, he was not going to be allowed to forget either.

"God's a great guy to give Michael another chance like that," said Craig Hodges.

Actually, the ball was tossed in to Jordan by Brad Sellers, never to be mistaken for a savior, religious or otherwise, but the point is no less valid for its exaggeration.

Jordan was, he admitted, as low as he had ever been after Friday's overtime loss. "I had to swallow my pride, my words," he said.

But being Michael Jordan, he found encouragement without having to dry off. Jesse Jackson, for one, stuck his head into the shower Friday and told Jordan to forget what had happened and concentrate on Sunday.

"I had never been cheered up by a presidential candidate before," Jordan said.

His father, his friends, his teammates consoled him over the two long nights he had to wait to get

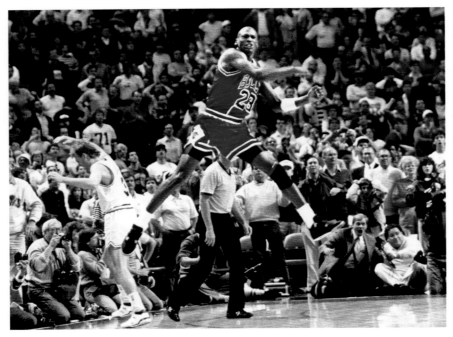

An exultant Michael Jordan celebrates his game-winning shot while a still-stunned Craig Ehlo heads off the court.

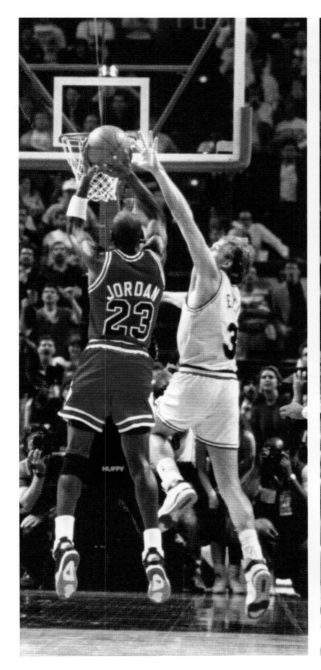

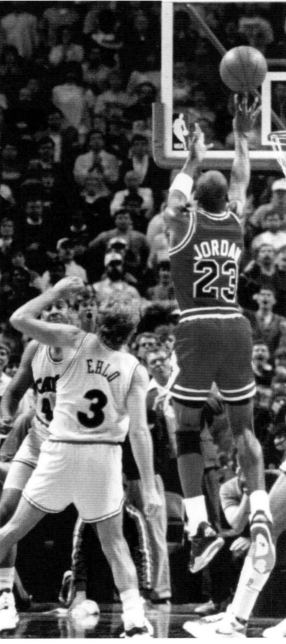

"I wanted a jump shot at the end. If I had taken it to the hole and gotten fouled, I didn't want to be at the free-throw line."

—JORDAN

even. And still he fought himself at the free-throw line, missing four, rattling others in.

"I wanted a jump shot at the end," Jordan said. "If I had taken it to the hole and gotten fouled, I didn't want to be at the free-throw line."

That is as close to fear as Jordan will ever admit. It was still going to be Jordan winning or losing for the Bulls. If Jordan had missed the shot, if he had to live through a long summer with the memory of losing two games he could have won at the end, possibly even Jordan's boundless confidence might have been forever diminished.

That was the risk Jordan took with nearly 40,000 unfriendly eyes knowing what he was going to do and 20,000 angry throats roaring against it.

And that is why such a simple, unspectacular jump shot that took the Bulls no further than they have already gone is the fuel of myth.

What it will all amount to will now unravel against the New York Knicks.

"You know what I heard when the ball went in?" Jordan said. "Nuthin.' Not a word."

Silence can be the loudest applause.

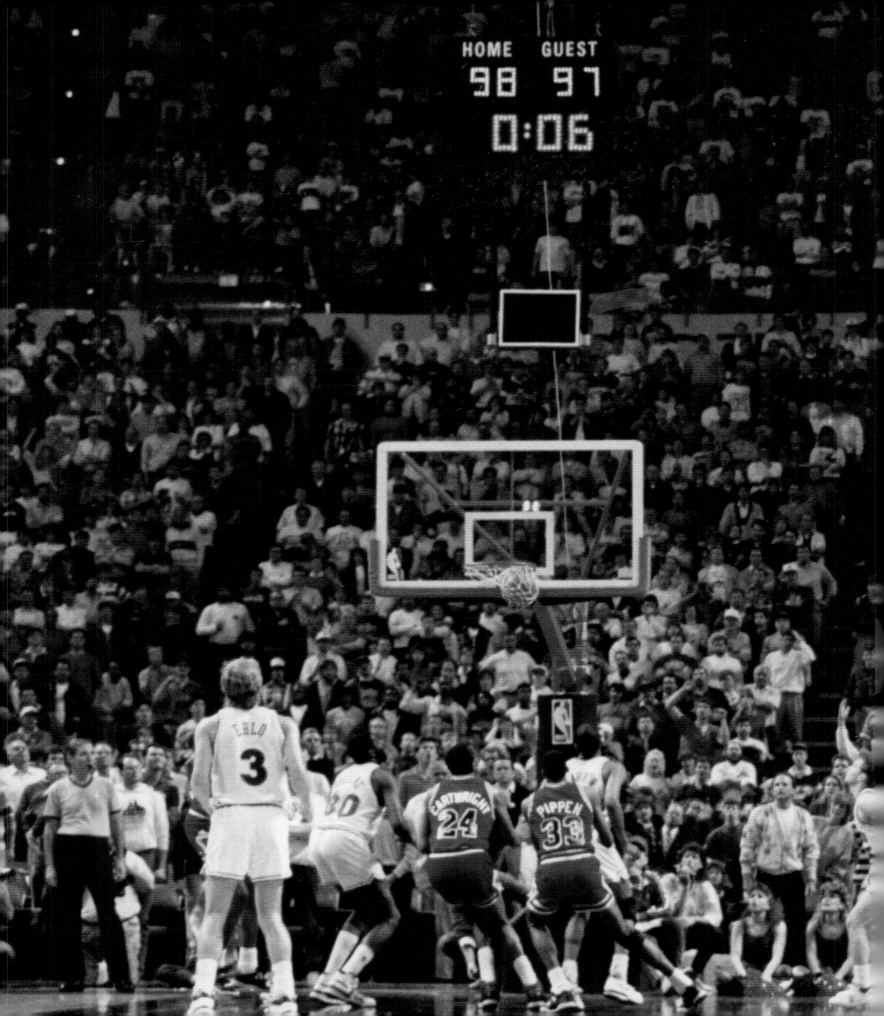

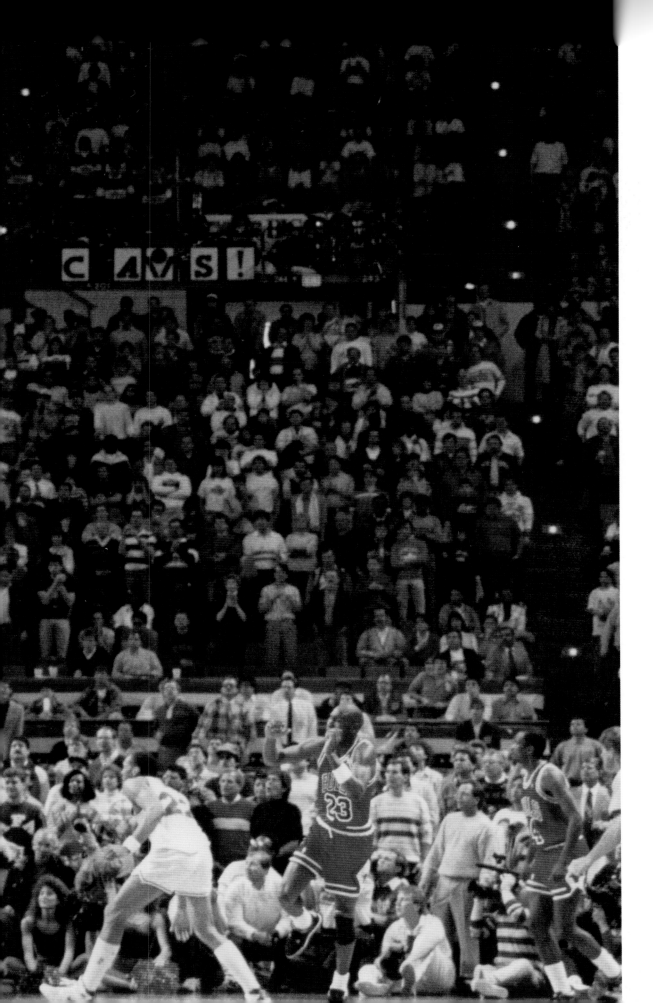

"You know what I heard when the ball went in? Nuthin'. Not a word."

—JORDAN

Michael Jordan moves the ball downcourt during Game 6 of the Eastern Conference final on June 2, 1989 at the Stadium. The Bulls lost 103-94 and were eliminated from the playoffs by the Pistons for the second year in a row.

Unable to overcome the Pistons and 'The Jordan Rules,' Doug Collins was fired and replaced by Phil Jackson.

Pistons end Bulls' joyride

June 3, 1989

This dizzying carnival ride called the Bulls' season, soaring and plummeting almost from moment to moment, supplying thrills and trepidation throughout, finally came to an end with equal shares of sadness and smiles.

"I'm disappointed, but it's been an enjoyable season and we proved to a lot of people we're a team to watch in the future," said Michael Jordan, who dragged a bruised heel and reinjured groin through 42 thrill-packed minutes, collecting 32 points and 13 assists.

But that wasn't enough as the Detroit Pistons prevailed 103-94 before 18,676 screaming fans in the Stadium funhouse to take the Eastern Conference finals four games to two.

Detroit fought off a comeback by the Bulls, who came from 10 points down in the fourth quarter to trail by only two and had the ball and a chance to tie with 8:45 left.

The Pistons now move on to meet the defending champion Los Angeles Lakers in a rematch of last year's NBA Finals.

To do so, it took Isiah Thomas' best game of the series—33 points, 17 in the fourth quarter—as well as a concerted defensive effort by the Pistons to slow down Jordan and force him to get his teammates more involved in the offense.

After Jordan scorched the Pistons for 46 points in Game 3, Thomas and fellow guard Joe Dumars made a suggestion to coach Chuck Daly, and its concept was starkly simple. Let's not let Jordan beat us again, they said. Let's take a chance on the other guys beating us.

"The more you make him think as a point guard—that's important: 'as a point guard'—the more beneficial it is for us," explained Thomas, himself a point guard.

Their plan was to run at Jordan as soon as he received the ball, to double- and even triple-team him quickly and force him to involve his less talented teammates. Daly called these tactics the "Jordan rules." Jordan was held to 18 shots in Game 4 and a ridiculously low 8 attempts in Game 5. He was 13 for 26 from the field in Game 6, but even that improved effort couldn't bail out a beaten-down Bulls team.

"If any of his teammates had stepped up, we'd have been in trouble," Pistons forward Dennis Rodman said after the series-clincher.

Jackson gets Bulls job

July 10, 2989

The Bulls will conclude a frenzied five days of controversy and condemnation by naming Phil Jackson as their new head coach.

Jackson, 43, a former player with the New York Knicks and Nets, a former head coach in the Continental Basketball Association and a Bulls assistant since 1987, will be introduced as the 12th coach in Bulls history, and the third hired by owner Jerry Reinsdorf since 1985, at a late afternoon news conference.

Doug Collins, who had a 137-109 record over three seasons, was fired for what the Bulls termed "philosophical differences." Both sides reportedly agreed not to publicly discuss the situation or air their grievances.

Jackson will be walking into perhaps the most pressurized job in the NBA, one in which even success may not be enough. Collins was a highly popular figure in Chicago, and the Bulls did exceptionally well with him as coach, winning 40 games his first season, a 10-game improvement, and 50 the next, and although the team won 47 last season, it went farther in the playoffs than in any season since 1975.

Jackson would almost have to make the league finals to reach any level of achievement in the minds of many.

Well-liked and respected among the players, Jackson is generally considered about the only person in the organization other than Reinsdorf not fearful of criticizing Michael Jordan.

One Bulls player relates the story of Jackson last season telling Jordan and several other players they shouldn't have gone out after a victory, that their late night led to a loss in the next game when the team tired. Jordan told Jackson he didn't agree with him, but later told teammates that he respected Jackson for stating his opinion.

There also was some concern that Jackson might believe others felt he caused Collins' demise. Collins often told associates that Jackson was hired by the Bulls to get his job and he clearly often was uncomfortable with Jackson by his side.

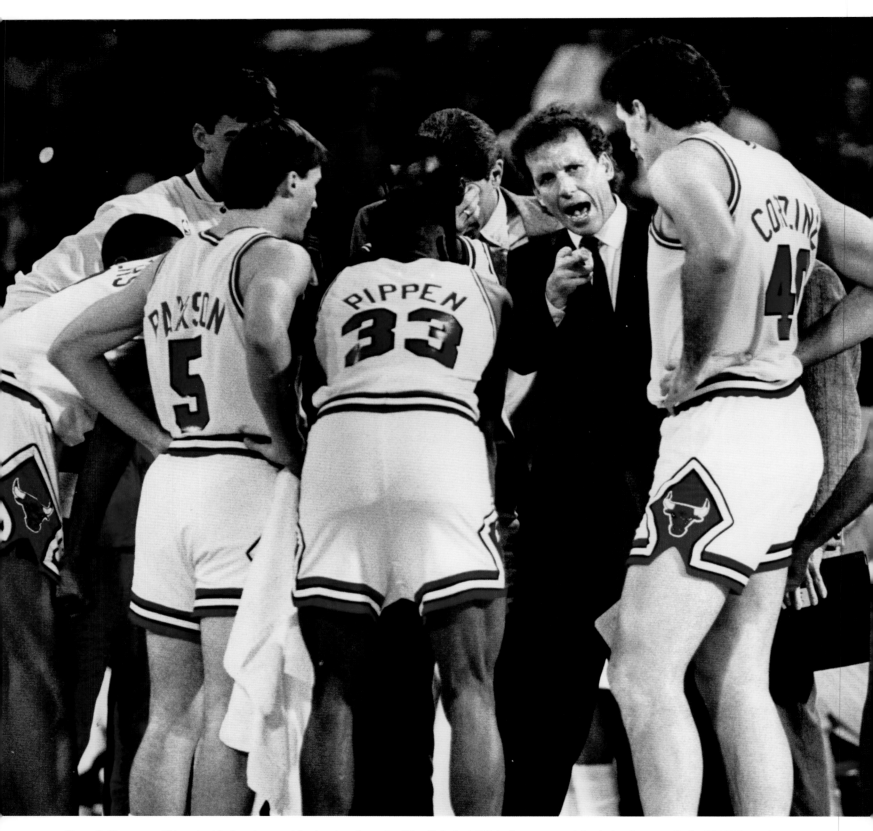

Doug Collins was a TV analyst before he was hired as head coach of the Bulls in 1986. In three years at the helm, he compiled a 137-109 regular-season record and took the team to the conference final in 1989.

Doug Collins

FIERY, DRIVEN COACH BURNED BRIGHT BUT CRASHED HARD

HEAD COACH

1986–89

It was June of 1989, and the Bulls had just lost to the Detroit Pistons in the Eastern Conference finals, yet people were feeling good about Chicago's NBA team.

And the surest sign of that was that people were feeling good about Bulls owner Jerry Reinsdorf, whose threats to move the White Sox and sacking of Harry Caray had made him about as popular in Chicago as the ticks that carry Lyme disease.

"Someone came up to me in a mall this morning and thanked me for a great season, for the Bulls being such an exciting team," Reinsdorf related to an associate. "It looks like even I'm making a comeback."

Which made it all the more unlikely that Reinsdorf would risk achieving insect status again by firing his popular coach, Doug Collins, without an explanation.

Yet, that's just what Reinsdorf did.

Why?

Well, it certainly would have been easier to let Collins stay, even if Reinsdorf wanted him out. He owed Collins another year's salary—which Collins would collect—the team exceeded everyone's expectations and good will toward the organization was at an all-time high. If Reinsdorf thought Collins was about to fail with the Bulls, why not let him do so and then fire him?

Because, as hard as it might have been to digest at the time, Reinsdorf believed he saw a bleak crash coming for his team and Collins, and he decided to take action before the results turned disastrous for both.

Granted, it's hard to see the future. But Reinsdorf felt he saw what was becoming of Collins and the Bulls, even if most outside the organization didn't.

Reinsdorf saw a developing disintegration of his team, with virtually every player angered and frustrated by playing for Collins and several even plotting to cause the coach an embarrassment that might get him fired.

Reinsdorf saw a driven, insecure Collins, grasping desperately to succeed while fighting madly not to fail.

He saw his coach missing sleep and meals and breaking down in his office over the pressures of the job.

Reinsdorf saw Collins' staff being splintered apart by his egoism. The top assistant, Phil Jackson, who would become the Bulls' next coach, was given the silent treatment by Collins, and his venerable ace assistant, Tex Winter, was barred from practices for a time because he dared speak his opinion about Collins' coaching mistakes.

Reinsdorf saw Collins running out players he didn't want, such as Charles Oakley, then not utilizing his replacement, Bill Cartwright. He saw Collins, after agreeing to use draft choices for specified amounts of time during the season, banish the previous year's No. 1 pick, Will Perdue, to the bench.

Reinsdorf saw his general manager, Jerry Krause, persuade him to hire Collins and then watched Collins try to get Krause fired so he could have his job, too.

Reinsdorf saw his superstar, Michael Jordan, being burned up by Collins, whose insecurity-driven style wouldn't allow him to adequately rest Jordan.

Reinsdorf saw Collins burning the candle at both ends, a fiery, driven coach on the floor and a man given to excess in his lifestyle off the floor.

Here was this gleaming, powerful locomotive of a coach barreling down the track at punishing speeds, seemingly heading in the right direction.

But the brakes weren't working, and the bolts were coming loose, and just around the hill there were unseen dangers.

Jerry Reinsdorf hit the brakes for his coach, and to all it appeared unnecessary. But maybe people need victims to truly assess a tragedy.

The irony of Collins' dismissal after three successful seasons as the Bulls' coach is that much of it is blamed on Krause, considered Collins' longtime rival.

But it was Krause who had the most to lose by Collins' firing because it was he who fought hard for Collins' hiring. Reinsdorf wanted no part of Collins.

"You mean the TV guy?" he said then.

"When I fired Doug (Collins)," said Jerry Reinsdorf in 2008, "I made a statement—that many people have thrown in my face – that he got us from Point A to Point B but couldn't get us to Point C. It's proved to be right because Doug was young and very emotional."

Before being hired by the Bulls, Collins' resume was brief and a little uneven. As a player, he was an All-State shooting guard at Benton High School in southern Illinois and went on to star at Illinois State. He was the No. 1 pick of the 1972 draft by the Philadelphia 76ers after playing for the U.S. Olympic basketball team. His NBA career ended before he was 30, cut short by injury after eight seasons.

Collins had spent one season as a volunteer assistant coach at Pennsylvania and two years as an assistant coach at Arizona State. He was an analyst for four years for CBS-TV.

Reinsdorf respected Krause's judgment and let the general manager have his choice—but not before Reinsdorf sat with Collins for five hours and videotaped their meeting. He did so because when he hired Stan Albeck, he recalled once, "I talked and he shook his head, so I thought we were in agreement. This time I listened."

Reinsdorf, friends said, watched that tape many times, often remarking that if Collins had kept his word, there wouldn't have been problems.

Yet, early on, Collins split with Krause and angled for his job, and this deeply offended Reinsdorf.

Reinsdorf is old-fashioned enough to have high ethical standards and he values morality. Collins' effort to dump Krause struck him as highly immoral. In addition, Reinsdorf frowned on Collins' lifestyle.

There was nothing illegal in that lifestyle, just that it was more like a player's. That's not surprising, because Collins was so young and close to playing age after being forced to retire prematurely because of knee injuries. But Reinsdorf was worried about the influence such behavior might have on young players such as Scottie Pippen and Horace Grant.

And it was risky even bringing Collins in to coach. He was an excellent broadcaster, probably the best in the basketball business, but had little coaching experience. Tying him to the responsibility of guiding a young team in a major city with a superstar such as Jordan just seemed to exacerbate the pressures.

Some players said Collins changed dramatically in his three seasons. Where once he was supportive, in his final season he became exceedingly critical. Where once he was an accessible "players' coach," in his final season he locked himself away to watch films for hours on end.

Many players then came to resent what they called his "I won, they lost" syndrome, saying that in his postgame analyses he too often listed himself as the only one who did all he could for the victory. He yanked reserves in and out in short spurts, then said he had no bench.

Many also resented Collins' taking credit for motivating the players, the assumption being that without him they were a slothful bunch who just came to collect their paychecks. It was a tactic that irritated many in management, because the Bulls went to great lengths to draft and sign motivated, hard-working, good-citizen type players after inheriting the likes of Quintin Dailey and Orlando Woolridge.

The publicity surrounding player-coach rifts usually centered on Jordan, and Jordan had his problems with Collins. But he did not have Collins fired. Jordan always worried about being perceived the way the Lakers' Magic Johnson was after he supposedly had Paul Westhead fired, and his disputes with Collins were often minor compared to some that other players had.

During the 1988–89 season, three players, including two starters, conspired to catch Collins in some situation that might prove embarrassing enough to get him fired, so intense was some of the resentment.

Players such as Brad Sellers and Sam Vincent became dispirited by Collins' constant abuse, eventually proving of little use. Management despaired when it obtained Cartwright for Oakley and then Collins became reluctant to use Cartwright in key situations. They kept getting Collins point guards, an average of two a season, and he kept demanding new ones in his apparent inability to turn the offense over to any of them.

DOUG COLLINS

» **Born:** July 28, 1951 in Christopher, Ill.

» **College:** Illinois State University

» **Years in NBA:** 1973–81 as player; 1986–89, 1995–98, 2001–03 and 2010–13 as head coach

» **Hired by Bulls:** May 19, 1986

He had agreed to play Perdue an average of about 10 minutes a game, depending on situations, but essentially sat Perdue out for a season. And he would have had three more youngsters coming in for the 1989–90 season.

He drove Jordan almost to mutiny before the heralded change to point guard in March by constantly putting him in "must-score" situations after not calling his plays at other times in the game. Even Jordan realized he was being overused, and eventually asked out of his point guard role.

Collins often abused players during games with loud accusations of ineptitude and streams of epithets that occasionally were aimed at the stands—even at home—in tense situations.

He warred with his assistants and discouraged their participation in the media (a common financial source for NBA assistants) to prevent them from gaining higher profiles.

He always viewed Jackson as a rival and had associates report to him on whom Jackson talked to. He blew up and became sharply defensive of critiques of his coaching.

But Collins was not incapable as a coach. He was bright and had a quick mind and was always fast to adjust in the chess match that NBA games become.

Yet, his inexperience was a glaring weakness. He never truly developed a philosophy for the game. Veterans who came to the Bulls were amazed by his lack of a plan from game to game, his constant series of changing plays and his insistence to management, despite its knowledge to the contrary, that he wasn't creating new plays daily.

He had little feel for defense and turned that over to Jackson, who along with assistant John Bach developed that as the Bulls' major weapon outside of Jordan.

But none of this was a secret to Collins. In frequent sessions with Reinsdorf, these issues and others were discussed, with attorney Reinsdorf always taking notes.

Once he showed some notes, with observations, to a friend. Reinsdorf had scribbled in the margin: "Wants to be Mike Ditka."

Indeed, Collins was impressed by Ditka's success and apparently was driven to duplicate it. And he moved in Ditka's wake, picking up some commercials with his good looks, intelligence and articulate style and developed a positive image through his ease on camera on local TV and the success of the team.

But Reinsdorf also was among the few privy to the darker side and could see how the pressures of the job were getting to Collins.

Even as the Bulls were walking off the court after that sixth-game loss to Detroit, Reinsdorf apparently anticipated changes ahead.

"Doug was good for us three years ago," Reinsdorf reportedly told an associate. "He was the kind of coach to get us to a certain level. But now we need to get to the next level. The question is, can he take us there?"

The answer he came to obviously was no.

Collins was rumored to be returning to the Bulls as head coach in 2008, but he reportedly pulled himself out of consideration for the job at the last minute. Reinsdorf, who had been wavering on the idea of bringing Collins back, agreed that calling off the reunion was best for both sides.

"I love Doug Collins," Reinsdorf said. "It's not a great thing for friends to jeopardize a relationship for business. And relationships with coaches always end at some point.

"I didn't push Doug to this decision. But while I was hesitating, he came to his conclusion. I'm disappointed because I won't be reunited with Doug. But in my heart, I know he made the right decision."

Collins, who forged a friendship with Reinsdorf after Reinsdorf fired him in 1989, said he was equally at peace with the outcome.

"I just knew over the last few days that Jerry was really struggling over whether or not to do this, and I didn't want Jerry to have those struggles," Collins said in a telephone interview. "I love him. And I didn't want him feeling that kind of angst.

"This is absolutely mutual. When this first came about, there was a tremendous amount of excitement about this possibility. And I'm losing that. The feeling now is more, 'Should I do this?' Once I got to that point, it meant no." 🏀

CHAIRMAN

1985–

Jerry Reinsdorf

HEAD OF HIS CLASS

Jerry Reinsdorf's parents had never pressed him about grades. After a straight-A performance as a freshman, he figured the only hard thing about high school was juggling his class schedule so it would be finished before the Dodgers game started. That he would coast into 203rd place among a senior class of 987 at Erasmus Hall High School in Brooklyn seemed of little significance until graduation day.

During the lengthy ceremonies, Marian Reinsdorf could not help but notice that almost everyone in her son's class had been given some sort of award. Her Jerry, her first-born, had only a diploma, which made it look to Marian as if he had come away empty-handed.

As they were walking home along the streets of the Flatbush section of Brooklyn, Marian Reinsdorf could bite her tongue no longer. In a tone that was both pained and pointed, she asked Jerry, "Couldn't you have won just one thing?"

"After all these years, I still look back at that as a turning point in my life," he said.

"Somewhere along the line, I developed a mad desire to excel, and I guess it was that walk home from graduation, realizing I had embarrassed my mother. I promised her things would be different in college."

If anything is true about Jerry Reinsdorf, it is that he is a man of his word.

He went on to win the outstanding senior awards at both George Washington University and Northwestern Law School. He became a successful lawyer, then a founder of Balcor, the innovative real estate syndication business that made him fabulously wealthy and thousands of investors at least a little richer. He turned into the co-owner of the Chicago White Sox and principal owner of the Chicago Bulls. He became the most powerful man in Chicago sports and, arguably, one of the most powerful in the country.

Is that enough, Ma?

If a mother's plaintive remark seems a remarkable motivation for such achievement, the why is no more unusual than the how. After making good on the word to his mother, Reinsdorf would need no more than the same verbal promise to close multimillion-dollar deals.

"In the last 15 years, Jerry and I have done $1 billion in business, most of it with a handshake," said real estate developer Alex Spanos, who also owns the San Diego Chargers. "He'll change contracts a year later if they don't agree with the intent of what was said."

If choosing fairness over legal formality seems an odd attitude for a lawyer, it is only one of the seeming contradictions about Reinsdorf. That he calls himself "shy but outgoing" does not explain how he has been able to remain a public figure who is pleased to walk unrecognized down the street.

"Jerry is shy as he can be," said Arthur Rubloff, another Chicago real estate mogul. "You can be in a room with him for an hour, and if you don't say anything to him, he won't bother you. If sports gives him a lot of power, I can't conceive of him as the kind of guy who would swing a club around."

Said late Yankees owner George Steinbrenner, once a critic, later a friend: "Jerry has no ego."

That is not entirely true. When the talk turns to box baseball, one of the many street games Reinsdorf played as a boy, he waxes eloquent about his skills in making a rubber Spaldeen ball "fluke"—bounce sideways, backward or forward after it was pitched.

"I was the best at that," he said, wishing for a Spaldeen to prove his point.

Such ingenuous bravado went with the territory in the Brooklyn where Reinsdorf was born in 1936 and grew up for all but a one-year family move to California. His father, Max, couldn't survive outside Brooklyn, although his prosperity there was more psychic than financial.

Max Reinsdorf, like his wife the child of Polish immigrants, was what is best described in Yiddish as a tummler, which loosely translates to wheeler-dealer. He dealt mainly in used sewing machines that were resold and refurbished in Mexico. His penchant for being too generous with credit meant that, although Marian Reinsdorf never worked outside the home to help support the family of five, Jerry was still sleeping on a rollaway cot when he was 17. "We were lower middle-class," Reinsdorf says. "We generally didn't have a car, and I didn't go to summer camp like most of the kids. My summer camp was Ebbets Field."

He didn't go there because of his father, who had little interest in anything but work. Jerry's interest in the Dodgers stemmed, at least apocryphally, from the day when a 9-year-old friend had chosen listening to the game over coming out to play. A curious Reinsdorf went home and turned on the game, which was, appropriately, a revelation. He soon learned that in Brooklyn, the Dodgers were a religion, and he became a perfervid convert.

That meant keeping score of all the games, arriving at Ebbets Field at 8 a.m. to be the first general admission ticket-holder in the park and reacting with so much bitterness to the Dodgers' move west that he gave up the faith entirely for a couple of years. Most of all, it meant that baseball, like Brooklyn, was in his blood.

"Brooklyn is not an inherently funny word, but the Brooklyn accent, in which one pronounced 'oil' as 'earl' and 'earl' as 'oil,' was amusing," wrote Roger Kahn in "The Boys of Summer," a book that has justifiably gained biblical stature among Brooklynites of Reinsdorf's generation. "But dialect, all dialect . . . is the stuff of easy, rough humor."

Even when accents have long faded, the ability to live with a laughable—but essentially harmless—stereotype stayed with the Brooklynite. There remains in Reinsdorf an insouciance about conventions that could only have come from Flatbush.

"When we had very little money, we'd go out together and eat lousy—but cheap—Chinese food," said lawyer Allan Muchin, a long-time friend of 24 years. "I'm not sure Jerry could tell the difference between good and lousy Chinese food even now."

"Jerry is not a complicated guy," said Andy McKenna, a friend and, as former chairman of the board of the Cubs, a one-time baseball rival. "His success comes because he is basic."

Reinsdorf owns Cadillacs because they are sold by one of his sports investors, Gene Fanning. He reads a few biographies and a lot of business publications. His private time is spent with his wife, Martyl—a jewelry designer who keeps herself out of all stories about Jerry—and four children.

"I don't think I'm very interesting, and I'm not as learned as many of my friends," he says. "I don't know a whole lot about art or music."

Or fashion. Businessmen of Reinsdorf's stature are a generally dyspeptic lot who dress in gray, pinstriped suits, repp ties and wing tips. He remains pleasantly overweight and resolutely committed to several unflattering shades of brown.

"I always thought he had 13 or 14 brown suits," said Bob Judelson, a co-founder of Balcor, "but one day I snuck into his closet and my worst suspicions were confirmed: He had two."

When Reinsdorf was selling Balcor to Shearson/American Express three years ago, he ran out of clothes because it took three days to put the final touches on a deal he thought could be worked out in hours. He went out and bought a blue, polyester shirt for $7.50 and a tie for $5. Wearing those and a brown suit, he signed the $103 million purchase agreement.

"You expect Jerry to be much taller or much louder or much fancier," Judelson said. "Instead, it's ugly brown suits with shirts that don't match and a guy so shy he would live in a closet if he could."

"There is no deviousness and no hidden agendas with Jerry," said U.S. Sen. Donald Riegle (D-Mich.), both a friend and Balcor investor. A Balcor project in which Riegle invested $15,000 was expected to return $280,000 after 12 years.

"When the lawyers were complicating things in our deal, I got up at a critical point, said, 'Jerry, you work it out for both of us,' and left the room," said Peter Cohen, chairman of Shearson. "I had complete confidence that he wouldn't take advantage of me."

That such a persona could add up to $103 million only proves that clothes don't make the man. Friends

In 1981, Jerry Reinsdorf and Eddie Einhorn led a group of investors that purchased the White Sox from Bill Veeck for $20 million. Four years later, a Reinsdorf-led group purchased the Bulls for $9.2 million.

attribute Reinsdorf's success to both his integrity and his ability to listen—and remember.

"We were playing trivia in a cab coming back from the airport one day, and I was feeling pretty good because I could remember the actors and characters on 'Howdy Doody' and 'Captain Video,'" Judelson said. "Jerry said, 'How about the credits?' He could remember the writers, the producers, the assistant directors."

Former White Sox general manager Roland Hemond recalled meetings in which Reinsdorf apparently did nothing. He would sit silently, puffing one of the half-dozen $2.50 Mouton Cadet cigars he smokes each day as a defense against noshing. Ten days later, Reinsdorf would bring up details of the meeting to Hemond, who would have to refer to his notes.

"He analyzes a subject, tackles it and puts it behind him," Hemond said. "Jerry is able to handle many diverse things at the same time."

Reinsdorf trained himself that way. He wanted to be a tax lawyer, ("If you were a Jewish kid and couldn't stand blood, you became a lawyer," he said), but took a friend's advice to start out with the Internal Revenue Service and learn how the other side works. He went on to a large Chicago law firm, Chapman & Cutler, leaving when he felt that promotions would depend more on length of service than talent.

During his three years at Chapman & Cutler, Reinsdorf began to develop the interests that would occupy the next 15 years. While working on tax problems for several doctors, he arrived at the solution of personal incorporation to set up pension plans at a time the IRS took the position that such corporations were not valid.

"A guy in Detroit, Fred Gordon, gave me a great idea: For what I would charge the doctors to incorporate, I would represent them all the way to the Supreme Court at no additional charge," Reinsdorf said. "The question finally went to court in a case brought by two other lawyers."

Once the idea of personal incorporation was approved, the doctors—many of whom, according to Reinsdorf, would invest in any kind of crazy scheme as a tax shelter—started asking him about ways to use their money. "I thought real estate was the answer, but I didn't know anything about it," Reinsdorf said.

He learned from Judelson and Neil Bluhm, two of the founders of JMB Realty. Together, they worked out public real estate syndication deals for small investors.

"Jerry took real estate out of the province of the wealthy," Muchin said.

The idea was so popular that Reinsdorf, after trying unsuccessfully to buy into JMB, convinced Judelson to form their own company. If that seemed like a risky move for a man with a wife, four children and a house in the suburbs, it was actually a small gamble for a man who labels himself "a social liberal and a business conservative."

"I had no net worth, so I wasn't risking anything," Reinsdorf says. "I had enough money to support myself for a year, and if the business failed, I could go back and be a lawyer.

"But I overestimated my knowledge of real estate. Without Judelson, Balcor would have failed."

It almost did anyway when recession hit the industry in 1974–75. Reinsdorf and other partners in the company borrowed $3 million as individuals to maintain investor confidence by funding deficits in operating revenues.

"There were some bankers who believed in me," Reinsdorf said. "They probably thought a truck would run me over so life insurance would pay them before I could stiff them."

Balcor apparently stiffed no one. When one of Reinsdorf's law school classmates was found guilty of misappropriating $5 million in escrow funds from Balcor investors, the company immediately took the loss.

Reinsdorf had no reservations about the contract provision that gave Sox pitcher Floyd Bannister investments with no-loss guarantees. "We don't lose money on our deals," Reinsdorf says.

"Jerry is a man of great integrity in every way," Rubloff said. "American Express (now part of Shearson/Lehman Bros.) wouldn't be interested in many people as partners."

Reinsdorf was interested in selling because he "felt it was time to cash out." He continued at Balcor partly to insure a performance that would bring the second payment of the "earnout" deal in 1987. Shearson paid $53 million in 1982 with $50 million more contingent on earnings.

"I had the best of both possible worlds," Reinsdorf said. "I had made enough money so I wouldn't have to work again. If business stayed good, I would get the second payment. If it didn't, I already had the first."

By then, the business of sports was taking up more of Reinsdorf's time. He was ready to buy a 3 percent

> ## "People said you should go to Vegas. And I say no because I've used up all my luck."
> —JERRY REINSDORF

interest in the Bears if the controlling McCaskey family hadn't exercised its option on the stock surrendered by former general manager Jim Finks.

"If the Bears were for sale, I'd like to have the opportunity to buy them," Reinsdorf said shortly after acquiring controlling interest in the Bulls.

Neither the White Sox, for which a group led by Reinsdorf and Eddie Einhorn paid $20 million in 1981, nor the Bulls, for which his group paid $9.2 million in 1985, were actively being shopped when he bought them. Reinsdorf had no trouble attracting investors.

"If I knew what I know now about baseball's economics, I never would have gotten into it," Reinsdorf says. "I wouldn't have been able to lie about the profit potential to investors. I thought we had a chance to make some money when we got in. Now I'm in it for psychic enjoyment."

"If Jerry wanted to buy a steel company even in this economy, I'd back him," said Muchin, an investor in both the Bulls and White Sox.

Nick Kladis, a White Sox investor in previous owner Bill Veeck's group, was badly miffed when he wasn't asked to join Reinsdorf's board of directors for the baseball team. Four years later, Kladis became a limited partner in Reinsdorf's Bulls.

That they are Reinsdorf's Bulls became clear when, only a few weeks after saying there would be no immediate changes, he fired general manager Rod Thorn. The owner's operating style depends on a concentration of decision-making power, and he isn't afraid to exercise it.

"When Jerry bought the White Sox, I sensed some concern on his part about working with a large group of investors," said McKenna, who helped negotiate the sale for Veeck. "I remember Jerry saying, 'I have the answer: It won't be a democracy.'"

Some people dismiss Reinsdorf as extremely lucky. Reinsdorf bought into sports just as the industry was about to explode in profitability, and when Michael Jordan was not yet a megastar.

Said Allen Sanderson, a professor at the University of Chicago who teaches a class on sports business, "Everything outside of that is tinkering at the edges."

Critics assert that Jordan made Reinsdorf. To some extent, that is true—but Reinsdorf was intelligent enough to exploit the opportunity.

And Reinsdorf does not deny luck. He recalled a meeting of White Sox executives in 1984 when the team was considering solutions to some serious financial problems.

"Somebody said: 'What if all these things don't work? Then what do we do?'" Reinsdorf recalled. "I turned to (executive vice president) Howard Pizer and said, 'Tell him, Howard.'

"And Howard said, 'We'll get lucky.'"

That strategy—if you can call it one—has paid off for Reinsdorf more than once.

"This was several months before the (2008) draft," Reinsdorf recalled, "and John (Paxson) said, 'We really need a point guard.' And I said, 'Ah, we'll win the lottery, take Derrick Rose.' I was acting silly, and it worked out. People said you should go to Vegas. And I say no because I've used up all my luck. I walked into Michael Jordan. Hey, you don't succeed in this world without a certain amount of luck. If you're successful and you think you're successful because you're so smart, then you're heading for a fall. It doesn't work that way. You have to have luck and you have to have people helping you out. I have nothing to not be humble about.

"The key is just having good people and they stay forever. But I wish my name was Williams or Johnson or something like that. Because even people who don't recognize me, recognize the name. If my kids go charge something in the stores, the name is recognized. I can't imagine what the plus is of being recognized. If I go to a restaurant, I make a reservation, and if they're booked, I don't go. If they want to comp me, I tell them if you insist on comping me, I'm never coming back. I'm not a mooch. I just want to be a regular person. I just happen to like hanging around sports."

Despite his love and knowledge of sports, Reinsdorf still has trouble comprehending why he gets far more attention for running his sports teams than he does for a business like Balcor, which could raise $1 billion from investors in a single year. That is why he rejects any notion of real power for a sports magnate.

"I'm important in sports, but I'm not powerful," Reinsdorf says. "You're not powerful unless you can cause people to act in a certain way. People may care about what I do, but I don't have the ability to make things happen."

He is forgetting one thing: Jerry Reinsdorf was able to make his mother happy. 🏀

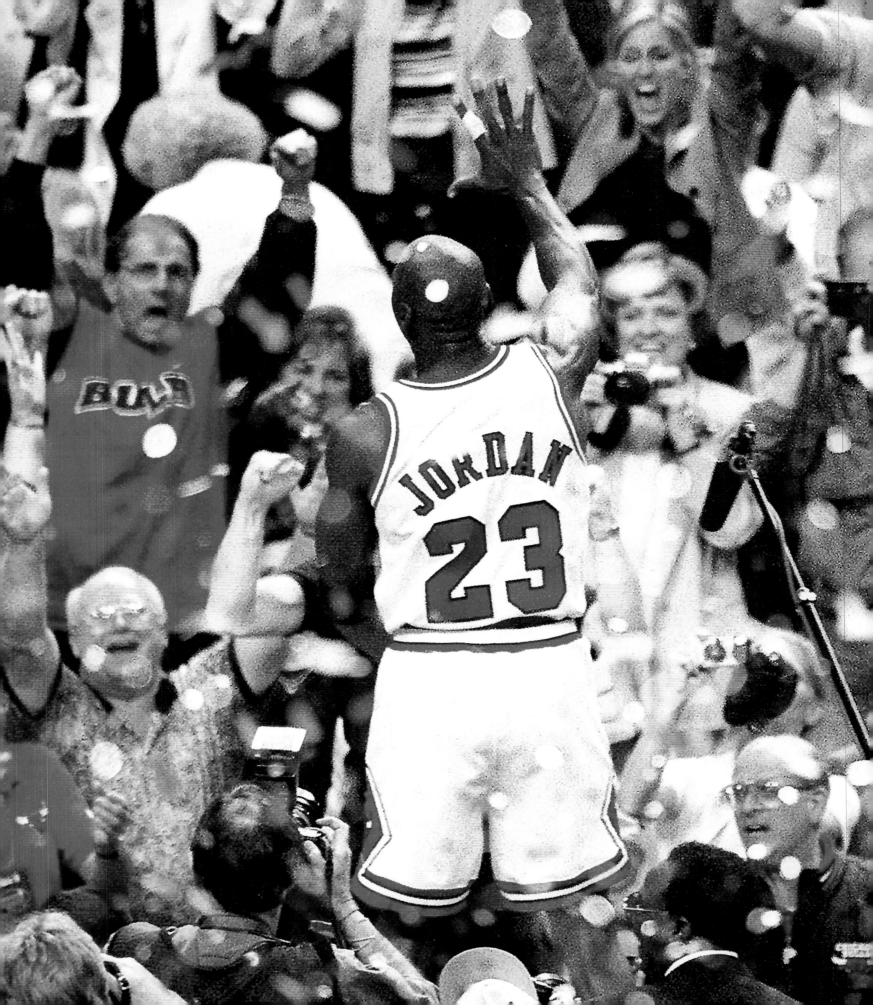

The Bulls captured the first of six NBA championships in eight seasons by beating the Lakers in five games of the 1991 NBA Finals, beginning a dynasty that transcended basketball and made the franchise a worldwide brand. Jordan's marketing appeal and otherworldly play—he won four regular-season MVP awards, two All-Star Game MVP awards and six NBA Finals MVP awards in the decade—helped him rival Muhammad Ali as the most recognizable athlete in the world. Pippen joined Jordan as a perennial All-Star and All-Defensive team mainstay. They also helped lead the original Dream Team to Olympic gold at the 1992 Barcelona Summer Olympics. Following his father's murder, Jordan shocked the sports world by retiring for the first time at age 30 just before 1993 training camp. Following a minor-league baseball stint, Jordan returned late in the 1994–95 season. His first full season back produced an NBA-record 72-10 mark as general manager Jerry Krause reshaped the team, swapping out John Paxson for Steve Kerr and Horace Grant for Dennis Rodman. Toni Kukoc captured the 1996 Sixth Man of the Year Award as another three-peat began. By its end, the dynasty collapsed upon itself, the infighting between Krause and Phil Jackson leading to Jackson's departure, Jordan's second retirement and a sign-and-trade of Pippen. Krause's open courting and hiring of Iowa State's Tim Floyd for the 1998–99 season fast-tracked a rebuild that never took shape.

Opposite: Michael Jordan stands atop the scorer's table and acknowledges the Stadium crowd on June 13, 1997 after the Bulls defeated the Utah Jazz 90-86 in Game 6 to win their fifth championship.

1990s HIGHLIGHTS

Scottie Pippen celebrates during the waning seconds Wednesday.
Tribune photo by Jim Prisching

High five! Bulls are champs!

June 12, 1991
With Game 5 victory in Los Angeles, Bulls claim their first NBA title. Michael Jordan is named Finals MVP.

June 14, 1992
With a 97-93 victory in Game 6, the Bulls brush off the Trail Blazers for their second consecutive NBA title. Jordan wins his second NBA Finals MVP Award.

Bulls find repeat sweet

June 3, 1992
Michael Jordan's string of six three-pointers propels Bulls to 122-89 win over Portland in Game 1 of the NBA Finals at the Stadium.

March 28, 1990
Jordan scores career-high 69 in a 117-113 OT victory over Cleveland.

May 27, 1991
Bulls sweep Pistons in the Eastern Conference final with a 115-94 victory in Game 4 at the Stadium.

May 29, 1992
Bulls knock off Cleveland 99-94 in Game 6 of the Eastern Conference final, earning their second straight trip to the championship round.

Bulls end Piston reign of terror

1990 **1991** **1992**

Game 7 anything but lucky for Bulls

May 20, 1991
Michael Jordan is named NBA Most Valuable Player for the second time.

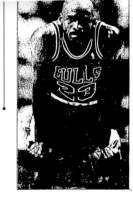

June 3, 1990
Bulls lose Game 7 of the Eastern Conference final 93-74 to the Pistons in Detroit.

On 7th day, Bulls lay Knicks to rest

May 17, 1992
Coming off a sweep of Miami in Round 1 of the playoffs, the Bulls need the full seven games to eliminate the Knicks in Round 2, taking the decisive game 110-81.

May 18, 1992
Michael Jordan is named the NBA's Most Valuable Player for the second year in a row.

June 20, 1993
John Paxson's three-pointer with just under four seconds to play gives the Bulls a 99-98 victory over Phoenix in Game 6 and clinches their third straight NBA championship. Jordan is named Finals MVP for the third time.

Three-mendous!

May 13, 1994
With Scottie Pippen refusing to come off the bench after a timeout, Bulls rookie Toni Kukoc hits a last-second three-pointer to give the Bulls a 104-102 victory over the Knicks in Game 3 of their second-round playoff series.

May 3, 1994
Bulls close out first-round sweep of Cleveland, winning Game 3 95-92 in overtime.

May 18, 1994
Bulls lose pivotal Game 5 of second-round series 87-86 to the Knicks on New York. The game turns on a questionable foul call by referee Hue Hollins with 2.1 seconds remaining and the Bulls up by one. Knicks eliminate the Bulls in seven games.

June 4, 1993
Despite falling behind two games to none to the Knicks in the Eastern Conference final, the Bulls storm back to win four straight, taking Game 6 96-88 and advancing to the NBA Finals for the third consecutive year.

Oct. 6, 1993
Michael Jordan shocks the sports world by announcing his retirement from basketball at age 30.

July 29, 1994
Horace Grant leaves Bulls to sign six-year deal with Orlando Magic.

1993

1994

May 17, 1993
Bulls sweep Cavs to reach East final.

Feb. 7, 1994
The White Sox sign Michael Jordan to a minor-league contract.

Feb. 23, 1994
Scottie Pippen scores a game-high 29 points in the All-Star Game in Minneapolis. The East wins 127-118 and Pippen is voted the game's MVP.

Aug. 3, 1993
Michael Jordan's father, James, is found shot to death floating in a South Carolina creek, some 60 miles from where his vandalized car is found on the side of a road in North Carolina.

April 16, 1996
Bulls defeat the Bucks 86-80, becoming the first team in NBA history to win 70 games in a season.

April 21, 1996
Bulls end their record-breaking regular season with a 103-93 victory over the Bullets in Washington. The Bulls finish 72-10.

May 27, 1996
After sweeping Miami in Round 1 and defeating New York four games to one in Round 2, the Bulls finish off Orlando in the Eastern Conference final, winning Game 4 106-101 to sweep the series and advance to the NBA Finals.

Oct. 2, 1995
Bulls trade center Will Perdue to San Antonio for forward Dennis Rodman.

June 16, 1996
Bulls defeat Seattle 87-75 in Game 6 of the NBA Finals to win their fourth championship. Michael Jordan is named MVP of the Finals.

March 18, 1995
With a simple two-word statement—"I'm back"—Michael Jordan announces his return to the NBA.

Ringmasters

March 19, 1995
In his first game back, Jordan—wearing jersey No. 45—plays 43 minutes and scores 19 points on 7-for-28 shooting. The Bulls lose 103-96 to the Pacers in overtime.

May 28, 1997
After cruising through the early rounds of the playoffs, the Bulls secure a trip to the NBA Finals by defeating Miami 100-87 in Game 5 of the Eastern Conference final.

1995

1996

1997

May 18, 1995
Orlando eliminates the Bulls from the playoffs with a 108-102 victory in Game 6 of the second round.

May 10, 1995
Jordan switches to his former No. 23 jersey and leads Bulls to a 104-94 win over the Magic, evening their second-round series at a game apiece.

June 11, 1997
Playing at less than 100 percent due to a stomach virus, Michael Jordan scores 38 points in Game 5 of the Finals, a 90-88 win over the Jazz in Salt Lake City.

May 4, 1995
Bulls defeat the Hornets 85-84 to win their first-round playoff series three games to one.

May 20, 1996
Jordan is named NBA MVP for the fourth time in his career.

June 13, 1997
Bulls win their second consecutive title—and fifth in seven seasons—by defeating the Jazz 90-86 in Game 6 of the NBA Finals. Michael Jordan wins his fifth Finals MVP Award.

July 23, 1997
Phil Jackson signs a one-year contract to return as head coach. The Bulls announce that the 1997–98 season will be Jackson's last with the team.

Aug. 26, 1997
The Bulls sign Michael Jordan to a one-year contract reportedly worth $36 million.

May 31, 1998
Once again, the Bulls breeze through the first two rounds of the playoffs before running into a stubborn Indiana Pacers team in the Eastern Conference final. The series goes the distance, but the Bulls prevail, winning Game 7 at home 88-83 and setting up an NBA Finals rematch with the Utah Jazz.

June 7, 1998
The Bulls hold the Jazz to 54 points and take Game 3 of the Finals 96-54. The 42-point margin is the largest in NBA Finals history, and the 54 points by Utah are the lowest total in any NBA game in the shot-clock era.

June 14, 1998
With the Bulls down by a point late in Game 6, Michael Jordan steals the ball from Utah's Karl Malone and breaks down court to hit a jump shot that seals a series-clinching 87-86 victory. The championship is the Bulls' third straight and sixth in eight seasons.

Jan. 13, 1999
Michael Jordan announces his retirement—again.

July 23, 1998
Bulls hire Iowa State's Tim Floyd as their new head coach.

April 2, 1999
Bulls suffer most one-sided defeat in franchise history, losing 115-68—a margin of 47 points—to the Orlando Magic at the United Center.

April 10, 1999
Bulls are held to 49 points, an NBA-record low in the shot-clock era, and lose 82-49 to the Miami Heat at the United Center.

June 30, 1999
With the first pick in the NBA draft, the Bulls select Duke center Elton Brand. The Bulls also select St. John's forward Ron Artest (later known as Metta World Peace) at No. 16.

1998

1999

Jan. 18, 1999
The dismantling of the Bulls championship squad accelerates. The Bulls agree to a sign-and-trade deal with Houston, sending Scottie Pippen to the Rockets for forward Roy Rogers and a draft pick. They also trade guard Steve Kerr to the Suns for Chuck Person and a draft pick, and ship center Luc Longley to Phoenix for Mark Bryant, Martin Muursepp, Bubba Wells and a draft pick. Of all the players they acquire, only Bryant will be in uniform for the Bulls when the season begins.

Oct. 28, 1998
NBA cancels all games through November.

Jan. 6, 1999
After an all-night bargaining session, the players' union and management agree to end the lockout. The agreement includes the league's first salary cap for players. The shortened season—50 games for each team instead of the usual 82—is set to start in the first week of February.

5
Enough said.

An indomitable dynasty swept away decades of turmoil and frustration.

A ride we'll never forget

It really all began in 1989.

Sure, Michael Jordan joined the Bulls in 1984 out of the University of North Carolina—a good player, it was generally agreed, but not one you could necessarily build a team around, said Rod Thorn, the Bulls' general manager at the time.

That changed quickly, however—on Day One of training camp that year.

Jordan had come from a gold-medal-winning U.S. Olympic team, and the coach of Spain's team had the best summation of his play: "Jordan go up, he stay. Everyone else come down."

But the Bulls were the NBA.

Didn't matter.

The Bulls had a pile of top draft picks on the roster: Orlando Woolridge, Quintin Dailey, David Greenwood, Sidney Green, the best and the most athletic the colleges then could supply.

Jordan drove around them and through them and jumped over them.

"The first day," recalled Kevin Loughery, then the Bulls' coach, "we knew we had something special."

There were glimpses here and there of what was to come—Rookie of the Year in 1984–85, an All-Star Game starter, a record 63-point playoff game against the Celtics in 1986.

But it wasn't until 1989 that the Jordan Era truly began. It was Game 5 of the first round of the Eastern Conference playoffs against the Cleveland Cavaliers, who had finished the season 10 games ahead of the Bulls, and the deciding game was in Cleveland.

The three writers then traveling with the Bulls had picked Cleveland to win in three, four and five games.

Before Game 5, Jordan walked over to the press table. He pointed to one and said, "We took care of you." Then he pointed to another and said, "We took care of you." And to the one who'd picked Cleveland in five, he said, "And you're next."

Jordan would do it with a shot at the buzzer, then go into New York and knock out the Knicks, who had finished five games ahead of the Bulls that season. After surprising Detroit in the first round of the conference finals, the Bulls lost to the eventual NBA champions in six games.

But by then the message was clear: We're coming.

Two years later, the Bulls would win their first NBA title, sweeping the two-time defending champion Pistons out of the conference finals, then storming past Magic Johnson and the Lakers in the Finals, brushing aside a Game 1 loss with four straight victories, three of them in Los Angeles.

When Jordan was handed the trophy in the locker room afterward, he cradled it and he cried, frustration and relief spilling out after six years of playoff failures.

But that would be just the beginning for the Bulls. Any subsequent tears would be shed by opponents as the Bulls cut a swath through the NBA not seen since the glory days of the Boston Celtics in the 1960s.

They went on to three straight titles, but the success and the attendant attention took a toll. Jordan, physically and mentally exhausted and devastated by the murder of his father, took more than a year off to regroup and to dabble in baseball.

When he returned, the Bulls won three more titles in 1996–97–98, putting together arguably the best season in NBA history when they were 72-10 in 1995–96, Jordan's first full season back. The Bulls won 69 games the next season and 62 this season. They beat five different teams in the Finals, and never had to go past a sixth game. They won 11 of 17 games on the road in the Finals. Jordan was Finals most valuable player six times. He has won 10 scoring championships and five MVP awards.

They were the Bulls. The NBA was their china shop.

Now they're the trophy case. But what memories there are.

Basketball wasn't invented in 1984, or even in 1963 when Michael Jordan was born.

In fact, Chicago spawned the great Harlem Globetrotters and George Mikan and the great Chicago Gears of the old National Basketball League. The NBA gave Chicago a try in the early 1960s with the Packers, who became the Zephyrs, who eventually moved on to become the current Washington Wizards. The Bulls were born in 1966 and became a league power under coach Dick Motta with guards Jerry Sloan and Norm Van Lier and forwards Chet Walker and Bob Love in the 1970s. But they never could get past the great centers of the era, Wilt Chamberlain and Kareem Abdul-Jabbar, and they broke apart in the late '70s, leaving Chicago a pro basketball wasteland until Jordan fell into the Bulls' lap in 1984.

Having left North Carolina after his junior year, he was the third pick in the draft, behind centers Hakeem

Michael Jordan huddles with coach Doug Collins during the 1989 playoffs. Collins took the Bulls to the conference final that year, but was fired afterward and replaced by assistant Phil Jackson.

Olajuwon and Sam Bowie. And he was an immediate attraction as the Bulls doubled their attendance and made the playoffs for the second time in eight seasons.

And a big change was brewing in the executive suite.

A real estate entrepreneur named Jerry Reinsdorf, whose group had bought the White Sox from Bill Veeck, put together another group and purchased the Bulls. Almost immediately Reinsdorf got a letter from one of his White Sox scouts, Jerry Krause, outlining a plan to rebuild the franchise, and it sold Reinsdorf. Krause, who had scouted for the Bulls in the Motta era, was named vice president of basketball operations, and he brought in an NBA veteran, Stan Albeck, to coach his young team.

The first big roadblock came a few days into the 1985–86 season, Jordan's second, when he suffered the only major injury of his career, a broken foot. He would miss 64 games, but more significant was the beginning of a rift between Jordan and management.

The team wanted Jordan to skip the rest of the season so as not to risk further injury. Jordan wanted to play and claimed the team was trying to lose games to improve its draft position.

Jordan eventually was allowed to play limited

minutes, a decision that cost Albeck his job. And that was the backdrop to one of the great games in NBA playoff history.

It was the first round, and the Celtics, on their way to an NBA title, would sweep the Bulls. But Jordan would force two overtimes in Boston Garden and score a playoff-record 63 points before finally being vanquished by the Celtics.

"It was God disguised as Michael Jordan," Larry Bird said.

And it was the start of something.

The Bulls hired a fiery former All-Star, Doug Collins, as their coach. They acquired John Paxson from the San Antonio Spurs and drafted Charles Oakley, a brute-force power forward whom they eventually would trade to get a center, Bill Cartwright.

But it still was Jordan's show.

He completed the most awesome season since Chamberlain's heyday, setting team scoring records with games of 58 and 61 points. He averaged more than 37 a game and became the first player since Chamberlain to score more than 3,000 points in a season. By the playoffs, though, Jordan had little left, and the Bulls were again swept again by the Celtics.

Three playoffs: Record, 1-9.

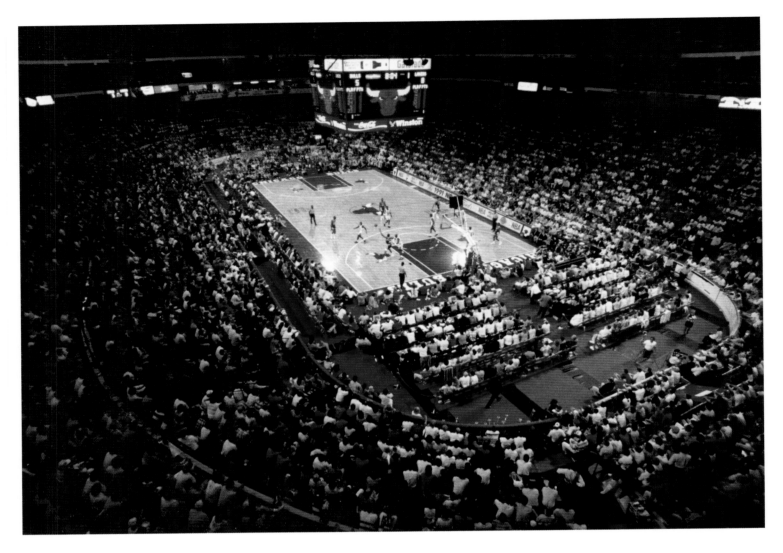

At long last, Chicago Stadium is host to an NBA Finals game on June 2, 1991. The Bulls lost the series opener 93-91 to the Lakers, but won the next four games to claim their first title.

But the Bulls improved to 40 victories, near-.500 respectability, and then added the pieces that would mean a championship.

With a draft pick acquired in a previous trade of Jawann Oldham, they switched picks with Seattle on draft day and selected a wiry youngster from Central Arkansas, Scottie Pippen. With their own pick they took a lean youngster from Clemson, Horace Grant.

It would take a few years, but the "supporting cast," as Jordan would dub them as they were upsetting Detroit in 1991, was in place.

With the two rookies who did everything together, including shopping for clothes, dogs, automobiles and homes, the Bulls won 50 games for the first time in 14 years. They also won a playoff series for the second time in 13 years when they knocked out Cleveland in the five-game first round and then lost in five to the Pistons.

A rivalry was starting.

The Pistons had Isiah Thomas, a Chicago native, and the Bulls had Jordan, who would soon own Chicago.

The Pistons were still working on getting past the Celtics, so the Bulls would have to wait. But Jordan won his first MVP Award even as relations with the front office continued to sour. He questioned the wisdom of trading his buddy, Oakley, for Cartwright before the 1988–89 season. Jordan saw Oakley not just as a friend, but as a protector. He didn't believe Cartwright could defend the Bulls' basket, but the wily former Knick started paying dividends with his play against Patrick Ewing as the Bulls knocked out the division champion Knicks in the second round.

Once again, however, they'd be bounced by the Pistons, this time in six games, the last one at home after Bill Laimbeer knocked out Pippen in the opening minute.

It was starting to hurt.

And people began to wonder. Days after the season ended, the Bulls stunned the city by firing Collins, whose emotional enthusiasm was considered a driving force. One time, in fact, Collins had literally fought against the Pistons, ending up in a wrestling match on the floor with Rick Mahorn.

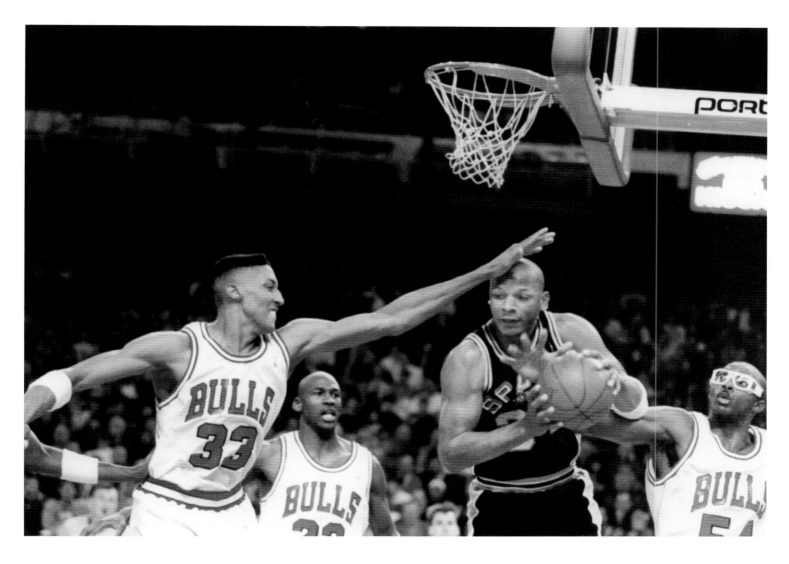

But the Bulls had an idea. An assistant named Phil Jackson, a onetime NBA flower child whom Albeck had rejected for his staff, would take over, providing calm and direction.

Jackson started by telling Jordan he didn't need to score so much, reminding him that only one player in NBA history, Kareem Abdul-Jabbar, had won a scoring title and a championship in the same season.

Jordan thought he was being put into a box; Jackson said it was a triangle.

It was the offense long envisioned by Krause, whose first hire was assistant Tex Winter, guru of the equal-opportunity "triple post" offense. John Bach, another veteran assistant, would direct the trapping "Doberman" defense, modeled somewhat after the defense from Jackson's playing days with Red Holzman's Knicks.

There were immediate results. Jordan won another scoring title and went for a team-record 69 points against his favorite patsies, the Cavaliers. And the Bulls won 55 games, second most in team history.

This franchise was now a player.

The Bulls went the distance with Detroit in the 1990 conference finals, but the Pistons won Game 7 after Pippen came down with his famous migraine headache. Detroit swept the Lakers for a second straight NBA championship, but the Pistons knew their era was ending.

The Bulls were quickness and youth. The Bulls were ready.

But they didn't look like it when they opened the 1990–91 season with a 6-6 record, then went into Detroit and got blown out. It would be a turning point. It was time to get serious.

Isiah Thomas broke his wrist, and the next time the Bulls went to Detroit they won, their last game before the All-Star break. They came out of the break winning 17 of 18 and dominated the NBA all the way to their first NBA title. They swept the Knicks in the first round, beat the 76ers in five in the second round and swept the hated Pistons in a conference finals performance so demoralizing that Detroit's players left the floor before Game 4 ended.

Johnny Bach's stifling "Doberman defense" was a key to the Bulls' dynasty. Here Scottie Pippen (left), Michael Jordan and Horace Grant surround San Antonio's Terry Cummings.

The Pistons named the road to their new arena "Two Championship Drive."

"Change that to Four Sweep Drive," Pippen proclaimed.

The beast was dead.

Then it was the Lakers, and invincibility.

The Bulls swept through the NBA the next season, opening 37-5 and finishing with 67 victories.

They were the Invinci-Bulls.

They did get a scare from the Knicks in the conference semifinals, going to a seventh game, but they won it by 29 as Jordan had 42 points. Then it was a chance to celebrate at home when they rallied from a 15-point fourth-quarter deficit to beat Portland in six games.

Forget the repeat, it was time for a three-peat.

But it would not be as easy.

B.J. Armstrong had replaced Paxson in the starting lineup and fellow 1989 first-round pick Stacey King was playing more. The Bulls won 57 games, but it was an excruciating march to another title.

The stories of Jordan's gambling with unsavory characters refused to go away. And during the playoffs, the media pounced on reports of Jordan's late-night gambling junkets to Atlantic City. Jordan grew more remote, and it seemed the Bulls' streak would end when the Knicks took the first two games of the conference finals in New York.

But the Bulls blew out the Knicks in Game 3 in Chicago and sent the series back to New York even at 2-2. Game 5 was pivotal. The Knicks had a chance to win, but spectacular defense by Jordan, Pippen and Grant denied Charles Smith a layup opportunity in the final seconds. The Bulls escaped 94-92 and went home to knock out the Knicks in six.

They'd do the same to Phoenix in the Finals, but in more dramatic fashion as Paxson hit a three for the three-peat.

"Just like I always envisioned in my driveway growing up," Paxson said.

The Chicago Stadium was getting the wrecker's ball, and though no one realized it at the time, so was the infant dynasty.

Jordan's father, James, was murdered that summer while he rested in his car along a North Carolina highway. James Jordan was not only father, but also friend, confessor and buddy to Michael. It was James Jordan whom he cried with while holding the trophy

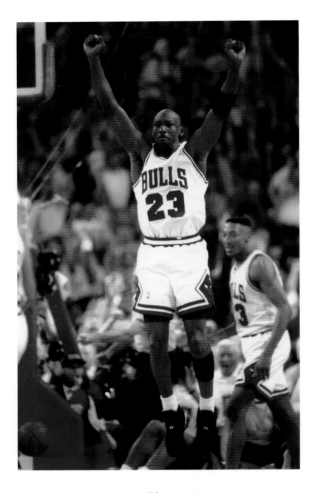

that ended seven years of frustration in 1991.

Jordan was devastated, and just days before the opening of training camp, he called Reinsdorf with the news: He was retiring.

The nation was stunned.

Jordan had become more than a basketball player. He was a symbol for America, a hero, an icon, the embodiment of the American Dream.

Jordan would embark on a quixotic attempt to play major-league baseball, an attempt to fulfill a promise to his late father, who always wanted Michael to be a baseball player.

The team was stunned. A statue of Jordan was raised outside the new United Center.

But Jackson had prepared the team for life without Jordan. Anchored by Pippen and Grant, the Bulls won 55 games in 1993–94 and played as pure a brand of team basketball as had been witnessed in the NBA since the great Celtics teams of the '60s.

The Bulls were on the verge of a monumental upset of the Knicks in the Eastern Conference semifinals when a questionable call by referee Hue Hollins—who would become a nemesis—sent Hubert Davis to the free throw line for two shots in Game 5. The Knicks would go on to a one-point victory. The Bulls evened the series the next game, but lost Game 7 in New York.

Opposite: Michael Jordan celebrates during the Bulls' 105-97 victory over the Pistons in Game 2 of the Eastern Conference final on May 21, 1991 at the Stadium. After being eliminated by the Pistons in three consecutive postseasons, the Bulls swept Detroit and advanced to their first NBA Finals.

After the season, Grant moved to Orlando as a free agent.

The Bulls came close to trading Pippen to Seattle for Shawn Kemp, but the deal fell through when Seattle backed out. The team was being dismantled, creeping along at barely .500 in 1994–95 when Jordan made his famous two-word announcement: "I'm back."

It was March 18, and it culminated a frenzied two weeks in which Jordan tantalized the team and the nation with the possibility of a return. He didn't want to get involved in baseball's bitter labor problems, so he started practicing with the Bulls. Even President Clinton acknowledged Jordan's return during a news conference.

The Bulls lost Jordan's return game in Indianapolis, but won 14 of 17 with him and fell to Orlando in the conference semifinals only because they couldn't defend old buddy Grant. The Bulls had Jordan. But they needed to replace Grant.

For years the Bulls had despised Dennis Rodman. During the 1991 playoffs, Pippen suffered a deep gash in his chin when Rodman threw him into the stands. As a Piston, Rodman was one of the prime Bad Boy tormentors of the Bulls.

But he could rebound, and the Bulls needed that so much they were willing to put up with his costumes and makeup and wild tattoos. They traded Will Perdue to San Antonio for Rodman just before the opening of the 1995–96 season, and the NBA would never be the same.

It was Superman, Batman and Rodman.

Opponents played more to not get embarrassed than to win.

By early February, the Bulls were 41-3 and the talk was of breaking the Lakers' record of 69 wins in a season. It would not be a problem. The players wanted it. This was special, they knew, and they wanted history to know it too.

They got No. 70 in Milwaukee with three games left.

Jordan was MVP of the league, the All-Star Game and Finals. Toni Kukoc won the Sixth Man Award. Jerry Krause was Executive of the Year. Rodman was the leading rebounder, Jackson was Coach of the Year.

The Bulls swept Miami, beat New York in five, swept the Magic, and then won the first three against Seattle for a 14-1 playoff run. Two losses to the Sonics merely delayed the inevitable . . . and again allowed them to win the clincher at home.

Jordan again let his emotions come forth. Determined to erase the disappointment of the '95 playoffs, he worked as hard as he ever had the previous summer. And the clincher came on Father's Day. He fell to the floor with the ball as the final buzzer sounded and wept openly, a promise achieved for himself and his late father.

Off the Bulls went again the following season, winning 17 of their first 18; they were 42-6 at the All-Star break.

They fell just short of 70 again with 69 wins and then ripped through the playoffs with an 11-2 record before a tightly played Finals with the Utah Jazz. The Bulls won in six games, and most memorable was a heroic effort in Salt Lake City with the series tied at two games each. Jordan was sick and barely able to get out of bed, but he scored 38 points and carried the Bulls to a two-point win. After the game, he fell, almost dazed, into Pippen's arms.

The Bulls clinched it back home the next game, and it was five championships in seven years, and it might have been seven straight titles had Jordan not left to play baseball.

And then, a sixth.

It was anything but easy.

Pippen missed the first part of the season because of foot surgery, and Jordan had to carry the team. He was MVP and scoring champion again, but the possibility of a breakup hung over the Bulls all season. In November, Pippen said he didn't want to play for the team again, but returned in January and was customarily solid in his role as Jordan's sidekick.

Jackson said he would not return, and Jordan said he wouldn't play for any other coach but Jackson. Though Rodman wasn't suspended even once, it was still a strange season, with the Bulls gathering themselves to win 62 games, matching Utah for the best record in the NBA and then taking the Jazz in the Finals despite lacking home-court advantage.

The Bulls made the 1990s a special time, and everyone involved had the time of his life. They entered the lore of sports with the Celtics, Lakers, Yankees, Canadiens, Steelers and Packers. But they did it perhaps more impressively, certainly with more panache and personality than any of the greats.

If there is a Hall of Fame for teams, the Bulls have to be right there at the front. What a strange, wonderful ride it was. 🏀

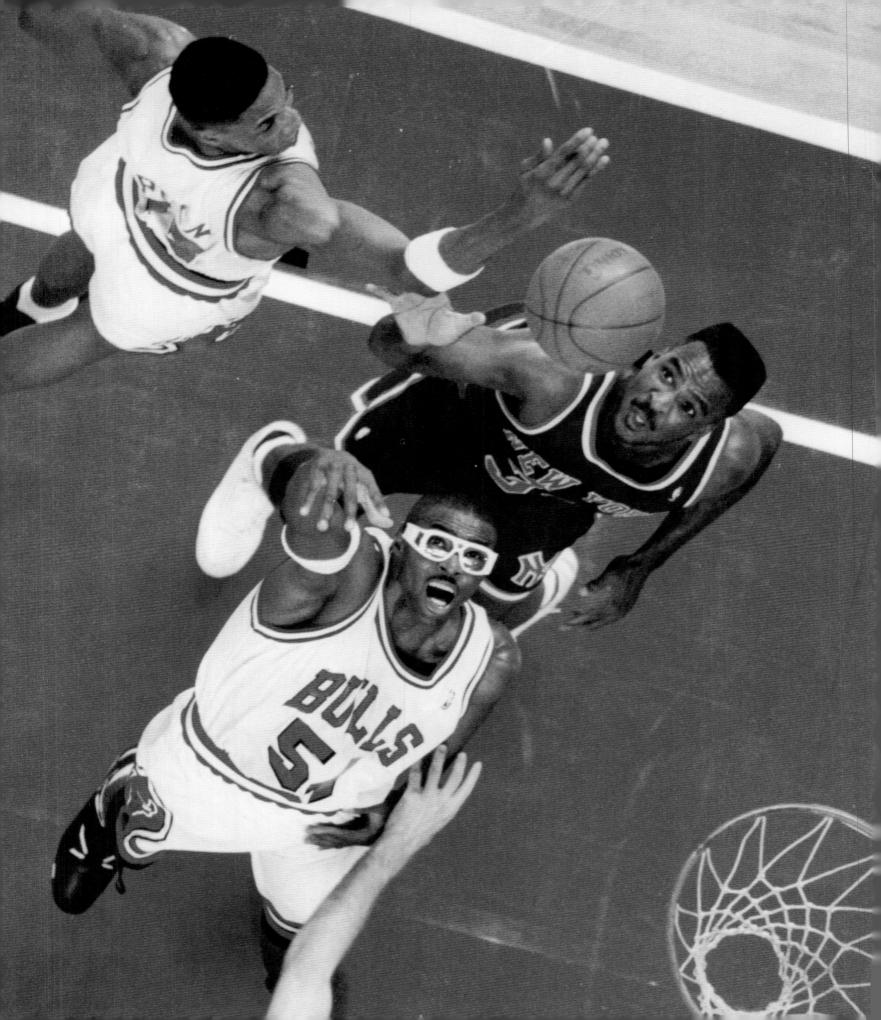

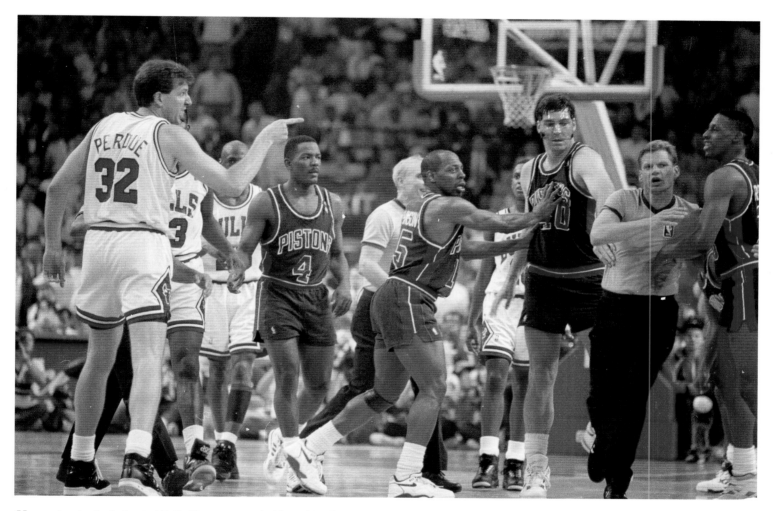

Above: In a typically heated Bulls-Pistons game in May, 1991, Bulls center Will Perdue gestures at Detroit's Dennis Rodman (far right) as a referee tries to intervene. The Bulls finally vanquished the "Bad Boys" in a cathartic four-game series sweep.

Opposite: Scottie Pippen (left) and Horace Grant defend against the Knicks' Charles Oakley in the playoff opener on April 25, 1991 at the Stadium. The Bulls won 126-85 and went on to sweep the series in three games.

An easy—but crucial—win over Charlotte clinched home-court advantage.

Bored Bulls still hammer Hornets for No. 60

April 20, 1991

CHARLOTTE, N.C. – This wasn't a game that meant much for the Bulls, who already had clinched the Central Division title and the best record in the Eastern Conference.

And there were a few early signs the Bulls weren't taking it that seriously. But the Bulls finally won their 60th game of the season 115-99, the first time in franchise history they have reached the 60-win plateau.

"We thought before the game even started they'd throw in the white flag and surrender," said Scottie Pippen. "But they really fought back and it was good we could hold them off."

The Hornets (26-55) cut a 24-point late third-quarter Bulls lead to four with five minutes to play.

"We knew they were going to bring it together sometime during the game and we slid a little bit at the end of the third and let them back in the ballgame," said Bulls coach Phil Jackson.

But Michael Jordan, who led the Bulls with 41 points, took over in the fourth quarter. That's when he scored 18 of his points as the Bulls pulled away with a 21-9 burst to close the game.

"We came out and played extremely well and everyone got involved," said Jordan. "The second team came out in the second quarter and gave a little bit away and changed the tempo of the game. The third quarter we were relaxed and they came on strong and we were then in a dogfight. In the fourth quarter I started going at it. I felt very loose and very energetic and I started taking my opportunities when I saw them."

And if the game didn't have a bearing on the final standings or the Bulls' playoff opponent—as they'll open the playoffs next Thursday against the Knicks—then it was an opportunity. For the win enabled the Bulls to become just the ninth NBA franchise to win 60 games in a season.

"We're happy to have had a chance to win 60," said Jordan. "We may not get the opportunity again. We set a goal to win the division title and we did that, and home-court advantage means a lot in the playoffs."

And seeing as how the Bulls have it all the way through the Eastern Conference playoffs, Jackson has already started to look ahead. He said he plans to return Bill Cartwright to the starting lineup Sunday after a game off, but hopes to play Jordan less after Jordan played 39 minutes Friday.

"I played Michael a little too much," said Jackson. But he also said, particularly the way the game went, that he wants to see an effort from the reserves.

"I didn't feel like the guys coming off the bench were fired up about winning the game," said Jackson. "I thought they were a little hesitant about their shots. We've got to get some aggression back from the bench."

Seasons with 60 or more wins

Year	Record	Coach	Postseason
1990–91	61-21	Phil Jackson	Won NBA championship
1991–92	67-15	Phil Jackson	Won NBA championship
1995–96	72-10	Phil Jackson	Won NBA championship
1996–97	69-13	Phil Jackson	Won NBA championship
1997–98	62-20	Phil Jackson	Won NBA championship
2010–11	62-20	Tom Thibodeau	Lost in Eastern Conference final

The Bulls out-bullied the Pistons to reach the NBA Finals for the first time.

Bulls end Piston reign of terror

May 28, 1991

AUBURN HILLS, Mich. – Go ahead Charlie Brown, kick that football. It's going to stay right there. And you, Tinkerbell, we believe. And we're applauding. Once-sleepy basketball kingdoms, like Chicago, can come to life. And they can even go to the ball.

Fairy tales do come true.

The Bulls are going to the National Basketball Association finals for the first time.

"I'm extremely pleased for Michael Jordan," said Bulls coach Phil Jackson after the Bulls had completed a four-game sweep of the Detroit Pistons in the Eastern Conference finals Monday with a lopsided 115-94 victory here.

"For Bill Cartwright, Craig Hodges, Cliff Levingston, John Paxson, guys who've been around the league seven, eight, nine years, this is particularly sweet for them. We're very happy for their effort and the way our young players like Scottie Pippen and Horace Grant have hung together well and found a way to do it."

The Bulls did it against the two-time defending champion Pistons, the Bad Boys: Zeke, Buddha, Worm, Spider and Microwave. Call 'em toast. They really weren't so fearsome after all, just a bunch of old guys hiding behind a screen of terrorism.

"We didn't expect to sweep this team," said Jordan, who led the Bulls with 29 points, eight rebounds and eight assists. "You have to give a lot of people credit, the team as a whole, not one individual or two."

With Pippen scoring 23 points and adding 10 assists, Grant scoring 16 points and getting nine rebounds and John Paxson contributing all 12 of his points in a frenzied first quarter, the Bulls swept a defending champion for just the third time in NBA history. Even better, it was their nemesis, the Pistons, who have eliminated the Bulls from the playoffs the last three seasons and from the conference finals the last two.

"We were very strong mentally and they were a little weaker mentally and we kept the pressure on them," said Jordan in a jubilant, but restrained, Bulls' locker room. "We never broke our focus and they never broke us mentally."

Although the Pistons would try physically. It was a last stand of desperate men Monday and the Bulls, as they had in the first three games of the series, would not crack.

Paxson went jaw-to-jaw with Bill Laimbeer after being pushed into the stands on a drive, with the Pistons leading 22-20 in the first quarter.

"I wanted him to know I wasn't going to back down," said Paxson, who went on to score 10 points in 96 seconds to give the Bulls a lead they would never relinquish.

Dennis Rodman then shoved Pippen into the stands early in the second quarter after the Bulls had taken a 42-34 lead. Pippen crashed into the first row of seats and took a few minutes to clear his head.

The attack sent the Bulls' bench into a frenzy and rushing toward midcourt as a flagrant foul, oddly enough, was called on Laimbeer.

"You play, you play," Grant screamed at Pippen as he wobbled to his feet.

"They really weren't focusing on basketball," said Pippen. "Basically, Rodman's been making those stupid plays for the last couple of years, but I've been retaliating and giving him the opportunity to let that work to his advantage.

"We put our main focus into basketball, as we have all this season," added Pippen, who was marvelous throughout the series, averaging 22 points, 7.8 rebounds and 5.3 assists while loudly answering his critics and doubters. "I wanted the opportunity to play in the conference finals again," said Pippen. "And I did."

The Jordan influence

Before Michael Jordan's arrival in 1984–85, the Bulls had failed to qualify for the playoffs in six of the seven previous seasons. Here are the playoff results since then:

1984–85: Eliminated by Milwaukee 3-1 in first round

1985–86: Eliminated by Boston 3-0 in first round

1986–87: Eliminated by Boston 3-0 in first round

1987–88: Beat Cleveland 3-2 in first round. Eliminated by Detroit 4-1 in Eastern Conference semifinals.

1988–89: Beat Cleveland 3-2 in first round. Beat New York 4-2 in Eastern Conference semifinals. Eliminated by Detroit 4-2 in Eastern Conference finals.

1989–90: Beat Milwaukee 3-1 in first round. Beat Philadelphia 4-1 in Eastern Conference semifinals. Eliminated by Detroit 4-3 in Eastern Conference finals.

1990–91: Beat New York 3-0 in first round. Beat Philadelphia 4-1 in Eastern Conference semifinals. Eliminated by Detroit 4-0 in Eastern Conference finals.

The
**1991
NBA**
Finals.

(Best of seven)
BULLS vs. Lakers
(Bulls win series 4-1)
Game 1: Sunday, June 2
Lakers 93, BULLS 91
Game 2: Wednesday, June 5
BULLS 107, Lakers 86
Game 3: Friday, June 7
BULLS 104, Lakers 96 (OT)
Game 4: Sunday, June 9
BULLS 97, Lakers 82
Game 5: Wednesday, June 12
BULLS 108, Lakers 101

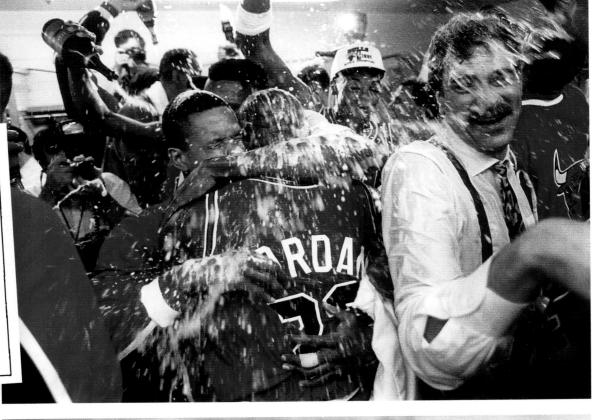

"I'm just happy for everyone, all of us—the organization, the city, the people of Chicago. It's an unbelievable feeling because we did it as a team. I can't wait to get home and share this with the city."

—JOHN PAXSON

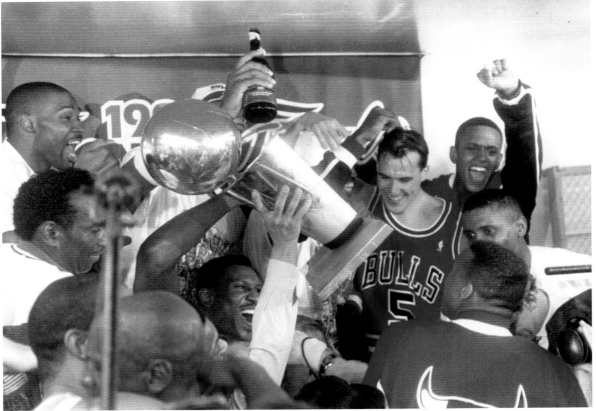

Winning his—and the franchise's—first NBA title brought Michael Jordan to tears.

Bulls stampede to first title

June 13, 1991

INGLEWOOD, Calif. – Champions!

"I never lost hope," said a tear-stained Michael Jordan, whose 30 points and 10 assists helped the Bulls wrap up their first NBA title with a thrilling 108-101 victory over the Los Angeles Lakers. "I'm so happy for my family and this team and this franchise. It's something I've worked seven years for, and I thank God for the talent and the opportunity that I've had."

The Bulls plowed through the playoffs with a 15-2 record (including a 7-1 mark on the road), second best in NBA playoff history. They won the last four games of the Finals—including all three at the Forum—to win the series 4-1.

Champions!

"It's going to taste sweet for them," said Lakers star Magic Johnson, who came into the joyous Bulls locker room to congratulate Jordan. Even a triple-double by Magic—16 points, 20 assists and 11 rebounds—wasn't enough to overcome the destiny-driven Bulls in the decisive Game 5.

"I'm just happy for everyone, all of us—the organization, the city, the people of Chicago," said John Paxson, whose 20 points included 10 in a crucial three-minute stretch late in the fourth quarter after the Lakers had tied the score at 93. "It's an unbelievable feeling because we did it as a team. I can't wait to get home and share this with the city."

Champions!

"Pax was the key," said Bulls coach Phil Jackson. "M.J. was finding him and he stepped up and hit the shot."

"That's why I've always wanted him on my team and why I want him to stay on my team," said Jordan, holding the Larry O'Brien championship trophy while flanked by his wife, Juanita, and father, James, in the Bulls locker room.

Jordan played all 48 minutes, as did Scottie Pippen, who led all scorers with 32 points. It was the first time during these playoffs that someone other than Jordan had led the Bulls in scoring.

> **"[The championship] means so much. Not just for me, but for this team and this city. It was a seven-year struggle. It's the most proud day I've ever had."** —MICHAEL JORDAN

Pippen, who also had a playoff-high 13 rebounds, popped the first champagne bottle as the team came sprinting into the locker room, dumping the bubbly over a bubbling Horace Grant.

"We're going to celebrate for at least two days," said Pippen.

Amidst the glee, veteran center Bill Cartwright could be heard quietly saying, "Finally."

For a long time, Jordan sat along one of the long benches in the visitors' locker room. In many ways, it was his party.

He hid his head in the arms of his wife for a long time after receiving the MVP trophy and cried. Finally, he picked up his head as reporters and photographers gathered in a tightening circle.

His eyes were red and tears glistened on his cheeks, reflecting in the lights. It could have been champagne, but it wasn't.

"I never showed this kind of emotion before in public," he apologized, though he didn't have to. He really is human. For years, he's threatened and cajoled, been praised as the best example of team basketball and vilified as the worst example. He basked in the spotlight put on him, but was also cursed by it. Could he be a winner?

"We started from scratch, on the bottom, not making the playoffs when I got here," said Jordan.

"It took seven years, but we won. This should get rid of the stigma of the one-man team. We have players that make us an effective basketball team."

All champions!

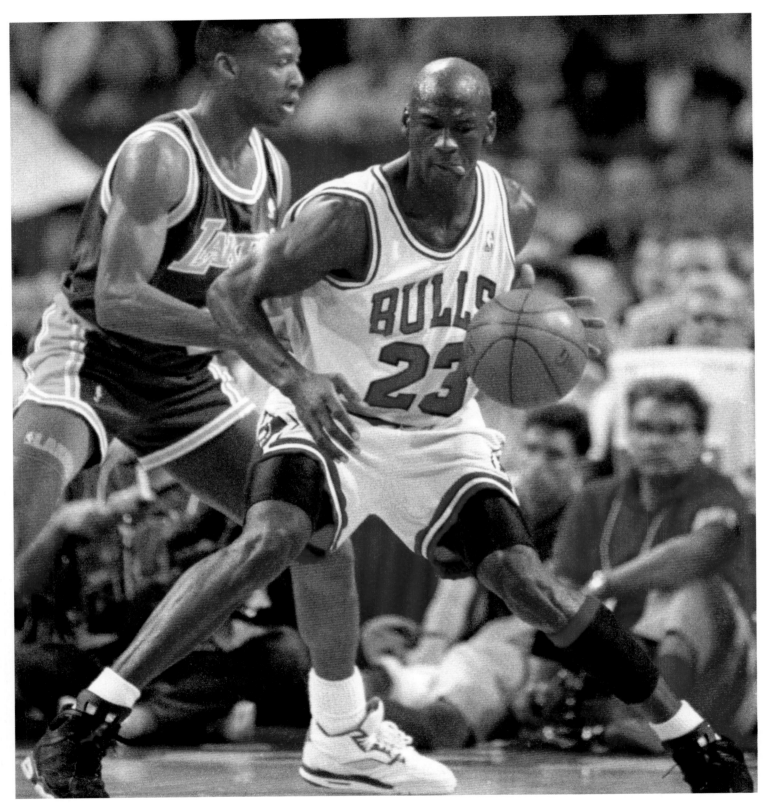

Above: Michael Jordan works against the Lakers' Byron Scott during Game 2 of the NBA Finals on June 5, 1991 at the Stadium. The Bulls recorded their first Finals victory in franchise history, routing Los Angeles 107-86.

Opposite: John Paxson and Scottie Pippen, two keys to the Bulls' first title run, embrace during the 1991 NBA Finals.

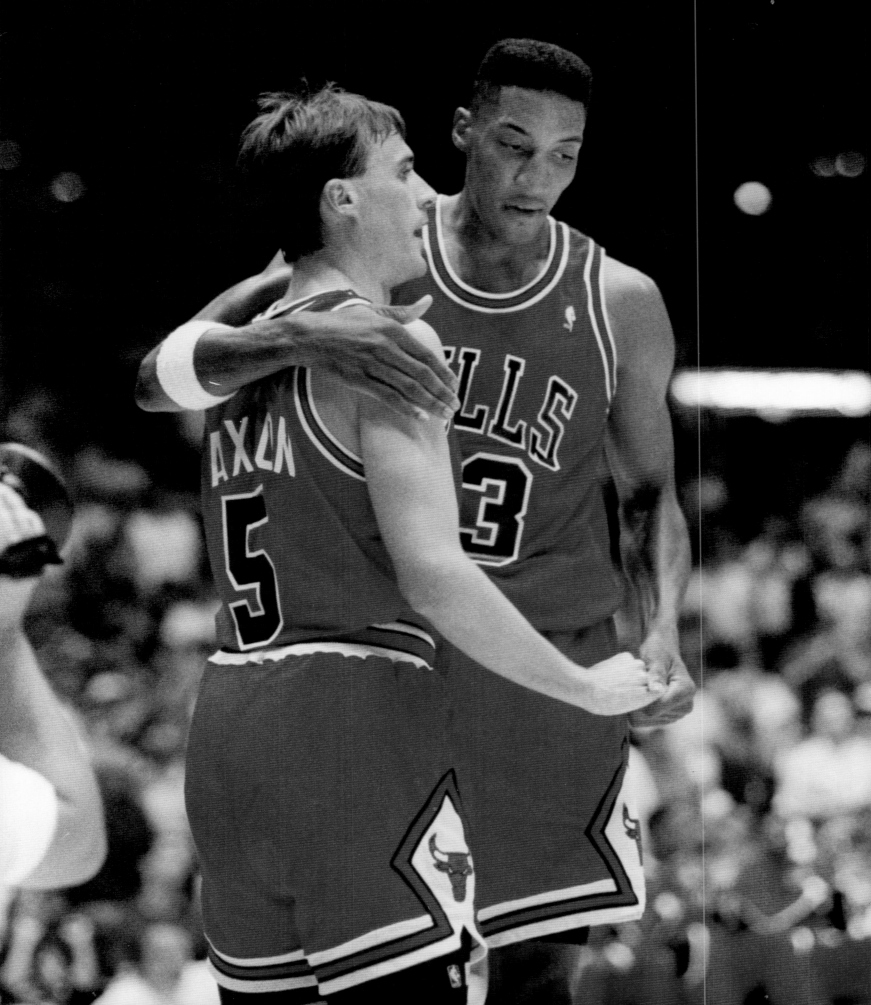

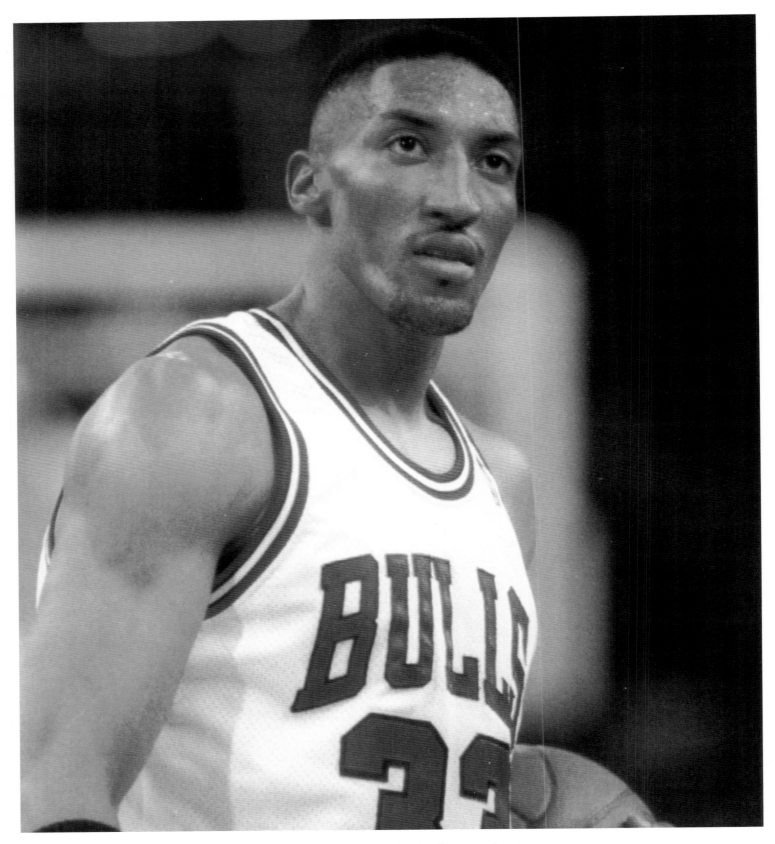

Scottie Pippen was a seven-time NBA All-Star and was named to the All-Defensive first team eight times.

Scottie Pippen

'HE ROSE ABOVE IT ALL'

On an August night in Springfield, Mass., the birthplace of basketball, Scottie Pippen entered the Naismith Basketball Hall of Fame.

It's an honor that perhaps only Pippen believed was possible while growing up a gangly kid in Hamburg, Ark., the last of 12 kids living in two rooms.

The tale of Michael Jordan not making his high school varsity team as a sophomore has become legend. But Jordan eventually landed a scholarship to North Carolina. Pippen entered NAIA University of Central Arkansas in Conway, Ark., as a student manager.

"I always respected how he had risen out of the circumstances that he came from," Bulls Chairman Jerry Reinsdorf said. "He rose above it all."

That's a fitting image for Pippen, who soared to international prominence as a six-time NBA champion with fellow Hall-of-Famers Jordan and coach Phil Jackson.

Chicago lived through Pippen's ascent, so the accomplishments easily roll off the tongue: seven All-NBA teams, 10 All-Defensive teams, an All-Star Game Most Valuable Player Award in 1994, two Olympic gold medals, inclusion in the NBA's all-time top 50.

But it was the way Pippen played—with poise and grace and unselfishness—that led so many former teammates to call him their favorite player with which to toil.

"He had a great sense of humor," longtime assistant coach Johnny Bach said in a phone interview. "I remember one time he came to practice five minutes late. And he said, 'My cat died.' I've heard a lot of excuses, but I've never heard that one. Even Phil laughed at that one.

"He could laugh in pressure situations. It wasn't that he was a clown. But he could break tension. And he grew so much and became authoritative. Let's face it: He came from a tiny town in Arkansas all the way to the NBA. That's a hell of an adjustment he made, and he made it quickly. He kept adding as his career progressed—skills, leadership, you name it. That's a rare trait."

It's also why Pippen was able to rise above some very public missteps to claim his place as a Bulls icon—and in NBA immortality. His familiar No. 33 has hung in the United Center rafters since December 2005. And he represents the Bulls forever in Springfield.

That, famously, took some major maneuvering.

Pippen's performances at several pre-draft camps, most notably in Portsmouth, Va., created a strong buzz in 1987. The Bulls were picking eighth and 10th.

"I knew we had to get ahead of Sacramento, who was picking sixth," former general manager Jerry Krause said.

Krause said he began talking to then-SuperSonics executive Bob Whitsitt three hours a day, targeting Seattle's fifth pick.

"The night before the draft at about 4 in the morning, Whitsitt said to me, 'If the player that I want is not available at No. 5, I'll do this deal,'" Krause recalled.

Krause said Clippers owner Donald Sterling told Reinsdorf shortly before the Clippers' fourth pick that Sterling's franchise was taking Georgetown's Reggie Williams, which Krause relayed to Whitsitt.

"And he says, 'Our deal is on. That's the guy we wanted,'" Krause recalled.

Few could know the draft rights to Olden Polynice, whom the Bulls selected for the Sonics at No. 8, would prove so valuable. When Krause ended a Joe Wolf-Horace Grant debate by listening to strong coaching-staff support for Grant at No. 10, the mood was ebullient.

"There was a feeling in the room that night that we might've drafted a championship," Reinsdorf said.

Or six.

"People don't remember Scottie didn't start that first year; Brad Sellers did," Krause said. "And that helped him because he was able to come in with no pressure on him.

"But he was so unselfish and always a good passer. He fit perfectly in the triangle when Phil took over for Doug (Collins), who was great for him his first two seasons. He might've been one of the best triangle players ever.

"And he was such a great athlete. . . . When we drafted him, I thought worst-case scenario he'd be a

"He made Michael a better defensive player because Michael gambled, and it was often that Scottie moved up to cover for Michael. . . . He had such good instincts."

—COACH JOHHNY BACH

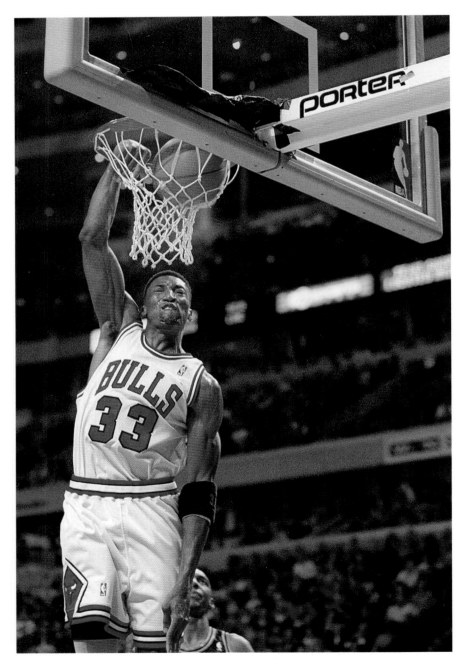

With his ability to bring the ball down the floor and initiate the offense, Scottie Pippen was often called a "point forward."

great defender. But I knew if he learned to shoot, he could be a star. Still, he had such great progression that he surpassed all expectations."

From the Bulls' first championship over the Lakers in 1991 to the grueling, seven-game Eastern Conference finals victory over the Pacers that led to the sixth title in 1998, Pippen's defensive dominance shined.

His shadowing of Magic Johnson in 1991 turned that series after the Bulls dropped a heartbreaker at home in Game 1. And his blanketing of everyone from point guard Mark Jackson to power forward Derrick McKey in the taut Game 7 victory over the Pacers in 1998 demonstrated his unique combination of length and savvy.

"What set Scottie apart defensively was his versatility," Krause said. "He had the ability to guard so many different players."

Added Bach, credited as the architect of the "Doberman" defense: "With his long strides, he could recover fast. He had good vision. He had long arms. You couldn't throw the ball over his head. And in many cases, you couldn't throw the ball past him. He could guard forwards small or big. And he was quick and long enough to disrupt guards.

"And he made Michael a better defensive player because Michael gambled, and it was often that Scottie moved up to cover for Michael. . . . He had such good instincts. It wouldn't have been a Doberman defense without him. He was so aggressive. And he loved playing that end too."

Pippen's occasional petulance featured clashes with management over salary and personnel, public trade demands, two near-trades and, most infamously, his refusal to re-enter Game 3 of the 1994 Eastern Conference semifinals against the Knicks because Jackson designed the last-second shot for Toni Kukoc.

"That was cleared up in the locker room by him right after the game," ex-teammate Bill Wennington said. "He understood he made a mistake and let his emotions get the better of him and told us. Then it was over."

That incident came at the tail end of Pippen's emergence from the prodigious shadow of Jordan, who had retired abruptly before the 1993–94 season. Pippen averaged 22 points, 8.7 rebounds, 5.6 assists, won the All-Star Game MVP Award and led the Bulls to 55 victories.

If not for Hue Hollins' foul call on Pippen, which led to Hubert Davis' winning free throws in Game 5,

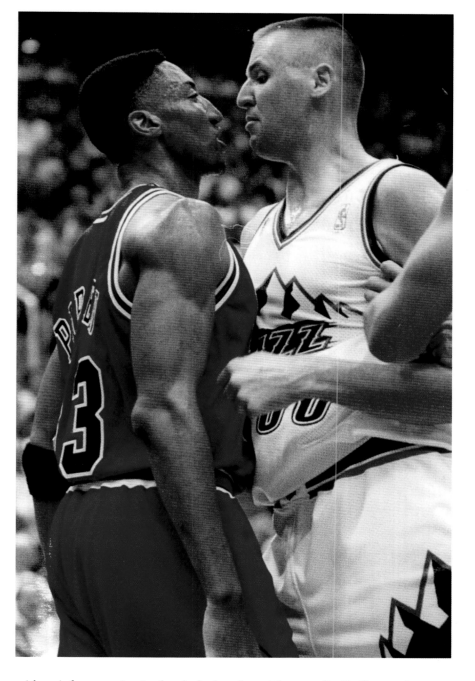

SCOTTIE PIPPEN

- » **Born:** Sept. 25, 1965 in Hamburg, Ark.
- » **Height:** 6-8'
- » **Weight:** 210
- » **College:** University of Central Arkansas
- » **Years in NBA:** 1987–2004
- » **Acquired by Bulls:** June 22, 1987 from Seattle SuperSonics with a 1st round pick in trade for Olden Polynice, a 3rd round pick and a 1st round pick; reacquired as a free agent July 20, 2003

the Bulls might have advanced unexpectedly to the conference final.

"That was my favorite team, even more than any of the championship teams," Reinsdorf said. "We didn't have time to plan for Michael's retirement. But that team scrapped, hustled. They never should've won as many games as they won after having lost Michael.

"I would've preferred to see Michael remain the main guy. But I was proud to see Scottie step up and be the No. 1 guy."

When Jordan returned from his baseball hiatus, the dominant duo racked up the Bulls' second three-peat. And Pippen continued to earn his teammates' trust and admiration for his selfless style.

"He was accountable for his actions on the floor," Wennington said. "Usually, other players get blamed for stars' mistakes. Scottie wasn't like that."

When the dynasty dissolved, the Bulls signed-and-traded Pippen to the Rockets. That began his five-season run in the Western Conference that included four successful seasons with the Trail Blazers.

One of John Paxson's first moves after succeeding Krause as general manager in 2003 was to sign Pippen to a two-year contract that summer. Though Pippen played just 23 games before he physically was forced to retire, his locker-room presence positively affected young Bulls such as Kirk Hinrich.

"He helped restore a culture of professionalism," Paxson said.

Ultimately, even with his missteps, that is how Pippen will be remembered—a professional who met whatever challenge the game dictated. For someone who once raised questions about his commitment

with an infamous migraine headache in a Game 7 loss to the Pistons in the 1990 Eastern Conference finals, Pippen overcame all with his commitment and competitiveness.

"Of course I have a favorite memory: It was the last game against Utah in 1998," Reinsdorf said. "Scottie had a horrible back problem. He kept going back into the locker room and getting treatment. He was in excruciating pain. But he managed to get through that game.

"That was a remarkable performance. And it speaks to what kind of competitor Scottie was." 🏀

Scottie Pippen, shown here squaring off with Utah's Greg Ostertag, was a versatile and tenacious defender who could be matched up against almost any opponent.

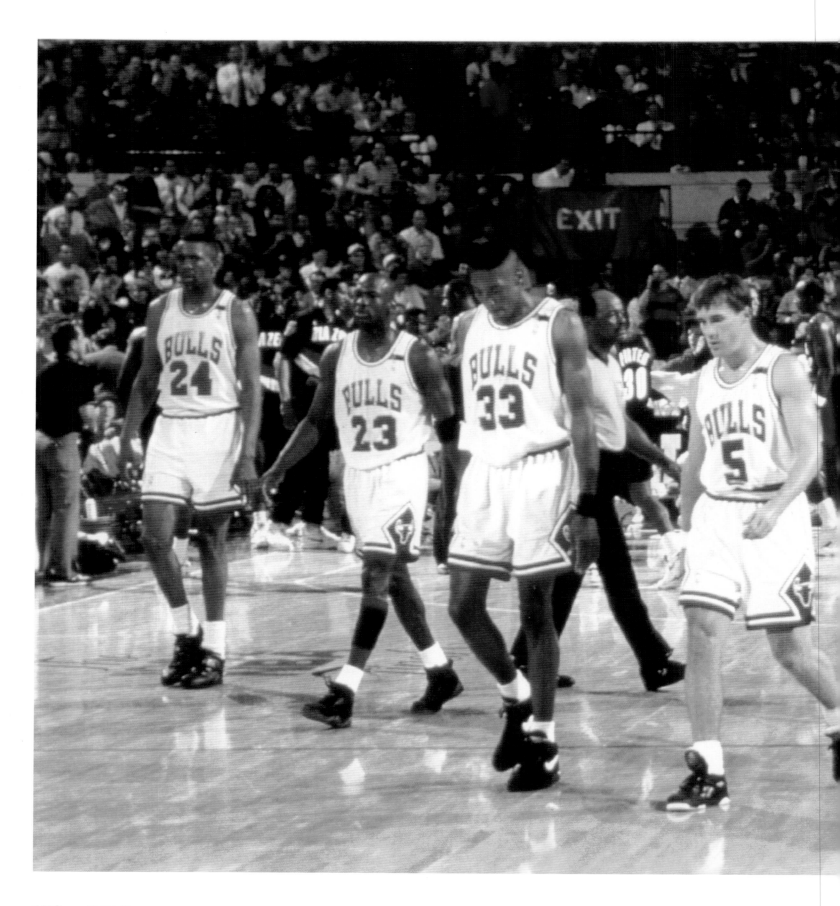

The starting lineup for the Bulls' first three peat—from left, Bill Cartwright, Michael Jordan, Scottie Pippen, John Paxson and Horace Grant—strides down the floor during Game 3 of a first-round playoff series against Atlanta on May 4, 1993 at the Stadium. The Bulls won 98-88 to sweep the series en route to their third consecutive NBA title.

Jordan could only shrug as his barrage of three-pointers took down the Blazers.

Bulls unleash Air raid

June 4, 1992

One game. One victory. That's all it was, the Bulls all insisted, with sincere expressions and serious tones and all the believability they could muster in the wake of a truly unbelievable two hours. Hard as they tried, however, they could not dim the moment.

Their 122-89 rout of the Portland Trail Blazers in Game 1 of the NBA Finals reminded us that there is no predicting the drama of sport and no comprehending the wonder of Michael Jordan.

It was one of those nights where your vision is slightly blurred; the scene a sequence of slow-motion moments that require a look at your neighbor to make sure it is all really happening.

In person at the Stadium, or on television at home, it could not have mattered. Count yourself truly blessed if you witnessed Jordan's magic in any form at all. For as much as he has shown us before and as much as we expect from him later, this night stands out as a sparkling addition to his legend.

His 35-point first half cast the series into a light no one could have expected and set the tone for a blowout few could have foreseen—especially not at the outset. The Blazers nailed their first seven shots while the Bulls struggled at 2 for 10, and Portland led by eight with less than five minutes left in the first quarter.

Then Jordan fell into his groove. He scored 10 straight points for the Bulls during his first hot streak and finished the quarter with 18 points on 7 for 13 from the field. Still, Portland trailed by only three after one and by just a point with 6:34 left in the half.

Then Jordan took the game, his game, into a different realm. At 4:49, he hit a three, his fourth in six attempts. Next came a pull-up jumper, a drive around Drexler, followed by another mid-range shot.

"Michael's barrage was incredible," said coach Phil Jackson. "I marveled at it."

In a 47-second span, Jordan lit up the crowd and entered the surreal with two long threes sandwiched around a tomahawk jam off a miss by Pippen.

As the Blazers signaled for a timeout, the crowd was screaming itself into hyperventilation, and Jordan himself seemed overwhelmed. He fought back a smile and shrugged as if to say he couldn't believe it, either.

His first-half magic ended with a record 35 points in 19 minutes, breaking Elgin Baylor's NBA Finals mark of 33 in a half, set against Boston in 1962.

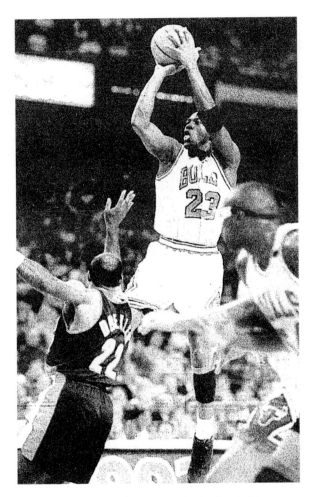

Michael Jordan scored 35 points in the first half to propel the Bulls to a 122-89 victory over the Trail Blazers in Game 1 of the 1992 NBA Finals.

Jordan set postseason records with his six three-pointers—for the half and the game—and inspired his teammates to heights they had not previously reached in these playoffs. He finished with 39 points and 11 assists.

"The threes were like free throws," he said of his uncommon long-range barrage. "I didn't know what was happening, but they were going in."

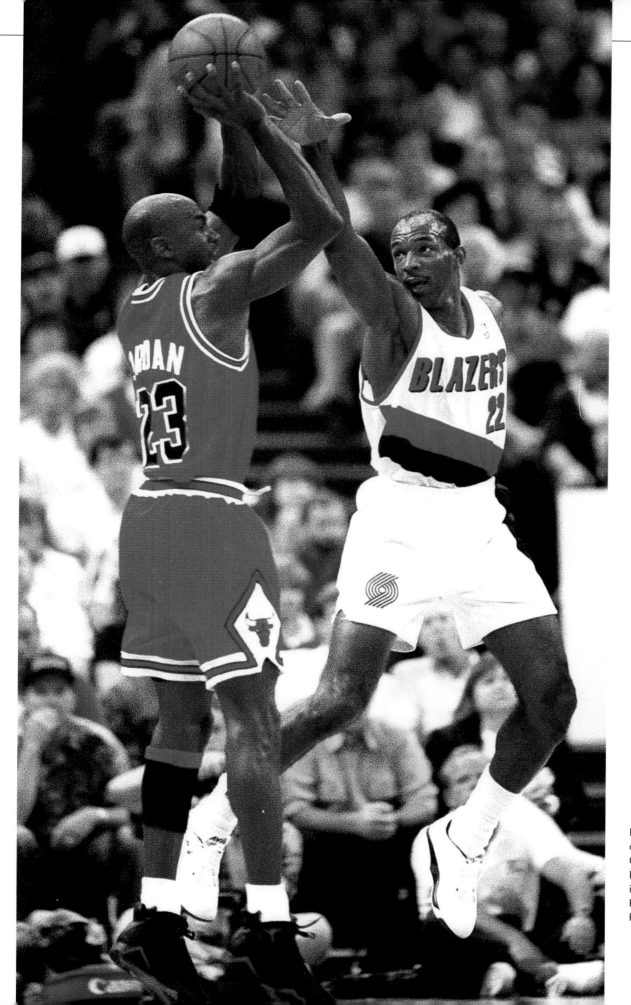

Michael Jordan shoots
over the Trail Blazers'
Clyde Drexler during the
Bulls' 119-106 victory
in Game 5 of the NBA
Finals on June 12, 1992 in
Portland.

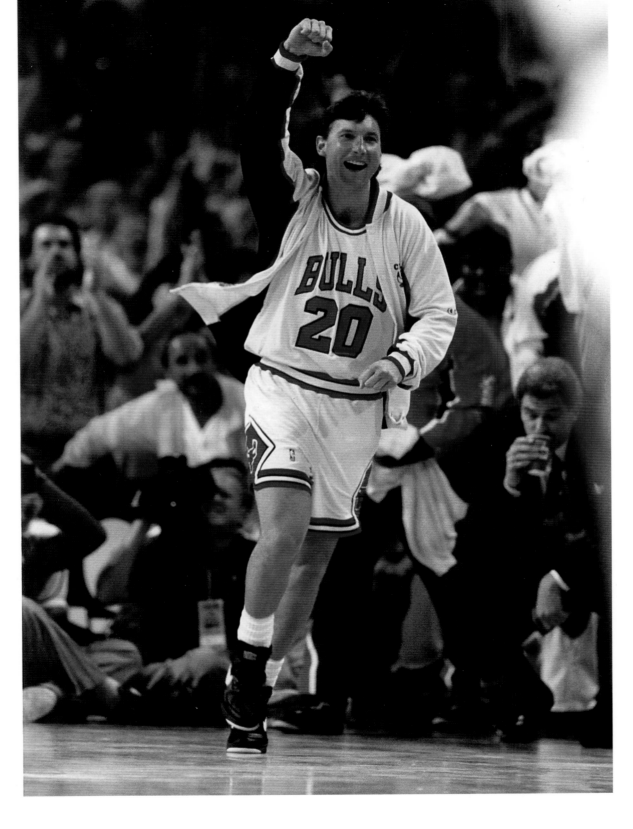

"I hope that the people of Chicago appreciate what we've done. There's only one way to achieve something once you've won and that's to win again. This is truly special."

—JOHN PAXSON

Reserve guard Bobby Hansen cheers on his teammates from the sidelines during the closing minutes of the Bulls' 97-93 victory in Game 6 of the 1992 Finals on June 14, 1992 at the Stadium.

One was fun, but two was twice as nice in front of a hometown crowd.

Bulls find repeat sweet

The details—and what incredible details they were—are secondary.

Mere blips in one huge, amazing evening. The heart-pounding fourth quarter. The courageous bench contribution. The records that fell as the Bulls made history.

All of them will fade with time. And what we will be left with days from now, months from now, years from now, is the big picture. The memory of watching a team achieve pure, unadulterated satisfaction. The image of 12 men dancing like children and some 18,000 fans loving every second of it.

This was victory just as sweet as it gets, a 97-93 triumph over the Portland Trail Blazers Sunday night that gave the Bulls the 1992 NBA championship, their second consecutive world title.

The Bulls battled back from a 17-point deficit late in the third quarter and set an NBA Finals record by coming from 15 behind in the fourth. The offense would not quit. The crowd would not let them.

"Going into that fourth quarter," said John Paxson, "Phil (Jackson) said, 'Fifteen points is nothing if we can regain momentum,' and it worked just like he said."

At the start of the fourth quarter, the Bulls lineup—with the exception of Scottie Pippen—consisted of reserves Stacey King, B.J. Armstrong, Scott Williams and Bobby Hansen.

Pippen, whose ability to perform under pressure had been questioned in the past, crushed the demons and muted his critics by leading the fourth-quarter band of renegades with poise and cool. Pippen rose to the occasion and finished this unforgettable night with 26 points, five rebounds and four assists.

And, never to be overlooked, there was Michael Jordan, the man who defies explanation. Jordan—who led the Bulls in scoring every game in this postseason—capped off the clincher with 12 of the Bulls' last 17 points to finish with 33.

Jordan was the Most Valuable Player of these finals, a unanimous selection, an undeniable selection and a repeat selection in the regular season and finals. An NBA first. Perfect.

"I'm just so glad Chicago drafted me eight years

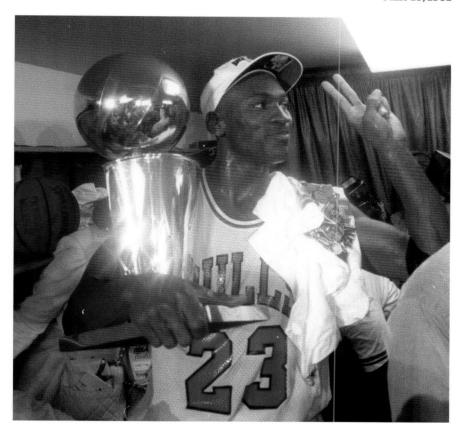

"I'm just so glad Chicago drafted me eight years ago.... This is a great town to play for. I love it. And I hope to play here forever." —MICHAEL JORDAN

ago," Jordan said. "If they didn't, I don't think I could do what I did, being a part of back-to-back championships. This is a great town to play for. I love it. And I hope to play here forever."

"I hope," said Paxson, "that the people of Chicago appreciate what we've done. There's only one way to achieve something once you've won and that's to win again. This is truly special."

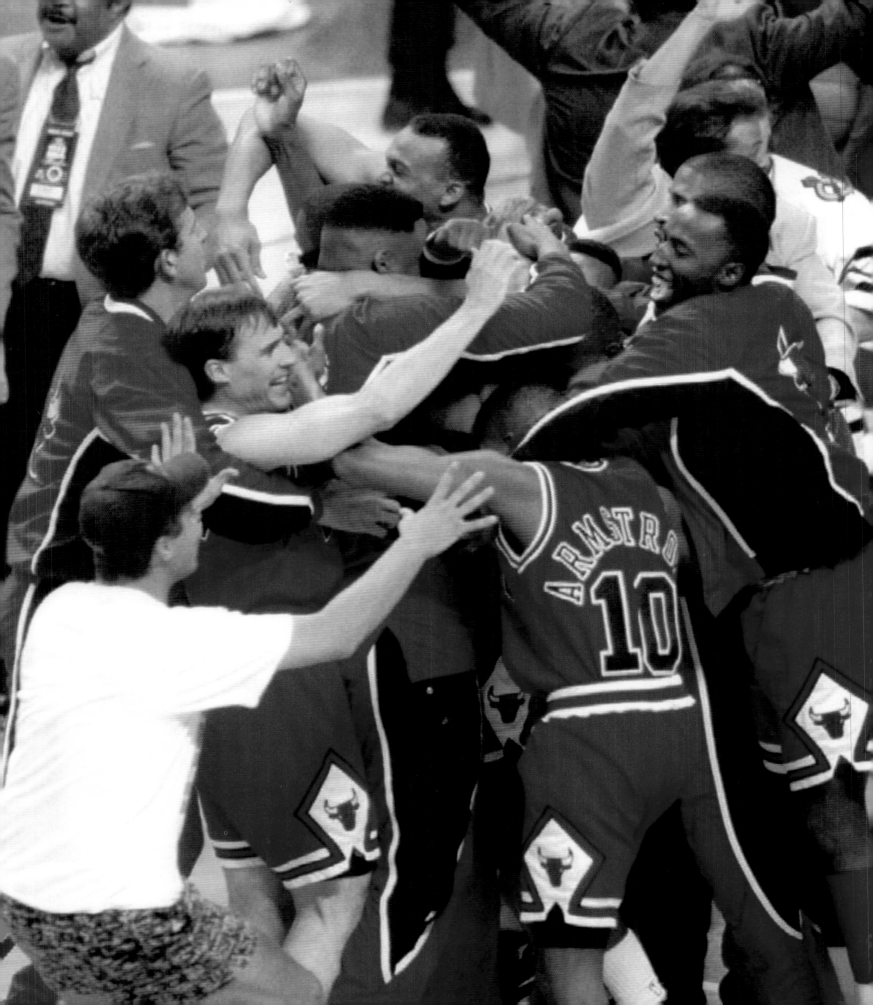

By eclipsing the Suns, the Bulls one-upped the repeat with a three-peat.

It's more than victory—it's history

June 21, 1993

PHOENIX – History repeats itself, it was once said, because nobody listens.

But they do when history repeats itself twice, when, despite all odds, a group takes on history and wins.

The Bulls were seeking a destination where few have gone, a place where only the aristocracy of sport resides—names offered in solemn reverence, like Boston Celtics, Montreal Canadiens, New York Yankees, Notre Dame football, UCLA basketball.

And now, Chicago Bulls.

The Bulls won their third consecutive NBA title by outlasting Phoenix in Game 6 Sunday 99-98 on a three-point shot by guard John Paxson with 3.9 seconds remaining. Horace Grant sealed the historic night by blocking the Suns' Kevin Johnson's last-second shot attempt.

"I can't think of a more dramatic finish for us," Bulls coach Phil Jackson said.

With every intention of hanging on to their old moniker and re-establishing control in the NBA Finals, the Bulls defended their two world titles by surviving this night like they have survived this season—by fending off their opponent again and again and again.

The Bulls led by as many as 11 points in the second quarter, but the Suns closed the gap to five at halftime and wiped out an eight-point lead at the end of three quarters to lead by four with less than a minute remaining.

Michael Jordan, unanimously named the series' most valuable player for the third straight year, finished with 33 points and a record average of 41 points per game in the NBA Finals. As he has done so many times before, he carried this team when it needed it most.

"One or two plays makes the difference between being a part of history and not being a part of history," Jordan said. "And when you're a part of it, you cherish it. This means so much to all of us. More than I can say."

Leading by eight going into the final period, the Bulls did not score their first point until one of two

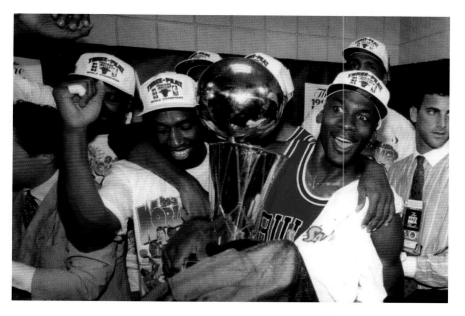

free throws by Jordan fell more than 6 minutes into the quarter.

The Suns outscored the Bulls 9-1 to tie the game at 88-all, then took their first lead since early in the first quarter on a three-pointer by Dan Majerle to go up by one with 5:05 remaining. Buoyed by the frenzied sea of purple-and-orange-clad fans who stood for most of the fourth quarter, the Suns turned up their defensive intensity and forced three 24-second violations in the fourth quarter, two in the final 3:19.

The Bulls would end up scoring just 12 points and hitting just 5 of 18 shots in the fourth. Down four with less than a minute to play, things indeed looked glum.

But a driving layup by Jordan following a rebound on a missed shot by Frank Johnson brought the Bulls to within two and Paxson's three-pointer was the game-winner.

The Bulls. The best. Those who ignore history, it is said, are doomed to repeat it. But history in Chicago is for those who three-peat it.

Trent Tucker (left) and Michael Jordan share a hug after the Bulls won their third consecutive NBA championship June 20, 1993 in Phoenix.

Opposite: The Bulls celebrate on their home court after defeating the Portland Trail Blazers four games to two in the 1992 NBA Finals.

Horace Grant won three championships in his seven seasons with the Bulls.

Horace Grant

ROLE OF A LIFETIME

54 POWER FORWARD/ CENTER

1987—94

He wasn't a very tough rookie, just over 200 pounds if he was dripping wet. But Horace Grant wasn't working up much of a sweat back then. The hard work was yet to come. He was feeling pretty good about himself, pretty cocky, a lottery draft pick coming to help Michael Jordan get somewhere.

It was 1987, and the defending champions were the Boston Celtics. And they had this guy. Looked a little slow to Grant, not much of a jumper. Larry Bird.

"I started talking a little trash to him," Grant recalled, a knowing smile starting to ripple his face. "I'm saying, 'You're not going to score. You're not getting this basket.'

"I remember him then telling me exactly what he was going to do to me. He says he's going to fake me left and then he's going to shoot a right-hand hook over me. And then he goes and does it and scores."

It was the end of trash talking for the hot-shot kid from Clemson and the start of a basketball career of hard work and often overlooked effort that made Grant one of the most successful players in NBA history.

Grant started for four NBA champions. At the time of Grant's retirement, he and Wilt Chamberlain were the only players to be starters in the Finals for three different teams.

Grant also grew into one of the most durable players in the league, appearing in more than 92 percent of the games his teams played. When he ended his career in 2004, the power forward ranked among the all-time leaders in playoff games.

"It's been absolutely great, even the controversial times," said the 6-foot-10-inch, 245-pound Grant, who left the Bulls for the Magic in 1994 after a pay dispute with management. "I have no regrets. Basketball gave me everything I have. I came from this small town (Sparta, Ga.). No one gave me a chance. They said I'd be back working in the one factory we had.

"And to make it in the pros and last 15 years, to be able to get my mom a house and take care of people has been a blessing."

Grant became a catalyst in the Bulls' aggressive defensive trapping schemes and the pre-eminent rebounder on the first three championship teams.

"I remember looking at him at first," recalled Phil Jackson, "and I was thinking, 'Here's this skinny, 6-9, 6-10 kid' and trying to imagine him taking (Charles) Oakley's spot—and I couldn't. But as we watched him day in and out and saw his performance and his capability and the way he was learning every day and getting up from taking a beating, then we knew he could do the job."

Grant was among the elite role players in the game. Role players don't apply for the job. The pay isn't usually the best and the stardom infrequent. They don't shoot the ball much, make many All-Star teams or win many awards.

Just championships.

They are the unsung heroes of champion teams: the guys who set the screen for the shooter, save the ball for someone else, make the steal and throw ahead for the dunk.

"I thought Horace, when he was with the Bulls, was as good a role player as there ever had been," said longtime NBA player and coach Doc Rivers. "You obviously need the stars to win, but you cannot win without that single role player either. They have all these awards, Sixth Man, Most Improved. I always said there should be one for role players since they're so important.

"On those great Bulls teams, Jordan and [Scottie] Pippen were all over pressing. Horace was that third guy, a big man roaming the floor and creating havoc with that press, which I still think is the single best press of all time. They're unique guys who want to win and are happy doing their service."

Grant was a part of some of the greatest teams of the last two decades, from his stay with the Bulls in 1987 through 1994, then on to Shaquille O'Neal's Orlando team in 1994–96 and then the Lakers team with O'Neal and Kobe Bryant in 2000–01.

"Chicago I'd have to say was the best," Grant said, "and I was so fortunate to play with guys like Michael and Scottie, but also Bill Cartwright, B.J. Armstrong and John Paxson. I tried to bring hard work. I'm proud of being a role player, because I know without them a team can't function.

"It's nice to know people depend on you. I think my record speaks for itself. I played hard every night." 🏀

HORACE GRANT

- » **Born:** July 4, 1965 in Augusta, Ga.
- » **Height:** 6-10'
- » **Weight:** 215
- » **College:** Clemson University
- » **Years in NBA:** 1987–2004
- » **Acquired by Bulls:** June 22, 1987 in 1st round (10th overall) of NBA Draft

The death of his father led Jordan to walk away from the game at his peak.

End of an era—Jordan to retire

Oct. 6, 1993

Having tired of the NBA grind and the seemingly endless string of controversy that has followed him and the Bulls for the last two years, Michael Jordan will announce his retirement from professional basketball Wednesday.

The final blow was the death this summer of Jordan's father, James, who was also Michael's best friend. James Jordan was murdered last July in an apparent robbery.

Sources in the Bulls organization and close to Jordan confirmed Tuesday night the rumors that had been sweeping the city and the NBA since last weekend: Perhaps the greatest player in NBA history, at age 30 still in his prime, has decided to cut short his career after nine professional seasons.

Although the announcement at the Berto Center in Deerfield will stun the basketball and sports world, those in the team's organization were beginning to get some hints in recent months that Jordan, who had carried the Bulls to three straight NBA titles, was considering this choice.

Just last week, Bulls owner Jerry Reinsdorf was asked if he expected Jordan to finish the remaining three years of his contract.

"I don't know if he'll play the whole three years," said Reinsdorf. "But he'll make the right decision. All I care about is if he makes the right decision.

"It has been a privilege for all of us to watch him play. It must have been like watching Babe Ruth play. Sometimes I wonder if we don't get used to it. He's going to go at some point. I just hope he goes at the right time for him, and not too soon.

"I don't think he'll leave too late. I don't see him hanging around like Julius Erving did, or Carlton Fisk did.

"But I hope he doesn't go too early. If he does, he might be sorry. I don't want him to regret having gone early. I don't want him to quit for the wrong reason. But whatever the right time for him is, that will be great."

That was the message Reinsdorf, general manager Jerry Krause and coach Phil Jackson tried Tuesday to send to Jordan. They told him he should take some time to consider his decisison, that there was no rush and he shouldn't do anything he might regret.

But the sources said Jordan was adamant, that he had thought out his decision carefully and intended to follow through.

A sense of career burnout lingered over Jordan's decision, based on what Bulls insiders are saying. They said Jordan said he had done all he could, had accomplished all he cared to in professional basketball. After being acknowledged as probably the greatest player ever, after doing what rivals Magic Johnson and Larry Bird couldn't—leading his team to three straight titles—nothing more was left for him in the game, the sources said.

Speculation arose after the death of James Jordan that Michael might retire. But Jordan seemed to allay much of that with an appearance in a charity golf tournament soon thereafter. He also was spotted around the community several times playing golf at his favorite courses. In addition, he had agreed to throw out the first ball at the White Sox playoff opener Tuesday night.

But an undercurrent led many close to the Bulls to wonder whether something was up.

Jordan has three years left on his $25 million contract, which he signed in 1988. He was to earn about $3.9 million this season, and Bulls officials did not talk about Jordan's finances.

When asked just last week about giving Jordan a contract extension to get him to stay with the Bulls and play in the new Chicago Stadium, which Jordan had talked about never playing in, Reinsdorf said:

"Michael doesn't play for money," Reinsdorf said. "Money is not what motivates him. It's the joy of playing the game. And that comes from winning and being so good."

But Jordan has told the Bulls the joy is gone.

And so is he.

> ## "Michael doesn't play for money. Money is not what motivates him. It's the joy of playing the game. And that comes from winning and being so good."
>
> —JERRY REINSDORF

So long, Michael, it's been great

Oct. 7, 1993

They already were sweeping up after Michael Jordan. In small clumps at the Berto Center, there was David Stern, the commissioner, and Jerry Reinsdorf, the owner, and Jerry Krause, the chief clerk of the Bulls.

Their duty was to explain the inexplicable, to try and fill with their inadequacy the huge hole that had just been left in their sport, in their franchise and in the heart of the town where they still would have to do business.

Jordan himself had left the building. This was no longer his mess or his concern.

His life was his own again.

They tried to put the best face they could on the bizarre and confusing. They understood, they said, and wished Jordan well.

To hear Reinsdorf tell it, he had practically insisted Jordan get on with his life. Reinsdorf said he always had thought Jordan was the Babe Ruth of basketball. Reinsdorf said he had changed his mind. Ruth was the Jordan of baseball.

The place was thick with such embellishment, the kind that usually requires a widow and an open bar.

The agent was there, too, of course, David Falk, and other assorted "endorsees," as Jordan called them, the corporate creatures who used Jordan's image for pay. All were poorer than they had been just moments before.

The media, local and national, legitimate and electronic, caught early airplanes and double-parked their trucks to be there. The air crackled with transponder coordinates, and the floor was a menace of cables and cosmetics.

There were fewer cameras, and certainly less make-up, at the surrender of Japan.

This went live, network and cable, and the messengers of the moment talked over Jordan on cellular phones to distant places. Yes, they said, he is quitting. Yes, they said, he has left the door open to come back. Yes, they said, it certainly is tragic.

Assorted accomplices in the Bulls' three championships were spotted among the great gaggle of media, explaining how they would carry on without Jordan, refusing to consider how they had gone so suddenly from being feared to being the Milwaukee Bucks.

Scottie Pippen, now the man, said he had dreamed of this day when Jordan's considerable shadow would be gone and the Bulls would be his to lead. It sounds worse than Pippen probably meant it to.

Phil Jackson, the coach, was more a phantom than usual, indulging no one's appetite for detail. It is understandable. Jackson now will have to work for a living.

For most of a very long night and half a morning, Chicago had waited for the punch line. On talk shows, in elevators, on public transportation, strangers shared a common disbelief the same way they had shared a common glory.

A city's life and pride has been so tied for so long to the achievements of one young man from North Carolina, this was like having surgery without granting permission.

Is Michael really leaving? Why? Why?

The answer, from the man himself, was that he had run out of challenges. To be 30 years old and to have done everything is an extraordinary dilemma to confront.

Red Kerr, the old coach and broadcaster, leaned on a cane from his hip replacement and said that he had seen every point Jordan had ever scored as a Bull.

Had we known this was a contest, maybe we all would have kept better memories.

By the time the place was empty and silence was nourishing the irrefutable truth, on the other end of town, the White Sox were about to try again to keep the sort of promise that Jordan had made trite.

His legacy is that winners are expected here. No team that follows will be permitted less.

Between the Sox and Jordan, being in Chicago Tuesday was like attending a wedding and a funeral at the same church.

All you needed was a dark suit and enough tears.

Michael Jordan announces his retirement from the NBA on Oct. 6, 1993 at the Bulls' practice facility in suburban Deerfield. Seated next to Jordan (right to left) are Jerry Reinsdorf, Phil Jackson and Jerry Krause. Standing behind them, in sunglasses, is Jordan's long-time running mate Scottie Pippen.

Johnny Bach

HE UNLEASHED THE 'DOBERMANS'

Several times each week, Johnny Bach would find a quiet place in his home and put pen to paper, his exquisite cursive detailing observations or words of encouragement intended for coaches— some he knew, some he didn't—around the country.

Bach was a lot of things: Accomplished coach at the collegiate and NBA levels over a 56-year career. A decorated World War II veteran. A minor-league baseball player. An NBA player who played basketball for Vince Lombardi, starred at Fordham and also studied at Brown of the Ivy League. An accomplished painter of watercolors.

But above all, Bach, the defense-minded assistant coach under Phil Jackson during the Bulls' first three-peat from 1991–93, was a sharer of knowledge, a generous soul.

"Coach Bach was truly one of the greatest basketball minds of all-time," Michael Jordan said. "He taught me so much, encouraged me, worked with me and really helped to mold my professional game. Without him, I don't know that we would've won our first three championships. He was more than a coach to me. He was a great friend."

That the greats of the game voiced their love for Bach shouldn't surprise. He offered so much of it behind the scenes—some from the "tough love" category—that it resonated for life.

"I love Johnny Bach," said Doug Collins, who hired him for his staffs on the Bulls, Pistons and Wizards. "He taught me so much about the game and about life."

Known as the architect of the Bulls' "Doberman" defense, Bach drew widespread credit for his defensive tactics and unconventional motivational tactics. A decorated war veteran who was one of the first military occupiers of Nagasaki after the atomic bombing, Bach would sprinkle speeches and film sessions with military references and drop the ace of spades—the card of death—for big victories.

> **"You know what that Doberman defense was built on? Trust. Who created that trust? Johnny."**
>
> —HORACE GRANT

"You had to be athletic to play it but you know what that Doberman defense was built on? Trust. Who created that trust? Johnny," Horace Grant said in a phone interview. "If Michael went for a steal and didn't get it, he knew Scottie (Pippen) and I would have his back."

Bach and Grant shared a special bond. Both were twins; Johnny's twin brother, Neil, was lost at sea in 1944 during World War II.

"He related to my personality," Grant said. "We could talk about anything. It's just something about being a twin. And we talked about that a lot. But it was something deeper than that. I needed a father figure that could connect with me on more than a coach basis. Sometimes, the advice he gave me was tough to swallow. But I did and 99.9 percent of the time, he was right."

"Johnny's old war stories were fascinating," said Pippen, "and more importantly they helped us realize what it meant to come together as a team."

Born in Brooklyn in 1924, Bach played 24 games with the Celtics before Fordham hired him in 1950 as one of the nation's youngest major college coaches.

Bach spent 18 seasons there and became the school's all-time winningest coach before moving to Penn State for 10 seasons. During this stretch, legendary coach Henry Iba tabbed Bach to assist the 1972 U.S. Olympic team, on which he coached Collins and which lost that controversial gold-medal game to the Soviet Union.

The bitter experience was one reason Bach took a one-year break from coaching to fly commercial planes after returning to Penn State. From there, Bach moved to the NBA and served as the Warriors coach from 1983–86.

That's when Collins and then-Bulls' general manager Jerry Krause hired Bach, who teamed with close friend and offensive guru Tex Winter on a legendary staff.

"He was brilliantly organized. That comes from his military background. Every 'i' was dotted and every 't' crossed," Collins said. "He had such a great feel for people. He might give you a gruff exterior. But he had a heart of gold and a sensitive spirit."

"He would always call me Paul Douglas Collins, my full name. He would say to me, 'That mistake you're about to make, I've already made.'"

"No, Horace, it's 0-0."

Pretty much any time the Bulls seized a big lead at halftime during the first three-peat, Johnny Bach would trot out the same routine.

Somehow, Horace Grant—all guts and gullibility—would fall for it.

"Right before we'd go back on the floor to warm up for the second half, Johnny would ask, 'What's the score, Horace?'" John Paxson recalled. "Horace's mind would immediately go to work and he'd try to come up with the score. But Johnny would say, 'No, Horace, it's 0-0.'"

The trick spoke to Bach's quest for perfectionism and old-school motivational tactics, even in the face of supremely talented multimillionaires.

"Johnny always wanted all of us to know that we were to go out in the third quarter and play with the same intensity that got us the big lead in the first place," Paxson said. "He wanted us to put the opponent away."

But despite his influence on those championship runs, Bach's first stint with the Bulls ended unhappily. A brief, rather coldly worded press release in 1994 announced the severing of the eight-year association.

"I was shocked," Bach said at the time. "I've not said anything in any way about retirement. I want the opportunity to stay in coaching."

Although Bach always was a favorite of Bulls players, his relationship with team management has been tenuous at best. Brought on staff in 1986 by Jackson's predecessor, Collins, Bach was thought of as "Collins' guy," and often mistrusted by Krause in matters of upper-level decisions.

Bach had become so weary of the misguided notion held by Krause that he was "leaking" information to the media that he asked to be "taken out of the loop" and not even included in meetings regarding personnel decisions and the like. Over the years, Jackson was forced to become a referee between Bach and Krause.

Krause often threatened to fire Bach over insignificant or imagined matters, and Bach was further shaken by the fact that he never had more than a one-year deal.

The decision to let Bach go was ultimately left to Jackson, whose only public words on the matter came in the form of a statement which read: "We have decided to change some facets of our coaching and teaching situations over the next couple of years, and this is the first step in that process. John has been a great asset to our staff, and we wish him the best of luck in future endeavors."

Bach moved to assistant jobs in Charlotte, Detroit and Washington. The last stop is where he developed a strong friendship with fellow assistant Patrick Ewing. The Hall-of-Famer received the first Johnny Bach Award from Fordham in 2012, given annually to the individual who has had lasting impact on basketball and embodies Bach's drive and passion. Other winners include P.J. Carlesimo, Jackson and Collins.

John Paxson brought Bach back to the Bulls in July 2003 as one of his first moves after succeeding Krause. Bach stopped coaching in 2006 but remained actively involved as an occasional consultant.

"He took pride in the fact that he never missed a day of work for any reason," Paxson said. "He was a product of that generation when there was personal pride in showing up and doing your job each day and he did so with energy and enthusiasm. You didn't see Coach Bach have a bad day."

Bach spent his post-NBA years pursuing his passion of painting and had a Skokie art gallery display his watercolor work in a 2007 exhibit. He also was a volunteer coach at local high schools and for wheelchair basketball teams.

During the Bulls' 2015 training camp, Bach was on the sidelines, viewing practices. Coach Fred Hoiberg said he treasured his talks with Bach.

"Just a remarkable man," said Stacey King, who has a tattoo on his forearm in tribute to his coach. "Every time you saw him, he was so full of life."

JOHNNY BACH

» **Born:** July 10, 1924 in Brooklyn, N.Y.

» **College:** Fordham University

» **Years in NBA:** 1980, 1983–86 as head coach; 1979, 1980–83, 1986–98, 2000–06 as assistant coach

» **Hired by Bulls:** June 20, 1986, rehired July 15, 2003

Without Jordan, the Bulls were still formidable—but not champions.

Kukoc averts Bulls disaster

May 14, 1993

It would be tempting to call Game 3 reminiscent of the first two games in this Eastern Conference semifinal series. Strong first three quarters by the Bulls. A powerful Knicks finish. Home-court support a factor.

Tempting, yes, but oh, so shortsighted. For the Bulls' 104-102 victory was much larger, much more dramatic and ultimately stranger than anything that has preceded it and perhaps anything that will follow.

The kicker: Toni Kukoc, as he had done in three now seemingly mundane regular-season games, launched an 18-foot dream of a jumper over Anthony Mason at the buzzer to save the Bulls. It closed the gap in this best-of-seven series to 2-1, with Game 4 here Sunday. For a very long time, no one left the Stadium, savoring this improbable, satisfying and extraordinarily gut-wrenching evening.

The gut-wrenching: New York came back from a 22-point deficit, outscoring the Bulls 36-14 from 1 minute 18 seconds of the third until Kukoc's game-winner.

The improbable: The last shot, set up in a timeout with 1.8 seconds left, came with Scottie Pippen off the floor after the Bulls' star exchanged harsh words with coach Phil Jackson and benched himself. An apparently contrite Pippen gathered his teammates in the dressing room after the game for a five-minute

"We were fortunate to bail ourselves out of that game." —JACKSON

players-only meeting and tried to resolve the matter, which could seriously fracture team unity.

The satisfying: Survival in a game that included an ugly bench-clearing incident at the end of the first half, which resulted in the ejections of Knicks starting guard Derek Harper and Bulls reserve Jo Jo English.

"We were fortunate to bail ourselves out of that game," said Jackson.

The only truly happy person after the game seemed to be the beleaguered Kukoc, who performed similar heroics in nailing the winning shots against Milwaukee, Orlando and Indiana during the regular season.

This time, he came around a screen and took the inbounds pass from Pete Myers, who replaced Pippen.

Kukoc called it "one of the best" moments of his career. "After the ball went in, I was very happy, but I realized it was only one game. We have another one in two days, and if we lose that, it wasn't such a big shot."

And how about the pressure of taking a shot like that? "It's easy," said Kukoc. "You just shoot the ball and then hope it's going to go in."

Foul finish: Knicks answer the call

May 19, 1993

The anger was palpable, as salty on their tongues as the sweat of three toil-filled hours ultimately wasted.

With 2.1 seconds on the Madison Square Garden clock, a skinny kid named Hubert Davis lay sprawled on the floor beyond the three-point arc, while a veteran named Scottie Pippen flailed his arms in anger at a foul call that can be filed along with the most dramatic moments of a series already steeped in ecstasy and anguish.

With the Bulls leading by one, Pippen had flown toward Davis, who straddled the three-point line a mere five seconds after the in-bounds pass from Charles Oakley to John Starks, and let fly with a seemingly desperate shot.

The desperation, however, immediately shifted to the Bulls as Pippen drew the call for hitting the right forearm of Davis after the shot was released. While all

around him nervous tension raged, the former North Carolina Tar Heel calmly sank two free throws, with a Bulls timeout sandwiched in between, to seal New York's 87-86 victory. It gave the Knicks a 3-2 lead in this best-of-seven series, which heads back to Chicago for Game 6 Friday night.

The Bulls' last play—left open to multiple options—was aborted when the inbounds pass of Pete Myers was batted away from Pippen by Anthony Mason under the basket. Starks scooped up the loose ball as the final buzzer sounded.

"It was a great basketball game," said an ashen Phil Jackson. "A lot of comebacks, a lot of dramatics. (Thursday) we'll read 'em and weep. I've seen a lot of things in the NBA, but I've never seen what happened at the end of this game before."

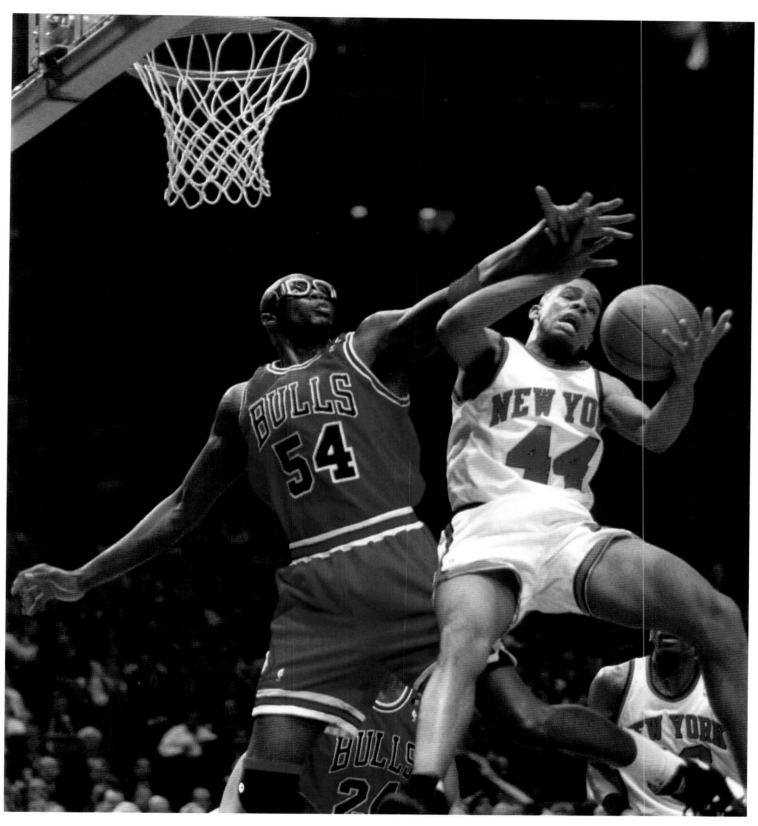

Horace Grant can't prevent the Knicks' Hubert Davis from snagging a rebound in Game 2 of a second-round playoff series in May, 1992. The Jordan-less Bulls were eliminated by New York in a closely contested seven-game series.

Horace Grant's departure didn't sit well with owner Jerry Reinsdorf.

Grant reneged: Reinsdorf

July 30, 1994 ·

When all was said and done, the breakup of Horace Grant and the Bulls was not unlike many other relationships gone sour. Eventually, it all dissolved into a matter of pride, of who jilted whom first.

And so, in a race to the microphone Friday, Bulls chairman Jerry Reinsdorf got in the first word, making

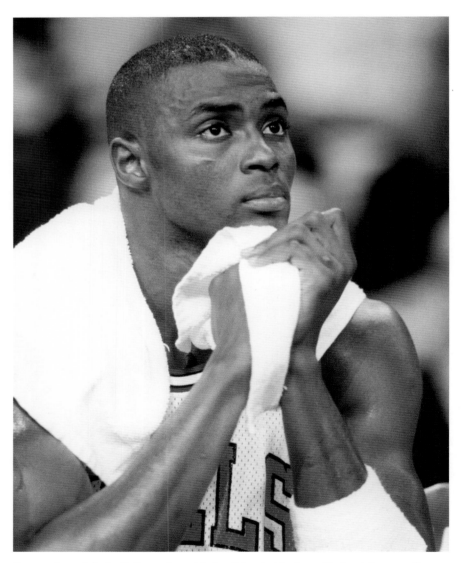

Horace Grant left the Bulls to sign with the Orlando Magic and helped them spoil Michael Jordan's comeback in the 1995 playoffs.

an unusual announcement that the team had "decided not to pursue Horace Grant's services anymore."

That news was decidedly moot, however, for at almost precisely that moment, Grant was signing a six-year, $22 million deal with the Orlando Magic.

Grant's odyssey into free agency left all parties with a bitter aftertaste. In the end, Reinsdorf, trying to convince Bulls fans he did not simply allow an All-Star forward to walk out the door, leveled several accusations against Grant and his agent, Jimmy Sexton.

Reinsdorf said Grant reneged on a handshake agreement that would have paid him $20 million plus incentives over five years. He said Grant lied about the context of the meeting, refused to meet with Reinsdorf over the last three months and, perhaps most damning of all, he said Grant faked injuries and illness last season, costing the Bulls the regular-season Eastern Conference title.

"I've always known that sports morality is different than most businesses," said Reinsdorf. "I've accepted it. I don't like it. But there comes a time when you have to draw the line and can't turn the other cheek anymore."

Grant is the second Bulls player from the championship era to leave via free agency in the last two days. Scott Williams signed Thursday with Philadelphia.

"In time, I will tell my side of the story," said Grant. "But now everybody sees why the majority of players want out of Chicago."

According to Reinsdorf, the Bulls had been trying to sign Grant the last two years, with the promise of making him "the highest-paid Bull of all time," but never received a counter-offer.

Reinsdorf's most serious charge came when he was discussing the club's overall treatment of Grant. "We've always tried to treat Horace with a great deal of respect. Many times I've told Horace we love him personally and think he's a great basketball player. We tried to keep him happy and never criticized him for the 'blue flu,' even though the number of games he didn't play this year because of the blue flu probably cost us the Eastern Conference regular-season championship."

Reinsdorf was referring to the career-high 12 games Grant missed. But why, if Reinsdorf believed Grant deliberately held himself out of games, would he even try to re-sign him? Reinsdorf said it was out of respect for the wishes of Krause and Jackson. "So I swallowed my principles. Obviously it was a mistake."

Top: Demolition of Chicago Stadium begins on Feb. 3, 1995.

Bottom: John Davis of M&M Brick Co. cleans off a brick from the Stadium on April 28, 1995. The newly built United Center is visible behind the old building's skeleton.

With a two-word statement—"I'm back"—Michael Jordan returned to the Bulls.

Court is back in session

March 19, 1995

The words did not have to be eloquent or poetic. They did not even have to be spoken, and weren't.

They came Saturday in a crisp, two-word fax.

"I'm back."

And from Bulls coach Phil Jackson, this classic understatement:

"Today, Michael Jordan was activated as a Chicago Bull."

Activated, indeed.

Jordan will be in uniform Sunday against the Indiana Pacers, honoring his retired No. 23 by donning No. 45, initiating a historic comeback and reinvigorating a nation's sports landscape that has been marred by labor strife.

Bulls owner Jerry Reinsdorf said in an interview he expects Jordan to play three to four more years. That instantly changes the outlook of the franchise, which had planned wholesale rebuilding this summer. And it all but insures that the nucleus of Jordan, Scottie Pippen and B.J. Armstrong will remain in Chicago.

More immediately, the expectations for a rather mediocre Bulls team suddenly brighten. Just three games above .500, the Bulls now head into their final 17 regular season games with a real shot at contending for a fourth NBA title.

But the Bulls still are missing three key players from their championship run. Gone among others are Jordan's treasured backcourt mate John Paxson; the team's noble center, Bill Cartwright; and fierce defender and rebounder Horace Grant.

In their places are role players such as Steve Kerr, Bill Wennington and Pete Myers, as well as Toni Kukoc, who came to Chicago from Croatia largely for the chance of playing with one of the greatest players in the world.

Even with Jordan's imminent return, Jackson warned against expecting too much of a club that has several liabilities, including rebounding and defense.

But he allowed with a wry grin, "We're going to get some scoring, I'll tell you that."

So, what of the legend? Surely his return will expose Jordan to comparison with his very best days. Attempting to defend his short-lived decision to play baseball, Jordan addressed the very same issue in an interview last summer.

"People said, 'You'll taint your image as a basketball player by playing baseball,'" Jordan said. "But

Michael Jordan leaves the Bulls' practice facility on March 18, 1995 after announcing his return to the NBA.

you can't do that. You can't touch what I did in basketball. You can't touch it. You can never take that away from me."

Over the last week, Jordan spoke to friends of his anger at the eight-month-old baseball strike, and of his boredom at the thought of inactivity. But apparently the goal of taking the Bulls back to the top proved an irresistible challenge.

"I've got three words—thank you, baseball," said teammate Will Perdue. "That's all I've got to say."

Pacers destroy storybook ending

March 20, 1995

He's back.

Well, at least halfway back.

In one of the most theatrical comebacks in sports history, Michael Jordan appeared somewhat out of step with his teammates and out of touch with the bottom of the net.

Perhaps most followers of basketball's pre-eminent showman have been out of touch with reality when it came to assigning realistic immediate expectations.

Yet the Bulls managed to force overtime before succumbing 103-96 to the Indiana Pacers at sold-out Market Square Arena.

"We were worried for three quarters that we weren't going to give Indiana a game," said Bulls coach Phil Jackson. "At least we came back and gave them one."

Jordan connected on only 7 of 28 shots while winding up with 19 points. He did manage three steals and a team-high six assists.

> **"[My performance] was pretty disappointing, from my standpoint. . . . Indiana is playing well, and the Bulls were playing well . . . until I came back."** —JORDAN

"It was tough for us to adjust to his presence," said Bulls guard Steve Kerr. "It completely changes people's roles within the team. And those are things we are going to have to adjust to before the playoffs."

Jordan played 43 minutes in his first game back after a brief fling with baseball. His left leg cramped up after he fouled Indiana's Reggie Miller with 3 seconds to play in regulation.

"It was pretty disappointing, from my standpoint," said Jordan of his performance. "As competitive as I am, I wanted to do well. Indiana is playing well, and the Bulls were playing well . . . until I came back."

For MJ, the past is now

March 29, 1995

If you're talking the theater of the absurd, the world of the supernatural or the basketball career of Michael Jordan, it wasn't that incredible.

With only a handful of games under his belt after nearly two years off, Jordan strolls into the grandest, most intense basketball arena of them all, into another exaggerated buildup, into comparisons of Muhammad Ali and Frank Sinatra returning to Madison Square Garden after long absences . . . and blows it all away. He made this game his own, scoring 55 points, dishing out the game-winning assist to an open Bill Wennington for the Bulls' 113-111 victory over the New York Knicks—and then said with a straight face that, yeah, this is about right.

"I knew I wasn't that far away," he said. "I guess it took four games to really get my rhythm down. I was nervous it was going to take longer."

Can Jordan keep this up? "I don't know," he shrugged. "That's the fun thing about it. Tomorrow, you don't know what I will do."

Lost in the drama is the fact that the Bulls are now four games above .500 at 37-33, their best winning percentage all year with 12 games left in the regular season. So what was the significance of beating a team against whom the Bulls would open the playoffs if they began today?

"It was a statement Michael Jordan is back to play basketball, no question," said Bulls coach Phil Jackson. "But I don't know if it's a statement that we're back to playing our kind of basketball yet."

With the game on the line, all eyes were on Jordan. But his eyes were on a teammate.

Jackson said the coaching staff told Jordan that Ewing had left his man to double-team the ball on the three previous Bulls possessions. Jordan then took the inbounds pass and drove straight upcourt. But when the roving Ewing came over to double him on the right wing, Jordan threaded the ball to a wide-open Wennington for the slam.

"I'd be lying if I said I was coming out to pass the ball," Jordan said. "I was coming out to score, but then Patrick came over to help and I saw Bill."

With 72 wins, the 1995–96 Bulls set a record that would stand for 20 years.

For the record, Bulls break barrier

April 17, 1996

MILWAUKEE – For a quarter of a century, the number 70 has looked like a faraway object.

Winning 70 games in the NBA was the sports equivalent of John F. Kennedy boldly aiming for the moon. It was like Cal Ripken shooting for Lou Gehrig's consecutive games streak.

And just as Ripken eclipsed one of sports' most untouchable records a few months ago, the Bulls got their hands on a record many thought never would be attained.

But it almost didn't happen Tuesday.

What took months for the Bulls to accomplish came down to an intense final three minutes at the Bradley Center against a Milwaukee Bucks team that didn't want to share the same page with the Bulls in NBA history books.

But after a wild comeback in an even wilder game, the Bulls officially took their place in NBA history, capturing their 70th victory to pass the 1971–72 Los Angeles Lakers with a memorable 86-80 victory.

When it was over, there was a subdued celebration. There were victory cigars, but the mood wasn't much different than after any of the Bulls' previous 69 victories. They seemed more relieved than anything else.

NBA history was finally theirs.

"I'm happy and relieved at the same time," Michael Jordan said. "But it's going to take some time for it to really sink in."

"There were so many distractions and so much hype about the 70 wins," said Dennis Rodman, somewhat of an authority on distractions. "Getting it over was more of a relief for us. We played like crap."

Jordan preferred the word "ugly."

"It was a very ugly game," he said. "But sometimes ugly is beautiful."

Now the Bulls can relax somewhat. Or can they?

"It puts us in a position where there's a little more pressure on us," said Scottie Pippen. "Everybody expects us to win the championship now. We've proven all season that no team can dominate us. Now we have to prove it again."

> ## "It was a very ugly game. But sometimes ugly is beautiful."
>
> —MICHAEL JORDAN

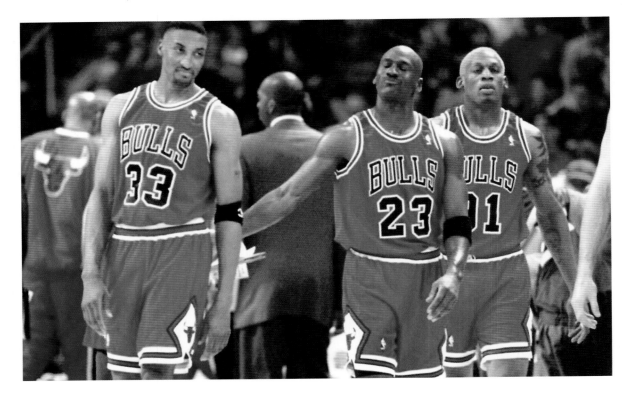

Scottie Pippen, Michael Jordan and Dennis Rodman head out to the court for the second half of an 86-80 win over the Bucks on April 16, 1996 in Milwaukee. The victory was the Bulls' 70th of the season, an NBA record.

Reflecting on a record-setting season

April 22, 1996

LANDOVER, Md. – There was Michael Jordan, pressed into a corner, talking about what he called "the best regular season I've ever had." There was coach Phil Jackson, his bad back against the wall, reminiscing about how it had begun.

And there was Dennis Rodman, behind sunglasses and a goatee dyed Bulls red, putting it all in his own perspective.

After wrapping up their NBA-record 72-win season with a win over the Bullets Sunday, there was less celebration than reflection, less focus on the present than on the future.

"This year has kind of taken everybody by surprise, even us," Jordan said. "I didn't think we could win 72 games—not at the beginning of the season."

It was a season that left Jordan enjoying the game again, something he found difficult to do in his last full season with the Bulls, when he abruptly quit to play baseball.

"I got so bogged down in the way my life had become I wasn't enjoying myself," Jordan said. "I forgot a lot of simple things about the game—how it can make you feel better. Sometimes you don't realize that until you get away from the game."

Jackson looked back to the first game of the season, when an injured Scottie Pippen saw limited playing time against the Charlotte Hornets and Luc Longley served a one-game suspension for throwing a punch in an exhibition game.

"We started out very unstable, and we've ended very much like that," Jackson said, noting Ron Harper was out for the last two games with a sprained ankle. "But this team has found a way—all the way through this year—to constantly bridge the gaps with different personnel."

And always, Jackson said, there was Jordan.

"He picked us up," said Jackson. "He was the leader. He encouraged the players, kept them going towards this 72-win season. That, more than anything else, says what this season was about."

The record-setting season was honored with several awards and accolades. Jordan won his eighth career scoring title and was named the league's most valuable player for the fourth time in his career. Jackson was named Coach of the Year. Toni Kukoc was the league's Sixth Man of the Year. And general manager Jerry Krause was named the NBA's Executive of the Year for putting it all together, including such moves as trading for the sometimes troublesome Rodman, who won his fifth straight rebounding title. Jordan, Rodman and Pippen were each named to the NBA All-Defensive Team. Jordan and Pippen were picked for the All-NBA Team as well.

> **"We knew there was a lot of work to be done, and we put a lot of work into this. Now we've accomplished history."** —JORDAN

And through a long, seven-month season, the Bulls managed to overcome every adverse or potentially adverse situation.

The only major injury they fought was a calf injury that sidelined Rodman for 12 games in November and December. Instead of struggling without a key cog in uniform, the Bulls were 10-2 with Rodman out of the lineup. Rodman was back in uniform on Dec. 6, just in time to help the Bulls get past the New York Knicks.

That victory was one in a string of 13 straight the Bulls racked up through the end of November to the end of December, their only loss in that stretch coming against the Indiana Pacers. Then, for an encore, they reeled off a franchise-best 18 straight victories.

The Bulls always seemed to prevail, even during Rodman's much-publicized head-butting incident with referee Ted Bernhardt. Rodman missed six games; the Bulls didn't miss a beat.

"We were able to maintain a certain focus all season," Jordan said. "We knew there was a lot of work to be done, and we put a lot of work into this. Now we've accomplished history."

At the beginning of the year, Jordan said, there was some concern about "how well we would all mesh together." He mentioned Rodman, in particular.

But Rodman as a San Antonio Spur proved different from Rodman as a Bull.

"I survived the season—that's it," Rodman said. "I survived the season without any major altercation. . . . The last game of the season and I'm here."

Chicago is title town once again after Bulls shoot down the Sonics.

Four-closure

June 17, 1996 ·

History will tell us that the 1995–96 edition of the Bulls was a great team. Just how great will be debated for years.

The Bulls knew this. They knew, in the eyes of some, that their greatness would be questioned, had been all season. There was talk that their record-setting 72 regular-season victories came courtesy of a seriously diluted league. Then came the talk that

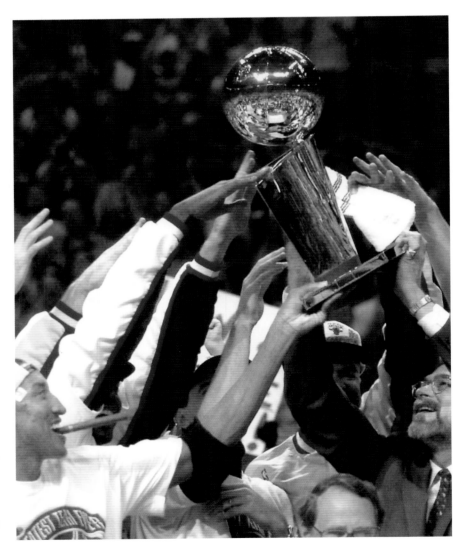

The Bulls hoist the Larry O'Brien Trophy after winning their fourth NBA title in 1996.

losing back-to-back games to the Seattle SuperSonics after taking a 3-0 lead in the NBA Finals proved that the Bulls weren't all they were cracked up to be.

They were determined to erase any of the doubt.

"We had a lot that we wanted to prove," said Scottie Pippen, who was speaking for himself as much as for the team. "We wanted to show the world that we were still the greatest team and that Chicago still deserves a championship."

The Bulls showed the world on their home court, where they had lost just twice during the regular season. They grabbed their place in NBA history by putting an exclamation point on their record-setting season with an 87-75 victory over the Sonics at the United Center on Sunday to take the seven-game series 4-2, capturing the franchise's fourth title in six years.

Then the Bulls celebrated with their fans, some of whom had begun to doubt them. They celebrated the end of a season full of expectations. The celebration was partly one of vindication.

"The one thing about this championship is, we were expected to win," said Bulls coach Phil Jackson. "Whenever you're expected to do something, the pressure is great on a basketball club. It's a relief to win rather than an exultation. It was a relief."

Perhaps that is why Michael Jordan, the Most Valuable Player of each and every one of the Bulls' championship runs, sprinted off the court at the end of the game and headed to the quiet Bulls locker room to cry. He too had to shoulder the many expectations, especially since his 18-month hiatus from the game ended in disappointment. After a brief fling with baseball, Jordan returned to the Bulls last season, only to have the Orlando Magic knock his team out of the playoffs.

Jordan felt as if it was his fault. He wanted nothing more than to hug that championship trophy again, proving that he was again the player he once was. It was very emotional for Jordan, playing on Father's Day after losing his father, James Jordan, before retiring from the game.

"I was blessed to be healthy throughout the season and blessed to be able to get the game ball of the championship game and bring a championship back to Chicago," said Jordan, who led the Bulls with 22 points. "It happened on Father's Day, which makes it even more special. There's no way to really describe it."

Dennis Rodman (center), an unselfish rebounder and a world-class defender, was the missing piece of the puzzle that helped the Bulls achieve their second three-peat.

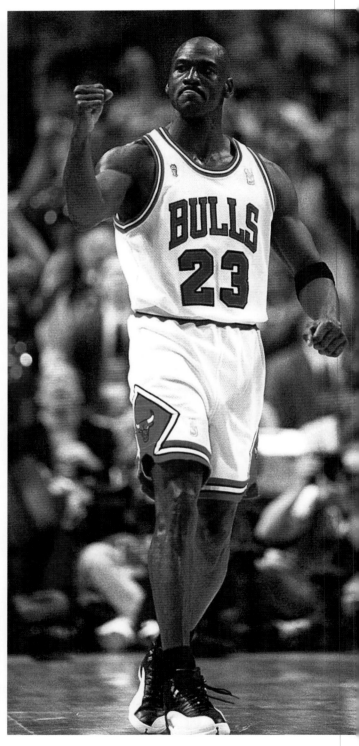

Left: Michael Jordan, Jud Buechler, Scottie Pippen and Toni Kukoc huddle on the United Center floor late in a game during the 1997 NBA Finals.

Right: The Jazz stinger: Michael Jordan pumps his fist after hitting the shot that gave the Bulls an 84-82 victory over Utah in Game 1 of the NBA Finals on June 1, 1997.

The "flu game" added another chapter to Jordan's amazing legacy.

Queasy does it

SALT LAKE CITY – Even when he's deathly ill, Michael Jordan does a remarkable impersonation of Superman.

There was Jordan, sick as could be an hour before Game 5 of the NBA Finals on Wednesday night, leaving his teammates to wonder if he had enough strength just to put on his uniform, let alone play.

Of all the times for Jordan to be human, this wasn't the night. The Bulls had lost Games 3 and 4 to Utah here. The Jazz came into Game 5 with a 23-game home-court winning streak, including all 10 postseason home games. No way did the Bulls want to head home looking at a 3-2 deficit in the series. They had never experienced that in their previous four title runs.

Jordan played, of course. He played spectacularly, scoring 38 points and hitting a huge three-pointer with 25 seconds left that gave the Bulls the lead for good in their 90-88 victory.

They have a 3-2 edge in what has turned into a tough, competitive, white-knuckle series. They can wrap up their fifth title in seven years with a victory in Game 6 on Friday night at the United Center, or, failing that, on Sunday night in Game 7.

That's two chances to win one game on a floor where they haven't lost two straight games in two seasons. You have to like their chances if Jordan shows up.

Team doctors said he has a stomach virus that could have been brought on by food poisoning.

"It's obvious he's still a concern," coach Phil Jackson said. "He's dehydrated. He hadn't eaten all day. He's in a pretty weak state right now. So we'll just have to take what we can out of this."

Which is one of the biggest victories in franchise history.

The Bulls headed home with history on their side: No team has come back from a 3-2 deficit in the Finals to win Games 6 and 7 on the road. And since the 2-3-2 format was introduced in 1985, no team has swept the middle three games at home, which the Jazz had a chance to do.

"It's tough to beat a team three times," Jazz coach Jerry Sloan said. "They showed why they're a championship team. We have a tough assignment ahead of us."

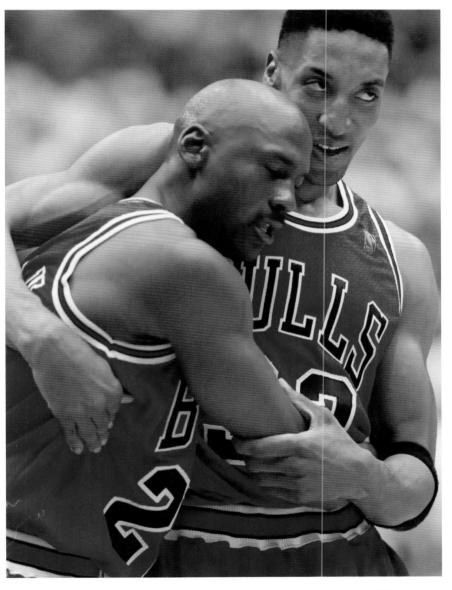

Scottie Pippen helps Michael Jordan stay on his feet during Game 5 of the NBA Finals on June 11, 1997 in Utah. Stricken with stomach problems, Jordan still managed to score a game-high 38 points and lead the Bulls to a 90-88 victory and a 3-2 lead in the series.

Steve Kerr's clutch shot was the Jazz stinger as the Bulls won their fifth crown.

The Jackson Five

June 14, 1997

The long journey ended late Friday night, much the way it played out over the previous seven months.

From November to June, there were ups-and-downs. Quite a few hairy moments. Big plays that kept the Bulls in games. Big shots delivering victories. Particularly the hard victories.

So when Steve Kerr hit the 17-foot jumper that will be remembered every time people recall the Bulls' fifth championship, it was appropriate. The basket came at the end of an uphill battle, almost magnifying how tough this journey truly was.

Bulls coach Phil Jackson didn't need a do-or-die shot to remind him.

"I didn't enjoy this journey," he said with a smile big enough for all the United Center to see. "This was filled with injuries and suspensions. But we had a great run, didn't we? It was wonderful."

And it's over. The season came to a close with a thrilling 90-86 victory over the Utah Jazz in Game 6 of the NBA Finals before 24,544 screaming fans at the United Center. The Bulls successfully defended their title, claiming the franchise's fifth championship in seven years by taking the best-of-seven series 4-2.

5 Enough said.

"This was filled with injuries and suspensions. But we had a great run, didn't we? It was wonderful."

—COACH PHIL JACKSON

Kerr hit the shot, a wide-open jumper that hit the bottom of the net with just five seconds left, putting the Bulls up 88-86. Then, after a Jazz timeout, Toni Kukoc deflected Bryon Russell's inbounds pass intended for Shandon Anderson. Scottie Pippen stretched, got his hands on the ball and found a sprinting Kukoc for a wide-open slam.

Within the celebration of the moment was an enormous sense of relief.

"I was a little frustrated because we kept getting so close to the mill and the mountain but we couldn't get over the hump," Michael Jordan said after leading the Bulls with 39 points. He was named the series' most valuable player, as he has been in all five of the Bulls' championship runs.

The Bulls knew this title run would be tough. They didn't expect it to be this tough.

After being tested during a three-game sweep of the Washington Bullets in the opening round, there was a second-round series against the Atlanta Hawks, which featured their only postseason loss at the United Center. The Bulls took that series in five games, but their reign as possibly the league's best-ever team was beginning to be doubted.

The Eastern Conference finals against the Miami Heat also was decided in five games. The Bulls played their best basketball when they had to against Pat Riley's team, but their inconsistency remained a question mark.

Then came the Finals and the tenacious Utah Jazz.

"Not every ride is a smooth ride," Dennis Rodman said. "And everybody expected us to bounce back and win it all again. In Vegas, they had us even money. But we looked at it as a big challenge. That's all it was—a big challenge. Every night we had to find a new way of getting ourselves motivated . . . that was the difficult part."

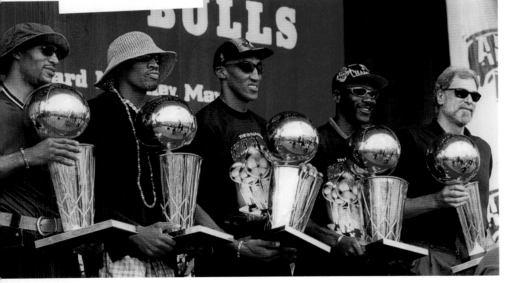

Ron Harper, Dennis Rodman, Scottie Pippen, Michael Jordan and Phil Jackson pose with the team's five championship trophies at a rally on June 16, 1997 at Chicago's Grant Park.

Opposite: Michael Jordan launches a shot over the outstretched arm of Utah's Jeff Hornacek during the 1997 NBA Finals.

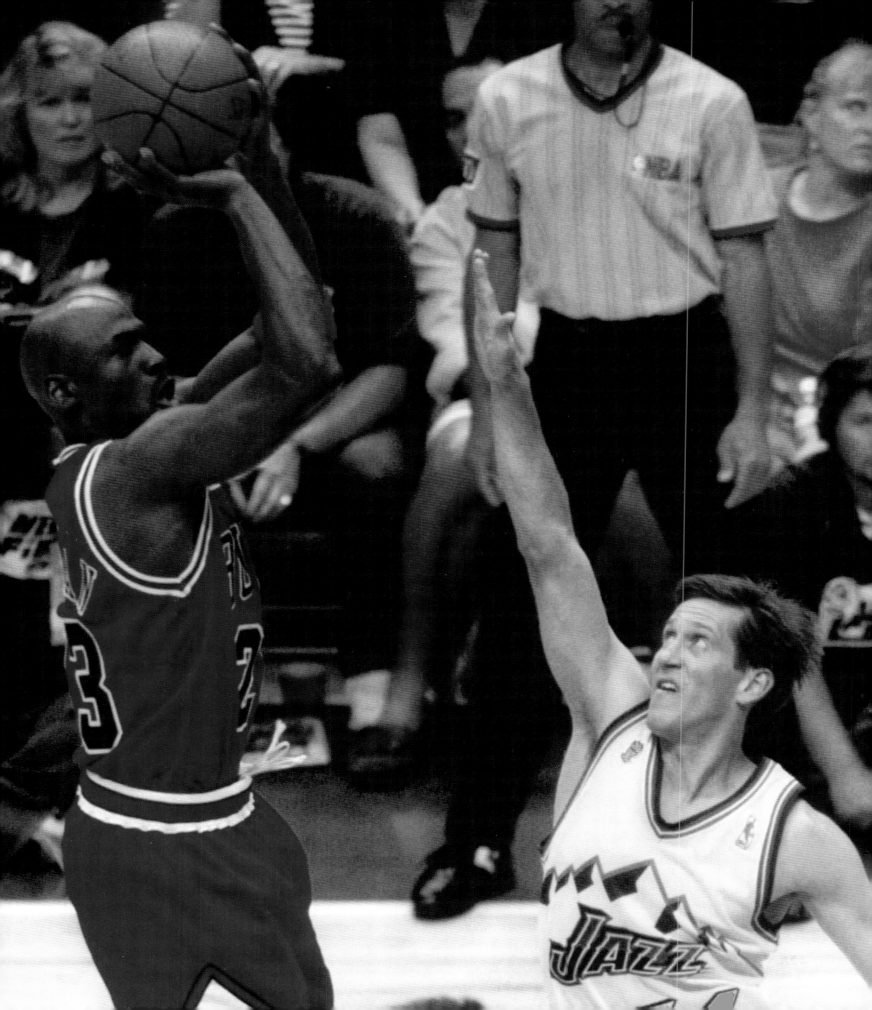

HEAD COACH

1989–99

ASSISTANT COACH

1987–89

Phil Jackson

COACH WITH A CALLING

The Naismith Basketball Hall of Fame doesn't place inductees in team caps like its baseball counterpart or else officials would have had a doozy of a debate when Phil Jackson entered in 2007.

The numbers paint the picture:

Nine seasons, 545 regular-season victories, six NBA championships and an enduring association with Michael Jordan from his Bulls days.

Eleven seasons, 610 regular-season victories, five NBA championships and a defining partnership with Kobe Bryant during his Lakers association.

It's a fascinating debate, to be sure: Who can claim Phil, Chicago or Los Angeles?

Jackson's Bulls were a perfect 6-0 in their Finals appearances, making the final round 66.7 percent of the time during his tenure. Jackson's Lakers reached the Finals seven times in 11 seasons—63.6 percent of the time—winning five and losing two.

That said, his Bulls' playoff winning percentage of .730 far exceeds the .652 from his Lakers' runs.

So, which is it?

"He's always going to be a Bull," Ron Harper declared in a phone interview from his New Jersey home. "No matter who else we played for, I'm a Bull, MJ's a Bull, Phil's a Bull.

"What we did as a team is going to be hard to ever duplicate. We had guys who truly loved to play the game and loved to be teammates. Phil has done a great job in L.A. and when we won there, it was fun. But deep in our hearts, we'll always be Bulls."

Indeed, Harper won two rings with Jackson in Los Angeles after playing such an integral role in the Bulls' second three-peat from 1996–98. Jackson called his defensive whiz shortly after taking the Lakers' job following his one-year sabbatical during the lockout-shortened 1998–99 season.

"He was like, 'Ron, what are you up to?'" Harper said. "I said, 'Phil, I'm going to hang them up now.' He said, 'Go play golf, but you're going to play in L.A.' I was like, 'Huh?' He said, 'You're going to play here with me.'

"My first day there, I saw Shaq get a defensive rebound and go from one end to the other. I was like,

'Man, Shaq has those skills?' I told Phil we're going all the damn way. We have the guys. We just need to get their heads on right.

"And that's what Phil does best wherever he coaches. He knows how to motivate people. He's a coach who believes everyone has a role on the team. And you have to buy in."

The contrasts between the two situations couldn't be starker.

Chicago is a blue-collar town with harsh winters and the late Gene Siskel sitting courtside during the glory days.

Los Angeles is Hollywood with Pacific breezes and Jack Nicholson front-and-center for fandom.

"The best way to put it is he has adapted to his environment," said former Bull Will Perdue. "That's another area where you talk about Phil's intelligence."

Like Harper, Perdue leans toward calling him a Bull.

"People still ask if that 72-win team is the best ever," Perdue said.

Jackson was the first Bulls player, coach or executive to be inducted into the Naismith Basketball Hall of Fame. His children graduated from Deerfield High School, so his formative roots are in Chicago.

During his rookie season for a bad Bulls team, Ron Artest used to talk reverentially about Jackson, who left Chicago the year before Artest was drafted. Later, Artest got the chance to play for him, citing Jackson as a major reason he signed a free-agent contract with the Lakers in 2009.

Leave it to the colorful Artest to distill the debate to its simplest terms.

"I think he'll be remembered for both," Artest said. "He has done great things in both places. Great, great things."

And that's just it: Ultimately, Jackson is a basketball coach who experienced ridiculous success at two stops.

On June 22, 1998, the day he formally announced he was leaving the Bulls, he stopped for an impromptu conversation with reporters in the Berto Center parking lot on his Harley-Davidson motorcycle.

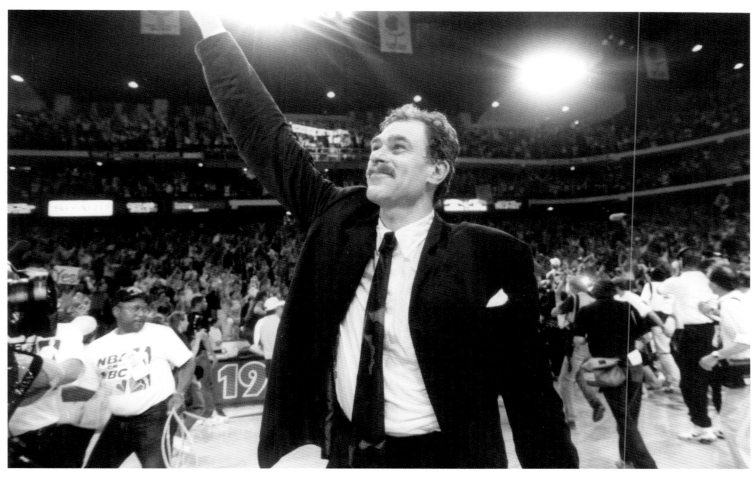

"I was fortunate," Phil Jackson said, shown here after Game 6 of the 1992 NBA Finals. "I was given a chance... to coach a team ready to win a championship."

Behind him, a sign said: "Caution: Autos only. No motorcycles, bicycles or pedestrians."

Jackson always has been his own man. Maybe he's nobody else's.

He was a gangly kid, sometimes described as having the physique of an upside-down hanger. His legs and arms bobbed and flailed like he was a scarecrow when he ran, but Phil Jackson could play basketball.

Tiny Williston High School in North Dakota, where Jackson spent his adolescent years, became a statewide phenomenon in a place where basketball is not king. Jackson led his team to a state crown, which helped him go to the University of North Dakota, where he became an All-American and a second-round draft choice of the New York Knicks in 1967.

Growing up in small towns in Montana and North Dakota, with a father who was a lay preacher and a mother who was an evangelist, Jackson had little feel for the secular world—especially for Gomorrah, otherwise known as New York.

Red Holzman, his Knicks coach, recalled Jackson saying in their first meeting: "I'm very pleased the Knicks thought so highly to draft me, but I'm having second thoughts. My original plans were to attend graduate school and become a minister. I still think about that."

Holzman persuaded him to change his thinking, and the 6-foot-8-inch Jackson went on to play 13 years in the National Basketball Association, two with championship Knicks teams, though he was injured most of the 1970 title season.

But when he took the Bulls head coaching job in 1989, Jackson finally was being placed, in a sense, in the spiritual role he once considered. His mission was to take his congregation to the holy land, even if it was merely the NBA championship.

Opportunity didn't come easily to Jackson, born Sept. 17, 1945, in Deer Lodge, Mont.

With the Knicks, Jackson was known as a flake, which is the general NBA definition of anyone who reads something other than the sports pages on the road. He read philosophy and religion, among other

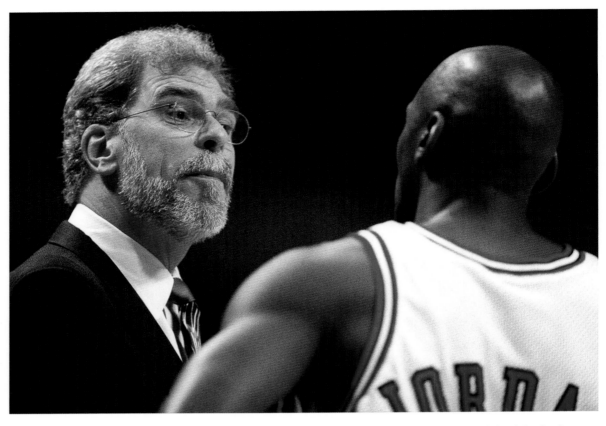

One of Phil Jackson's greatest attributes was his ability to blend the talents of a superstar like Michael Jordan into a team-oriented style of play.

topics, worked on the New York Times crossword and debated politics with his roommate, Bill Bradley, who later became a U.S. Senator. In the summers while they were playing, the two often worked on Native American reservations in the Northwest.

Jackson reflected the spirit of the 1960s, wearing a beard and becoming involved in Athletes for George McGovern and the 1972 Democratic campaign.

This is how he inscribed his basketball book "Maverick", written in 1975 with close friend Charlie Rosen, to Holzman: "Thanks for teaching me the game. I am still learning. I admired the method but sometimes questioned the role. Is it worth it working for the truth?"

Holzman said he never quite understood what that meant, but the other part of Jackson's message was clear. He admired Holzman's quiet intensity toward the game, his defensive principles and team concepts, which he practiced successfully with the Albany Patroons of the CBA, posting a 134-106 record.

To those who suggested stepping into Doug Collins' shoes was a difficult job, Jackson noted he replaced former teammate Dean Meminger on a strife-ridden Albany team in 1983 and went on to lead it to the league title the following season and earn Coach of the Year honors.

Jackson was a defensive specialist as a player, and his flapping arms caused opponents havoc; he averaged only about 7 points a game. Jackson's defensive orientation comes not just from Holzman. He played his college ball at North Dakota for Bill Fitch.

At the time, his family was wondering just what he was up to. His parents moved from parish to parish throughout the Northwest, his mother a brilliant and prophetic evangelist who was credited with performing miracles and preached the apocalypse. Jackson didn't see a doctor until he was 6 and didn't receive shots until he was 14. Any illness was treated mostly with herbal remedies.

Holzman says Jackson was among the smartest players he ever had. Like Holzman, Jackson also coached in the Puerto Rican summer leagues, where he was named coach of the year in 1984.

From 1978–81, he finished his playing career with the Nets, also serving as an assistant coach. Then he did some color broadcasting and went into a health and athletic club business in Montana with friends while coaching the Patroons and living in Woodstock, N.Y.

He proudly proclaimed his allegiance to the Grateful Dead musical group and their followers, called "Deadheads." But, for Jackson, that name fit only his taste in music.

"He's always going to be a Bull."

—RON HARPER

» **Born:** Sept. 17, 1945 in Deer Lodge, Montana

» **College:** University of North Dakota

» **Years in NBA:** 1967–80 as player; 1979–81 and 1987–89 as assistant coach; 1989–98 and 1999–2011 as head coach; 2014– as executive

» **Hired by Bulls:** October 10, 1987 as assistant coach; named head coach July 10, 1989

"Basketball has been an adventure," Jackson said days before his induction into the Hall of Fame. "My basketball life, like me, became more family and togetherness, the long nights in North Dakota driving 200 miles on icy, two-lane roads to play basketball, the CBA [coaching and driving the van], coaching in Puerto Rico summers, it all gave me the background and the endurance to stick with it with great support from my family.

"It was a team. You took one of us, you took us all [with four children]. That was the most special thing (Jackson read a poem by son Ben at his Hall of Fame induction about the minor-league coaching times). It was emblematic of what I wanted to be known as being a coach. Teaching a team philosophy.

"I definitely didn't think I'd be here. I tried to get out many times. I always hoped I'd have a higher calling. My mother wanted me to be a minister. . . . I always told my mother, 'I may not have a congregation, but I have 12 disciples.' With the rosters now at 15, I can't use that anymore."

But that concept stands as testament to one of the most remarkable and successful coaching careers in professional basketball history.

Jackson knows he has had the good fortune to get the teams and players he has coached, but it's also not so easy to succeed when you are supposed to. Jackson's teams did, generally embodying the characteristics of good team play, hard work and commitment, always rallying around their spiritual leader, Jackson.

"I was fortunate," Jackson said. "There probably were more qualified people. . . . I was given a chance— though I was not that young (44 when he took over the Bulls in 1989)—to coach a team ready to win a championship. I was relatively inexperienced as an NBA coach, but I felt experienced in those situations.

I'd had playoff success my whole basketball life. I remember Jerry Krause asking me to wear my [Knicks] championship ring. He felt it would show that young Bulls team what we were going for.

"I thought that team was my calling. It seemed natural with Michael to incorporate team play with that one-man superstar. Michael recognized it."

Though one of the most celebrated and successful coaches of the last two decades, the trip to the Hall of Fame for Jackson seemed unlikely for a counterculture rebel of the 1970s who mostly was ignored by the NBA until Krause took a chance on him as a Bulls assistant in 1987.

Often chided for his fondness for Eastern religions and Zen, a smoldering competitiveness continued to drive Jackson. That competitive streak would fuel his success and often leave opponents shaking their heads in despair and defeat.

He credits the acquisition of Bill Cartwright as the key to filling out the Bulls' first championship group.

"I lobbied for the trade," Jackson said. "But it also gave Krause confidence I knew what to do with personnel and gave him confidence in me to hire me as coach [when Doug Collins was fired].

"Then getting [Dennis] Rodman when Orlando became a power in our conference and changing our style of play by moving Ron Harper to point guard were changes that led to the best record ever in the NBA," Jackson said of the 72-10 team in 1995–96. "That was the best Bulls team, but the 1991–92 team (67 wins) was deeper with athletic talent. I felt it was time to go [after 1997–98]. If Michael and Scottie wanted to stay, we probably could have eked out one more title and I would have stayed, but the wheels were kind of falling off that team.

"The Lakers were another big windfall. Del Harris is a solid coach with a great reputation, but he left and there was an opening. It just seemed preordained, meant to happen."

"It's great to have a good team and good fortune," Jackson said. "The success the [Bulls] had was unparalleled. It's one of those things I look back on and I'm amazed at. Even sometimes I'm watching classic ESPN and see all those great wins and the team opportunities provided to me."

Jackson gave back as well, helping lift his team when it seemed all so unlikely. Basketball immortality only seems appropriate. 🏀

The dynasty's days were numbered with one-year deals for Jordan and Jackson.

1 more year for Jackson

July 24, 1997

Apparently lost amid the huge sigh of relief surrounding the re-signing of Bulls coach Phil Jackson for one more season were stark words from general manager Jerry Krause.

"Beyond this contract, Phil agrees it's better we part company," Krause said with an air of finality. "At the end of next season, there will be a new coach here. We certainly want to look at building for the future."

Krause seemed relieved the lengthy Jackson contract fiasco finally had been resolved when the now lame-duck coach signed a deal worth $5.7 million.

That done, Krause made it clear, the beginning of the end is here. The time has come, unofficially, for the franchise to move on when these Bulls' remarkable championship run closes with the end of Jackson's contract.

Bulls Chairman Jerry Reinsdorf insisted Jackson has no problems with this deal, because Jackson doesn't want any part of a wholesale rebuilding process.

"Phil wanted to come back for one last year to try to defend our world championship," Reinsdorf said in a statement. "It has always been our intention to bring Phil back for that last season and then turn our attention to building for the future."

Reinsdorf told the Tribune he and Jackson agreed it would be Jackson's final season as coach for the Bulls during a meeting the two had last Friday in Montana.

"Everyone agreed that we have a good chance to win it this year but it's not likely this team could win two more years," Reinsdorf said. "Plus, Phil has surgery on his hip that he wants to have. Phil said from the beginning he only wanted to coach one year. There is nothing new about it other than a confirmation."

So, after one final title run, with the Bulls not only defending the championship they won in June but attempting to capture the franchise's sixth title in eight years, the inevitable rebuilding process will begin in earnest. It will be done without Jackson. It probably will be done without Michael Jordan, who is next in line to be re-signed.

With all the principal components in place, the Bulls are prepared to go out with a bang and then start from scratch with a younger set of players and an upstart coach—possibly Iowa State's Tim Floyd—in 1998–99.

"There is a point where you look toward the future," Krause said. "Phil did not want to come back and coach a team that would be in a rebuilding situation. We felt it was just time to say, 'OK, this is the way it is going to be.'"

On the scent of a 6th

Aug. 28, 1997

Michael Jordan is back.

Was there any doubt?

During a brief meeting in Las Vegas involving Jordan, agent David Falk and Bulls Chairman Jerry Reinsdorf, Jordan agreed to a new one-year contract.

Terms of the deal were not disclosed, but Jordan is believed to have been offered at least $36 million—a 20 percent raise over last season.

Reinsdorf, who originally wanted Jordan to consider a two-year deal, backed off that idea. Reinsdorf did, however, tell the Tribune he had no intention of guaranteeing Jordan that Scottie Pippen would not be traded. Jordan sought to have a no-trade provision for Pippen included in his contract after the Bulls entertained offers for Pippen before the June NBA draft.

Reinsdorf and Jordan must have come to a compromise; their meeting lasted no more than an hour.

"Jerry and I have a special relationship which enables us to work co-operatively," Jordan said. "I am committed to Chicago and to winning. So is Jerry."

"I think the special relationship that exists between Michael and Jerry facilitated this agreement," Falk said.

"The next order of business will be Dennis (Rodman)," Bulls general manager Jerry Krause said. "We want Dennis. We'll start on him right after Labor Day."

"Then," Krause said, "we'll start the business of getting training camp put together."

For what possibly will be the Bulls' last title run for a while.

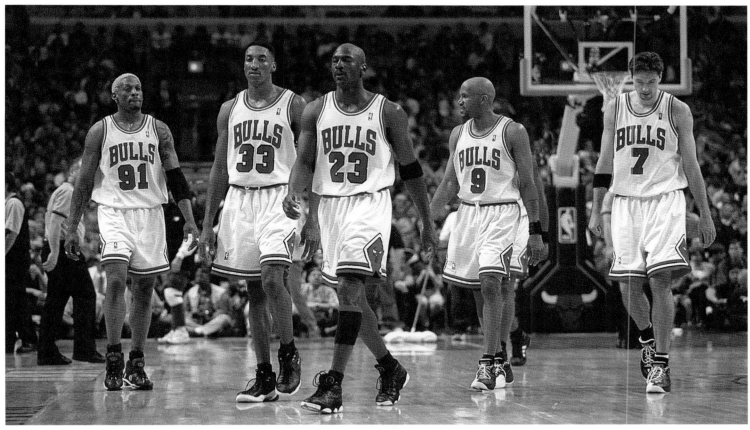

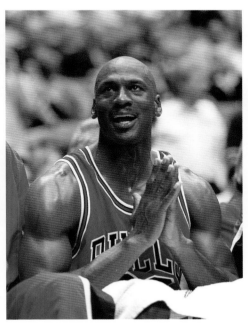
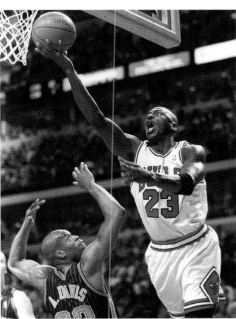

Top: The second three-peat featured a lineup of (from left) Dennis Rodman< Scottie Pippen, Michael Jordan, Ron Harper and Toni Kukoc.

Bottom, from left: Scottie Pippen fights for a rebound in Game 1 of a first-round playoff series against the Nets on April 24, 1998 at the United Center; Michael Jordan has the smile of a winner as time winds down during the Bulls series-clinching 116-101 victory over the Nets on April, 29, 1998; Indiana's Antonio Davis is helpless as Michael Jordan goes in for a layup during Game 1 of the Eastern Conference final on May 17, 1998 at the United Center.

It's won and done after Jordan seals sixth title with steal and game-winning shot.

The joy of

June 15, 1998

SALT LAKE CITY – If the final chapter of Michael Jordan's career was completed on Sunday night, his role in the final gripping moments of a sixth championship for the Chicago Bulls would forever mark the perfect ending.

With the capacity crowd at the Delta Center roaring in anticipation of a Utah victory that would have forced a seventh game of the NBA Finals, Jordan's steal and two scores in the last 37.1 seconds secured Chicago's shocking 87-86 triumph over the Jazz.

The statistics will claim that Jordan's performance was less than artistic. Jordan's 45 points, his high for the playoffs this year, came on 15-of-35 shooting.

But with Scottie Pippen limited by a back injury, Ron Harper ill and Dennis Rodman ineffective, with Toni Kukoc's 15 points representing the team's only other double-figure scorer, the Bulls became most dependent on Jordan at the most important point of their season.

Trailing by three points with 41.9 seconds to go, Jordan drove from the right side, slipping by Bryon Russell and John Stockton for a layup with 37.1 seconds remaining.

Then with the Jazz searching for Karl Malone, Jordan chose not to follow Jeff Hornacek through a screen. He turned, reached with his right hand, and slapped the ball from Malone's grasp.

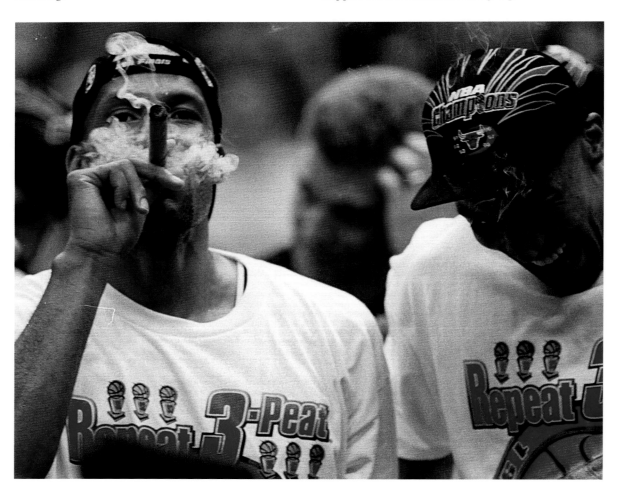

Ron Harper puffs a post-game cigar on the floor of the Delta Center after the Bulls defeated the Jazz 87-86 in Game 6 of the 1998 NBA Finals to win their sixth title.

six

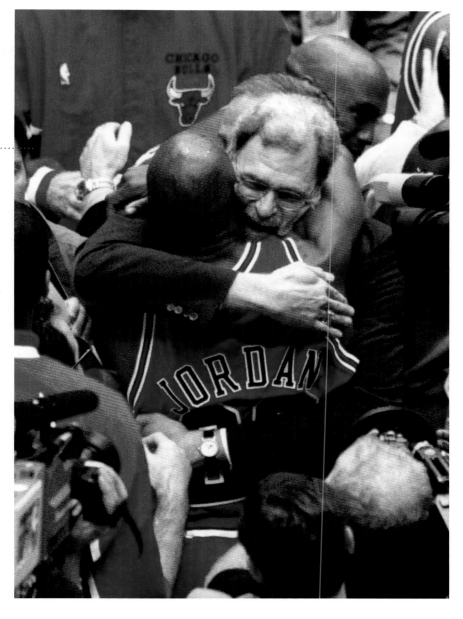

Only 18 seconds remained in a one-point game. At the other end, Jordan created an opening in front of Russell by faking a drive. His 17-foot jump shot, from the left side of the circle, gave the Bulls the lead with 5.2 seconds to go. After a timeout, Stockton missed a three-point shot with 1 second to play, and the series was over.

Jordan scored eight of his 16 fourth-quarter points in the final 2:07, his team's last eight points of the season. He lengthened a nearly unmatchable Hall-of-Fame resume. Jordan was voted to a sixth Most Valuable Player Award, the most for any player since it was instituted for the Finals in 1969. Only three times has a player been named MVP for the All-Star Game, the regular season, and the Finals. Jordan completed his second sweep Sunday night.

He passed Elgin Baylor with 1,167 career points in the Finals, third behind Jerry West and Kareem Abdul-Jabbar. He extended a record streak to 35 Finals games with 20 or more points.

The expansion of a legend is harder to measure. A year ago, in the same building, Jordan's 38 points while suffering from food poisoning, including a game-winning three-point shot, was considered a high point of his career.

"I don't think you could top the performance he had in that game," said Phil Jackson, the coach of the Bulls. "But he topped it tonight. I think it's the best performance I've seen in a critical situation."

There was no reprise of Jordan's playful gesture on a championship night a year ago, when he shrugged on the floor of the United Center, added a sixth finger to his collection, and made a suggestion that was not fulfilled until Sunday night.

Here, soon after the celebration began, Jordan's motion was emphatic—five fingers on an open left hand, plus a right index finger, pushed toward the ceiling again and again. There were no tears on his face at the end of the game.

"I think it was bittersweet in the sense that it was the toughest route, toughest challenge in the six championships that we've won," Jordan said. "I was more competitive than I ever was, because I wanted to win more than I ever did."

The element that separates this victory from the five to precede it is the assumption of The Last Championship, a concept so foreign to a place that until recently had considered its most recent titles ancient history.

This experience would not hold the wonder of the first one, in 1991, when Jordan hugged the championship trophy as he would a small child, closed his eyes, and cried. It could not possess the passion of the beginning of the second three-peat, on Father's Day 1996, when Jordan, his father now gone, collapsed to the court and sobbed.

Our parents and grandparents can still tell us about all those players whose skills led us to call them by one name—Mikan in his youth, Russell at his best, Oscar and Wilt when they dominated the game.

If this is really the end, if number 23 exits this way—score-steal-score, with one last MVP trophy in his hands—another generation can take pride in its response, now and forever: Sure, those players were great. But we were there when Michael played.

> "I think it was bittersweet in the sense that it was the toughest route, toughest challenge in the six championships that we've won." —JORDAN

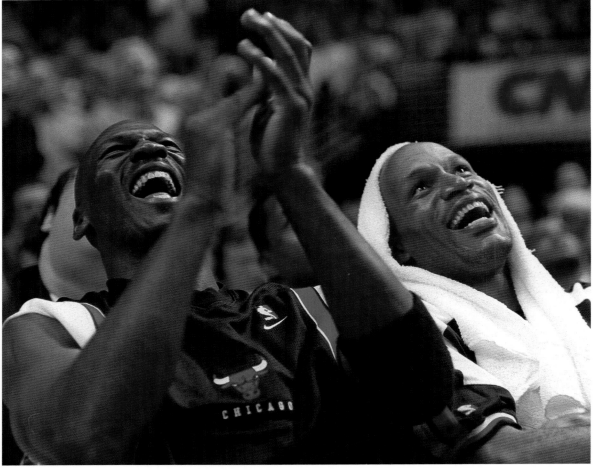

Top: Michael Jordan and Ron Harper laugh as they rest on the bench during the Bulls' historically lop-sided 96-54 victory over the Jazz in Game 3 of the NBA Finals on June 7, 1988 at the United Center.

Bottom left and center: Pair of sixes: Michael Jordan holds up six fingers after the Bulls won Game 6 of the 1998 Finals to clinch their sixth title. (Can these two similar images share a common caption? Writing two would seem redundant, unless you feel we need to ID Randy Brown in the center image.)

Bottom right: Scottie Pippen holds the championship trophy aloft after the Bulls wrapped up their second three-peat with a victory over the Jazz in Utah.

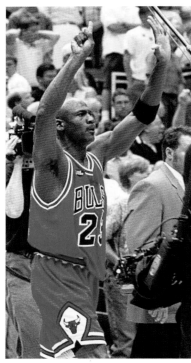

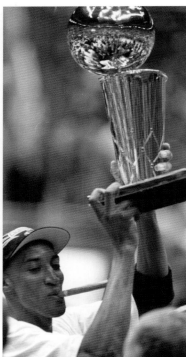

Top, from left:
Michael Jordan savors a cigar after his Bulls smoked Utah in the 1998 NBA Finals; Another pair of sixes: Michael Jordan hoists his sixth NBA Finals MVP trophy after winning his sixth NBA title in 1998; Bulls executive Jim Stack (left) and a champagne-soaked Jerry Krause share a hug after the team's sixth title.

Bottom: It's a three-for-all as (from left) Ron Harper, Scottie Pippen and Phil Jackson hoist the hardware at a rally on June 16, 1998 in Grant Park after the Bulls' second three-peat.

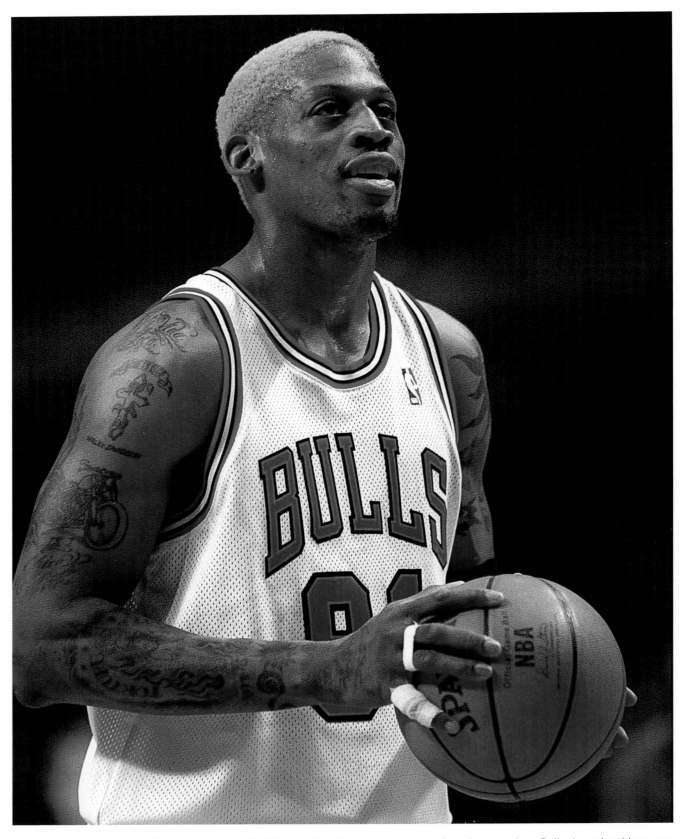

Once a member of the rival Pistons—a.k.a. the "Bad Boys"—Dennis Rodman became a key player on three Bulls championship teams.

Dennis Rodman

'WHATEVER THE TEAM NEEDS . . . I'LL DO IT'

91 POWER FORWARD
1995–98

When you have green hair, more tattoos than skin and a chain looped through your belly button, you probably shouldn't be too terribly surprised when people pass judgment.

Dennis Rodman always said he didn't care what we, the public, thought anyway, and one tended to believe him.

Alan Steinberg, a noted author and a Chicagoan, wrote "Rebound—The Dennis Rodman Story." Steinberg tells the story of a somewhat overindulged Rodman, who grew up without a father but with a caring mother and in the shadow of two wildly talented basketball-playing sisters, all of whom seemed to blame themselves for his troubles. Born in Trenton, N.J., but raised in Dallas, Rodman was arrested at 19 for stealing watches from a gift shop while a janitor at Dallas-Ft. Worth Airport, charges that were dropped when he returned the merchandise. After an 11-inch growth spurt, Rodman then turned to sports, playing organized basketball for the first time at 20, when he went to Cooke County Junior College in Gainesville, Texas. But he flunked out after a semester and returned to Dallas, where he did little else but play video games and get into trouble until his mother kicked him out of the house at 22.

Faced with life on the streets, a job or a hitch with the Marines, Rodman accepted an offer to go to Southeastern Oklahoma State Junior College. Even faced with homelessness, however, Rodman didn't grab at the scholarship offer. The coach made his recruiting pitch to Dennis' bedroom door before he finally would emerge, wearing only his underwear. So there is a history there.

Rodman's mother has long blamed herself for her son's problems since she allowed him to grow up believing his father was a great man who simply chose to abandon him, rather than telling him that his father was emotionally abusive and unfaithful.

In describing Rodman, Steinberg uses words like "emotionally reserved," "closed" and "insecure."

"I saw him . . . as an extraordinarily shy person," said Steinberg, waiting for the expected guffaw, which, of course, he received. But he is sincere. And when you read the part about Rodman growing up with facial sores and allergies thought to be stress-related, and becoming increasingly withdrawn, you can see it.

"He requires special attention like Michael Jordan," said Steinberg, "but whereas Jordan comes across with class and dignified, Dennis, coming from the Pistons, has a bad image."

He also has a different hair color for every day of the week, which made it hard to command a great deal of respect from some people. But then, who's to say

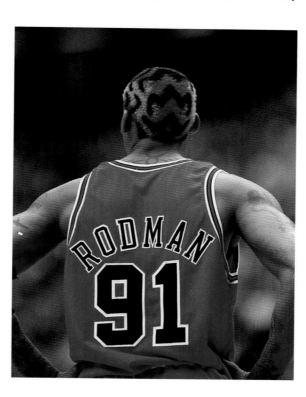

"People want to judge me for what I've done off the court. They should wait to see me play."
—RODMAN

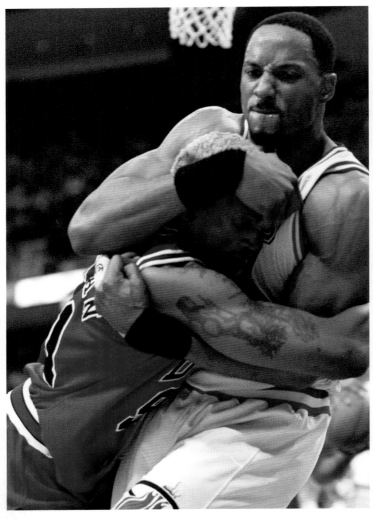

Miami's Alonzo Mourning puts Dennis Rodman in a headlock during a game in 1997.

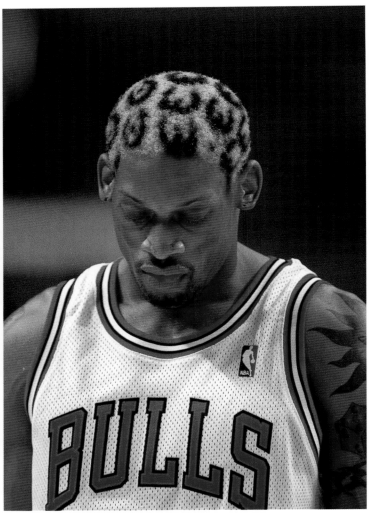

Dennis Rodman's flamboyant personality—and colorful hairstyles—often overshadowed his Hall-of-Fame abilities as a player.

> "I won't even go down in history as one of the best and I don't care."
> —RODMAN

that "different" isn't simply in the eye of the beholder? "He really wants to be special and one way to be special is to draw attention to yourself," said Steinberg. "He can't help himself.

"Having green hair is just his way of psychologically overcompensating for his weakness, which is insecurity. We all find a way to act like we have green hair. The sad thing is, we don't value eccentrics. Why can't it just be for fun?"

"Dennis is like a demon to everybody," said Jordan, who had his share of memorable battles with Rodman and the "Bad Boy" Pistons. "We all have demons. We all have dreams. We all have things we would love to do but (we don't) because of our conscience or subconscious or little angel on the shoulder.

"We all live them through Dennis. How many times have you ever wanted to wake up and change

your hair four or five times in a week? I'm pretty sure some people have and they live that moment through Dennis."

Bulls general manager Jerry Krause realized that Rodman's eccentricities contributed to his popularity, but he'd also liked to think that Rodman's play accounted for the adoration.

"When I spoke with him in the off-season, I said, 'Dennis, this is a blue-collar town and you're a blue-collar player,'" Krause recalled. "You bust your butt and people will love you in Chicago."

Despite initial reservations, Krause traded Will Perdue to San Antonio for Rodman.

"(Special assistant) Jim Stack really deserves the credit for that," Krause said. "He had suggested we look at him and I said, 'That's nuts.' He talked me into doing the homework."

The homework revealed that Rodman, while far

Dennis Rodman's aggressive and fearless style of play may have irritated opponents, but it endeared him to fans and teammates.

DENNIS RODMAN

- » **Born:** May 13, 1961 in Trenton, N.J.
- » **Height:** 6-7'
- » **Weight:** 210
- » **College:** Southeastern Oklahoma State
- » **Years in NBA:** 1986–2000
- » **Acquired by Bulls:** Oct. 2, 1995 from San Antonio Spurs in trade for Will Perdue

from a cherub, was, in Krause's words, "a bright person who knew what he was doing."

"San Antonio let me go to Chicago so I could bring the Bulls down," Rodman said.

Rodman was coming off a year in which he grabbed 16.8 rebounds and 7.1 points per game while shooting 57.1 percent from the field.

His numbers as a Detroit Piston were even higher. In 1991–92, he corralled a mind-boggling 18.7 rebounds per game and scored 9.8 points per contest on 53.9 percent shooting.

All told, Rodman won five NBA championships—three with the Bulls and two with the Pistons—during a 14-year career that also featured seven rebounding titles, two Defensive Player of the Year awards and seven first-team All-Defensive nods.

Rodman said he cared little for accolades.

"I fit in the mold with the little people," he said. "I don't care if I'm one of the best. I won't even go down in history as one of the best and I don't care."

What will Rodman go down in history as?

One, for making rebounding a glamorous art form.

Two, for winning the hearts of advertising executives despite being the antithesis of the clean-cut jock. This is a man who in his best-selling book, "Bad As I Wanna Be," delved into controversial topics such as suicide, cross-dressing and homosexuality.

Three, as a Hall-of-Famer, inducted in 2011.

"What people forget about Dennis is how great a teammate he was," said Krause. "He was about winning. And he could guard any position."

"People think I'm mentally ill," Rodman said in 1993. "But people should look at what I've done on the court. I've made them happy. People want to judge me for what I've done off the court. They should wait to see me play. I know my job and I do it. Whatever the team needs to get over the hump, I'll do it. I'm here to take care of business." 🏀

Tex Winter

HE PUT THE HEAT IN BULLS' OFFENSE

Jerry Reinsdorf was beaming in early 1985, his White Sox not long removed from a division title and his deal to acquire one of the city's other sports jewels, the Bulls, finally done.

But there was much to be dealt with: the firing of the coaching staff and hiring of new coaches, the disposal of Quintin Dailey, Wes Matthews, Orlando Woolridge, Jawann Oldham and Sidney Green, and the hiring of someone to run it all.

For the latter, Reinsdorf turned to a familiar White Sox face, scout Jerry Krause, who had a long run as a scout in the National Basketball Association several years before.

And on March 26, 1985, Krause was hired to replace Rod Thorn.

That night, watching from Baton Rouge, La., was Fred "Tex" Winter, a legendary collegiate basketball coach and teacher who was now in an advisory position at Louisiana State.

Winter, a kindly, if somewhat quirky gentleman, brightened when he saw Krause on television, for they were good friends—Winter, the coaching giant at Kansas State, having befriended the rumpled scout many years earlier.

> **"We had that type of system, but we didn't have anybody who knew it and could teach it like Tex."** —PHIL JACKSON

Winter was retired then, having left his last head coaching job at Long Beach State, but Dale Brown had persuaded him to come to Louisiana to show his players some of his vaunted teaching techniques.

Those techniques, which have been copied for years by coaches around the nation, helped less talented teams at Kansas State often defeat Wilt Chamberlain's teams at Kansas and took Winter to a pair of Final Four appearances.

"He'll be calling me in 24 hours," Winter remarked to his wife while watching Krause on television.

And the call came, but later that night, less than a day after Krause had become basketball chief for the Bulls.

Because it was that day, with the Bulls then struggling to get 40 victories for the season despite a star-studded lineup that included Michael Jordan and with thousands of empty seats the standard, the first thing Krause wanted to talk about with Reinsdorf was Tex Winter.

Reinsdorf, of course, had heard of the great collegiate coach, but he couldn't understand Krause's urgency.

"Jerry," said Krause, "he's the Charlie Lau of basketball."

"Hire him," commanded Reinsdorf, who was a great believer in methods of the master baseball hitting instructor to whom Krause referred.

And that season, under new Bulls coach Phil Jackson, the Bulls developed a new offense based on the principles Winter gleaned from the great master coaches of all-time and refined through his own practice.

Essentially, it was a team-oriented offense that emphasized hitting the open man and fast breaking with plenty of motion.

In some ways, it was reminiscent of the style used in New York when Phil Jackson played for Red Holzman and the Knicks won two NBA titles.

"We had that type of system," said Jackson, "but we didn't have anybody who knew it and could teach it like Tex. Red didn't know it like that."

The offense, which is identifiable by a series of triangles formed by the players on one side or toward the middle of the floor, is based on what the defense does, meaning the ball is supposed to swing away from congestion and cuts and screens based on defensive moves.

"It's an offense that can be unattractive to a player because it seems you're dictating to him skills like cutting, splitting action, the low and high and pinch posts," Bach said. "A lot of people ran away from it quickly. And he could be hard-headed and opinionated about it. But it's a very attractive offense if players recognized the freedom in it."

For Winter, it was a chance to be a teacher again.

"It's really what I always wanted to be," said Winter.

Winter was a nationally regarded high school pole-vaulter, and good enough despite being just 5-foot-8-inches tall to earn a basketball

scholarship at Oregon State. World War II interrupted that, but set him on his life path. He played basketball in the service for Sam Barry, the renowned Southern California coach, who brought Winter there after the war. Barry was a disciple of Ward "Piggy" Lambert, the Purdue coach and pioneer of the fast break who won a dozen Big 10 titles.

At the time, Pete Newell, who was to become the guru for NBA big men, was playing at Loyola of Los Angeles and he and Winter, who was playing with the likes of Bill Sharman and Alex Hannum, became close.

Winter devoted his time to studying these great basketball minds and the game. He memorized former Indiana U. and Stanford coach Ev Dean's "Progressive Basketball," a teaching bible to some, watched 16 millimeter game films constantly and took notes, most of which he still has.

"I just took an interest and studied the game," said Winter, who is most conspicuous before games feeding passes to the team's big men. "It was like a hobby. The strategy intrigued me and I'd had a lot of diversification in my basketball background, so I took something from everyone I knew and developed some things on my own."

And at 24, he was offered a head coaching job at Ventura Jr. College, but his mentor, Barry, suggested he become an assistant at Kansas State for Jack Gardner, who played for Barry.

"He felt I needed the experience," says Winter.

So Winter went and within three years, Kansas State was in the Final Four. Then in 1951, at age 28, he became the youngest head coach in the nation when he took the Marquette job, but he went back to Kansas State when Gardner left in 1953.

And in 15 years there, Winter won eight Big Eight titles, producing two No. 1 teams.

And he did it with what came to be known as the triple-post offense, the elements of which he later brought to the Bulls.

Winter eventually felt some distance from Kansas State was necessary, his wife desiring to return to her Pacific Northwest home. So he left Kansas State to his assistant, Cotton Fitzsimmons, and went to the University of Washington, where he didn't have a losing season in three years for a program that had just one winning campaign in the past six.

But college life was changing in the late 1960s.

"I loved to teach and work with youngsters," said Winter, "but everything was getting ugly, the recruiting and things on campus."

And Winter also became curious about whether his principles could succeed in professional ball. When Newell became general manager of the San Diego Rockets, he brought in Winter as coach.

The club moved to Houston within weeks of Winter's hiring and soon changed management. Winter was a victim of the transition.

Considered one of the game's great offensive innovators, Tex Winter influenced generations of coaches, including championship-winners Phil Jackson and Steve Kerr.

Tex Winter (center) huddles with Bulls players Randy Brown (left) and Ron Harper (right) during a 1999 scrimmage. Winter "was a great teacher," said John Paxson.

TEX WINTER

» **Born:** Feb. 25, 1922 in Wellington, Tex.

» **College:** University of Southern California

» **Years in NBA:** 1971–73 as head coach; 1985–2004 as assistant coach

» **Hired by Bulls:** July 8, 1985

But he couldn't stop coaching. He gave Northwestern a try and had a 42-89 record, his only losing stint anywhere, but it also renewed his friendship with Krause, the gym rat frequenting Winter's practices.

"I think I went from the fourth-winningest coach to 15th when I was there," said Winter with a laugh. "We had some good wins. But it's a hard place to win, although I still believe it's possible."

Winter then went to Long Beach State for five years and finally decided in 1982, after coaching almost 40 years, that it was time to retire.

"And," said Winter, "I've been working ever since."

He stayed with the Bulls through the 1998–99 season, then joined Jackson's staff on the Lakers. He retired—for good, this time—after the 2003–04 season.

Winter's legacy is sealed, thanks to the championships he won in Chicago and Los Angeles. Former players speak of him reverentially, even those he pushed the hardest.

"Tex is the one who probably criticized my game more than any other," Michael Jordan said.

"When I first came (to Chicago) and Michael was in his second year, I was just amazed," Winter said. "I thought his reflexes, his reactions, his jumping ability, his anticipation was the best I'd ever seen. I wasn't convinced at that time he was the total player. But as far as individual abilities, attributes, were concerned, he was the best I'd ever seen.

"I said to myself then, 'Well, if he has a proper grasp of the game of basketball, and he should have because of his background at North Carolina, then he'll be the greatest player of all time.' And that's the way it turned out. Eventually he became a complete player, particularly when we did go to the team concept and not rely on him individually all the time."

But he admitted Jordan could be aggravating.

"Oh, yes. Many times. Many times," Winter said with a laugh. "I'm sure I aggravated him even more so. But I don't think it was too hard (convincing him to accept the triangle). I think Phil Jackson did a tremendous job of convincing Michael and Michael always has had a great deal of respect for coaches. The term coach means a lot to Michael and, more than that, Michael wants to win.

"He puts winning above all else, everything he does, really. Once he felt the only chance we had to win championships was the team concept Phil Jackson sold and the triangle offense, he embraced it. It took a little time, and you had to prove things to Michael. He doesn't accept things at face value."

"Tex is a genuine human being," said John Paxson. "He always remained steadfast to his belief about how basketball should be played. I still remember he would be critical when it came to fundamentals, even with Michael Jordan. He used to always say MJ didn't throw a precise enough chest pass. That's how he analyzed the game, with an unbelievably educated and well-trained eye.

"He was a great teacher and the art of teaching the game is becoming a lost art in many respects. I'm honored I was able to be around Tex because he gave me a greater appreciation for the game." 🏀

The dynasty is dismantled with a flurry of trades and the hiring of a new coach.

Floyd gets job; now what?

July 24, 1998

Forget any game-winning plays Tim Floyd has drawn up in his 12-year college coaching career. Forget all the blue-chip players he has wooed with his recruiting skills or the heat-of-the-battle decisions that led to his five NCAA tournament appearances.

Without question, Tim Floyd made the smartest move of his basketball career, saying all the right things and making all the right moves regarding the most precious commodity in sports—Michael Jordan.

No matter what his job title with the Bulls is—director of basketball operations, coach-in-waiting—Floyd, most recently the Iowa State coach, made it quite clear what he thinks about the megastar player whose loyalty to Phil Jackson could preclude any sort of working relationship between two people who have never shared a word.

"As far as Michael Jordan goes, I think he is absolutely the greatest player to play his position, the greatest player to ever play the game," Floyd said. "If Phil doesn't return, I hope Michael will come back and play with me. I really do."

The Bulls announced Floyd's addition to their staff during a news conference in which they also extended Jackson an invitation to return. Jackson resigned last month after coaching the team to six championships in eight seasons.

"The one thing I didn't want was to have anything to do with Michael Jordan not wanting to return and play basketball," Floyd said of his willingness to wait for the coaching job. "I know what he means to this city. I know what he means to Chicago Bulls fans worldwide. And I know what he means to the NBA."

Along those lines, Floyd contacted Buzz Peterson, Jordan's former North Carolina roommate and current Appalachian State coach, hoping Peterson could serve as an intermediary between the two strangers.

"Michael is as good a business person as I know," Peterson said, "and all he said to me was, 'Buzz, don't let Tim base his decision on what I'm going to do. I don't know what I'm going to do.'"

Just last week, though, Jordan reiterated that he has no desire to play for any coach other than Jackson. Jordan mentioned Floyd by name, saying he has nothing against the 44-year-old coach but that he's not interested in being involved in a rebuilding effort.

Bulls shippin' Pippen

Jan. 19, 1999

Scottie Pippen is on his way to the Lone Star State.

And once again he's hardly the only star.

The Bulls agreed to trade Pippen to the Houston Rockets once the NBA lockout officially ends and training camps open.

That would unite Pippen with former league Most Valuable Players Hakeem Olajuwon and Charles Barkley and instantly make the Rockets one of the top contenders for the NBA title this season.

Pippen will sign a five-year contract worth $67.2 million and starting at close to $11 million in the first season. The deal also includes incentives that could increase Pippen's take to $82 million over the five years.

In exchange, the Bulls will get 6-foot-10-inch forward Roy Rogers and a second-round draft pick of the Vancouver Grizzlies that the Rockets control.

Given his past rancor toward Bulls management, Pippen departed in a conciliatory mood. But the team did him a favor—the sign-and-trade transaction enabled him to make several million dollars more than he would have if he'd signed with Houston or any other team as a free agent. The most the Rockets could have paid Pippen as a free agent was about $45 million over four years.

Though clearly the biggest and most attention-getting, the Pippen deal was one of three the Bulls effectively agreed to as the team begins to position itself for the future.

The Bulls also traded Luc Longley to the Phoenix Suns and dealt Steve Kerr to the San Antonio Spurs.

7 SMALL FORWARD/
POWER FORWARD

1993–2000

Toni Kukoc

EUROPEAN PIONEER

Toni Kukoc laughed about his awkward first season with the Bulls, about the way his veteran teammates "let you know you were a rookie in any way they could."

A native of Split, Croatia, Toni Kukoc joined the Bulls in 1993 with an impressive portfolio as three-time European Player of the Year.

But he was an unproven rookie in the eyes of his new NBA teammates, who forced him to adhere to the traditional hazing of first-year players.

Joining a group of future Hall-of-Famers wasn't easy for Toni Kukoc. "You could tell he was not happy with the way he was being treated," said teammate Will Perdue.

"I still had to carry the bags on and off the bus and the plane," Kukoc recalled. "When I came, I was a No. 1 player [in Europe], I'd played seven years [professionally] and I was treated the same as [rookie] Corie Blount. It was like, 'Corie and you—what's your name?—get the bags off the plane.' For me it was harder to accept."

The biggest adjustment for Kukoc was overcoming general manager Jerry Krause's overly enthusiastic courtship, which offended the then-sensitive Bulls stars. Scottie Pippen openly derided Kukoc to get at Krause, a longtime target of Michael Jordan's.

"I was 22, 23, just married with a 10-month-old kid coming here and running into the media that was messed up with Scottie and Michael and Jerry, and I'm spinning around," Kukoc said. "I was always getting thrown into something."

Kukoc seemed to shrink from the spotlight initially, a problem exacerbated by his difficulties with the English language.

"You could tell Toni was not happy with the way he was being treated," teammate Will Perdue said. "The only thing he had to base that on was the fact that he was an all-star and a guy who could do it all over in Europe. It was almost like he was being treated like he was at the bottom of the barrel here in the NBA and he really couldn't figure out why."

"I came to the NBA to prove myself," he said. "There was a big question about the European players, if they were good enough to play in the NBA. It was a great thing coming to the team that you know was the three-time world champ and still had a chance to win it a few more times."

At 6 feet 11 inches and 235 pounds, Kukoc was known as a finesse player. He was aware that some questioned his game and his toughness before he came to the NBA.

"There had been a lot of hype about Toni coming over here and playing and Toni making an impact on this league," Perdue recalled. "A lot of the guys within the league took it personally. Whether you're a European player or a first-round pick in the draft, guys are going to make you go out there and earn their respect. They're not just going to give it to you."

"I had to prove everything. I had to prove the way I play, the way I am, what kind of person you are . . . everything. It was not easy."

—TONI KUKOC

understood just how physical or how demanding the NBA style of play was," Perdue said.

In his early years with the Bulls, Kukoc was a frequent target of coach Phil Jackson and Jordan, the floor leader. Teammates were sympathetic, but they understood the rationale.

"I think Phil was particularly hard on him to make him better and to get him to realize that you can't rely on the past . . . to get him to work on his game," said Bill Wennington, once a Jackson target himself. But Kukoc "took it personally a lot. That may have slowed him down a little bit," Wennington said. But "Toni adapted his game more toward the NBA style of play as opposed to the European style."

The opportunity to play with Jordan was one of the reasons Kukoc was attracted to Chicago. But Jordan retired for the first time two months after the Bulls and Kukoc announced their deal.

"When he first came here, he was not particularly thrilled with the fact Michael retired or the style of play that was required of him in order to be successful," Perdue said.

"Over in Europe they played the 2-3 zone, so he had to work on his man-to-man defense. For a while, every point he scored he would pretty much give up on the other end. He worked on that and tried to become more of a complete player instead of someone who is just spectacular on the offensive end."

Kukoc became accepted but, more important, so was his game. He was named NBA Sixth Man of the Year in 1996, and his 13 points per game off the bench was vital to the 1996–98 championship teams. The Bulls traded him to Philadelphia in 2000 but he was traded again just over a year later, this time to Atlanta. He eventually wound up in Milwaukee and played four seasons with the Bucks to close out a 13-year NBA career.

Kukoc was a pioneer of sorts, a groundbreaker.

"When I came, the NBA wasn't sure of European guys," Kukoc said. "They'd say, 'OK, we'll get you in the second round [of the draft].' Now the players are so good you can't wait. The age when they actually get to the NBA now, the Europeans are better players."

And they owe considerable thanks to Toni Kukoc. 🏀

While the challenge was difficult to accept initially, Kukoc later understood the reasons for the skepticism.

"The guys on the team knew more about the guys coming out of college than the guys coming from Europe," he said. "When I got in here, nobody knew what I looked like or the way I played. They didn't know anything about me. Maybe Michael (Jordan) and Scottie (Pippen) knew a little about me because they played against the Croatian team in Barcelona (during the 1992 Olympics).

"So when I got here to the Bulls, I had to prove everything. I had to prove the way I play, the way I am, what kind of person you are . . . everything. It was not easy, especially not knowing the language well enough then to communicate with the guys. But I fought my way through it."

Perdue remembers Kukoc's initiation period with the Bulls.

"He had played against American teams in international competition, but I don't think he realized or

TONI KUKOC

- » **Born:** Sept. 18, 1968 in Split, Croatia

- » **Height:** 6-10'

- » **Weight:** 192

- » **Years in NBA:** 1993-2006

- » **Acquired by Bulls:** June 27, 1990 in 2nd round (29th overall) of the NBA Draft

While not unexpected, Jordan's second retirement still felt like it came too soon.

Into thin air

Jan. 14, 1999

As he walked onto the United Center floor for what would be his last time as a Chicago Bull, all eyes were upon Michael Jordan. He was as confident as ever, joking as he passed friends and teammates. His wife Juanita by his side, Jordan moved with his customary ease to the podium, smiling as he prepared to make the statement that not only would end an era but change the face of professional sports.

Michael Jordan then said the words everybody expected but nobody in Chicago really wanted to hear or believe.

"I am here to announce my retirement from the game of basketball," he said.

It wasn't as shocking or as dramatic as the first time Jordan walked away from the game, in October 1993. But with his announcement Wednesday, Jordan apparently ended one of the most fascinating and accomplished careers in sports history. At the age of 35—he turns 36 next month—Jordan put behind him 13 years of dominance, which included six NBA championships, a record 10 scoring titles, five Most Valuable Player awards and countless memories for thousands upon thousands of basketball fans.

"This is a day that I hoped would never come. It has to be the toughest day in the history of the Chicago Bulls."

—JERRY REINSDORF

And unlike his announcement of five-plus years ago, Jordan's words had an air of finality to them. This time, he really means it, although he left a sliver of hope for those who are not yet ready to let him go.

"It's not really 100 percent, but it's close," he said. "That's where I stand. I'm not going to say never. But I will say 99.9 (percent)."

Jordan said he made the decision seven months ago, after the Bulls capped a grueling postseason run by beating the Utah Jazz in six games for their third straight NBA title and sixth in eight years. Jordan scored four points in the final 41 seconds of Game 6 and set up his game-winning basket with a steal.

Afterward, Jordan told Bulls Chairman Jerry Reinsdorf of his intentions. Reinsdorf suggested he take the summer off to rest and make sure retirement was what he wanted.

After the NBA's labor dispute extended his summer by three months, Jordan didn't waver. He said the timing was perfect for his departure, that he couldn't push himself to get ready for even an abbreviated 50-game season.

Jordan discussed his decision with teammates Scottie Pippen and Ron Harper when he returned Monday from the Bahamas. He let the rest of the Bulls know Tuesday.

"From a career standpoint, I've accomplished everything I could as an individual," Jordan said. "Right now I don't have the mental challenges that I've had in the past to proceed as a basketball player. I'm sure people will say that there are a lot of challenges that could evolve. For me to start something and then at the middle of the season lose interest and lose my motivation is unfair to the people I'm working with and working for, and to the fans. I alleviated that by saying, 'This is the perfect time to walk away from the game.' I'm at peace with that."

Jordan acknowledged that the decision was a tough one.

"I'm doing a good job of trying to hold back the emotions because it's like taking back something I truly have loved," he said. "I started when I was 12 years old and I'm 36 next month, so 24 years I've been playing the game. It's sad that I'm leaving the game but it's happy that my life is starting to go into a whole new stage. Basketball, to me, was the first stage. It got me to this point in my life. I knew it had to end."

Reinsdorf presented Jordan with his 1998 championship ring and then had Jordan's re-retired No. 23 displayed in the United Center rafters. "This is a day that I hoped would never come," Reinsdorf said. "It has to be the toughest day in the history of the Chicago Bulls. It's a tough day for Chicago; it's a tough day for the NBA. It's a tough day for basketball fans all over the world—for Michael Jordan fans all over the world."

While Bulls general manager Jerry Krause stood in a roped-off area to the side of the podium with future Bulls coach Tim Floyd, Jordan downplayed his differences with management and how those differences might have affected his decision.

When Krause re-signed coach Phil Jackson last season with the emphatic assertion that it would be Jackson's last contract with the Bulls, Jordan viewed the move as pushing Jackson out the door. When Floyd was brought in as Jackson's replacement, Jordan said he never would play for Floyd.

Michael Jordan, shown here with his first wife, Juanita, leans back for a laugh during his retirement press conference on Jan. 13, 1999.

"I'm doing a good job of trying to hold back the emotions because it's like taking back something I truly have loved. . . . Basketball, to me, was the first stage. It got me to this point in my life. I knew it had to end."

—JORDAN

Jordan repeatedly said the only way he would come back to the Bulls was with Jackson as coach. Reinsdorf twice asked Jackson to return to the team to appease Jordan, calling him again as recently as last week. Jackson declined, but Jordan said even if Jackson had come back, it might not have affected his decision.

"That's a big 'if,'" Jordan said. "I retired the first time when Phil Jackson was the coach. I think that even with Phil the coach, I would have had a tough time, mentally, finding the challenge for myself. Although he (Jackson) could somehow present challenges for me, I don't know if he could have presented a challenge for me to continue on with this season.

"Even though midway through (last) season I wanted to continue to play a couple of more years, at the end of the season I was mentally drained."

Jackson, traveling in Mexico, wasn't on hand for the ceremony but issued a statement thanking Jordan for their time together and wishing him well in retirement.

NBA Commissioner David Stern had pleaded with Jordan to come back for one more year and help smooth over the bad feelings the league is likely to encounter in the wake of its labor troubles. But Stern acknowledged it was a perfect time for Jordan to retire.

"This is not a sad day, this is a great day because the greatest basketball player in the history of the game is getting an opportunity to retire with the grace that described his play," Stern said.

Jordan said he intends to live in the Chicago area and held out the possibility of remaining involved with the Bulls in retirement. He has urged the team to re-sign longtime sidekick Scottie Pippen, a free agent, and rebuild the team around him. But for now, he said, it might be better to make a clean break from the Bulls, and the league.

"The best way to survive without Michael Jordan is to somehow start to live without him," Jordan said. "I'm always going to respect the Chicago Bulls. It's given me great joy to be a part of the organization. But life without Michael Jordan sometimes has to be without Michael Jordan's input."

Life without Michael Jordan officially began Wednesday.

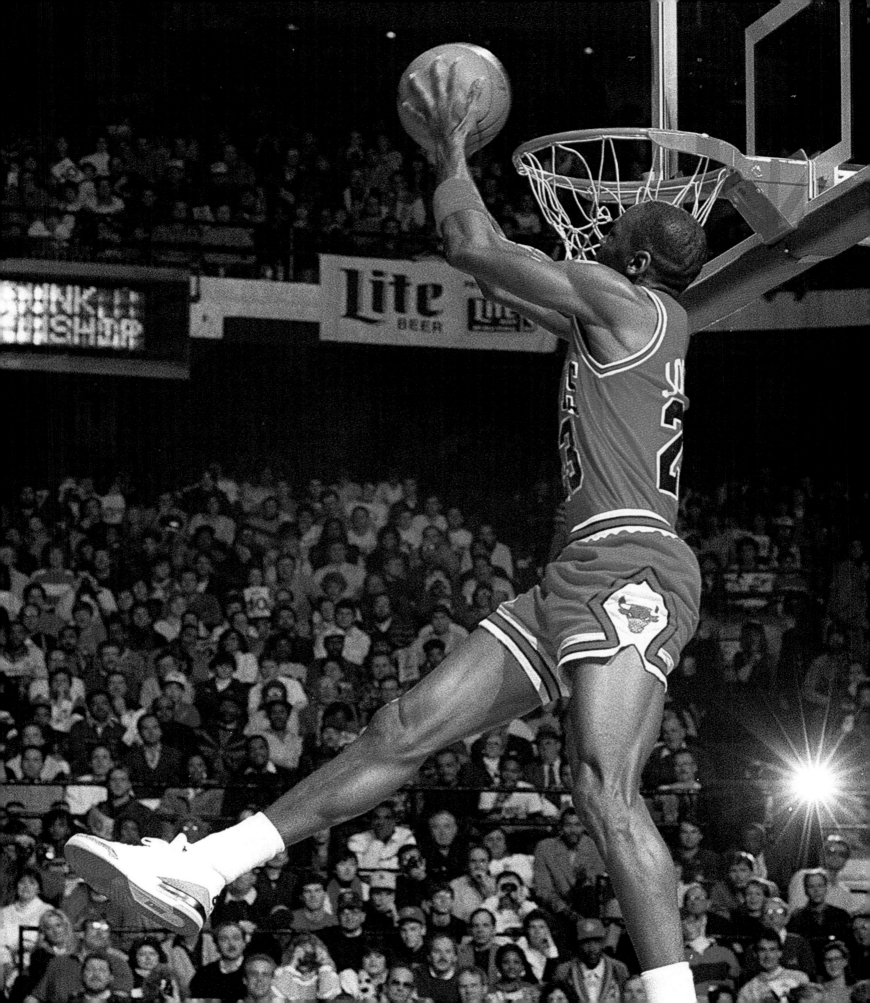

Michael Jordan

ABOVE ALL

Before Michael Jordan arrived in 1984 and for several years afterward, Chicago wasn't a city that had a lot of experience with championships. The city always seemed to have great athletes—Walter Payton, Gale Sayers, Dick Butkus, Bobby Hull and Ernie Banks, among others—but didn't have the championships to go with them. There were a few great teams—the '85 Bears, the '63 Loyola Ramblers, the '61 Blackhawks, the Cubs from way back when—but none of them could sustain their excellence. Jordan showed the city how it was done, this thing called winning. The ingredients were these: Take perhaps the greatest athlete in the history of team sports and add a "supporting cast," as he liked to call his teammates. The recipe produced six NBA titles and left an imprint on the city's sports landscape that likely will last as long as these games are played. The inscription on the statue that stands outside the House That Jordan Built—also known as the United Center— eloquently sums up Jordan's legacy. The words come from the Norman Maclean novella "A River Runs Through It," and they capture both the unprecedented brilliance of Jordan's career and the poignant inevitability of his departure. "At that moment I knew, surely and clearly, that I was witnessing perfection. He stood before us, suspended above the earth, free from all its laws like a work of art, and I knew, just as surely and clearly, that life is not a work of art, and that the moment could not last."

Opposite: All eyes are on Michael Jordan as he ascends to the basket during the 1988 slam-dunk competition at Chicago Stadium.

SCHOOL DAYS

Feb. 17, 1963
Michael Jeffrey Jordan is born in Brooklyn, N.Y., the third son of James and Deloris Jordan. The family moves to Wilmington, N.C., before his second birthday.

1977
Jordan wins outstanding athlete award at Trask Middle School.

Fall 1978
As a 5-foot-9-inch sophomore at Emsley A. Laney High School, Jordan is deemed too short and cut from the varsity team. Coach Clifton "Pop" Herring selects 6-8 sophomore Leroy Smith instead.

Summer 1979
A motivated Jordan, who has grown five inches, makes the varsity as a junior. As a senior, he averages 29.2 points, 11.6 rebounds and 10.1 assists per game.

April 11, 1981
Jordan stars in the McDonald's All-American game with Patrick Ewing and Chris Mullin, setting a record with 30 points.

Michael Jordan poses with his first car in front of his Wilmington, N.C. home in this undated photo from the 1980-81 Laney High School yearbook.

March 29, 1982
As a freshman at North Carolina, Jordan nails the game-winning shot against Georgetown for a 63-62 victory and the national title.

March 27, 1983
Despite 26 points from Jordan, the No. 2 Tar Heels are upset in the Elite Eight by Georgia. Jordan is named the Sporting News College Player of the Year.

March 3, 1984
In a double-overtime game against Duke, Jordan scores 25 points. The victory marks the first time in 10 seasons an ACC team has gone undefeated in conference.

March 22, 1984
Jordan scores just 13 points and the Tar Heels are upset by Indiana in the Sweet 16.

May 5, 1984
After winning the Naismith and Wooden College Player of the Year awards, Jordan turns pro after his junior season at North Carolina. He finishes his college career with an average of 17.7 points per game and 54 percent shooting.

THE NBA

June 19, 1984
The day Sam Bowie became a trivia answer. In perhaps the most infamous of NBA drafts and the most celebrated day in Bulls history, Jordan is selected third overall behind Hakeem Olajuwon and Bowie.

Summer 1984
During the Olympic Games in Los Angeles, Jordan combines with Ewing and Mullin to lead the U.S. team to a gold medal. Jordan averages 17.1 points per game for the team coached by Bob Knight.

Oct. 26, 1984
Wearing a No. 23 Bulls jersey for the first time, Jordan scores 16 points in his NBA debut, a 109-93 victory against the Washington Bullets in Chicago Stadium. After the game the rookie said, "While fans expect me to score a lot, I am quite satisfied to be a decoy."

Nov. 17, 1984
Footwear will never be the same again. Jordan debuts the first of his signature line of sneakers in a game against the 76ers. The red-black-and-white shoes violate league policy, and Nike pays the fine for Jordan. The Air Jordan I becomes available to the public in 1985.

Dec. 10, 1984

Jordan appears on Sports Illustrated's cover, elevating under the hoop in his red Bulls uniform, under the headline "A Star is Born."

Feb. 10, 1985

Jordan makes his All-Star Game debut. Controversy arises with talk of a "freeze-out" supposedly led by Pistons star Isiah Thomas to keep the ball away from the popular rookie. Thomas later denies this was intentional. Jordan shoots 2-for-9, scoring seven points in 22 minutes of play.

April 24, 1985

Jordan scores 35 points in his first playoff victory, a 109-107 win in Game 3 of the first round against the Milwaukee Bucks.

April 26, 1985

The Bulls are eliminated by the Bucks three games to one. Jordan averages 29.3 points.

May 1985 ··>

Jordan is named NBA Rookie of the Year after averaging 28.2 points and playing all 82 games. "I feel like I know I did the right thing coming out of school early," he said at the end of the season.

Oct. 29, 1985

Jordan breaks a bone in his left foot in the third game of his second season and misses 64 games. The Bulls win 30 games despite his absence and snag a playoff berth.

March 15, 1986

Jordan returns to action, scoring 12 points in 13 minutes during a 125-116 loss to the Bucks. His minutes slowly increase through the remainder of the season.

April 20, 1986

In Game 2 of the first round, Jordan torches the Celtics for a postseason-record 63 points in a 135-131 double-overtime loss at Boston Garden. "I think it's just God disguised as Michael Jordan," Celtics great Larry Bird said.

April 22, 1986

The Bulls are eliminated from the playoffs in three games by the Celtics.

Summer 1986

Jordan, who was nine credits shy of graduating when he left for the NBA, returns to North Carolina to earn his degree in geography.

Nov. 1, 1986

Setting the tone for the season, Jordan scores 50 points in the Bulls' opener—a 108-103 victory against the New York Knicks.

In the end, Jordan's No. 1

Michael Jordan's love for the game of basketball was rewarded Thursday when he was selected as the National Basketball Association's Rookie of the Year. It was a decisive verdict over Houston center Hakeem Olajuwon, the No. 1 pick in last summer's NBA draft and touted by some as the league's top rookie.

In voting by 78 members of the media, Jordan received 57½ votes to 20½ for Olajuwon. They were the only players receiving votes.

"This award is nice, I'm very happy," Jordan said. "It's like 'The End' in a movie. It caps off a dream season for me.

"I wasn't really thinking about winning this award at the beginning of the season. Well, yeah, maybe it was in the back of my mind.

"I'm happy to come in and do a lot better than most people expected. It's all been a lot of fun and I've gotten a lot of enjoyment. Maybe I'll never have another season like this with all the hype and all the attention on my career."

Bulls coach Kevin Loughery, who watched Jordan compete in all 82 games despite various minor ailments, was impressed by the rookie's love for the game as much as anything else. He would see similarities between Jordan and the pros of his day who played the game with a passion.

"Michael just loves to play," Loughery would say. "If these guys were walking past a playground and there was a game going on, I don't think anybody on the team would stop and play. Michael would."

"Yeah, I would play," Jordan said. "Whenever I go back home (Wilmington, N.C.), I go back to the same playground and play ball with all the old guys. Lots of times, pro players will just sit around and watch. Not me. I've just got to play."

Jordan, who was selected No. 3 in last June's draft behind Olajuwon and Portland center Sam Bowie, took the NBA by storm and led the league in total points scored this season, finishing third in average with 28 points a game. The 6-foot-6 guard was also fourth in steals with 2.39 a game.

Although he played some games with a sprained ankle and others with a sprained thumb, he led the Bulls in scoring, rebounding, assists and free-throw percentage and was second in blocked shots. His presence accounted for the Bulls nearly doubling their attendance from the previous year.

Feb. 7, 1987

At the All-Star Game in Seattle, Jordan soars to his first of back-to-back dunk contest victories.

April 16, 1987

After dropping 61 points in a loss to the Atlanta Hawks, Jordan becomes the only player other than Wilt Chamberlain to score more than 3,000 points in a season. He also sets a league record by scoring 23 straight points in the game and becomes the second player (after Chamberlain) to score 50 or more points in three consecutive games.

April 28, 1987

For the second straight season, the Bulls are swept in three games by the Boston Celtics.

May 1987
Jordan wins the first of his 10 NBA scoring titles (37.1 points per game). He would go on to win the award the next six seasons—a feat that matched Chamberlain's record.

Feb. 6, 1988
With hometown fans cheering in Chicago Stadium, Jordan and Dominique Wilkins go toe-to-toe in the dunk contest. Jordan wins, recording a perfect score with a slam that lifted off at the free throw line.

Feb. 7, 1988
In his fourth All-Star Game, he earns his first MVP honors, scoring 40 points in the East victory.

May 8, 1988
With Jordan scoring 39 points, the Bulls beat the Cavs 107-101 to claim a first-round series victory. It marks the first time Jordan advances to the conference semifinals.

May 18, 1988
Jordan scores 25 points, but the Bulls' season ends with a 102-95 loss in Game 5 to the Detroit Pistons, who take the series 4-1 and become a roadblock for Jordan over the next few years.

May 1988
After averaging 35 points, 5.5 rebounds, 5.9 assists and 3.2 steals per game, Jordan becomes the first player to be named league MVP and defensive player of the year in the same season.

Jan. 25, 1989
With 33 points in a 120-108 loss to the 76ers, Jordan surpasses 10,000 career points. He'll go on to win his third straight scoring title, averaging 32.5 points per game.

May 7, 1989
Jordan nails what becomes known as The Shot for a 101-100 victory over Cleveland in the playoffs, a bucket that long haunted Cavs fans. The hanging foul-line jumper over Craig Ehlo at the buzzer in Game 5 clinches the first-round series for the Bulls.

May 19, 1989
With a 113-111 Game 6 victory against the Knicks, Jordan scores 40 points and advances to the conference finals for the first time in his five-year career.

June 2, 1989
The Bulls lose grasp of their 2-1 series lead and fall 4-2 to the Pistons in the finals.

July 11, 1989
Phil Jackson is elevated from assistant to head coach of the Bulls to replace Doug Collins. Jordan thrives under Jackson's system.

Sept. 2, 1989
At 3:30 a.m. in the Little White Chapel in Las Vegas, Jordan marries Juanita Vanoy in front of four guests.

March 28, 1990
Jordan scores a career-high 69 points against the Cavs in a 117-113 victory. He hits 23 of 37 field goals, goes 21-for-23 on free throws and grabs 18 rebounds.

June 3, 1990
The Bulls fall to the Pistons in the playoffs for a third straight season. The Pistons, who double- and triple-team Jordan, eliminate the Bulls in Game 7 in Detroit 93-74.

Jordan soars to MVP award

Michael Jordan rose to the top of his profession this season, an ascent now validated with the National Basketball Association's Most Valuable Player Award.

The Bulls' star becomes the first Chicago player to win the award and only the fourth guard honored since 1956. Jordan received 665 points and 47 first-place votes from the media to beat out Boston's Larry Bird, who had 527 points and 16 first-place votes. Last year's MVP, Magic Johnson of the Lakers, was third with 508 points and 16 first-place ballots.

Jordan's won a second straight scoring title by averaging 35 points a game and also was named the NBA's Defensive Player of the Year after leading the league in steals. He is the first player to win a scoring title and the defensive award in the same season.

Jordan is the only player to finish a season with 200 steals and 100 blocked shots, accomplishing that feat the last two years.

"Winning this award has always been one of my biggest goals in basketball," Jordan said. "It is a similar feeling to winning College Player of the Year (while at North Carolina). But this means a little more because of the caliber of the athletes. You're talking about 276 of the best athletes in the world. Now, you are the MVP. That doesn't happen too many times."

Jordan believed it should have come a lot closer to happening last season. That was when he became only the second player to score 3,000 points in a season, yet lost in a landslide to Johnson in the MVP voting.

Jordan set out to prove he was more than simply the NBA's fastest gun. He never rested on defense. Though he remained the show on offense, he worked to include his teammates with improved passing.

He wound up with 173 fewer points, but 108 more assists, 19 more rebounds, 23 more steals and 6 more blocked shots. He shot 53.5 percent from the field compared to 48.2 percent last season. Surrounded by a more talented cast, particularly rookies Scottie Pippen and Horace Grant, Jordan led the Bulls to their first 50-victory season in 14 years.

"He is the best player in basketball right now, and we're winning," Bulls coach Doug Collins said. "The knock on Michael last year was his team wasn't winning. They can't say that now."

April 21, 1991
Jordan scores 18 points in the regular-season finish against the Pistons, having led the Bulls to a 61-21 season and earning another scoring title by averaging 31.5 points per game.

May 1991>
Jordan is named league MVP for the second time.

May 27, 1991
Jordan scores 29 points in a deciding Game 4 victory against the Pistons, a sweep of the team that had eliminated the Bulls in three consecutive playoffs.

June 12, 1991
In winning his first championship, Jordan scores 30 points with 10 assists and five steals as the Bulls defeat the Lakers 108-101 in Game 5 of the NBA Finals. Jordan cries during the locker-room celebration and receives the first of six Finals MVP awards.

May 18, 1992
Michael Jordan is named the NBA's Most Valuable Player for the second year in a row and third time in his career.

June 3, 1992
Jordan torches the Trail Blazers in Game 1 of the Finals with 35 first-half points.

June 14, 1992
Jordan scores 33 points and earns his second championship with a 97-93 win in Game 6 against the Blazers.

Aug. 8, 1992
With 22 points from Jordan, the U.S. Dream Team wins a gold medal with a 117-85 victory against Croatia at the Barcelona Olympics.

October 1992
Jordan's name surfaces in drug and money-laundering trial of convicted cocaine dealer James "Slim" Bouler. Jordan initially says a check to Bouler for $57,000 was a business loan. Under oath, Jordan acknowledges the check was payment for gambling losses.

Jan. 8, 1993
Jordan reaches 20,000 career points, becoming the second-fastest to do so, behind Chamberlain.

May 24, 1993
Jordan sparks controversy by gambling in Atlantic City casinos the night before Game 2 of the Eastern Conference finals against the Knicks. He's criticized the next night for shooting 12-for-32 in a 96-91 loss.

June 20, 1993
The Bulls win their third championship. Jordan has 33 points, eight rebounds and seven assists against the Phoenix Suns in the clinching 99-98 Game 6 victory.

June 22, 1993
The Bulls celebrate a third NBA title in Grant Park.

Jordan MVP by a landslide

The notion has been discussed often among the Bulls this year whether a team can win a National Basketball Association title with the league's leading scorer. Only one team since 1950 has done it—the 1971 Milwaukee Bucks.

But if the question is whether a team can win a title with the league's Most Valuable Player . . . well, the answer is yes. It has been done five times in the last 11 years.

The Bulls and Michael Jordan hope to make it six in the last 12 after Jordan was named MVP for the second time in his career.

"I think, for the last five or six years, my years have been very consistent," Jordan said during his acceptance ceremony. "But this year is a little bit more special because my teammates have really stepped up to give me the contribution I have needed and we have needed to put us in a position to win a world championship. I think they get the credit for pushing me to being MVP. My stats have been very similar in the last few years, but the team's success in winning 61 games has enabled me to win the MVP award.

"When your team wins, all the individual accolades will take care of themselves . . . I'm happy to receive this award, but I'd much rather be back here in June picking up a ring and having everybody celebrating."

Jordan won by a landslide, with 77 first-place votes and 891 points to 10 first-place votes and 497 points for Lakers star Magic Johnson. Jordan was the only player named on all 96 ballots. It was the widest margin of victory since 1986, when Larry Bird won for the third straight time with more than 90 percent of the votes.

Jordan, 28, in his eighth season with the Bulls, won his fifth straight scoring title this season, averaging 31.5 points a game. That was his lowest total since 1985–86 when he was injured and substantially less than the 35 a game he averaged in 1987–88 when he won his first MVP Award.

It's hard to find fault with Jordan, though some have tried. Jordan had a rebuttal ready for his critics.

"It's been said for many years that Michael Jordan didn't make his teammates better," Jordan said. "Well, I've never considered myself a baby-sitter, where I've had to make everybody better. You've got to have that desire to go out and achieve.

"That's what Detroit's always done to us, saying it was the Jordan Rules, that no other player on this team could hurt them. This is when you have to dig within yourself and step up and earn your respect."

1ST RETIREMENT

July 12, 1993
On the eve of baseball's All-Star Game, Jordan competes in a celebrity home-run derby.

Aug. 3, 1993
A decomposed body is found in Gum Swamp Creek, about 60 miles southwest of Fayetteville, N.C. Two days later, a Lexus is found near Fayetteville with the vanity license plate UNC0023 missing.

Aug. 13, 1993
Officials identify the body as that of James Jordan, Michael's father.

Sept. 7, 1993
Daniel Andre Green and Larry Martin Demery are charged with first-degree murder, armed robbery and conspiracy to commit armed robbery as suspects in the slaying of Jordan's father.

Oct. 5, 1993
Jordan throws out the first pitch at a White Sox game.

Oct. 6, 1993
Jordan announces his retirement from basketball: "I just don't have anything else to prove."

Nov. 6, 1993
In his first appearance at Chicago Stadium since his retirement, Jordan receives his championship ring.

The circus begins

Michael Jordan had seen 42 friendly pitches, swung at most of them and made contact on the ones he went after. A few were ripped sharply into the side of the net tunnel. A few.

But if the floor had been dirt instead of wood, the baseballs hit by the Greatest Basketball Player Ever would have dug a moat.

"I was nervous," Jordan said.

The White Sox put the refugee from Jerry Reinsdorf's other team into one of their uniforms and trotted him out for probably 200 reporters, photographers, videocam people and hangers-on at the Illinois Institute of Technology's gymnasium.

Joined by actual Sox players Mike Huff and Joey Cora, he threw, he fielded ground balls, he caught little popups (thrown, not batted) and, finally, he hit against Sox batting practice pitcher Mike Maziarka.

Larry Monroe, White Sox vice president in charge of scouting, is handsomely paid to make just these kinds of evaluations. So he made one.

"If he were 19 years old," said Monroe, "he'd be a first-round draft choice.

"He's not 19 years old."

And then, as cameras clicked and flashed, Michael Jordan signed a baseball contract that will let him begin spring training in Sarasota.

"It's just the idea of trying to see if I can do this," Jordan said. "I've got a lot to prove, to my friends and family—and certainly to my (late) father, who I know is still watching me. That's a good driving force."

Chances of him actually making it?

"As much improvement as he's made, this is still a million-to-one shot," Schueler conceded. "He's got to learn a lot in a hurry."

To Jordan, it's a no-lose proposition.

"Either I fail and I feel happy with my (effort), or I succeed," Jordan said. "One of the two's going to happen. I'm not afraid to fail.

"I didn't do it as a distraction. I'm not doing it as a media hog. Retirement is a stage of life when you get to choose to do whatever you choose to do. I chose to try to play baseball, just to see if I could."

He'll know soon enough.

BASEBALL

Jan. 13, 1994
A Bob Greene column runs on Page 1 of the Tribune in which Jordan makes his intentions clear regarding the White Sox: "I want to go to spring training for one reason, and that's to make the team. . . . This is no fantasy."

Feb. 7, 1994
Jordan agrees to a minor-league contract with the White Sox.

March 4, 1994
In his first exhibition game, Jordan taps out in his one at-bat.

March 14, 1994
After an 0-for-14 start to spring training, Jordan notches his first hit, a grounder off the third-baseman's glove. It's also the date on a Sports Illustrated cover with the headline "Bag It, Michael: Jordan and The White Sox Are Embarrassing Baseball."

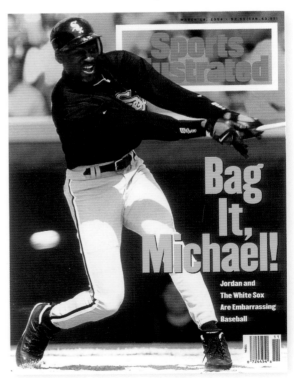

April 7, 1994
Jordan singles, doubles and drives in two runs to lift the White Sox to a 4-4, 10-inning tie with the Cubs in an exhibition game at Wrigley Field

April 8, 1994
Jordan debuts with the Birmingham Barons and goes hitless in three at-bats.

April 10, 1994
Jordan gets his first hits as a baseball pro, singling twice.

July 1, 1994
The Bulls announce that they will retire Jordan's number in November—and unveil a bronze statue of him outside the United Center.

July 30, 1994
Jordan hits the first home run of his pro career, then points to the sky as he crosses home plate, in tribute to his father.

Sept. 9, 1994
Jordan plays in the Scottie Pippen All-Star Classic—the final game at Chicago Stadium—and scores 52 points. He kisses the Bulls logo on the floor at game's end.

Nov. 1, 1994
Jordan's No. 23 jersey ascends to the rafters in the United Center—though it gets momentarily stuck halfway up.

Feb. 18, 1995
Day 1 of White Sox workouts during the players' strike. "I'm not here to break down what the players are trying to achieve," Jordan says.

March 2, 1995
Jordan stuffs his stuff into a Bulls duffel bag and leaves Sox training camp, after management said players would be moved to a minor-league clubhouse.

March 10, 1995
Jordan quits baseball, citing the sport's labor dispute's effect on his development.

THE RETURN

March 18, 1995
"I'm back."

March 19, 1995
Starting at guard . . . No. 45? Jordan plays 43 minutes and scores 19 points in his first game back, a 103-96 overtime loss at Indiana. "I really, truly missed the game," he says.

March 28, 1995
The Double Nickel. Jordan scores 55 points and dishes the game-winning assist in a 113-111 win at Madison Square Garden.

May 10, 1995
For Game 2 of a playoff series against Orlando, Jordan puts No. 23 back on. He scores 38 points in a 104-94 win.

May 18, 1995
Jordan shoots 8-for-19, scores 24 points and the Bulls' season ends with a Game 6 loss to Orlando.

July 1, 1995
The NBA locks out its players. The 80-day dispute ends in September.

Oct. 6, 1995
Jordan's first day of training camp since 1992. "I feel I can do basically the same things, but I'm more knowledgeable about myself and about the game," he says.

Oct. 23, 1995
Jordan and new teammate Dennis Rodman appear on the cover of Sports Illustrated. It is Jordan's 34th appearance, surpassing Muhammad Ali for most ever.

Nov. 3, 1995
Jordan scores 42 in the season opener.

Jan. 24, 1996
The Bulls, at 36-3, set a club record with a 27th straight win at home.

Jan. 28, 1996
Jordan scores 31 and the Bulls set a franchise record with a 15th straight win.

Feb. 11, 1996
In his first All-Star Game since 1993, Jordan scores 22 points in 20 minutes and earns game MVP honors.

March 7, 1996
Jordan hits 21 of 28 shots for an NBA season-high 53 points in a win over the Pistons.

April 12, 1996
The Bulls win their 68th game, surpassing the franchise record set in 1992.

April 16, 1996
Jordan shoots just 9 of 27 for 22 points, but the Bulls win an NBA-record 70th game anyway.

April 21, 1996
Jordan scores 26 as the Bulls end the regular season with 72 wins. Jordan (30.4 ppg) leads the NBA in scoring for a record eighth time.

May 20, 1996
Jordan wins his fourth MVP Award, getting 96.5 percent of the first-place votes, the highest percentage since media began voting in 1980–81.

May 27, 1996
Jordan scores 45 to exact revenge on Orlando for the previous year's playoff ouster, sweeping the Magic and gaining the NBA Finals.

June 16, 1996
On Father's Day, Jordan wins his fourth NBA title with the Bulls. Afterward, he brings the trophy to the dressing room, embraces it and weeps.

July 12, 1996
Jordan agrees to a one-year contract with the Bulls worth $30 million.

Jan. 21, 1997
Jordan once again torments the Knicks, this time scoring 51 points.

Feb. 9, 1997
Jordan posts the only triple-double in All-Star Game history—14 points, 11 rebounds, 11 assists—but Glen Rice is named MVP after scoring 26 points.

April 14, 1997
Jordan scores 30 and the Bulls reach win No. 69— but then lose their last two to miss back-to-back 70-win seasons.

April 27, 1997
Jordan explodes for 55 points in Game 2 of a first-round playoff series against Washington.

May 18, 1997
Karl Malone edges Jordan 986-957—no one else got a first-place vote—for Malone's first MVP Award. It was the second-closest voting since 1980–81.

NBA's Michaelangelo

Michael Jordan knew he was taking a chance when he returned to basketball last spring. He was playing with fate, he acknowledged, risking at least a ding to his considerable reputation and all but setting himself up for disappointment.

Up-and-coming NBA stars lined up to take his place, while the league secretly hoped that its next generation would make its mark.

But the future of the NBA will have to wait. The past is still present.

Jordan was named NBA MVP for the fourth time, surpassing former rivals Magic Johnson and Larry Bird, both of whom won three, and tying Wilt Chamberlain, who also won four. Bill Russell won five and Kareem Abdul-Jabbar won six.

Jordan received 96.5 percent of the first-place votes, the highest percentage since media began voting on the award in the 1980–81 season.

In his first full season back following an 18-month retirement, Jordan has proved that at 33, if he has missed a step, he's still a step ahead of everyone else.

In presenting Jordan his trophy, Bulls coach Phil Jackson quoted from his book "Sacred Hoops."

"(Coaching) Michael is like coaching Michelangelo, genius at work," Jackson said. "No one deserves this more."

Jordan averaged 30.4 points, 6.6 rebounds, 4.3 assists and 2.2 steals this season, and led the league in scoring for a record eighth season, surpassing Chamberlain. He said this MVP award ranks above the ones he won for the seasons of '87–'88, '90–'91 and '91–'92.

"I think this is more meaningful," Jordan said. "I learned a lesson that no matter how long you're away from the game or how great you were before you left the game, you can't just come back and think you can turn it right back on and take up where you left off."

June 11, 1997

In what would become known as the "Flu Game," a vomiting, dehydrated Jordan scores 38 points, grabs seven rebounds, dishes out five assists and hits the go-ahead three-pointer late in a series-shifting Game 5 win in Utah.

June 13, 1997

Jordan scores 39, grabs 11 boards, dishes to Steve Kerr for the game-winning jumper and then dances on the scorer's table after the Bulls win their fifth NBA title.

Aug. 28, 1997

After coach Phil Jackson signs a one-year contract, Jordan inks a one-year, $36 million deal.

Feb. 8, 1998

Jordan once again earns All-Star Game MVP honors.

April 18, 1998

Jordan drops 44 on the Knicks to seal his 10th NBA scoring title with 28.7 points per game.

May 18, 1998

Jordan wins his fifth regular-season MVP Award, tying Bill Russell for second-most in history.

June 14, 1998

In one of the most clutch performances in NBA history, Jordan scores 45 points in Game 6 against the Jazz for a sixth title. With the Bulls down three, he records a steal and two scores in the final 37.1 seconds, including "The Pose" after the shot over Bryon Russell—a 17-footer (with a bit of a push-off) with 5.2 seconds to go.

June 27, 1998

At his celebrity golf tournament in North Carolina, Jordan says he's "leaning" toward retirement.

SECOND RETIREMENT

July 23, 1998

Tim Floyd is announced as Bulls coach. Jordan previously was emphatic that he had no desire to play for anyone not named Phil Jackson or Dean Smith.

Oct. 13, 1998

NBA cancels first two weeks of the regular season.

Jan. 6, 1999

Owners and players reach agreement to end the lockout.

Jan. 13, 1999

Jordan announces his second retirement and says there's a "99.9 percent" chance it will stick.

THE WIZARDS

Jan. 19, 2000

Jordan joins the Washington Wizards as part owner and president of basketball operations.

April 19, 2001

Jordan hires Doug Collins, his former coach with the Bulls, to coach the Wizards.

Sept. 10, 2001

Jordan says he will make a decision about his future within 10 days.

Sept. 25, 2001

At 38, Jordan unretires again and joins the Wizards as a player, signing a two-year contract and donating his salary to relief efforts after the 9/11 attacks.

Oct. 30, 2001

In his first game as a Wizard, Jordan scores 19 points on 7-of-21 shooting in a loss to the Knicks.

Jan. 4, 2002

Juanita Jordan files for divorce. One month later, the Jordans jointly withdraw the divorce case.

April 2, 2002

Jordan plays 12 minutes and scores just two points in a loss to the Lakers. The next day he's placed on the injured list, ending his season.

Oct. 30, 2002
Jordan comes off the bench for the Wizards, scores just eight points in 25 minutes and botches a late breakaway dunk attempt.

Nov. 28, 2002
Jordan announces that he will retire for a third time after the 2002–03 season, saying there is "zero" chance of another return.

Jan. 24, 2003
In his final professional game in Chicago, Jordan receives a four-minute standing ovation during player introductions. "I love you all very much," he tells the crowd before scoring 11 points for the Wizards in a 104-97 loss to the Bulls.

Feb. 9, 2003
Jordan scores 20 points in his final All-Star Game, becoming the all-time leading All-Star scorer. He takes Vince Carter's starting spot after Allen Iverson and Tracy McGrady offered theirs.

April 11, 2003
The Miami Heat retire Jordan's No. 23 even though he never played for the team.

April 16, 2003
In the final NBA game of his career, Jordan scores 15 points on 6-of-15 shooting in a 107-87 loss to Philadelphia. He leaves the floor with 1:45 left after a fourth-quarter curtain call. "I'm a guy who loved the game," Jordan says afterward.

LAST RETIREMENT

May 7, 2003
The Wizards fire Jordan as president of basketball operations.

June 15, 2006
Jordan becomes part owner of the Charlotte Bobcats and becomes, according to the team, "Managing Member of Basketball Operations."

Dec. 29, 2006
Jordan and wife, Juanita, divorce after 17 years of marriage. Juanita reportedly receives a $168 million settlement.

May 2, 2007
In a pro-am round at the Wachovia Championship in Charlotte, Jordan plays with Tiger Woods. "This is great, no one knows I'm here," Woods says on the 10th tee.

January 2008
Nike rolls out the 23rd edition of the Air Jordan basketball shoe.

April 28, 2008
Jordan hires Larry Brown to coach the Bobcats.

April 6, 2009
Jordan is elected to the Basketball Hall of Fame class of 2009.

<·· **Sept. 11, 2009**
Jordan is officially inducted into the Basketball Hall of Fame.

Michael Jordan

'WHATEVER I HAD TO DO TO WIN'

23, 45 SHOOTING GUARD
1984–1993, 1995–1998

A STAR FROM THE START

The first signs came during the 1984 Olympic Games.

Bobby Knight didn't yell at him.

And when the Games were over and the U.S. team, led by Michael Jordan, had won the gold medal, the coach of Spain's team, Antonio Diaz-Miguel, was astounded.

"Everybody goes up and comes down," he said. "Jordan, he stays up."

The legend of the man who would fly was beginning, and finally a franchise that had its wings clipped some years before was about to take off.

Michael Jordan had hair back then, but mostly he had air.

The Bulls knew they had something special in the young star from North Carolina, although they had no idea how special Jordan was.

Kevin Loughery and Rod Thorn were perhaps the first ones to really know, the first ones who truly understood that Jordan might be the greatest basketball player the world had even seen.

It's not like Jordan wasn't a near-superstar already when he arrived for Bulls training camp in October 1984.

Jordan, who had exploded on the national collegiate basketball scene at North Carolina after growing from a lightly recruited player who couldn't make the varsity as a high school sophomore, had hit the shot that won the 1982 NCAA championship for North Carolina over Georgetown.

"I get tired of people coming up and asking me about 'The Shot,'" Jordan would complain afterward about the first of many such shots that remain fixed in the minds of basketball fans everywhere.

When Jordan finally joined the Bulls after winning a gold medal in the 1984 Olympics and being drafted third overall behind Hakeem Olajuwon and Sam Bowie, he still was believed to be an All-Star someday. Not *the* All-Star.

But then those first practices started and Loughery, then the Bulls' coach, and Thorn, then the general manager, watched in amazement. Jordan would take

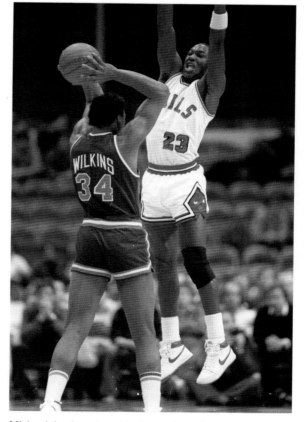

Michael Jordan played in front of small crowds at Chicago Stadium early in his rookie season.

the ball, dribble past three or four players and then dunk. He'd split or jump over double teams. He could get to the basket whenever he wanted. And he could hit a jump shot.

He couldn't be stopped.

Loughery and Thorn just looked at one another and smiled.

Jordan couldn't save their jobs; both were gone in a year when the Jerry Reinsdorf group purchased the Bulls. But Jordan certainly saved basketball in Chicago.

> **"Everybody goes up and comes down. Jordan, he stays up."**
>
> —SPAIN'S ANTONIO DIAZ-MIGUEL

In the 1983-84 season, the year before Michael Jordan was drafted, the Bulls drew an average of 6,365 fans per game to the Chicago Stadium. In 1984-85, Jordan's first season, the average rose to 11,887. By 1986-87, it was up to 15,871.

The Bulls had been a moribund and troubled franchise since the Bob Love, Jerry Sloan, Norm Van Lier, Chet Walker days of the 1970s. In the years that followed, the Bulls only made news when they were explaining bad draft picks, discussing players in trouble or rationalizing losing seasons.

They qualified for the coin flip for the No. 1 pick in 1979 and called wrong, getting David Greenwood instead of Magic Johnson. By 1984, they had about hit bottom.

So they started selling Jordan.

After scoring 16 points with admitted jitters in his first game, shooting 5 for 16 and making five turnovers, Jordan scored 37 points in his third game, and 45 with 10 rebounds in his ninth game. He also began what would become almost a trademark of payback games with 30 points and eight assists against the Portland Trail Blazers, who had bypassed him in the draft for Sam Bowie.

Jordan was an instant phenomenon; the Bulls began selling out on the road. Home attendance the season before Jordan arrived averaged about 6,300. It doubled in Jordan's first year, and after 1987 you couldn't buy a ticket to a Bulls home game.

TRIALS AND TURBULENCE

But controversy accompanied his greatness. In Jordan's first All-Star Game in 1985, Jordan scored seven points on 2-for-9 shooting. Isiah Thomas and Magic Johnson were said to have persuaded his teammates to freeze out Jordan because they thought he was showing them up by wearing different apparel and jewelry to the slam-dunk competition.

The publicity created rifts that took years to heal. But Jordan's ascent could not be stopped.

He was Rookie of the Year over No. 1 pick Olajuwon and it seemed like smooth sailing, but that quickly changed and Jordan suffered through the worst season of his NBA career.

The Bulls opened 1985–86 with wins over Cleveland and Detroit and were on the way to beating Golden State when Jordan suffered a broken foot. He would miss 64 games, but return for one of the most electrifying performances of his career, the one that catapulted him to NBA greatness.

It left Larry Bird calling him "God disguised as Michael Jordan." It was when Jordan hit a strong Celtics team for 63 points in a playoff loss.

But that season also began the feud between Jordan and Bulls management that would cost coach Stan Albeck his job.

Jordan wanted to return from his injury, but doctors told the Bulls that Jordan could hurt his foot again, and he was too valuable an investment to risk. The Bulls said he should sit out all season. Jordan accused the team of trying to lose to get a better draft pick.

Eventually a compromise was reached in which Jordan would play limited minutes. Albeck sided with Jordan.

During one game, after management criticized him for not taking Jordan out at his allotted time, Albeck lifted Jordan in the midst of a Bulls comeback with just seconds left. It proved a major embarrassment and would lead to the hiring of Doug Collins as coach.

Under Collins in 1986–87, Jordan was unstoppable and perhaps his most spectacular. On opening night

in New York he had 50 points to signal what kind of season it would be.

Jordan would average 37.1 points per game, his career best. Only Wilt Chamberlain had averaged more in a season.

The Bulls again were swept by the mighty Celtics in the playoffs as Jordan averaged 35.7. It would be the end of his playoff failures, if not his frustration.

It might be said Jordan became the complete player in 1987–88. He would win the MVP Award, his first of five, and also be named Defensive Player of the Year, thus being acknowledged as the best offensive and defensive player in the game.

He averaged 35 points for the season and showed that he was done losing opening-round playoff series. Against a talented young Cleveland team, Jordan scored 50 points in Game 1 and 55 points in Game 2, giving the Bulls enough cushion to hold off the Cavs in five games before they dropped a six-game series to the Detroit Pistons, who would become the Bulls' nemesis.

The Pistons would haunt Jordan and the Bulls for the next three years, denying them every season with their terroristic tactics and talent.

Yet Jordan only seemed to get better. In 1988–89, something of a breakthrough season for the Bulls, Jordan averaged eight rebounds and eight assists along with 32.5 points, the closest he would come to averaging a triple-double.

But the highlight of the season was the opening-round playoff series against the Cavaliers. They finished the season 10 games ahead of the Bulls, and on the last day of the season in a game at Chicago, Cleveland played only its substitutes and the Bulls their starters. The Bulls were written off after the Cavs won easily.

But Jordan scored 44 points in Game 3, 50 points in Game 4 and 44 points in the deciding Game 5 at Cleveland, including the much-shown "Shot" over Craig Ehlo to win the game at the buzzer.

The Bulls went on to beat the favored Knicks as Jordan hit them with 40 and 47 points in Games 3 and 4, but again they fell to Detroit in six games.

Jordan chafed at criticism that he was merely a great scorer and not a great player because great players won championships and made their teammates better.

It would take another year and the tutelage and guidance of new coach Phil Jackson, who took over for the 1989–90 season.

The Bulls would get to the seventh game of the Eastern Conference finals against the Pistons, winning every game at home easily behind superior youth and athletic ability. But they were unable to overcome Detroit's experience and guile.

They were getting close and they knew it, and when they won 17 of 18 coming out of the All-Star break in 1991, Jordan began to sense something.

The Bulls blew though the playoffs, casting the Pistons aside in four games. At long last, the bully had been beaten down.

The Bulls were on their way to becoming champions and Jordan was the king, and it would stay that way until he decided otherwise.

A BIGGER HILL TO CLIMB

The gratification in winning the 1991 NBA championship was exquisite. Getting past the Detroit Pistons in the Eastern Conference finals that year was critical in so many ways, and for the Bulls it signaled their coming of age.

The Bulls had the ability to go all the way, that much was clear. Now they had the confidence they needed to roll past the Lakers. And oh, did they have the legs.

Young and strong and sure, the sight of Jordan, Pippen and Horace Grant—all of 28, 25 and 25 years old, respectively—steaming down the court in transition was one to behold. And the Lakers, after a momentary blip in Game 1, simply got out of their way.

By then Jordan had learned not only that it was necessary to get his teammates involved if the Bulls were to win a championship, he figured out how to do it. It was almost too easy in that fifth and deciding game as he pulled up to the right wing, swung around and found the ever-waiting, ever-dependable John Paxson, who scored 10 of his 20 points in the fourth quarter to seal the victory.

No, the real challenge would come in repeating.

Physically, the Bulls still had the tools. The core would remain the same and establish its dominance over the rest of the league that was staggering. Night after night, an imposing defense assistant coach John Bach dubbed "the Doberman Defense" would convert turnovers into easy fast-break buckets and routine games into halftime blowouts.

Michael Jordan walked away from the Bulls and the NBA twice, but his love of the game—and his ultra-competitive nature—compelled him to return.

The tough part for the Bulls was mentally steeling themselves for the rigors of another long season and their first experience at being the hunted.

Along the way, the Bulls learned that not only did their own fans anticipate victory but fans in other cities demanded a show. "We've somehow created the expectation that you might see something memorable every night," coach Phil Jackson said.

Injuries to Bill Cartwright and Paxson served as a harness on a season that seemed destined for 70 wins. Along the way, Jordan experienced the exacting price of fame.

For the first time, he felt the sting of media criticism. First there were reports that he was unenthusiastic about playing on the 1992 Olympic team, reports he later acknowledged were intended to throw reporters off his trail.

Then there was his decision to skip the Bulls' visit to the White House, for which Grant took Jordan to task. The publication soon after of "The Jordan Rules" by the Tribune's Sam Smith exposed Jordan to unprecedented scrutiny.

At the 1992 All-Star Game, Jordan said he'd had nightmares about falling from grace. "Something has happened," he said. "I've done something wrong. Maybe I'm on drugs or something. But the attention around it is amazing. There are stories that say: 'I knew he was going to take a fall.' It's like they've been waiting for it and now it's here."

NBA Commissioner David Stern lectured Jordan in March 1992 for associating with those of "questionable character" after four checks totaling $165,000 from Jordan ended up in the hands of a convicted drug dealer and a slain bail bondsman who had been suspected of laundering drug money.

But as he would when other off-court problems surfaced, Jordan confronted the situation and publicly tried to make amends. "I was naive," he said at the time. "This was my most maturing season because you learn a lot about yourself and a lot about life; how to deal with negative situations."

On the court Jordan redefined himself as a superstar during this three-year period, developing not only into a legitimate team player but contributing signature individual moves that will never be forgotten. From the midair, hand-to-hand switch and basket over the heads of the Lakers in Game 2 of the 1991 Finals, to "the shrug" after nailing six three-pointers against Portland in Game 1 of the 1992 Finals, Jordan compiled a highlight reel of unbelievable clutch performances in championship conditions.

When the Bulls won their first championship in Chicago, completing a six-game triumph over Portland, we saw Jordan in unabashed glee, leading an impromptu line dance on the scorers table and wickedly flashing three fingers in a gesture we would see repeated time and again.

When he melted into a giant red jumble on the Phoenix Suns' court a year later, Jordan was exhausted. Another psuedo-gambling scandal had robbed him

of patience and another 82-game season of emotional energy. A month later, heartbroken at the murder of his father James, Jordan believed he knew what to do.

"I had lost the fun," he said.

Earlier that year Jordan told teammates that this would probably be it for him, and they laughed.

"You'll see," he warned them. "One day you'll turn around and I won't be here anymore."

DRIVEN TO THE EXTREME

As the mountain gets higher, it gets steeper and the climb becomes tougher. Jordan's play and records would often be overshadowed by feuds with teammates and management. He liked to deride Will Perdue as "Will Vanderbilt" for play he said was not worthy of a Big 10 school, and he mocked general manager Jerry Krause's physique and publicly said he'd be a better general manager. Jordan also had uncomfortable meetings with league and law-enforcement officials.

His world was becoming a fishbowl.

Once, during the 1990 playoffs when Jordan had stopped talking to the media, James Jordan had stopped a few reporters to try to explain for his son. "He's not mad at you guys," James said. "He's upset with his teammates. He's not sure they're trying as hard as he is and want what he wants. He's so frustrated. He just wants to win so badly."

Much has been excused in that pursuit, but that is Jordan.

As a rookie, he befriended teammate Rod Higgins, who was a good table tennis player. So Jordan bought a table for his basement so he could practice in order to beat Higgins.

Even weightlifting became a competition to him. Jordan ended up working out on his own so as not to end up in weightlifting bets with his teammates.

His betting habits have been well-chronicled in the media, and Jordan would delight in taking a few dollars from a coach or teammate wagering whether he could make baskets from different, odd positions.

He was driven by his personal competitive demons, which sometimes made him hugely unlikable. He could be cruel to teammates, piercing their egos with the knowledge he was superior. He called them his "supporting cast" and rarely hesitated to mention how many points he scored and who missed crucial fourth-quarter shots.

Yet, at the same time, Jordan could be compassionate and sensitive. He often cried at the sight of some of the terminally ill children who came to see him through programs like Make-a-Wish. And it was why Scott Williams broke down and cried during Jordan's session with his teammates before the press conference following the first retirement. Jordan had comforted and befriended Williams when Williams was going through difficult times as a rookie in dealing with the murder-suicide of his parents.

Jordan could be endlessly kind with his time for those in wheelchairs who attended Bulls game.

Of course, his moods and humor could and would change dramatically.

Angered one time when reserve Charles Davis had gotten a first-class seat on a team flight when Jordan, because he lacked seniority, was asked to sit in coach, Jordan taunted Davis unmercifully afterward.

Few could trade locker-room barbs with Jordan. He spared no one and hazed young players mercilessly and relentlessly. "Hope there's a jump shot in that box," Jordan would taunt when the poor-shooting Stacey King walked into the locker room with a package. But few could show the unending patience with wave upon wave of usually fawning media.

And no one could produce like Jordan, especially when the pressure was most intense and the spotlight the hottest. He always wanted the ball, and his teammates were glad to surrender it with the game tied in the fourth quarter.

Jordan's smile was electric and his eyes did seem to dance when he was around the game and the guys. He tired of it considerably since the first title and had to work harder to do what he always had found so natural. Yet the crowds only grew larger and the demands, if not the expectations, greater. Yet rarely was anyone disappointed.

At an exhibition game in Florida with 20,000 in attendance, Jordan, sore and bothered by some nagging injuries, didn't feel much like playing. But they had come for him—only him—and everyone, including Jordan, knew it. So he went out, hammered down a few dunks, winked, smiled and sat down.

"I had to," he explained about the performance. "They were expecting it."

No one was expecting what came next.

A RAGING FIRE REDUCED
TO EMBERS

Having **tired of the NBA grind** and the
seemingly endless string of controversy that fol-
lowed him and the Bulls for the previous two years,
Jordan shocked the world by announcing his retire-
ment from professional basketball in October of 1993.

The final blow was the death of Jordan's father,
who was also Michael's best friend. James Jordan was
murdered in July in an apparent robbery.

Perhaps the greatest player in NBA history, at age
30 still in his prime, decided to cut short his career
after nine professional seasons.

A week before the announcement, Bulls owner
Jerry Reinsdorf was asked if he expected Jordan to
finish the remaining three years of his contract.

"I don't know if he'll play the whole three years,"
said Reinsdorf. "But h''ll make the right decision. All I
care about is if he makes the right decision.

"It has been a privilege for all of us to watch him
play. It must have been like watching Babe Ruth play.
Sometimes I wonder if we don't get used to it. He's go-
ing to go at some point. I just hope he goes at the right
time for him, and not too soon."

When Jordan first retired from the NBA, he was
leaving pro basketball while on top of the game. He
departed with streaks of seven scoring titles and three
NBA championships.

He retired as the league's all-time scoring-average
leader at 32.3 a game. He also held the playoff scoring
records for three-game and five-game series and the
records for all-time playoff and All-Star Game scor-
ing averages. In addition, he was named to six straight
All-Defensive first teams.

The explanation was Jordan had done all he could
do and was no longer motivated. But the widespread
belief was Jordan was burned out and needed a rest
and would return someday, maybe even in time to
christen the new Chicago Stadium set to open in 1994.

But much had begun to change in that year before
he walked away, if only in subtle ways. It was in Game
5 of the 1993 finals against Phoenix, and Kevin John-
son stole the ball from Jordan to force a sixth game.
Those things didn't happen a few years earlier. Jordan
simply would split double and triple teams and dunk.
Jordan was needing to work two or three times as

hard as he ever did to accomplish what he always had.

Would Jordan return and, while undoubtedly re-
maining the game's best player, risk falling far short of
his own brilliant standards? He eventually did. Twice.
One return produced three more championships and
countless indelible moments. The other, performed in
the colors of the Washington Wizards, served only to
remind us how much he—and we—had lost.

The first phase of his career—before the initial re-
tirement—was arguably his best, and it went by in a
brilliant blur.

The next phase took him in a completely different
direction.

'IT'S SOMETHING THAT
USED TO BE'

A teller of tales could never have invented
it. As the sports world turned its attention to
the NBA playoffs in the spring of 1994, the man who
wasn't there—the Most Valuable Player in the previ-
ous three NBA Finals, the best player in the history
of the game, the player who led his team to the world
championship the year before, and the year before
that, and the year before that—passed the time on
an impossibly muggy afternoon in South Carolina,
with the promise of the unrelenting heat of summer's
long months stretching ahead of him, and, more im-
mediately, a game against the Greenville Braves of
baseball's Double-A Southern League scheduled for
sundown.

Michael Jordan was now a minor-league baseball
player.

"I guess maybe people believe me now, huh?" Jor-
dan said as he sat in the cramped-to-absurdity club-
house—really a free-standing wood-walled hut at the
far end of the left-field foul line. His teammates on the
Birmingham Barons edged past each other, and past
Jordan, to line up before industrial-sized tins of Pe-
ter Pan peanut butter on the meal table, where three
Honey Buns, sticky to the meltdown point inside their
plastic wrappers, awaited takers. Some of the Barons
were just a few years out of high school, kids who
grew up with posters of Michael Jordan on their bed-
room walls.

"Now don't go knocking minor league food,"

Jordan said, laughing. "I like the food down here. Steak and eggs, everywhere I go. I'm eating more grits than I ever ate in my life. Tell me where I'd get grits in Cleveland."

Cleveland being the Bulls' first-round opponent in the NBA playoffs that season. Cleveland being the basketball team that Jordan inevitably led the Bulls past on their way to the heights. On this day, highlights from the just-completed NBA regular season flickered on a TV set in the visitors' locker room at Greenville Municipal Stadium; Jordan did not look. Just around the corner from his locker were a washing machine and a dryer, for the visiting athletes to wash their uniforms.

"You know, I find myself watching the White Sox on TV more than I find myself watching basketball," Jordan said. The White Sox, during spring training, decided that Jordan was not good enough for the major-league squad; rather than walk away, he willingly went down to the minors to try to prove he could make himself learn these skills. "Isn't that wild? When I see the White Sox on TV, I know those guys, and I want to be with them again. It's the same for all of us on the Barons—everyone wants to make it to the White Sox—but with me, I watch them on TV, and it's like a goal, to earn the right to be with them again."

Extraordinarily loud music, the pleasure of very young men, pulsated through the tiny quarters. Jordan turned his back to the sound. The death of Richard Nixon, and the national debate over his legacy, had been in the news in recent days. Jordan said he was noticing something instructive in the aftermath of the former president's death.

"Maybe, when you die, people forget the adversities in your life," he said. "Maybe when you die they are willing to remember the good things . . . "

He stopped himself. "I don't know," he said. "There's still only one death I can think about. I can talk about what other deaths mean to me, but the fact is, no death means anything to me, other than my father's death."

His manager—his new boss—Terry Francona walked by, and gave Jordan a friendly tap on the shoulder. Jordan waved hello. He said that when he happened across basketball highlights on TV, it all seemed very distant to him.

"Like old times," he said. "Like how your world once was. You don't really know it anymore. It's something that used to be."

Still, he said, he felt more than a little melancholy that the Chicago Stadium would be closing forever, while he was away on this unlikeliest of odysseys.

"I do kind of wish I could get to see it once more," he said. "If I get back to town before they tear it down, I think that some of the guys who work there would let me in. I'd just like to walk around in there by myself. Just walk around and think. One more time."

'I'M BACK'

The words did not have to be eloquent or poetic. They did not even have to be spoken, and weren't.

They came in a crisp, two-word fax.

"I'm back."

And from Bulls coach Phil Jackson, this classic understatement: "Today, Michael Jordan was activated as a Chicago Bull."

Activated, indeed.

The baseball labor dispute had stretched into its eighth month, putting spring training on hold and putting Jordan in a difficult and unaccustomed position—bored and inactive. He had made some progress on the diamond, including a memorable performance in an exhibition game at Wrigley Field in which he had two hits, but it was clear that Jordan was not major-league ready.

Before long, Jordan was spotted at the Bulls' practice facility, sparking rumors that he was considering a return to the NBA.

The fax on March 18, 1995, confirmed it.

Immediately, the expectations for a rather mediocre Bulls team suddenly brightened. Just three games above .500, the Bulls now headed into their final 17 regular season games with a real shot at contending for a fourth NBA title.

Jordan, now wearing 45, the same number he had worn as a baseball player, returned to the court in Indianapolis for a game against the Pacers on March 19.

He was back.

Well, at least halfway back.

Jordan shot an uncharacteristic 7-for-28 in his return and the Bulls lost 103-96. But soon he would find his groove again, scoring 55 in a memorable game against the Knicks in New York. He helped the Bulls win a first-round playoff series against Charlotte, but

In his first home game following his initial retirement, Michael Jordan stands with his head bowed during the National Anthem on March 24, 1995. The Bulls lost 106-99 to the Magic, the same team that would later end their playoff run and spoil Jordan's comeback.

couldn't get them past a strong Orlando Magic team in Round 2.

"I'm happy I came back. I'm disappointed we lost, but I still love the game and still want to win championships," Jordan said.

"I've got that same hunger," he said, "and I'm willing to put forth the effort to make this team better and help this team get back to where it was. I'm only thinking about winning. Money comes and goes. The history books you don't forget. My dream was for coming back and I can only look forward to next season."

The Bulls were finished for the year and there was some thought that they might be finished as title contenders for the foreseeable future. Some observers thought it was time to break up the team, maybe even trade Scottie Pippen, in order to get Jordan a better "supporting cast."

But the Bulls weren't finished because Jordan wasn't finished being Jordan.

ANOTHER THREE AND OUT

Jordan's return resulted in three more championships for the Bulls, two more MVP awards for him and a record-setting 72-win regular season. The Bulls were once again the NBA's gold standard, and Jordan reclaimed his role as supreme ruler of the court. He reimagined his game, refined his fade-away jump shot and often relied more on guile and experience than explosive athleticism—though he still had plenty of that left to call upon when needed.

A new cast of characters arrived to help carry the load. The addition of Dennis Rodman as a rebound hound brought an element that had been missing since Horace Grant's departure. European import Toni Kukoc proved to be a valuable role player and scoring option. Steve Kerr took John Paxson's place as the designated spot-up shooter from long range.

It was another magnificent run—for Jordan and the Bulls—but as the team was marching toward a second three-peat, there was a growing sense that the dynasty's days were numbered.

The Bulls were still celebrating their sixth title when Reinsdorf requested a meeting with Jordan.

Jordan hadn't been taking Reinsdorf's telephone calls, but finally Jordan asked if Reinsdorf would come to Jordan's Near North Side office.

Reinsdorf had the same question everyone else did in Chicago, though it was somewhat more important that he know the answer: Would Jordan play another NBA season with the Bulls or retire?

"I talked to him on the plane coming back from Utah," Reinsdorf said, recalling the aftermath of the posed final shot that was Jordan's goodbye wave to the NBA. "He said he never was so tired in his life. He said it was his hardest year and he felt he had to carry the team in the Finals more than he'd ever had. He was totally exhausted, mentally and physically.

"When I talked to him (in late June), he said if he

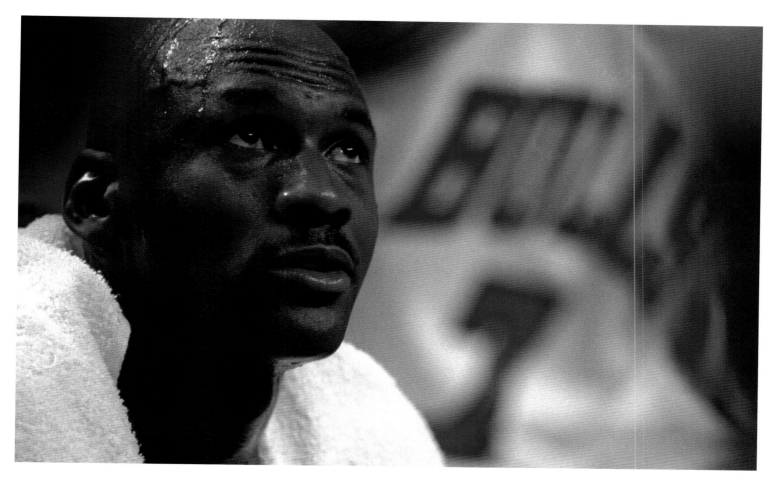

did come back, he thought we could have won again. But he said he wasn't coming back. I don't know what we could have done to have kept Michael playing another year. And without Michael, we weren't going to win the championship.

"Michael never said anything to me other than, 'I'm done playing. This is it.'"

And so, their dynasty ended.

The Bulls had been preparing for the end, even before Jordan made a definitive announcement.

"Every time Michael would play golf with someone I knew, they'd call me and tell me his plans, and it always was the same," Reinsdorf said. "There was no way Phil Jackson was going to coach another year. He'd been telling me for two years this was the end. And Michael told me (at their June meeting) even if Phil came back he doubted very much he'd play. But then people were saying with a short season he might play."

The plan's origins dated to 1998, when Reinsdorf sensed the end was near.

"First of all, when we made the decision a year ago to keep the team intact, we knew the price of going after a sixth championship: We wouldn't be able to get value in trading our players for current talent," Reinsdorf said. "We gambled, and the gamble paid off. We won the sixth championship."

Reinsdorf refuted a rumor that Jackson would have been willing to stay on if he'd been given general-manager's responsibilities.

"Phil never asked me for more control," Reinsdorf said. "I always said he was the best coach in the NBA. He always said he was the best coach for this team."

But was Jackson nemesis Jerry Krause the best general manager? More specifically, if Krause were gone, would Jackson and Jordan have come back?

"I don't think Phil was coming back under any circumstances," Reinsdorf said. "And Michael a year ago told me, 'I have to reluctantly admit Krause has done a good job.' I said, 'Why don't you say that publicly?' He said, 'I can't. I don't like him.'

"The fact is, Jerry built two championship teams around Michael with all the role players, especially the last three years," Reinsdorf said. "As great as Michael Jordan was, he wouldn't have won any championships unless he was surrounded by the right guys."

But they won six. Could they have won more?

"The problem was how do you know when it's the end?" Reinsdorf said. "What I say now is, 'Enjoy that we won six titles in eight years and understand it doesn't happen.'

"This was a special team led by the greatest player of all time who would not be beaten. Clearly, this was

Michael Jordan told Jerry Reinsdorf that he was mentally and physically exhausted after his final season with the Bulls. "He felt he had to carry his team in the Finals more than he'd ever had," Reinsdorf said.

a dynasty that will be written about and talked about for years to come."

The joy of six titles was immeasurable, a bounty of championships few cities ever experience. Still, the ending was as painful as it was inevitable.

"Am I sad? Absolutely," Reinsdorf said. "On the one hand it's sad to see it come to an end, but on the other I'd rather that way than see us defeated. As a fan you have to really like that Michael retired as the equivalent of the undefeated heavyweight champion of the world.

"By retiring, the legend grows and grows and people will say we could have won nine, 10 championships in a row if he'd stayed," Reinsdorf said. "And the fact is we wouldn't have. The dynasty would have ended some day with somebody defeating us. Now we can say the dynasty ended because we were done."

AN AIR OF FINALITY

Jordan said the words everybody expected but nobody in Chicago really wanted to hear or believe.

"I am here to announce my retirement from the game of basketball," he said.

It wasn't as shocking or as dramatic as the first time Jordan walked away from the game. And unlike his announcement five years before, Jordan's words had an air of finality to them, although he left a sliver of hope for those who were not yet ready to let him go.

"It's not really 100 percent, but it's close," he said. "That's where I stand. I'm not going to say never. But I will say 99.9 (percent)."

In January 2000, Jordan got back in the game as the Wizards president of basketball operations, a

JORDAN'S STATEMENT

Well, we do this again for the second time.

I was telling my wife coming down, I felt like I was getting married. I guess the first and foremost thing that I want to do and I think everybody here, today is not just a day for Michael Jordan.

I think there's a lot of other serious things happening in the world. I think I wanted to take time out from my family and hopefully from you guys to give condolences to the officer that was killed in action who so happened to have his funeral presentation today at the same time, which is kind of unfortunate, and I think that puts a lot of things in perspective in terms of what life is really about.

My responsibility has been to play the game of basketball and relieve some of the pressure of everyday life for people who work 9 to 5, and I've tried to do that to the best of my abilities.

I think what's happened with his family and certainly the unfortunate circumstances that happened, I'd like to pass on my condolences from my family to his, and I'm pretty sure you guys mean the same thing.

I am here to announce my retirement from the game of basketball. There won't be another announcement to baseball or anything to that nature. I think

everyone has their own reasons. There's been a lot of speculation in terms of why. I'm pretty sure I could speak to that point once you guys get to ask questions.

I want to say thank you to both of the gentlemen here. Mr. Stern and Mr. Reinsdorf for presenting me with the opportunity to play the game of basketball and certainly giving me the opportunity to come to Chicago and meet my beautiful wife and build a family here and my family in North Carolina and a lot of my friends who came up here to support this day and who supported me once I stepped on the basketball court and even when I didn't play on the basketball court.

I want to say thanks to both those gentlemen and to all the fans in Chicago for allowing me to come here and they've adopted me to be one of theirs, and in response I've tried to step on the basketball court and get rid of the gangster mentality that Chicago was known for a long time. I think successfully, myself and my teammates and the whole organization has made an effort to change the perspective about Chicago. And we're hopefully going to be known as a championship city.

I hope it continues on even when Michael Jordan is not in uniform. I will support the Chicago Bulls. I think

piece of team ownership in his pocket. This was the king of the NBA finally taking his rightful place on the throne. Most everybody felt good about it, including owner Abe Pollin, who would enjoy the fruits of Jordan's presence until distrust on both sides poisoned their relationship.

The nation's capital was positively elated about Jordan's arrival, especially with the juicy idea that MJ could, might, pretty please don a uniform and come out of retirement. It was the tantalizing possibility that wouldn't go away.

Finally, after more than a year of sitting around his Wizards office, Jordan announced in September 2001 that he indeed was going to play again.

Jordan joined a rag-tag Wizards team loaded with rookies and castoffs. At 38, he was six years older than the next oldest player on the team, center Christian

Laettner. Jordan played two seasons in Washington under his former Bulls coach Doug Collins, averaging 23.7 points the first year and 19.5 points in the next—not too shabby for someone who was closing in on 40 and had sat out for three years—but he couldn't will the Wizards into the playoffs.

It wasn't supposed to end like that.

Jordan had written the perfect goodbye to his playing career with that game-winning, title-clinching steal-and-shot in Utah. He even framed it with a pause and a pose.

This last goodbye seemed inadequate and unbefitting for the man many say was the greatest ever to play the game.

At his Hall of Fame induction in 2009, Jordan nearly trash-talked his way through his acceptance speech, thanking all those slights—real and perceived—for

the game itself is a lot bigger than Michael Jordan.

I've been given an opportunity by people before me. To name a few: Kareem Abdul-Jabbar, Dr. J, Elgin Baylor, Jerry West, these guys played the game way before Michael Jordan was born. And Michael Jordan came on the heels of all that activity. And Mr. Stern and what he's done for the league and gave me the opportunity to play the game of basketball.

I played it to the best that I could play it. I tried to enhance the game itself. I've tried to be the best basketball player I could be. And next thing you know, here we are as a league. I think the league is going to continue on although we've had our troubles over the last six months. I think that's a reality check for all of us. It is a business but yet it's still fun, it's still a game and the game will continue on.

Once again, I've had a great time. And I can't say enough for the people who've supported me and my life will take a change. And a lot of people say, "Well, Michael Jordan doesn't have any challenges away from the game of basketball." Well, I dispute that.

Being a parent is very challenging. If you have kids you know that. I welcome that challenge and I look forward to it.

I will live vicariously through my kids as they play the game of basketball. If they don't, I will support that. My wife and I will do the same. We will do what we can as parents to make sure that happens.

That's the challenge that I have in front of me and I look forward to it.

Unfortunately, my mother, my family, my brothers and sisters could not be here. But as you see me, you see them. My father, my mother, and certainly my brothers and sisters, so they are here through me. They along with myself say thank you for taking me in and showing me the respect and certainly the gratitude that you have shown me over the years that I have been here.

I will be in Chicago for my career hopefully and for the rest of my life. My wife won't allow me to move anywhere else. So I will be in Chicago and I will support the Chicago teams. And that's all I really truly have to say. I thought of saying just two words: "I'm gone." But I figured I owe the fans and certainly the media a little bit more than that. So that's one of my reasons for being here.

I guess Jerry (Reinsdorf) wants to speak first before David (Stern). I pass it over to Jerry.

"I played it to the best that I could play it. I tried to enhance the game itself. I've tried to be the best basketball player I could be."

adding "wood to the fire" and motivating him in his unparalleled career.

Almost no one was spared in his mostly good-natured remarks:

- Legendary North Carolina coach Dean Smith for forbidding Jordan, then a freshman, to pose for a magazine cover.
- Leroy Smith, whom Jordan invited, for making the Wilmington (N.C.) E.A. Laney High varsity over him and the coach who made that decision: "I wanted to make sure he knew, 'You made a mistake, dude.'"
- The Hall of Fame for raising ticket prices for his induction.
- Reinsdorf for putting him on a minutes limit when he returned after breaking his foot in his second season.
- Krause for his infamous quote about organizations, not players, winning championships. Jordan did add: "The whole Bulls organization did a great justice for me and my teammates."

- Pat Riley. Isiah Thomas. Jeff Van Gundy, whom he called "the little guy." Bryon Russell. And many others.

"Thank you so much for giving me that motivation that I desperately needed," Jordan said. "I always did whatever I had to do to win."

Jordan cried as he first took the stage. He thanked his family, crediting them for providing much of his competitive spirit. He called his mother, Deloris, "a rock" and "an unbelievable woman."

This sentimental side matched Jordan's mood earlier in the day, when he tried to deflect accepting the title of the Greatest of All Time.

"When people say that, I cringe a little bit," Jordan said. "I never played against Jerry West. I never played against Elgin Baylor. I never played against Wilt Chamberlain."

Then came a brief pause, one of the most marketed smiles in history and another glimpse of what drove Jordan to greatness.

"I would've loved to, though," he said. 🏀

THE JORDAN TROPHY CASE

1982
NCAA championship (North Carolina)

1984
Adolph F. Rupp Trophy (most outstanding college basketball player)
John R. Wooden Award (most outstanding college basketball player)
Naismith College Player of the Year
Olympic gold medal

1984–85
NBA Rookie of the Year

1986–87
Slam Dunk Contest winner

1987–88
Slam Dunk Contest winner
NBA Most Valuable Player
All-Star Game Most Valuable Player

1990–91
Eastern Conference championship
NBA Most Valuable Player
NBA championship
NBA Finals Most Valuable Player

1991–92
Eastern Conference championship
NBA Most Valuable Player
NBA championship
NBA Finals Most Valuable Player
Olympic gold medal

1992–93
Eastern Conference championship
NBA championship
NBA Finals Most Valuable Player

1995–96
All-Star Game Most Valuable Player

Eastern Conference championship
NBA Most Valuable Player
NBA championship
NBA Finals Most Valuable Player

1996–97
Eastern Conference championship
NBA championship
NBA Finals Most Valuable Player

1997–98
All-Star Game Most Valuable Player
Eastern Conference championship
NBA Most Valuable Player
NBA championship
NBA Finals Most Valuable Player

2009
Naismith Memorial Basketball Hall of Fame

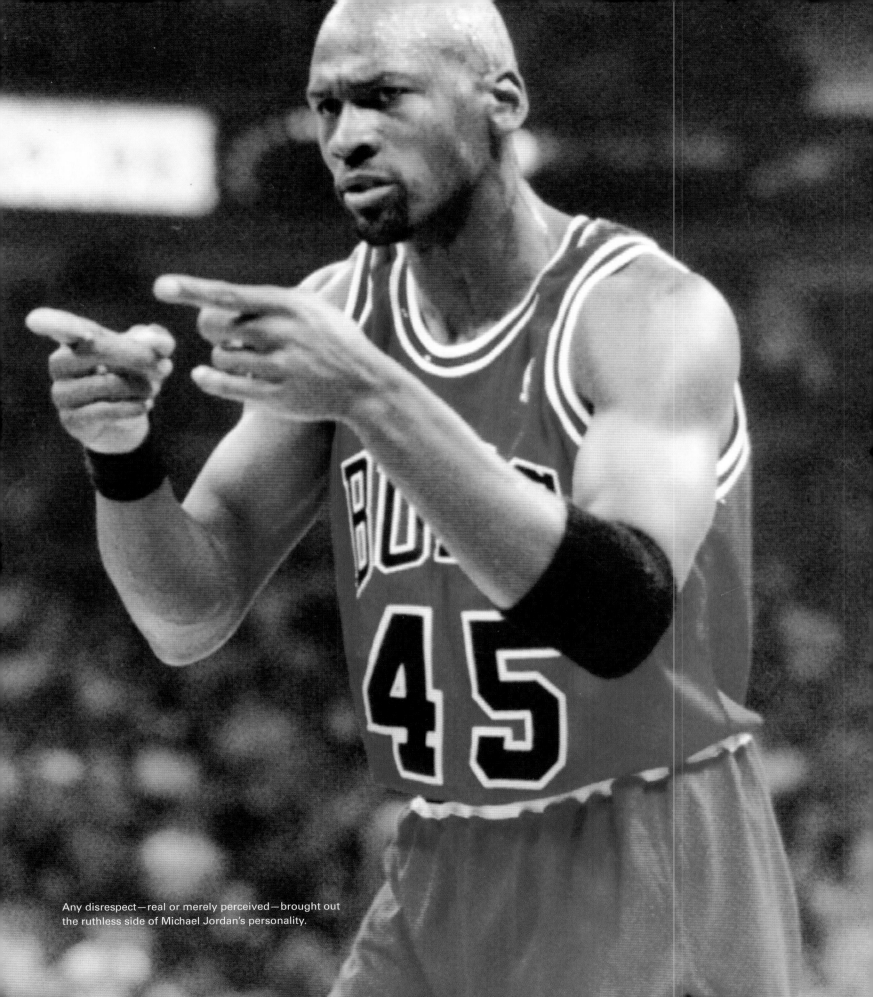

Any disrespect—real or merely perceived—brought out
the ruthless side of Michael Jordan's personality.

Get mad?
He'd get even.

His offensive artistry throughout his career served to obscure the fact that Michael Jordan also was a great defensive player . . . with a particular gift for settling scores at both ends of the floor with players or coaches he believed had slighted him. Some of his more vengeful performances:

Karl Malone
JUNE 14, 1998

Before the final shot there was the final steal. With 18.9 seconds left in Game 6 of the NBA Finals, Jordan stripped Malone of the ball to set himself up for his game-winner, an 18-foot jumper over Bryon Russell that delivered the Bulls' sixth NBA title in eight years.

If points off turnovers were credited to individuals, Jordan would have led the league in a runaway. Jordan's four steals in Game 6 gave him 376 for his playoff career, fourth all time.

Jeff Van Gundy
JAN. 21, 1997

In an aside to reporters, the Knicks' coach said Jordan "conned" opposing players by acting friendly toward them so they'd be reluctant to go all out against him on the floor. Jordan was incensed enough by the comment to drop 51 points on the Knicks in an 88-87 victory at the United Center.

"Con this, little man," he barked at Van Gundy as he ran by the Knicks' bench after one spectacular score.

"Con this, little man."

Jerry Stackhouse
JAN. 13, 1996

Stackhouse ignored the NBA's Golden Rule: Don't provoke Michael Jordan. And it cost him. Jordan helped hold 76ers rookie Stackhouse to 11 points on 4-of-11 shooting and scored 48 points himself, even though he sat out most of the fourth quarter of the Bulls' 120-93 victory in Philadelphia.

Before playing fellow North Carolina alum Jordan for the first time, Stackhouse was quoted as saying there weren't many people in the league who could stop him, including Jordan.

"I know he said a lot of stuff, but that was a motivational factor from a competitive standpoint," Jordan said. "I really didn't want to make it one on one or mano y mano."

Charles Smith
JUNE 2, 1993

With the Bulls and Knicks tied 2-2 in the Eastern Conference finals, Smith got the ball under the basket in the final seconds and could have sent the game into overtime with a layup or, better yet, a dunk. But he never got the ball to the rim as Jordan, Scottie Pippen and Horace Grant took turns blocking his shot.

The Bulls held on for a 94-92 victory and won the series in Game 6 back at Chicago Stadium.

Kerry Kittles
APRIL 25, 1998

The first game of the 1998 playoffs featured the upstart New Jersey Nets taking the Bulls to overtime before Jordan put the Nets away with a steal and dunk in the final minute of OT. The score was tied at 91 when Jordan stripped the ball from Kittles and broke free for a slam dunk. Jordan drew a foul from Kendall Gill and converted the three-point play with 43.5 seconds left.

Afterward, Nets coach John Calipari tried to save Kittles some face.

"Hey, (Jordan's) maybe the greatest defender on the perimeter to ever play this game," Calipari said.

LaBradford Smith
MARCH 20, 1993

Jordan hit his first eight shots and scored 47 points through three quarters. He also held Smith to 15 points in a 126-101 Bulls victory over Washington at Chicago Stadium.

Typical Jordan? Yes, but not for the reasons you'd think.

The night before, the Bulls had beaten the Bullets on the road, but Smith, averaging eight points, had scored 37 with Jordan guarding him most of the time. Unlike Stackhouse, Smith had provoked Jordan with his play rather than his mouth. Didn't matter.

"I felt sorry for my buddy from Louisville," Bulls forward Rodney McCray said.

This wasn't just business for Jordan, this was personal.

"I wasn't mad," Jordan said after the game. "I just wanted to concentrate. I took it personal. I wanted to redeem myself. I knew what I wanted to do and it was a matter of coming out and doing it."

Buck Williams
JUNE 14, 1992

The Bulls had tied the score in Game 6 of the NBA Finals after trailing by double digits most of the game when the Portland forward made a steal under the Bulls' basket. A big play.

But Jordan stole the ball right back from Williams and dunked it with 4:01 to give the Bulls an 89-87 lead. A bigger play.

The Knicks
MARCH 28, 1995

Jordan came into Madison Square Garden averaging 24.8 points in his first four games since returning to basketball after his 1½-year baseball sabbatical.

Not too shabby, but not too Jordanesque.

But following his 55-point performance in a 113-111 nationally televised victory over the Knicks, Jordan had made it clear that he was back.

"I knew I wasn't that far away," he said. "I guess it took four games to get my rhythm down. I was nervous it was going to take longer."

> ## "I took it personal. I wanted to redeem myself."

23 Michael moments

The moments are too many to count. Almost an overload to recall or collate. They overlap, spill in and out and through like so many basketballs hitting net during warmups.

But let the arguments begin. Here, in chronological order, are 23 Michael Jordan moments that define his evolution from superbly talented player to one of the all-time great teammates, the latter achievement too frequently overlooked when we replay the slam dunks and title-making jumpers in our minds:

1981–82 PRESEASON CAMP UNIVERSITY OF NORTH CAROLINA

During the first few Tar Heel practices, coach Dean Smith realized something from one-on-one drills. Despite the presence of such stars as James Worthy and Sam Perkins, no one could keep up with this skinny freshman, "Mike" Jordan. He was respectful of the various egos among teammates, but afforded no mercy on the court.

"We didn't have anybody who could guard him," Smith said in explaining his decision to make Jordan a rare freshman starter. "He was just a remarkable practice player. From his sophomore year on, every team we put him on would win."

In fact, Smith pulled Jordan aside during the March 29, 1982, NCAA title game just before the team returned to the floor after a final timeout. UNC was down by a point to Georgetown with 32 seconds left.

"If it comes to you, knock it in, Michael," Smith said.

It did and he did, beating Patrick Ewing and the Hoyas 63-62. He said all the right things after the game, gladly sharing the spotlight with leading scorer Worthy (28 points). Somehow lost in the night was Jordan leading Carolina with nine rebounds. Perkins pulled down seven.

"He was just a remarkable practice player. From his sophomore year on, every team we put him on would win." —NORTH CAROLINA COACH DEAN SMITH

OCT. 29, 1984

MILWAUKEE AT BULLS

In just his third pro game, Jordan scored 37 points, including 22 in the fourth quarter of a 116-110 victory. He broke Bob Love's club record for points in a quarter and more than filled the shoes of missing Bulls star Quintin Dailey.

By the end of his first month, Jordan had a 45-point game. By season's end he had surpassed 40 seven times and averaged 28.2 per game for the season. He led the Bulls in assists, rebounds and free throw percentage, showing his willingness to do the little things that help teams win.

"I'm not a superstar of this team and I don't want to overshadow anyone," Jordan said the night of the Milwaukee game. "I just want to mingle with the rest of the guys. I need the other 11 guys.

"A game like this, we have a feeling we can win now. I kept saying on the bench during the whole fourth quarter, 'We can win.' And they started to believe it."

APRIL 20, 1986

BULLS AT BOSTON

Nobody forgets this game or the 63 points Jordan put up against one of the best single-season teams in NBA history during a thrilling double-overtime Boston win. What slips from the mind is that Jordan scored 49 in the first game of this first-round playoff series, which the Bulls lost by 19 points. That didn't necessarily impress Larry Bird or Robert Parish. Both thought the Jordan of Game 2 was more the team player.

"He was getting his points right in the flow of the game," Bird said. "When he does that, it is scary."

"There's no telling what he would have done with another five minutes," Parish said.

FEB. 7, 1988

NBA ALL-STAR GAME

This was Jordan's coming-out party among pro basketball's elite. Three years removed from an All-Star snubbing orchestrated by Isiah Thomas, Magic Johnson and George Gervin, Jordan was the game's most valuable player on the strength of 40 points, including 16 in the final 5 minutes 50 seconds of the Eastern Conference's victory. He fell two short of Wilt Chamberlain's record, but refused to cut to the basket for an easy layup in the game's final seconds.

For his part, Thomas was excited about helping Jordan reach 40. Jordan playfully accused Thomas of trying to wear him out for a pending Bulls-Pistons game two nights later and felt more than satisfied with an All-Star weekend at Chicago Stadium that included a slam-dunk championship.

"I was happy with what I had done," Jordan said. "I didn't want to seem greedy . . . I get embarrassed when things are handed to me. My first 36 points were earned. The last four were respectfully given to me."

MAY 7, 1989

BULLS AT CLEVELAND

Known simply as The Shot, this was the first-round series winner Jordan hit over Craig Ehlo with no time left on the clock in Game 5. Just 3 seconds earlier, Ehlo had put Cleveland ahead by a point with a layup.

Off an inbounds play, Ehlo beat Craig Hodges on what Cavs fans gleefully anticipated as the victorious shot. Hodges hung his head in the Bulls' timeout huddle.

"Michael came up to me and said, 'Don't worry,'" Hodges recalled. "He said he was going to hit the shot."

No better way to pick up a teammate than that.

 MID-MAY 1989 BULLS AT NEW YORK

Jordan gets Bulls home free

Knicknacks no match for Jordan

Jordan and his Bulls teammates started to form the dynasty of the 1990s to follow. Three of the six games from their second-round playoff series with the Knicks are Jordan classics. Most impressive was his 47 points on a Sunday afternoon in Game 4, which he played with a pulled groin muscle. Knicks coach Rick Pitino accused Jordan of faking it, which got Jordan's attention as he watched television hooked up to an electric muscle stimulator after putting up 40 points, 15 rebounds and nine assists earlier that day in a Game 3 win.

"I played with Michael and I know when he's hurt, it really motivates him," Knicks power forward Charles Oakley said. "You don't know he's hurt until you see him in a cast."

In the Game 6 clincher, Jordan scored 40 points, once again sending Ewing home on the losing end. He scored eight of the Bulls' final 10 points, the last six on free throws.

 MAY 27, 1989 BULLS AT DETROIT

The Bulls didn't win this series, but rather than fold before a Detroit team that would win back-to-back NBA titles, Jordan and teammates matched the Pistons shot for shot and defensive stand for defensive stand. The peak moment: Game tied 97-97 and 28 seconds left. Detroit had the ball, and coach Chuck Daly called a pick-and-roll for Thomas and Bill Laimbeer.

As the clock ticked to 11 seconds, Thomas began dribbling right from the top of the key. Jordan slid with him until he bumped into Laimbeer. Referee Bill Oakes promptly whistled Laimbeer for an offensive foul. The Bulls went on to win 99-97.

"I know anytime Michael Jordan is involved in a play, you have to watch yourself," Laimbeer said, noting Jordan's increasingly lofty status. "You make sure you stay clear of him. I did my job properly. I set a regular screen, like I do a thousand times a year."

 MARCH 28, 1990 BULLS AT CLEVELAND

Jordan scored 69 points in a 117-113 overtime win. It was the ninth-highest scoring spree in NBA history and the best in a decade, yet no one was particularly shocked or even amazed. Jordan almost made it look easy.

Overlooked in his line—23 of 37 from the field, 21 of 23 at the free throw line—were his 18 rebounds, six assists and four steals. The Bulls' win clinched a playoff berth and evened their road record at 18-18 while extending to seven their then–club record for wins away from Chicago Stadium.

 MAY 27, 1991 BULLS AT DETROIT

The Bulls completed a sweep of Detroit for their first trip to the NBA Finals. Jordan, Scottie Pippen and Horace Grant shared the game's final moments in joyful repose on the bench, three of the happiest guys you will ever see. Their joy was intensified when some of the Detroit starters, led by Thomas, left the court before the game clock ticked completely down.

JUNE 5, 1991

L.A. LAKERS AT BULLS

Flight 7:47 took off with just under 8 minutes left in Game 2 of the Michael vs. Magic Finals. In the midst of a 15-2 run that sank the Lakers—for the series, it turned out, after an L.A. win in Game 1 created much nervousness in Chicago—Jordan scored on a wouldn't-believe-it-unless-I-saw-it-with-my-own-eyes shot.

He started by flying down the lane, headed for one of his resounding slam dunks that inspired fans and teammates alike. But former North Carolina teammate Sam Perkins stepped into Jordan's path.

Jordan adjusted like no other gravity-bound player on this planet. As his body soared upward, he brought the ball down while switching it from his right hand to his left. Then he rotated in mid-dunk, twisting to avoid Perkins and keeping his balance before banking the ball off the glass for a miraculous two points.

It might have been the Michael Moment.

"I probably couldn't duplicate it if I tried," Jordan said. "It was just one of those things."

"He did the impossible, the unbelievable," Magic Johnson said, with more than a little awe in his voice.

"He did the impossible, the unbelievable."
—MAGIC JOHNSON

JUNE 12, 1991

BULLS AT L.A. LAKERS

Title night has one lasting image. Michael hugging the NBA championship trophy and crying, with his father at his side.

JUNE 3, 1992

PORTLAND AT BULLS

The Bulls' second straight trip to the NBA Finals began with a record 35 first-half points from Jordan and . . . a shrug? Jordan hit six three-pointers in an 18-minute stretch to start the 122-89 blowout. After his final bomb, Jordan ran past the national TV announcers and turned his palms up, as if he himself didn't believe it. But know this: Jordan stayed late after that morning's shootaround to practice—you guessed it—long-range jump shots.

JUNE 14, 1992

PORTLAND AT BULLS

The Bulls won their second title with big contributions from bench players, including the little-used Bobby Hansen. Jordan hugged every one of them during a postgame celebration in front of the hometown fans that eventually had MJ and his teammates standing on the scorer's table in a noise frenzy that lasted a good long time. Jordan was wearing a newly creased Back-to-Back cap clenching the title trophy with his champagne-soaked jersey half out of his usually stylish basketball trunks.

"Two! Two! Two of them!" he yelled.

Never did Jordan seem more simply one of us, and it was great.

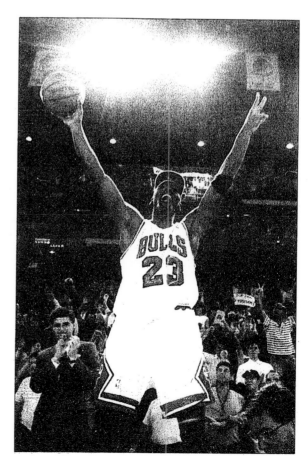

 ### JUNE 16, 1993

PHOENIX AT BULLS

The 1993 NBA Finals against the Charles Barkley-led Suns were more tenuous than most Bulls fans like to recall. A triple-overtime win in Game 3 inspired Phoenix to play three more tough games against the defending champions. In Game 4, Jordan dimmed the Suns' hopes considerably with 55 points in a 111-105 win at Chicago Stadium, where the Bulls subsequently lost Game 5 to make for lots of queasy stomachs.

Jordan tied Rick Barry for second on the all-time Finals single-game scoring list, behind only Elgin Baylor. Every basket was critical as the game went down to the final 30 seconds.

"I'm as much in awe of Michael Jordan as anyone else," Phoenix coach Paul Westphal said. "He's the best offensive point guard and defensive point guard of all time, the best offensive and defensive '2' guard, the best offensive and defensive small forward, and he's probably right up there in the top five at power forward and center."

 ### JUNE 20, 1993

BULLS AT PHOENIX

The final play of the Game 6 clincher for the Bulls' first three-peat was, of course, designed for Jordan. But he saw no seam, no flicker of daylight in the Phoenix defense. So rather than force a shot he passed to Pippen. Closely guarded himself, Pippen got the ball to Grant, who passed up an open shot to send the ball out to John Paxson beyond the three-point line. Paxson hit the shot with 3.9 seconds left.

Jordan's scoring line for the series: 31, 42, 44, 55, 41 and 33 points. He averaged 8.5 rebounds and six assists per game. Nobody ever played a better all-around Finals, unless it was Jordan himself during one of the other title years.

 ### MARCH 28, 1995

BULLS AT NEW YORK

Early in this "double nickel" game at Madison Square Garden, a just-back-from-baseball Jordan plopped down on the bench during a timeout next to new teammate Bill Wennington, who as a St. John's player knew plenty about the pressure of playing before New York crowds. Jordan looked Wennington squarely in the eye, saying, plainly and firmly, "I hate losing."

Wennington apparently heeded the advice/warning. After a spectacular night of weaving through, over and around the Knicks for 55 points in just the fifth game of his comeback, Jordan slipped the ball to Wennington, left open by Ewing, who could only grimace as the Bulls' reserve center slammed home the winning basket.

 ### MARCH 7, 1996

DETROIT AT BULLS

It required almost a full season at the new United Center, but Jordan finally felt comfortable shooting on his home floor. He scored 53 in a rout of Detroit, which raised the Bulls' home record to 30-0. It was just the sort of supreme confidence-builder Jordan could summon at any point of his career, which would include a fourth NBA title three months later.

Pistons coach Doug Collins, coaching his first game in Chicago since his firing in 1989, was yelling at referee Jack Nies after young Detroit star Grant Hill was called for a third personal foul just before halftime.

"Jack!" Collins screamed. "These guys are 30-0 here. You don't have to help them."

Jordan, his timing always impeccable, was running by when Collins made his plea.

"No, we're 29-0," Jordan said as he galloped past, smiling, "but we're about to be 30-0."

20 JUNE 1, 1997

UTAH AT BULLS

MJ always delivered biggest in the biggest games. In Game 1 of the 1997 Finals, against what Jordan himself deemed the toughest opponent the Bulls faced in the championship round, Jordan hit a 20-foot jumper over Bryon Russell as the buzzer sounded to break an 82-82 tie, the same deadlock Karl Malone couldn't crack with the ball and two free throws at the 9.2-second mark.

Rather than gloat, Jordan simply clenched his right fist. There was no smile, just more work to be done.

"It was not so much a celebratory moment as matter-of-fact," said Steve Kerr, the Bulls' reserve guard who drained the series-winning jump shot when Jordan passed to him in a planned move that only deepened the Jordan championship legend.

21 JUNE 11, 1997

BULLS AT UTAH

Jordan ate bad room-service pizza, threw up repeatedly, stayed in bed all day, lay down on the floor of the team bus and curled up in the fetal position embracing a bucket in a small room off the visitors' locker room until just before tipoff. He then proceeded to sicken the Jazz players, coaches and faithful with 38 points, seven rebounds, five assists and three steals. He hit the game-winning three-pointer with 28 seconds remaining in a 90-88 heart-stopper.

Right near game's end, Jordan fell into Pippen's arms as both headed toward the bench for a timeout. MJ dropped his head on Pippen's shoulder for more than a few seconds in a role reversal of the two stars' usual big-brother, little-brother relationship.

22 JUNE 14, 1998

BULLS AT UTAH

This hang time was of a different sort. After Jordan launched his game-winning 18-foot jump shot with 5.2 seconds left to clinch a sixth NBA title, the NBA's star of the ages stood at the top of the key briefly admiring his work. Jordan froze for just a second or two in follow-through position, as if to linger over his greatest moment on a basketball court.

At the 37-second mark, MJ hit a layup to pull the Bulls within a point at 86-85. With about 20 seconds left, Malone had the ball in close and was preparing to go to work; a basket would almost assuredly have forced a Game 7 in the raucous Delta Center. Jordan, naturally, had other ideas. He swiped the ball and Utah's chances with it, setting up the shot over Bryon Russell. The final score: Chicago 87, Utah 86 and two three-peats inspired and secured by Jordan.

"Karl never saw me coming," Jordan said later.

Hard to believe.

23 THE HALL OF FAME

Jordan showed why his competitive fire never will be extinguished as he officially entered the Naismith Basketball Hall of Fame. Jordan nearly trash-talked his way through his acceptance speech, thanking all those slights—real and perceived—for adding "wood to the fire" and motivating him in his unparalleled career.

But the speech had its lighter and more gracious moments. Jordan thanked coach Phil Jackson for "challenging me at times I needed to be challenged." Jordan also recounted an anecdote that summed up the way he changed the Bulls from a losing franchise to a championship one.

"I remember having a conversation with Tex Winter, who was an unbelievable coach," Jordan said. "I was coming off the floor and I had scored like 20 points in a row to win the game.

"Tex reminded me there's no 'I' in team. I looked back at Tex and said, 'There's an 'I' in win.'"

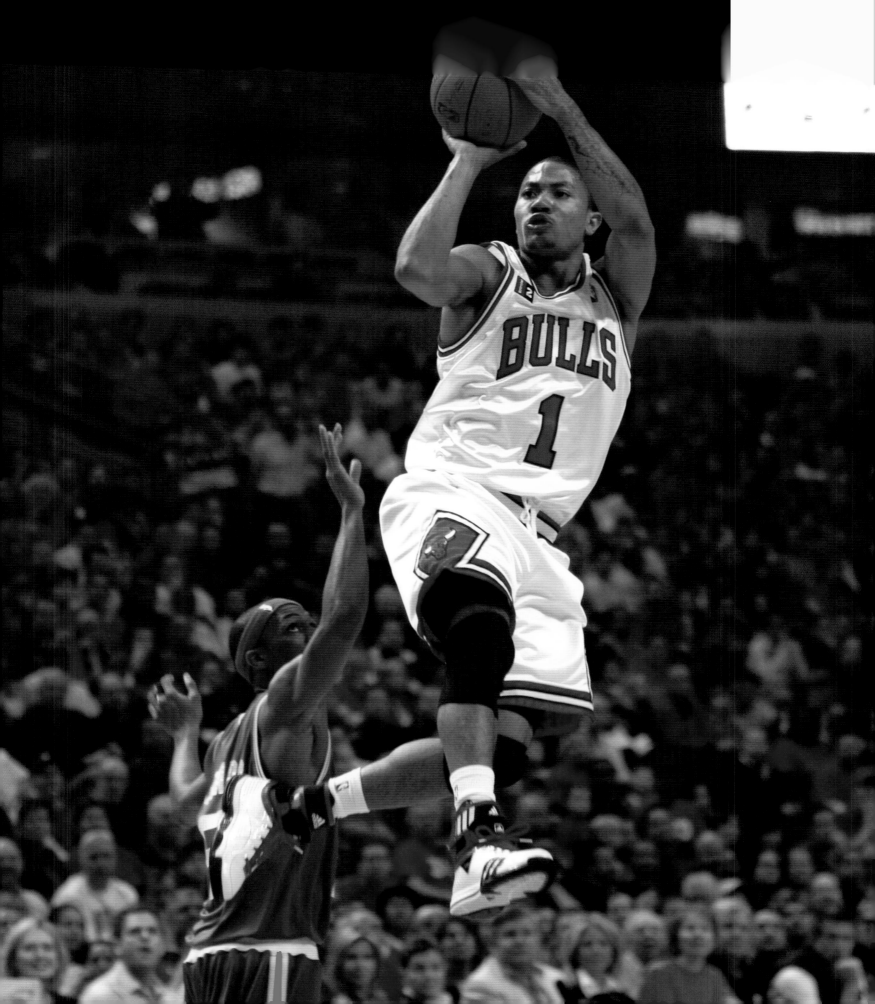

THE
2000s
AFTERMATH

During this mostly dark decade, the Bulls didn't just lose. They lost spectacularly. By the time general manager Jerry Krause flipped former Rookie of the Year Elton Brand for the draft rights to Tyson Chandler in an attempt to build around Twin Toddlers Chandler and Eddy Curry in 2001, the veterans had turned on head coach Tim Floyd. Krause forced Floyd to resign on Christmas Eve 2001 and turned to Bill Cartwright, a defensive stalwart from the first three-peat. A minor uptick to a 30-52 mark in 2002–03 and more young talent in NCAA Player of the Year Jay Williams created hope, but Williams crashed his motorcycle in June 2003, ending his career. Team Chairman Jerry Reinsdorf had forced Krause to resign, citing health issues, just months prior. John Paxson moved from his radio analyst chair to begin a steady succession of shrewd draft picks, including Kirk Hinrich in the direct aftermath of Williams' accident and Joakim Noah in 2007. Paxson also fired former teammate Cartwright in November 2003 and hired Scott Skiles from exile. Rookies Luol Deng, Ben Gordon and Andres Nocioni helped the 2004–05 Bulls overcome an 0-9 start and qualify for the playoffs for the first time since the dynasty ended. Two more playoff appearances followed, but Skiles wore out his welcome and was dismissed on Christmas Eve of 2007. The Bulls pursued Mike D'Antoni and even briefly considered bringing back Doug Collins before settling on the unproven Vinny Del Negro. Back-to-back 41-41 seasons produced two playoff berths and, more importantly, the arrival of Derrick Rose with the first overall pick in 2008.

Opposite: Hometown hero Derrick Rose was named the NBA's Rookie of the Year in 2009, the only Bulls player other than Michael Jordan to win the award.

2000s HIGHLIGHTS

Nov. 8, 2001
Timberwolves beat Bulls 127-74, a 53-point margin that represents the worst loss in franchise history.

Dec. 24, 2001
Tim Floyd resigns as head coach.

Dec. 28, 2001
Bulls name Bill Cartwright head coach.

Nov. 23, 2003
After a loss at Sacramento drops the Bulls' record to 4-10, head coach Bill Cartwright is fired.

Nov. 28, 2003
Scott Skiles named new head coach.

June 24, 2004
With the third pick in the NBA draft, the Bulls select Connecticut guard Ben Gordon. They also acquire the seventh pick from Phoenix and use it to select Duke forward Luol Deng.

May 11, 2000
Elton Brand named the NBA's co-Rookie of the Year, sharing the award with Houston guard Steve Francis.

June 27, 2001
Bulls draft a pair of high schoolers—big men Tyson Chandler and Eddy Curry—and deal Elton Brand to the Clippers.

Feb. 19, 2002
Bulls trade Brad Miller, Ron Artest, Ron Mercer and Kevin Ollie to Indiana for Jalen Rose, Travis Best and Norman Richardson.

June 26, 2002
With the second pick in the NBA draft, the Bulls select Duke guard Jay Williams.

Bulls' second take in first round a steal

| 2000 | 2001 | 2002 | 2003 | 2004 |

Nov. 3, 2000
Home sellout streak—which dates back to 1987—ends at 610 games.

April 18, 2001
Bulls end season on two-game winning streak but final record stands at 15-67, breaking the previous season's mark for worst in team history.

June 19, 2003
Jay Williams is seriously injured in a motorcycle accident on Chicago's North Side. He would never play again in the NBA.

Feb. 6, 2001
Team-record losing streak extends to 16 with 97-80 loss in Phoenix.

April 7, 2003
Jerry Krause resigns as Bulls general manager.

April 14, 2003
Bulls name John Paxson executive vice president of basketball operations.

June 28, 2006
With the second pick in the NBA draft, the Bulls select University of Texas-Austin forward-center LaMarcus Aldridge, then trade him and a second-round pick to the Portland Trail Blazers for Louisiana State forward-center Tyrus Thomas.

Bulls' take: What a deal!

Oct. 31, 2006
Bulls crush Miami 108-66, the worst season-opening loss for a defending champ in NBA history.

IT'S OVER TIME
Bulls' season and epic series draw to close

April 29, 2007
Bulls stun the defending champion Heat with a first-round playoff sweep, capped by a 92-79 road win in Game 4.

May 2, 2009
Four of the seven games go to overtime—including a double-overtime Game 4 and a triple-overtime Game 6—but the Bulls are eliminated by the Celtics, who win Game 7 in Boston 109-99.

May 4, 2006
Miami wins Game 6 of the first-round series 113-96, eliminating the Bulls four games to two.

May 17, 2007
With a 95-85 decision in Game 6, the Pistons eliminate Bulls four games to two in the second round.

June 28, 2007
With the ninth pick in the NBA draft, the Bulls select University of Florida center Joakim Noah.

June 26, 2008
With the first pick in the NBA draft, the Bulls select University of Memphis guard—and native Chicagoan—Derrick Rose.

Oct. 4, 2005
Bulls trade Eddy Curry and Antonio Davis to the Knicks.

2005 — **2006** — **2007** — **2008** — **2009**

July 13, 2006
Bulls sign free-agent center Ben Wallace.

July 14, 2006
Bulls trade Tyson Chandler to New Orleans/ Oklahoma City.

Dec. 24, 2007
Bulls fire head coach Scott Skiles.

June 11, 2008
Bulls name Vinny Del Negro head coach.

April 22, 2009
Derrick Rose is voted the NBA's Rookie of the Year.

Feb. 21, 2008
Bulls trade Ben Wallace to Cleveland in three-team deal.

Feb. 26, 2009
Norm Van Lier and Johnny "Red" Kerr tragically pass away on the same day.

May 6, 2005
Despite winning the first two games of the opening-round series, the Bulls lose the next four and are eliminated by Washington, falling 94-91 in Game 6.

A young Bulls team gets even younger after Elton Brand is traded and high schoolers Eddy Curry and Tyson Chandler arrive.

Bulls change brands, go from young to younger

June 28, 2001

At any given opportunity during the last two seasons, Bulls general manager Jerry Krause sang the virtues of Elton Brand.

Krause praised Brand's on-court skills, his off-the-court demeanor, his work ethic and, most emphatically, his likelihood for successful longevity in a league full of flame-outs. Krause often said Brand would long outlast him as a member of the Bulls organization.

Desperate times call for bold moves, and the Bulls certainly made a bold one when they traded Brand, the first overall selection in the 1999 draft and the ensuing season's co-Rookie of the Year, to the Los Angeles Clippers. In return, the Bulls received the rights to high school forward Tyson Chandler, the second selection in the draft, and fourth-year forward Brian Skinner.

Coupled with their selection of homegrown high school center Eddy Curry at No. 4 overall, the Bulls now have two 18-year-olds on their roster and have parted ways with the major piece of the first rebuilding effort.

"I think they're trying to restart it again," said Brand, who, in a classy move, visited the Berto Center after the deal to share his feelings and thank Chicago fans. "I'm not sure if it's a positive step. They have a lot of young guys and they'll just have to see what happens."

Indeed, after a season in which coach Tim Floyd presided over a roster with a staggering seven rookies, the Bulls, as of now, are even younger.

"It's going to be very difficult to replace Elton's 20 points and 10 rebounds night in and night out," Floyd said. "We recognize that. But this whole draft was based on potential, and we got a lot of it."

Krause defended his move.

"Youth is a concern," Krause said. "But when we got the opportunity to get two players who we had ranked in the top couple on the board, it's hard to turn that down. Two young athletes like that don't come along that often. This is not a denigration of anybody else because I can't say enough good things about Elton. He's going to be an All-Star."

> **"The last time we got two athletes in this building as good as [Chandler and Curry] in one day was the day [Scottie] Pippen and [Horace] Grant came here [in 1987]."**
>
> —JERRY KRAUSE

"We just got a unique chance. . . . The last time we got two athletes in this building as good as [Chandler and Curry] in one day was the day [Scottie] Pippen and [Horace] Grant came here [in 1987]. I was pretty happy that day."

With two teenagers on their team, the Bulls are now faced with figuring out how to make a pair of recent high school graduates fit in with the lifestyle of the NBA—which can be run-'n-gun on the court and off.

The Bulls acknowledged they had to build a support system that will help these youngsters fit in. It is an emotional, physical and financial transition that sports psychologists, coaches and agents say few teenagers are equipped to make.

Since 1995, when the Minnesota Timberwolves selected Kevin Garnett of Chicago's Farragut High School as the fifth pick in the draft, 16 high school seniors have been drafted, despite attempts by NBA Commissioner David Stern to pass an age requirement. Not all of them have made the leap as successfully as Garnett.

So far, the Bulls haven't made any special arrangements for their teenagers. But they say a strong support system is already in place, both on and off the court.

"It is a jump, but it's been done by people with character and when people have character, like Curry and Chandler, it can be done," said Krause.

Although Curry may face additional pressures as a local player, he has the advantage of having his family nearby.

"The Bulls won't let him fall through the cracks," his father, Eddy Curry Sr., said.

Jerry Krause's hand-picked successor to Phil Jackson abruptly resigns with three years left on his contract.

Losing, feuding finally push Floyd over edge

December 25, 2001

Taking a route that surprised some who are close to him, Tim Floyd resigned as head coach of the Bulls at a hastily called news conference at the Berto Center.

The stunning move came 3½ seasons after Floyd succeeded Phil Jackson and three weeks to the day after Floyd—in an attempt at unity that backfired—threatened to quit in an emotional team meeting with players.

Floyd exits with a career mark of 49-190 and three seasons remaining on a contract that called for him to be paid another $6.4 million. Floyd will receive an unspecified amount of that sum in a buyout, according to a team source.

Assistant Bill Berry will coach the Bulls on an interim basis, but general manager Jerry Krause said another coach could be in place anywhere from two days to two weeks.

Though the team denied it, Floyd all but confirmed that assistant Phil Johnson, an aide with whom he was closely aligned, had been fired.

Floyd delivered his farewell comments with his wife, Beverly, and daughter, Shannon, looking on, underneath the championship banners won by his predecessor.

"I think it's in everybody's best interests if I step away at this time," Floyd said. "This came up fairly quickly. We've had a tough season. Things just didn't work out.

"This is a place that has an incredible amount of tradition, which forces you to try to give your best even at times where you don't feel like being your best. It's why I came. At the same time, it has a lot to do with why I'm stepping away."

The 47-year-old native of Mississippi inherited a dismantled dynasty after arriving under the assumption he could persuade Michael Jordan to continue playing. Instead, Floyd got Brent Barry.

Still, Floyd thanked players who gave him effort. In fact, he thanked practically everybody with whom he came into contact—assistant coaches, fans, front-office personnel, Chairman Jerry Reinsdorf, team broadcasters—by name. A notable exception was Krause, who Floyd did say gave him a "wonderful opportunity."

Floyd and Krause's relationship stood at the center of a charged atmosphere surrounding the team this season. Floyd and the Bulls had lost dismally

"**This is a place that has an incredible amount of tradition, which forces you to try to give your best even at times where you don't feel like being your best. It's why I came. At the same time, it has a lot to do with why I'm stepping away.**" —FLOYD

in his previous three seasons, but this season's losing—the Bulls record stands at 4-21—carried with it the stench of controversy, from a public dispute with Charles Oakley to an emotional confrontation with Ron Artest over a dress code that prompted a team meeting.

Bulls sources indicated Krause and Reinsdorf tried to talk Floyd out of quitting at a series of recent meetings.

"This organization will go on from here," Krause said. "There is young talent here. It will improve."

Bill Cartwright becomes the first former Bulls player since Jerry Sloan to assume the role of head coach.

Back in the middle of it

December 28, 2001 ···

General manager Jerry Krause's search to find Tim Floyd's replacement didn't last long, mostly because he didn't have far to look and it consisted of one person: Assistant coach Bill Cartwright.

Team sources confirmed that Cartwright, 44, will be promoted to head coach for the rest of this season at a news conference Friday at the Berto Center. Cartwright's title is not expected to carry an interim tag, but the final 55 games of this season could be used as a tryout of sorts as Krause monitors Cartwright's transition from a sixth-year assistant to head man.

Financial figures were not available, but Cartwright will receive a raise to the neighborhood of $1 million. A team source said scout Pete Myers will be added to Cartwright's staff. Interim head coach Bill Berry will return to an assistant role.

Cartwright's promotion follows the trend of two previous successful Krause hires: Doug Collins and Phil Jackson. Those two were former NBA players who had little or no head coaching experience when Krause tabbed them.

Cartwright also joins a trend of recent hires—Indiana's Isiah Thomas, Detroit's Rick Carlisle, Orlando's Doc Rivers, New Jersey's Byron Scott, Portland's Maurice Cheeks—who played the game but made their head coaching debuts at the NBA level.

Some current Bulls players, most of whom weren't aware of Cartwright's imminent hiring, have talked favorably about working with a coach with NBA playing experience. One of those players, 17-year veteran Charles Oakley, was traded to New York for Cartwright in 1988 and now will play for him.

Krause made that trade, and Cartwright has enjoyed a solid relationship with him since—from playing on three Bulls championship teams to having Krause help him find doctors to correct a voice problem because of a fractured larynx to being hired as an assistant in 1996. The strong relationship certainly played a factor in Cartwright's hiring, given how badly matters had deteriorated between Krause and Floyd.

Krause said Cartwright, 44, would coach the Bulls for the remainder of the season and has a contract for three more seasons should he and management mutually agree that he continue.

As far as Cartwright is concerned, coaching is coaching, whether it's done behind the scenes as an assistant or in the glare of television cameras as the most public face of the organization.

"Of course, everybody loves to win," Cartwright said. "I despise losing and I'd love to win every game the rest of the year. But I think the biggest thing you can do is to try and see growth from this point on. Growth in how we're going to guard. Growth in how our players handle themselves on the floor. Growth in our ability to share the ball and help each other be successful.

"If we can do that, we'll become not only a better basketball team, but we'll win some games as well."

Jerry Krause (left) promoted assistant Bill Cartwright to head coach in December, 2001 after Tim Floyd abruptly resigned.

Bill Cartwright, who had a record of 51-100 as Bulls head coach, was hired to bring stability to a team in transition.

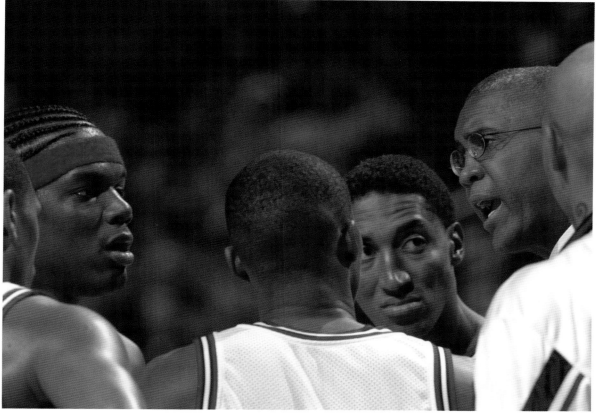

The Bulls hoped Bill Cartwright (right), a former NBA center, could serve as mentor to young pivot man Eddy Curry (left). Scottie Pippen (center) was also brought back to provide veteran leadership to the club.

The rebuilding plan was missing a point guard, a need the Bulls fill by drafting Duke's Jay Williams.

Williams will point way

June 27, 2002

Minutes after his team selected Jay Williams with the second pick of the 2002 NBA draft, Tyson Chandler appeared on the Berto Center practice floor wearing a Bulls jersey and a smile.

The jersey had Williams' name and college number—22—on the back.

Last season, that number belonged to Trenton Hassell.

"Trenton just got jacked, I guess," Chandler said, laughing. "This is JWil's show."

Learn the nickname. Take a deep breath. The tension has passed.

Houston cut through the political red tape and drafted Yao Ming with the first pick. And Bulls general manager Jerry Krause got in a good workout outside the Berto Center war room.

"He probably lost about 10 pounds pacing," Chandler said, again smiling.

Once Houston drafted Yao, nervousness left the building and smiles were in abundant supply at the Bulls' camp.

Krause and his staff selected the player they wanted, the one they believe will solidify the backcourt for years to come. Williams landed with the team for which he unabashedly pined to play, to the point that his young teammates want June to become October.

The Bulls' selection of Williams gives them a ready-to-play point guard, a leader and a good-looking guard rotation with Jamal Crawford and Hassell.

Jalen Rose and Eddie Robinson are a talented pair at small forward, and if either Tyson Chandler or Eddy Curry takes a step next season, the Bulls appear to have a competitive starting five and some depth.

"[Williams] is one of the few players in this draft who can have an immediate impact," said Bucks general manager Ernie Grunfeld.

"He has a big edge to him," coach Bill Cartwright said. "He's got a nice attitude. He wanted to throw you [media] guys out the day of his workout so that he could meet our guys. That lets you know that he's ready to go and ready to get after it."

The Bulls tried to build around a core of young players in the early 2000s, adding Duke guard Jay Williams to a lineup that included Eddy Curry and Tyson Chandler.

After the unexpected departure of Jerry Krause, the Bulls name John Paxson as his successor.

Sleuth's sudden exit a mystery

April 8, 2003

The shocking news of Jerry Krause's resignation was met by a gamut of emotions, from players shedding tears to talk-radio callers emitting cheers.

In a statement, Krause, 64, cited health concerns as the official reason for his departure after 18 seasons. But several of those close to him expressed skepticism that he voluntarily would leave a rebuilding effort that appeared to be turning the corner.

Team sources said Krause suffers from no known or disclosed serious illness.

He did battle pneumonia a few years ago, and he complained of back and neck pain from the constant travel through which the former scout still pushed himself. Often, Krause received treatment on the trainer's table, and the arrival of two grandchildren had softened him.

Still, the timing of the move raised eyebrows, especially given Krause's undying passion for his job and his constant claim that youngsters Tyson Chandler, Eddy Curry and Jamal Crawford had reinvigorated him. As recently as a preseason interview, he scoffed at the suggestion of retirement.

"The rigors and stress of the job have caused me some minor physical problems," Krause said in a statement. "Those problems can be eliminated if I lessen my load and concentrate on overcoming them. My first obligation is to accomplish that for my wife, children and grandchildren.

"Upon leaving, I'm very confident that we have assembled the key pieces so that the franchise can return to the NBA's elite teams in the very near future. I am not retiring. I'm going to take some time off and spend it with my family before making any decision on my future. I will leave my options open."

One team source said Krause told him he expected to be back in the league within a year. Another said Reinsdorf offered Krause a consultant's job, but that he declined.

"Jerry Krause is one of a kind," Reinsdorf said in his own statement. "He brought with him a vision of how to build a champion, and he proceeded to create one of the most dominant champions of all time. No basketball fan in America can begin to imagine the world-champion Chicago Bulls without his imprint."

Hiring Paxson an 'easy conclusion'

April 15, 2003

Associated with the Bulls since 1985 as a player, assistant coach and broadcaster John Paxson, 42, received a three-year deal to be the team's general manager.

Returning the Bulls to the ranks of the elite is his only goal.

"We want to win," Paxson said. "When you're a young team, sometimes you have built-in excuses and complain about not getting officials' calls or a poor road record. The next step is for those excuses to be put aside and to establish that we are ready to win."

Paxson partially detailed his philosophy for accomplishing this task, which included a desire for more toughness defensively and embracing the selfless concept of team.

As was the case when Bill Cartwright succeeded Tim Floyd, the search to find Jerry Krause's successor didn't take long and consisted of one candidate. Chairman Jerry Reinsdorf interviewed Paxson five

days after Krause's 18-year association with the Bulls ended.

Reinsdorf has long admired Paxson's knowledge of the game and the league, and the interview did nothing to diminish Reinsdorf's confidence in him.

"I wanted a general manager who understands the game, our direction, our talent and our tradition," Reinsdorf said. "I have for some time been convinced that John would someday make an exemplary NBA general manager."

Paxson said B.J. Armstrong, currently a special assistant to the general manager, would have an expanded role. And Paxson mentioned that he would lean on Gar Forman, who has the same title as Armstrong, and Ivica Dukan, the team's supervisor of international scouting.

"Their jobs became more important because of how far behind I am," Paxson said. "I'm behind the curve on college scouting. I'm going to rely on them."

Jerry Krause

THE SLEUTH

Really, **Jerry Krause always wanted** to be just one of the guys.

Like the big men on campus, really, the jocks. At about 5 feet 4 inches and 250 pounds, he never could, so he became their boss.

Sure, people didn't like Krause. He frustrated and fought with the media. He antagonized his best players in Michael Jordan, Scottie Pippen and Horace Grant, he eventually became enemies with Phil Jackson, his public manner and demeanor often were ugly. Few wore a suit as badly. But Krause did the job well.

He was the team's principal decision-maker when it won six NBA championships. Sure, Jordan was the main reason, and Krause didn't draft him. Former Bulls general manager Rod Thorn did. But Krause brought in Pippen, Grant, John Paxson and Bill Cartwright, and later Dennis Rodman. He inherited a mess of a team and turned it into an asset, getting valuable draft picks for players like Orlando Woolridge and Jawann Oldham, which enabled him to draft Pippen.

Krause was the man with the plan in those days. Rumpled, secretive, disgraced in Chicago as a Bulls executive years before when he was fired after a controversy over whether he tried to hire former DePaul coach Ray Meyer, Krause always bragged that he had a plan. It was what persuaded Jerry Reinsdorf—who didn't like him either, in the first place.

Krause had become a scout for the White Sox in the early 1980s when Reinsdorf purchased the team, and Reinsdorf remembered Krause at executive scouting meetings as an annoying man, badgering everyone. He actually suggested his firing at one point. But he was told to ignore Krause's manner, that he was a brilliant talent evaluator, and when Krause remained insistent that the team trade Cy Young Award winner LaMarr Hoyt for Ozzie Guillen, a little-known infielder, the deal was made and proved a winner for the White Sox.

When Reinsdorf acquired the Bulls, Krause asked for a chance to interview. Not knowing anyone in the NBA, Reinsdorf agreed. Krause produced a long memo detailing every move he'd make that so

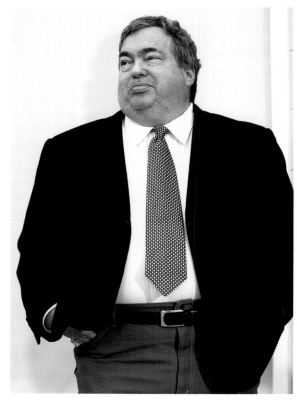

Critics claimed that Jerry Krause, who was a scout at heart, sometimes became too attached to his draft picks to evaluate them objectively as a general manager.

impressed Reinsdorf that he hired Krause. In his own way, Krause wanted to prove people wrong, like he did when he said he'd rebuild the Bulls after 1998.

Krause then carried out his plan—"addition by subtraction," he liked to call it then—getting rid of the cancers on the team, picking up cheap free agents like Paxson, drafting young talent like Pippen and Grant. He'd become too close to many of his picks, and it eventually was the influence of Doug Collins and Jackson that persuaded Krause to trade for Cartwright. Krause

didn't want to give up his first pick, Charles Oakley. But he finally went along and made the deal.

Over the years, many with championships, feuds developed with players. Fans always sided with the players. Krause's secrecy made enemies of the media. He'd threaten reporters, ignore fans, annoy players. But he did his job, so Reinsdorf kept him. Plus, if your team wins six championships, you deserve a chance not only to stay, but to try again.

Krause got that. But he couldn't conjure the magic again.

Associates and friends outside of basketball often asked Reinsdorf why he retained Krause. Reinsdorf was well aware that Krause had a legion of detractors.

"Take a number," Reinsdorf told them.

At his heart, Krause was a scout. And he was a good one. Sure, he made mistakes, like they all do. Krause was mocked for draft picks such as Brad Sellers, Jeff Sanders, Stacey King, Byron Houston, Dickey Simpkins, Jason Caffey and Corey Benjamin, and failed European additions like Dragan Tarlac and Roberto Duenas. But Krause had more spectacular successes, such as Pippen and Grant, trading for Cartwright and taking a chance on Dennis Rodman.

Sometimes he tried too hard. Jordan, when he was in a pensive mood, used to speculate Krause was picked on as a kid, so becoming a team executive, "someone important," as Jordan liked to put it, made Krause feel important.

Krause was born in the Albany Park section of Chicago and attended Taft High School. Like most boys, he was a sports fan. But he wasn't athletic. So he hung around the guys. Teenage guys, and jocks, being what they are, don't necessarily like guys who hang around. It essentially was the reason for the longtime bad feelings between Jordan and Krause.

Krause just wanted to be accepted. But social graces always were a problem. Once in an NBA executives meeting, Krause voted against a plan to change salary-cap rules by saying the Bulls won under those rules, so if others couldn't, it meant they

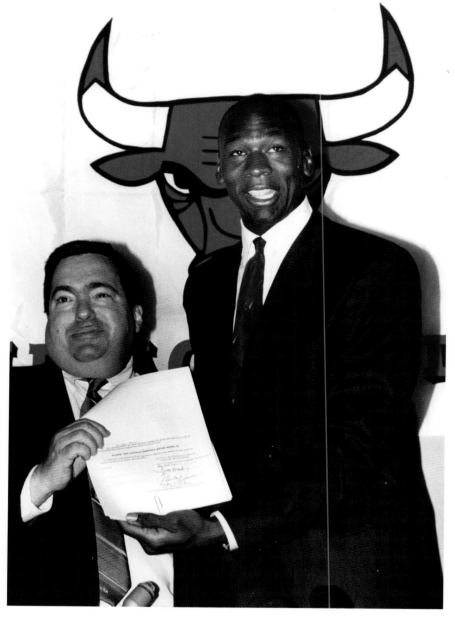

were badly managed. Several GMs stormed out at the insult. Krause was just trying to show he was as good as them—in his usual awkward way.

Colleagues joked Krause may have discovered Wilt Chamberlain, Bill Russell and Jerry West. And all on the same day. Krause bragged for acceptance. The guys, mostly former jocks, held their noses.

Krause went to Bradley and again hung around, becoming a team manager and backup baseball catcher. He took summer jobs in the local newspaper sports sections. His first job was as an office flunky for the Cubs. He badgered the old Chicago Zephyrs guys for a job as a gofer, going to Baltimore with the franchise. Just to be around the games, the guys.

Jerry Krause masterfully assembled a championship-caliber "supporting cast" around his superstar guard, Michael Jordan.

When the dynasty was dismantled after the 1997–98 season, Jerry Krause had to rebuild the Bulls from the ground up. In the subsequent two-plus seasons—1998–99 was shortened by a labor dispute—the Bulls won 13, 17 and 15 games respectively, a total of 45 victories. Before that, the Bulls had not won fewer than 47 games in a single season since 1986–87.

And when he was embraced, he never forgot.

Kindness by men like former Chicago baseball writer Jim Enright, former Bradley basketball player Dick Peterson and one-time baseball scout Fred Hasselman led them to deity status for Krause. He would tell stories about them, though it usually was about someone he discovered, something he did, someone he knew. Always trying to be accepted.

But always loyal. Often to a fault. He never forgot players who cared for him, and brought back Robert Parish and Oakley too late, gave Brent Barry a big contract and endlessly pursued Eddie Jones. Conversely, those who left were traitors. Krause turned on Billy McKinney, Tex Winter and eventually even Jackson because they dared depart.

Krause, unlike most NBA executives, hung around the trainers' room for massages with the players, traveled extensively with the team. It was worse during the championship years, and Krause was victimized by the star players, like he was the athletic bullies of his youth. Jordan mocked him as "Crumbs," saying he always had droppings from doughnuts on him. The players yelped when the team bus would pass a doughnut shop.

Krause tried to go along with the joke, usually on him.

Krause was nicknamed "the Sleuth" for the way he patrolled arenas in secret, hiding behind columns so colleagues might not know whom he watched. But he always found solace in the privacy, the loneliness

JERRY KRAUSE

» **Born:** 1939 in Chicago

» **College:** Bradley University

» **Years in NBA:** 1987–2004

» **Hired by Bulls:** Originally hired as scout in 1966; returned as director of player personnel on June 2, 1976; rehired as general manager/ executive vice president of basketball operations on March 26, 1985.

almost a relief. It was where Krause could shine and prove he belonged, scouting, finding the talent.

So he tried to say everyone in the organization matters, and it came out "Organizations win championships," not players. He never said it. Betrayed again by being inarticulate.

Krause always was relentless, though, calling agents dozens of times when he sought a player, seeing the same players constantly, believing there was someone who would miss something he would see, and he would show them all.

The troubles between Krause and Jordan can be traced back to the 1985–86 season, when Jordan broke a bone in his left foot in the third game of the season.

Jordan wanted to play as quickly as possible. Krause, Reinsdorf and doctors opted for a more conservative approach.

"I wouldn't have been able to live with myself if Michael had been hurt permanently," Krause says. "That injury drove a wedge between him and me for good."

Happier times followed. Krause's surprising hire of Doug Collins as coach worked to a point, and then, after a loss to the Pistons in the 1989 Eastern Conference semifinals, came Collins' equally surprising dismissal—and the ascension of Phil Jackson.

"I called Phil, sat him down in the office and said, 'Here's what it is. Go get 'em, Big Fella,'" Krause says. "Then I told him, 'Go back to Montana, let the media firestorm die down and this sink in.'"

What did Krause see in Jackson, whom he had hired as Collins' assistant out of relative obscurity from the Continental Basketball Association?

"I saw Bill Fitch," Krause says. "I saw Red Holzman. I saw a different breed of cat. I saw a drive in him. He tried to get a coaching job in the NBA for four or five years, and everybody turned him down. Everybody thought he was crazy. I was the only one who didn't think he was too crazy. I thought he was a little goofy. But I also thought he'd be a great defensive coach.

"I told Jerry what I saw. He said, 'OK.' And the rest is history."

Six championships in eight seasons. An NBA-record 72-10 season. Grant Park championship rallies serving as defining touchstones for Chicago sports fans.

"I remember we landed at O'Hare after we won the first title," Krause says. "Descending on the city, it was the most beautiful sight. I remember that feeling that it was your town, the town you grew up in, and you had provided it some happiness. I'm a proud Chicagoan. I really love this city."

Fans spewed venom at Krause for what came next. The courtship of Floyd during Jackson's tenure and, ultimately, Floyd's hiring. Anemic 17- and 15-win seasons. Draft busts such as Marcus Fizer and Dalibor Bagaric. The controversial Elton Brand-for-Tyson Chandler trade.

"No college coach can do it because the game has changed too much," Krause says of hiring Floyd. "I thought Tim was the one guy who could because he had the background with (Clem) Haskins. He had recruited underrated players and made them much, much better. He was a great teacher. I'd watch him teach in practice.

"You know what it came down to? I knew him too well. I went fishing with him 10 times and lost my objectivity. I really thought we were going to win again. That's still disappointing to me."

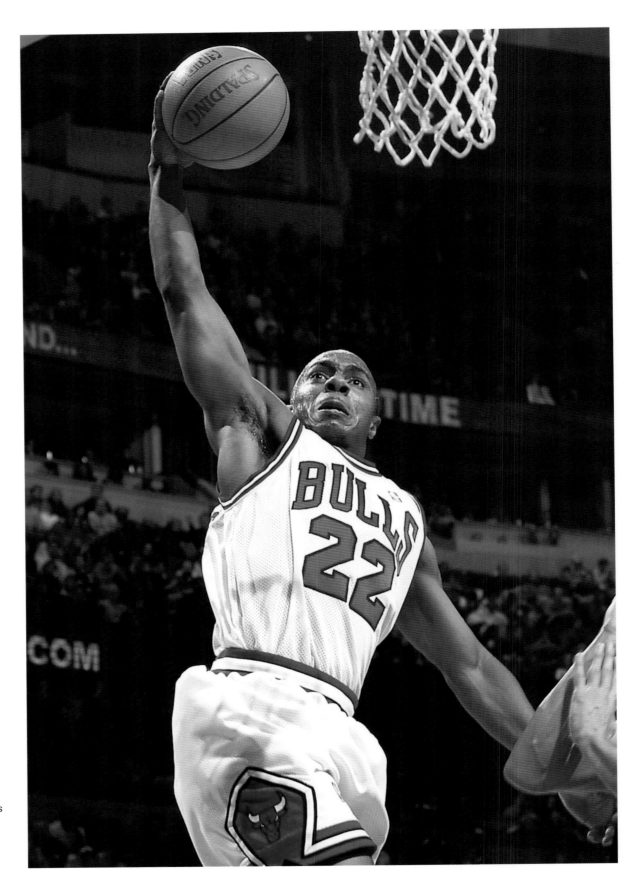

An explosive and highly skilled point guard, Jay Williams averaged 9.5 points and 4.7 assists per game in his rookie season with the Bulls. That season would be his last in the NBA after he was seriously injured in a motorcycle accident in June, 2003.

Jay Williams
A DIFFICULT JOURNEY

22 POINT GUARD
2002–03

Jay Williams' book "Life Is Not An Accident" is billed as "a memoir of reinvention," and it's not an easy read.

Many of the details surrounding Williams' June 2003 motorcycle accident that ended his Bulls career after one season are well known. Much of Williams' story after that is not.

Williams details the long and painful rehabilitation process, the depression he suffered during it and his subsequent failed comeback attempts. He lays bare his addiction to painkillers and the estrangement from his family, with whom he since has reconciled.

The book, released in 2016, wasn't easy to write, either. But Williams, a three-time All-American at Duke University before the Bulls selected him second overall in the 2002 NBA draft, is proud he persevered.

"It was hard for me to work through some of my own issues and also explain myself and my way of thinking back then compared to who I am now," Williams said. "Everybody has issues in their lives. Everybody has demons they deal with. Granted, my demons might have happened on a bigger stage, but I hope my story can help people find their way out of their own darkness.

"I've had friends who have gone through divorce and they've been in a horrific state of mind for years. I've had friends lose their jobs and go down dark paths. I've had friends who lost loved ones who could never really recover. What makes my accident any different?

"We're all trying to find our purpose and how to pick ourselves up out of that dark space. That's why I wrote the book."

Williams worked on the project for three years while also serving as a college basketball TV analyst. He said Mike Krzyzewski, his coach at Duke, flatly told him his first draft needed to be rewritten. Williams' literary agent told him to be honest and real in his subsequent drafts.

Williams is glad they did.

"When you go through something like that, you compartmentalize everything," he said. "I remember details, but I was so busy trying to find out who I am after the accident that I didn't spend much time reflecting on who I was. I'm not saying I was a bad kid, but I also was a kid.

"I remember when I decided to speak up about how badly (the Bulls) were playing, even though I wasn't playing well. I got crucified for that, but I came from a place (at Duke) where we operated differently. There was an adjustment period for me."

One day after practice, teammate Fred Hoiberg—who later would become the Bulls' head coach—pulled Williams aside.

"I'll never forget what he said," Williams said. "He said: 'You know what? What you said is OK because this is the first step we need in order for change to occur. Some of these growing pains we're going through are not OK. Some of these personalities we have associated with our team are not OK. We need to change the culture from within.'

"I had so much respect for Fred because Fred was the athlete my college coach always talked about me being. You get there early. You stay there late. You work your tail off. You study the playbook. You out-think your opponent. You're committed to the game. That's who Fred was and is."

Williams devotes one full chapter to his lone season in Chicago. In an interview about the book, he thanked the organization for the roughly $3 million buyout of his contract the two sides finalized in February 2004 despite Williams violating his contract by riding a motorcycle.

"I learned a lot about myself recounting what I did, how I partied, how I started to not care for a while. I was immature. I was really stupid, but we all do things we look back on when we're older and say, 'Why did I do that?' Mine just happened to cost me my career."

Williams hopes the book will inspire others in crisis. But as comfortable as he is with his present, he occasionally drifts to the past.

"You see what Derrick Rose and Jimmy Butler are able to accomplish and I'm not envious—I'm respectful," Williams said. "But I wonder about what could've been.

"Does Derrick come to Chicago if I'm there? Does Kirk Hinrich come if I'm still there? That's what I have to live with. It's part of my journey."

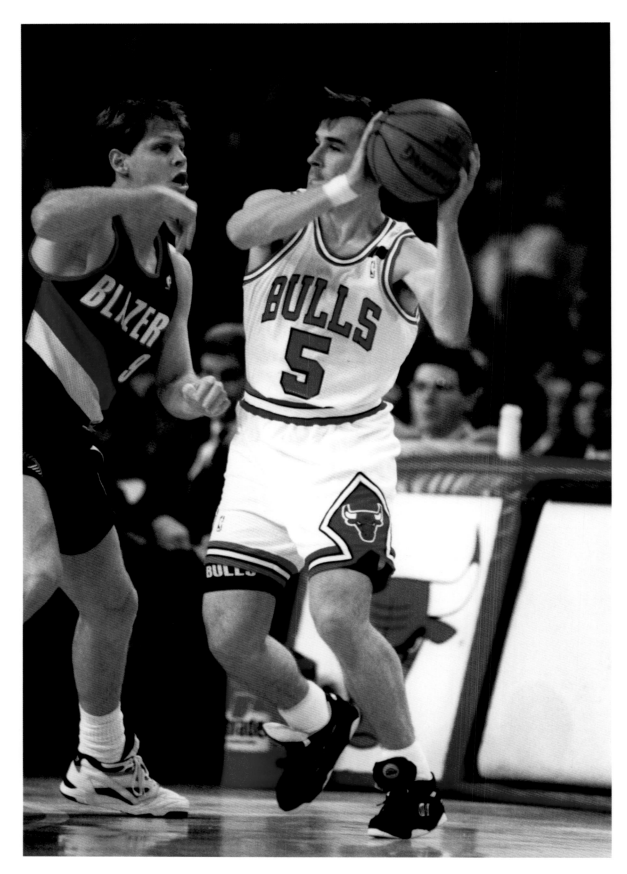

John Paxson protects the ball as Portland's Danny Ainge defends during Game 2 of the NBA Finals on June 5, 1992 at the Stadium. The Bulls lost 115-104 in overtime, but went on to win the series in six games.

John Paxson

ULTIMATE TEAM PLAYER

5 POINT GUARD
1985–94

ASSISTANT COACH
1995–96

BROADCASTER
1996–2003

GENERAL MANAGER/ EXECUTIVE VICE PRESIDENT
2003–

It would be easy to take a condensed view of John Paxson's life and say he was preparing for a job as an NBA general manager ever since he picked up the game. His father, Jim Sr., was an NBA player in the '50s, and older brother Jim Jr. starred at the University of Dayton like his father and later with the Portland Trail Blazers before becoming general manager of the Cleveland Cavaliers.

But the truth is, Paxson was preparing himself for virtually every major opportunity that could come his way, studiously planning and organizing and yet leaving himself available for whatever challenge might arise.

"He has sort of positioned himself all his life to be prepared but leave things open," his father said. "That's always been his attitude."

Growing up in the middle-class Dayton suburb of Kettering, Ohio, the two older Paxson brothers were always students of the game, their father said.

"From that perspective, they have some different qualities than others who were more concerned with the limelight and the dollars and prestige of the game," Jim Sr. said.

With a September birthday, John was always one of the youngest members of his grammar school class, but he was so determined to become a top player like his brother that he repeated the 8th grade to attend military school in Indiana. He has said he wouldn't have made the NBA if not for that decision.

Jim decided to follow in his father's footsteps and attend the University of Dayton, where his father had been one of the school's first great basketball stars. The younger Jim left as the school's second all-time leading scorer, making John's college choice quite easy.

"You have to understand Dayton and the community," John said. "Professional sports are in Cincinnati. As I came along and Jim already had made his reputation at Dayton, there was no way in the world I could live up to what my dad had done and what Jim had done. Going to Notre Dame was basically me trying to create my own identity."

John is the only one of Jim Sr. and Jackie Paxson's five children not to attend Dayton. Jim Sr. and Jackie met there. Three of John's cousins went there. When Jim Sr. sold his insurance business in 1990, he took a job raising funds for his alma mater.

"I love Dayton too," John said. "It just wasn't the place for me to stay."

The decision marked merely the first time that John chose a different path and didn't look back.

Paxson earned All-America recognition at Notre Dame and went to San Antonio as the 19th pick in the 1983 NBA draft. He played little his first two seasons behind such teammates as George Gervin, Johnny Moore, John Lucas and Alvin Robertson. Two years later he arrived in Chicago as a free agent, where he outlasted a virtual parade of guards, including Kyle Macy, Steve Colter, Sedale Threatt, Rory Sparrow, Sam Vincent and Craig Hodges, before becoming a starter at the beginning of the 1989–90 season. His chemistry with Michael Jordan on and off the court helped him stick around.

"Every year I felt I had to fight for my position," Paxson said. "I always felt a little anxiety around the trade deadline."

If it helps for a GM or a coach to have played, as so many claim, then Paxson should be able to relate to players of all abilities and on all levels.

"That's a very good thing," former Bulls teammate Bill Wennington said. "Especially today, players respect guys a lot more who have been through it, who understand. You always hear, 'He's never been through it, he doesn't know what's going on.' [With] somebody like John, who has been successful, guys are that much more willing to listen."

As for Paxson's ability to deal with player agents, his own history gives him an interesting perspective.

Like his brother, John hired Larry Fleisher, then head of the NBA Players Association, to negotiate his first contract. Unbeknownst to him, then-Spurs owner Angelo Drossos had a running feud with Fleisher, and the negotiations were more acrimonious than necessary. Paxson, who was paid $85,000 that first season, reported to camp two weeks late, was treated like "a criminal," in his words, and became almost phobic

> **"People respect what he brought as a player, his competitive fire. He's kind of the same way when he works now. The passion hasn't gone away."**
> —JOAKIM NOAH

about subsequent negotiations. In his first three years with the Bulls, he negotiated his own contracts.

Nothing came easily for Paxson in the NBA. From the moment the Bulls got him, all they could think of doing was trying to replace him.

First it was Kyle Macy starting ahead of him. Then the Bulls brought in Steve Colter around Michael Holton and Elston Turner. They traded for Sedale Threatt and then gave Paxson's starting job to Sam Vincent. Then they traded for Craig Hodges and made him a starter along with Michael Jordan.

And then they drafted a point guard, B.J. Armstrong.

"The funny thing is, it seemed like every year we tried to find someone better," Bulls Chairman Jerry Reinsdorf said. "But we couldn't. He was just a fundamentally sound player who knew who he was. And one of my biggest memories is Michael saying, 'If you trade John Paxson, you better trade me.'"

All the while, Paxson said nothing. He played point guard and shooting guard and quietly backed up whomever the Bulls played in front of him.

He was back in the starting lineup again in 1989 when the Bulls, in effect, began their championship run, going to a seventh game in the Eastern Conference finals. Then it was on to three straight titles, two with Paxson getting the majority of the playing time in the backcourt along with Jordan.

No one will say Paxson was the key to those titles. In fact, many continue to insist that he was just fortunate to play opposite Jordan, who drew so much attention Paxson could just stand and shoot.

Yet Paxson was much more. Although he averaged in double figures only twice while supposedly feasting off Jordan, Jordan also was allowed to expand his game because he had such an unselfish player next to him. It's a lot harder to sit back and not shoot for the good of the team than it is to demand the ball and shoot.

No one who ever has been in a Bulls locker room will remember ever seeing Paxson without an ice pack on his knees. But no one who ever saw him on the basketball court will say he didn't have ice in his veins. If not always the most talented, he was among the most fearless. And even the coaches marveled how he defended without much speed or jumping ability.

Always more interested in developing his game and staying in the league than in making as much money as he could, Paxson earned less than he might have been capable of much of his career.

Going into the 1992–93 season, Paxson had averaged $330,000 over the previous three years, not including a $200,000 bonus Reinsdorf gave him that last year to try to bring Paxson in line with other NBA starting guards.

But Krause did not want to re-sign the 30-year-old Paxson. It wasn't until the Spurs offered him a three-year, $4.4 million deal that the Bulls countered with a three-year, $3.75 million offer that he accepted only because he and his wife, Carolyn, wanted to stay in Chicago.

Of course, it came after the Bulls' first NBA title and Paxson's fourth-quarter shooting heroics in Game 5 against the Lakers. He later said the Bulls could have had him for a lot less if they had signed him earlier.

As his career wound down, Paxson was periodically asked about coaching. It seemed natural for a player who came from a basketball family and who was considered a coach on the floor. The assumption was that he'd eventually return to Notre Dame, either as a coach or athletic director.

But Paxson often scoffed at such suggestions, saying he couldn't imagine continuing on a pro athlete's schedule. When he did return to the game as an assistant coach a year after his retirement, he said it was not part of any plan in which he saw himself eventually moving to the front office.

"It was never like that," Paxson said. "That year was a great learning experience. Phil was wonderful. But I stepped away for all the right reasons. It wasn't that I was afraid of the commitment or the time. That never has been the case. I just saw I was going to be missing some things I didn't want to miss at that point in my life.

"I've never been one to make a decision and look back and say I regretted it. I've been pretty good at making choices. And after the year in coaching, I realized I needed to do something else, so I did it."

Carolyn Paxson, his high school sweetheart and wife of nearly 20 years, always has been supportive of her husband's career decisions.

"She always has told me, 'Do what you want to do,'" Paxson said. "I could tell her tomorrow that I got a job wherever and she'd be OK. I'm very lucky in that way."

Paxson was named executive vice president of basketball operations on April 14, 2003. The man he

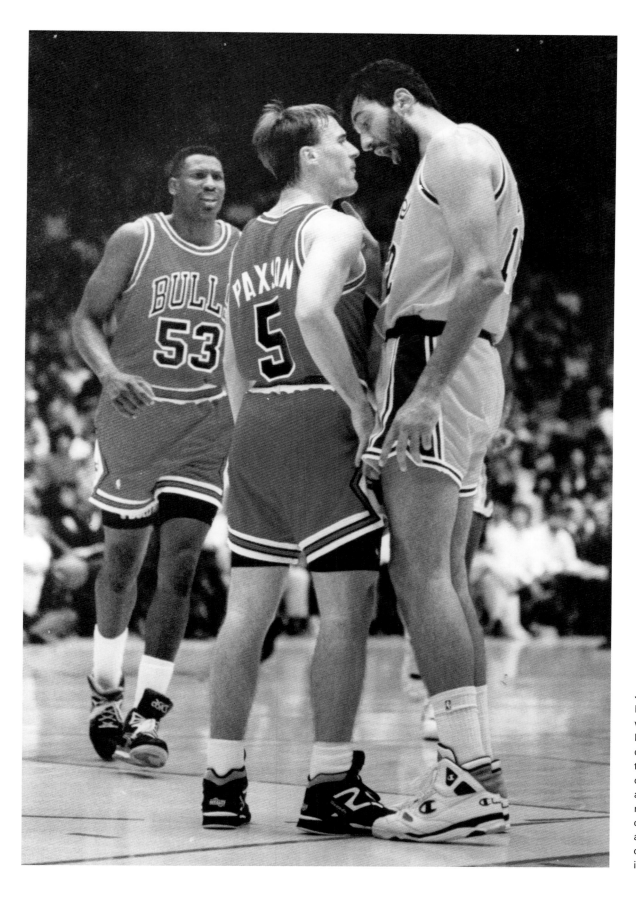

John Paxson, shown here going toe-to-toe with the Lakers' Vlade Divac, brought his competitive edge from the court to the front office. During his stint as general manager, he reportedly throttled head coach Vinny Del Negro in a heated disagreement over Joakim Noah's playing time.

John Paxson, shown here with assistant coach John Bach, earned the respect of his teammates and colleagues in all of his various roles with the Bulls. "He's a very good listener," said Gar Forman, who succeeded Paxson as the Bulls' general manager.

succeeded, Jerry Krause, invited Paxson to his home on Paxson's first full day as Krause's successor. They talked for 90 minutes.

"Rod Thorn did the same thing with me," Krause said of his predecessor. "I thought that was class. It's not complicated. You do that for good people."

Paxson has had opportunities to leave. Jordan tried to coax him into serving as his first coach when he assumed control of the Wizards. But Paxson didn't want to uproot his family, and Jordan hired Leonard Hamilton instead.

The seeds of such loyalty apparently were planted long ago.

"His contract was up and he came to me and said, 'I'd like you to negotiate my contract,'" Krause recalled.

"I said, 'Whoa, what do you mean?' He said, 'Well, tell me what the number is and we'll just do it that way.' I said, 'Pax, general managers don't negotiate players' contracts.' He said he'd like me to do it and trusted me.

"So I did it and gave him more than I should've. He probably knew that would happen. He's smart as hell. Three years later, his contract was up and I told him he was making too much now for me to do it, so he

needed an agent. He got David Falk."

Given that Falk owned a reputation as an uber-competitive representative, the choice seemed apt. Paxson as player was no stranger to technical fouls.

"He really got upset at referees," Reinsdorf said. "I asked him once, 'Why do you get so excited and why are you such a red ass?' His answer to me was, 'I can't stand injustice.'"

That competitiveness produced some missteps too. In March 2010, Paxson angrily confronted Del Negro inside Del Negro's office for exceeding a medically imposed minutes limit on Noah for the second time.

A brief altercation in which Paxson grabbed Del Negro's tie forced Reinsdorf to hire independent lawyers to investigate. Paxson publicly apologized.

Krause seemed to have his hands in every aspect of the organization, but Paxson demonstrated the ability to delegate. He relinquished some of the day-to-day duties when he hired Gar Forman to be the team's GM in 2009.

Jackson, who made a point of promoting both Paxson and Krause special assistant B.J. Armstrong as executive material, said it's no longer necessary to be a workaholic to succeed.

JOHN PAXSON

> » **Born:** Sept. 29, 1960 in Dayton Ohio
> » **Height:** 6-2'
> » **Weight:** 185
> » **College:** University of Notre Dame
> » **Years in NBA:** 1983–94 as player
> » **Acquired by Bulls:** Oct. 29, 1985 as free agent; hired April 14, 2003 as general manager/ executive vice president of basketball operations; relinquished general manager duties to Gar Forman in 2009

"You want to have a big enough influence to know what's going on everywhere in the organization," Jackson said, "but there used to be some disagreement on how much travel Jerry had to do as the GM. He felt it was very important to be on road trips with the ballclub early in the season, but at some point it's overkill.

"You have to be close enough to the club, but I don't think it would take that for a person of John's stature to know what's going on with the team. He sees the chemistry, and that's what basketball is all about. It doesn't always matter how much talent you have, it's how that talent is melded together. That's where John has intimate knowledge."

"(Paxson) really didn't like parts of the GM job," Reinsdorf said. "He hated dealing with agents and he really didn't like dealing with the media. That's why we made the change with Gar being the GM. They work as a team, and John has great insights and great talent evaluation skills, but he doesn't have to deal with (media) or agents."

Forman said it's the best working relationship he has experienced in 35 years in the business.

"For as much as he has accomplished in his life, from his playing career to when he was announcer and now as an executive, he's as down-to-earth and as humble a person as you could imagine," Forman said. "And he's a very good listener."

Players noted that latter quality as well.

"Me and Pax, our relationship grew each year," Derrick Rose said. "I'm able to hit him up whenever I want. During the USA Basketball camp (in 2014), that's the most we ever talked. We talked about the game. He talked to me about staying patient and not worrying about anything."

When the Bulls selected Joakim Noah ninth in 2007, some fans clamored for Spencer Hawes.

"I know it was a controversial pick. That's why I've got nothing but love for Pax," Noah said. "He gave me my opportunity, and I know it wasn't one of those easy decisions.

"I have so much respect for Pax because he played big games here and wore this jersey with so much pride. That's probably one reason he's still around. People respect what he brought as a player, his competitive fire. He's kind of the same way when he works now. The passion hasn't gone away."

Funk said Paxson's years as a broadcaster give him a perspective on the league and the Bulls that he could not have developed if he had been working in the front office.

"He's traveling with the team, he has been around the players after games, on their days off, he has seen them in all different situations," Funk said. "I don't know how many times over the last four or five years players and coaches have pulled him aside to ask him a question or talk to him."

"He was also able to look at the team from a perspective in which there was no pressure on him to make a decision. And he was able to stay around the game and in touch with guys he once played against, so he has stayed current and right up to date with everything going on in the NBA today. That's a huge asset."

Some might wonder what Paxson needs with a stress-filled job when he could lead the life of so many former athletes: broadcast, play golf, make speeches and the like.

But then you remember what Paxson once said about his retirement from the game one year after his greatest on-court triumph, and perhaps two knee surgeries past his prime, and you understand that it's simply not him.

"I had a bunch of people tell me to retire on that last shot in Phoenix," he said. "But the more people said that to me, the more I knew that would have been wrong. It would have been too easy. It would have said, 'This is a perfect world and life is great.'

"I needed a year to test my will and my heart and my desire. I learned a lot staying in this business. And I know absolutely for sure that I did the right thing."

When Kirk Hinrich's second stint with the Bulls ended in 2016, he ranked third in franchise history in assists, steals and games played as a Bull and eighth in career points scored.

Kirk Hinrich

GYM-RAT GEM

12 POINT GUARD/
SHOOTING GUARD

2003–10, 2012–16

The basketball hoops got erected early and, in a nod to those chilling west Iowa winters, strategically.

One hoop got set up outside. Another was installed in the living room, all the better for Kirk Hinrich to practice his shooting form year-round and round-the-clock.

Anytime a trip to the gym didn't work or a trip outside needed too much work—snow shoveling and all—Hinrich would take advantage of the vaulted ceilings in his Sioux City home and arch shot after shot at the 7-foot basket.

Sometimes, a Christmas ornament or two got in the way.

His father, Jim, the coach at the local West High School for 24 years, would analyze Kirk's form. And even at a young age, Kirk's form rang true.

Kirk is, after all, someone whose first word as an infant was "ball." Or so Jim says.

You want other signs that the coach's son was going to grow up and make his father proud? On the day Kirk was born, Jan. 2, 1981, Jim's team had lost three straight games.

That night, Sioux City West High won. Then they won six more straight.

"I thought that was a good omen," Jim Hinrich said the day after the Bulls drafted his son with the seventh overall pick in the NBA draft.

"He was basically raised in the halls and the gymnasium of West High."

John Paxson's first draft pick as general manager in 2003, Hinrich wasn't a popular choice at the time.

Dwyane Wade was known, the local product who took the practically local school—Marquette—to the Final Four.

If Paxson had traded for a veteran, that player would have been known, too, some big-name wing player who might have jazzed up the masses.

But Kirk Hinrich?

The skinny kid from Kansas with the goofy haircut? The guy who seemed to be running around on TV

screens in college basketball games forever, one of those anachronistic four-year players?

Hinrich was the seventh player chosen overall. That was the year LeBron James went No. 1, Chris Bosh went No. 4 and Wade went No. 5. Those three would later play an indirect role in Hinrich's future with the Bulls.

Jim Hinrich and Paxson are biased, but both think Hinrich wound up in the right place.

"I don't see him backing down from playing," Paxson said. "Any young kid is going to come in and have their ups and downs.

"We're not going to put a lot of pressure on Kirk to be any player other than who he is. Good, solid players find their way on the floor. And this kid will make good decisions."

Talk to anybody who plays or follows basketball. There is something about a coach's son.

He rides the buses at an early age. He picks up sweaty towels in the locker room as the kid ballboy. He listens in on team huddles, picking up things intuitively, developing a feel for the game.

Kirk and Jim's relationship was no different.

"He was a ballboy as soon as he could get down on the bench," Jim said. "He learned what made me tick and what I was trying to accomplish.

"Coaches' sons have an opportunity to see both sides of it, the negative and the positive. That's why I think it becomes more important to most of them to do the little things and recognize that no matter how good you are, you can't forget about the other four guys. This is a team game."

And one that Kirk played well enough to help lead his father's team to the 1999 Class 4A state title in Iowa.

It was about this time that Jim realized Kirk had a chance to be something special. He teamed with future Kansas teammate Nick Collison, a first-round pick of Seattle, to lead their AAU team to the national under-19 title game.

A banner career at Kansas followed.

Then came the next challenge, the NBA. Hinrich had previous connections to the Bulls.

KIRK HINRICH

- » **Born:** Jan. 2, 1981 in Sioux City, Iowa
- » **Height:** 6-4'
- » **Weight:** 190
- » **College:** University of Kansas
- » **Years in NBA:** 2003–
- » **Acquired by Bulls:** June 26, 2003 in 1st round (7th overall) in NBA Draft; reacquired as free agent July 23, 2012

Gar Forman, a special assistant to Paxson, spotted Hinrich at a tournament in Las Vegas between his sophomore and junior years of high school, when Forman worked for Tim Floyd at Iowa State.

Hinrich orally committed to Floyd and Iowa State later that summer. But when Floyd left to coach the Bulls, Hinrich backed out and eventually signed with Kansas.

"His whole world changed," his father said. "The funny thing is, he grew up a Bulls fan. With Michael Jordan, if you were in the Midwest, it was hard not to be a Bulls fan. They were synonymous with the NBA and success. He had all their videos, and he knew a lot of them word for word."

Such a detail isn't incongruous with Hinrich's basketball IQ.

Scouts described him as an intelligent player who sensed what the game needed and tried to deliver.

At Kansas, he played unselfishly and spectacularly, sometimes during the course of the same game.

Then he rarely relished talking about it. Those who have covered him on a regular basis say that, if he could, Hinrich would play each game in an empty gym with no attention or fanfare to follow.

"He's very humble," Jim Hinrich said. "I've always tried to enforce that you don't need to brag about accomplishments. They speak for you. He's extremely confident in his ability, but he doesn't need to talk about it."

This is Jim Hinrich speaking as a coach about his son. But on draft night in New York City, with his wife, Nancy, and his daughter, Jill, alongside Kirk, he had a moment as a father.

"It's hard to describe, but it was a very powerful moment," Jim Hinrich said.

"My wife and I have tried to make every event that our kids have been involved in. We're proud of them no matter how successful they've been. But that was fantastic."

Jim Hinrich finally resigned from Sioux City West to take a coaching and teaching job at North Kansas City (Mo.) High. He said he did so in part to be closer to a major airport so he can more easily follow Kirk's NBA career.

"From an early age, Kirk's big goal was to play for the West High Wolverines," his father said.

Eventually, his ambition—and the stage—got a little bigger.

By the time his NBA career ends, Kirk Hinrich will have played more games in a Bulls uniform than anyone except Michael Jordan and Scottie Pippen. He also ranks right behind Jordan and Pippen in career assists and steals. And no Bulls player ever has made—or attempted—more three-point field goals than Hinrich.

"The value of having a guy like Kirk is he can start, he can come off the bench, he can play the point, he can play (shooting guard). He's very versatile," said his former coach Tom Thibodeau. "He understands the game. He can provide scoring if you need scoring. But he runs the team very, very well. Guys get in rhythm. And his defense is outstanding."

In his first stint with the Bulls, Hinrich averaged 13.4 points and 5.8 assists over seven seasons. He also averaged 15.3 points in 34 playoff games. But his adhesive defense and six-season run as captain spoke to his leadership and value beyond statistics.

The Bulls traded Hinrich to the Wizards in 2010 so they could clear salary-cap space in hopes of signing one or more of the top free agents who hit the market that summer. LeBron James, Chris Bosh and Dwyane Wade wound up in Miami and the Bulls were left holding a bag of cash, some of which they eventually (and somewhat reluctantly) handed to Carlos Boozer.

At the 2011 trade deadline, Hinrich was dealt to Atlanta. He played another full season for the Hawks but returned to the Bulls as a free-agent in the summer of 2012, turning down a more lucrative offer from Milwaukee.

When Derrick Rose missed the 2012–13 season with an injury, Hinrich stepped into a starting role but

The son of a coach, Kirk Hinrich was known for his unselfish, team-first style of play. "He understands the game," said Tom Thibodeau.

battled injuries of his own. He started 60 games that season and 61 the following year when Rose was sidelined yet again.

In July of 2014, Hinrich once again passed on richer deals for the second time in three summers to re-sign with the Bulls. Hinrich is honest about how difficult it is to put your money where your mouth is.

"I thought about it hard. I really did," said Hinrich, whose second stint with the Bulls ended when he was dealt to Atlanta at the 2016 trade deadline. "When you're offered more money, no matter what you say, it's hard to turn down. But when you go through the thought process, you just come back to what's most important. I feel like I've been smart with my money. So I try to make the decision based on basketball and my family." 🏀

THE
2010s
HEIRS TO THE THRONE

The Bulls went all in for free-agent LeBron James in 2010, but James signed with the Heat and became the Bulls' annual playoff foil. The most painful exit came in the 2011 Eastern Conference final, after Tom Thibodeau's first season as coach produced a league-best 62-20 mark, an MVP Award for Derrick Rose and Coach of the Year honors for Thibodeau. The consolation prizes for losing out on James—most notably Carlos Boozer, Kyle Korver and Ronnie Brewer—created a more-than-the-sum-of-its-parts dynamic in the successful years to follow. But after a second straight league-best mark in 2011–12, Rose tore his left ACL in the opening game of the playoffs. Joakim Noah then went out with a serious ankle injury and the Bulls fell to the eighth-seeded 76ers. Following surgery, Rose sat out the entire 2012–13 season, drawing some fans' ire. When he tore his right meniscus just 10 games into his comeback in November 2013, the direction of the franchise changed again. Two-time All-Star Luol Deng got traded to avoid paying the luxury tax. And even Noah's spectacular 2013–14 season in which he earned first-team All-NBA honors and finished fourth in MVP voting came at a cost. He needed left knee surgery in May 2014 as the Bulls reshaped the roster again, chasing Carmelo Anthony and signing Pau Gasol in free agency. The Bulls went 50-32 in Thibodeau's last season, which featured infighting with John Paxson and general manager Gar Forman and ended with a fourth playoff dismissal by James, who had re-signed with the Cavaliers. Fred Hoiberg's hiring had the Bulls hoping for a better Iowa State-to-the-NBA transition than Tim Floyd's.

Opposite: A two-time NBA All-Star and the league's Defensive Player of the Year in 2013-14, Joakim Noah epitomized the grittiness and determination of the Tom Thibodeau-era Bulls.

2010s

May 4, 2011
Derrick Rose is named the NBA's Most Valuable Player, the youngest winner in league history at age 22.

May 26, 2011
Miami wins Eastern Conference final four games to one.

May 4, 2013
Bulls are pushed to a seventh game but eliminate the Nets 99-93 on the road.

May 15, 2013
The Heat closes out second-round series with four straight victories, taking Game 5 in Miami 94-91.

April 28, 2012
In the final minutes of Game 1 of their first-round series against the 76ers, Derrick Rose injures his left knee and is lost for the remainder of the series. The injury forces Rose to miss the entire 2012–13 season.

April 26, 2012
Bulls win second consecutive Central Division title.

Nov. 22, 2013
Derrick Rose suffers a knee injury that requires surgery and ends his season.

Feb. 18, 2010
Bulls trade Tyrus Thomas to Charlotte.

April 27, 2010
Bulls lose 96-94 to Cleveland in Game 5 of their first-round playoff series. The Cavaliers take the series four games to one.

June 23, 2010
Bulls name Tom Thibodeau head coach.

May 10, 2012
Eighth-seeded 76ers finish off first-round upset of the injury-depleted Bulls with a 79-78 win in Game 6.

DERRICK ROSE SIDELINED AGAIN

BACK ON THE CLOCK

Bulls' star guard out indefinitely, faces surgery on torn meniscus

| 2010 | 2011 | 2012 | 2013 | 2014 |

June 24, 2010
Bulls trade guard Kirk Hinrich to Washington, sign forward Carlos Boozer.

May 4, 2010
Bulls fire head coach Vinny Del Negro.

March 30, 2010
Bulls executive vice president John Paxson gets into an altercation with head coach Vinny Del Negro.

June 24, 2011
With 30th pick in the NBA draft, the Bulls select Marquette guard Jimmy Butler. The Bulls also acquire Nikola Mirotic, a forward from Montenegro, in a trade with Minnesota.

May 4, 2012
Center Joakim Noah injures his ankle during a 79-74 loss to the 76ers in Game 3 of the playoffs. He misses the rest of the series.

April 29, 2014
The Wizards win all three games in Chicago—capped off by a 75-69 decision in Game 5—and take the opening-round playoff series four games to one.

July 19, 2014
Bulls sign free-agent center/forward Pau Gasol.

DOWN THEY GO

April 30, 2015
Bulls wrap up their first-round playoff series four games to two with a 120-66 rout of the Bucks in Milwaukee.

May 10, 2015
LeBron James hits a buzzer-beater from the corner to give the Cavs a series-tying 86-84 win in Game 4.

May 14, 2015
The Cavs end the Bulls' season with a 94-73 victory at the United Center in Game 6.

May 28, 2015
Bulls fire head coach Tom Thibodeau. ·········>

June 2, 2015
Bulls name Fred Hoiberg head coach.

June 23, 2016
Derrick Rose is traded to the Knicks in a five-player deal.

July 2016
Bulls sign free-agent guards Dwyane Wade and Rajon Rondo.

| 2015 | 2016 | 2017 | 2018 | 2019 |

Jan. 15, 2016
Shoulder injury requires surgery and ends Joakim Noah's season.

Sept. 29, 2015 ················>
In the team's first practice, Derrick Rose takes an accidental elbow to the face and suffers a fractured orbital bone.

Feb. 24, 2015
Bulls announce that Derrick Rose will need surgery to repair a torn meniscus in his right knee. Rose misses the next 20 games.

Derrick Rose

CHICAGO'S NO. 1 SON

1 POINT GUARD

2008–

In the summer before Derrick Rose's freshman season at Memphis, head coach John Calipari received a report that Rose's knee was hurting him. Why would his knee be bothering him already, Calipari wondered.

The answer: Rose was toiling in the gym for six hours at a time. It might have been the first time in recorded history that a coach asked an elite player to stop working so hard.

Rose was accustomed to a payoff, having won two state titles at Simeon and reaching the NCAA tournament title game the following April. The question, as those close to him saw it, was how he would digest the inevitable multiple losses of an NBA season.

After all, the kid once cried after he lost an AAU game.

"[Calipari] made a joke about Derrick: Within the last two or three years, I think the kid hasn't lost more than five games," said Reggie Rose, Derrick's older brother. "And Cal was like, 'My God, when Derrick goes to the league and he loses 10 games, he might lock himself in a room.'"

Calipari recalled a film session with Rose early in his one-and-done season. As the video played on, a horrifying whimper caught the coach's ear.

A film room can be a repository for angst because it confirms any and all glitches in the system. Still, it's meant to be more classroom than torture chamber. Yet here came the plaintive moan, as if someone had drunk a glass of milk a month past its expiration date.

"Awwwwwwww."

Calipari was showing his gifted freshman point guard a mistake. Rose agonized. He groaned. He covered his eyes with his hands. As the next clip began, he slowly moved his hands away, like someone terrified of what a horror-flick killer might do next.

"He's going to be his own worst critic," Calipari said. "Someone around him has to be able to tell him, 'You're fine, would you stop?' It's not going to be what you write or what a coach says. It's going to be what he says to himself.

"He has an inner critic that's very, very tough. In (the NBA), you can't beat yourself up. If you beat yourself up, it's hard to break through. Because everybody else is trying to beat you up."

While at Memphis, a reporter asked Rose to describe himself, and he replied, "An unselfish guard who's willing to do anything to win. I mean, anything."

Derrick Rose was 19 when he came to the Bulls with expectations that only grew with the demands. And so you had to wonder:

How would someone so young handle the responsibility of being the face of a once-proud NBA franchise? How tough would it be to carry the hopes and dreams of a team's future as it struggles to recapture past glory?

Rose isn't going to hand over the answer—doing so would not be his style. He does not lecture, he listens, politely. Rose has plenty to say, but his voice remains at the same level, low and even, his mouth barely moving when he speaks, so that even when he smiles, which is often, you can miss it.

Same with sorrow.

But that's when the good-natured young man from Englewood stops talking completely for a time and gathers himself.

Tough? Playing the game you love in the city you love and getting paid millions of dollars for the privilege? No, tough was leaving home for Memphis, breaking from the small circle of friends he'd spent practically his whole life with and having to miss the funeral of one of those friends, who they said was killed playing Russian roulette.

"But he definitely wasn't playing Russian roulette," Rose says. "He would never do that. It was crazy. We were always together when we were younger. He had moved out to the suburbs with his father and he came back to the neighborhood for like a night. He told his mom he would be home that night . . . but he didn't make it.

"That was my first close friend who ever died. You have to fight through it, but it was tough, really tough."

Hopes and dreams? As a child, Rose never harbored any for the NBA. It wasn't that his mother discouraged him or told him it was unrealistic.

Opposite: Despite having astronomically low odds of landing the first pick in the 2008 draft, the lottery balls bounced the Bulls' way, allowing them to select homegrown start Derrick Rose.

Derrick Rose, shown here during media day in September, 2014, was a three-time All-Star with the Bulls and was named the NBA's Most Valuable Player for the 2010-11 season, the only Bull other than Michael Jordan to win the award.

"If I said I was going to be an astronaut, she'd say I was," he says of Brenda Rose, a single mom who raised Derrick and three siblings. "She wouldn't want to break my heart."

He couldn't fathom all of this until high school, at Simeon, where his skill and flair on the basketball court first marked him as something special. Before then there was only one obscure hope, one dream.

"I just knew I had to do something, I had to be something where I was going to take care of my mom," Rose says. "I knew my brothers and others in my family would be all right, but I felt like my mother was working too hard. She used to cry when she'd get the bills. It was tough."

Too much responsibility? How so? To be the type of person his mother taught him to be? To sign autographs and make appearances and show up on time to take private planes and stay at great hotels?

"This is the fun part," Rose says with a laugh.

No, responsibility is what he still feels to Englewood.

"I just want to give them hope because that's what we need right now," Rose says. "There's lots of shooting and fighting in our high schools now, to where they want to play games without fans. That's what hurts."

Rose donned jersey No. 25 at Simeon, the number the team's best players traditionally wear in honor of Ben Wilson, a star who seemed destined for the NBA until he was shot to death in November of 1984, the day before the first game of his senior season.

But Rose remembers a strict and safe Simeon and a less frightening Englewood than the one that is known as one of the most dangerous and violent neighborhoods in the city.

From June 1 to Aug. 31 of 2007, the summer before Rose left for college, the summer his friend Stephon Reavley died at 19 from what police called an "accidental" gunshot wound, there were 14 murders in Englewood. By the end of the year there were 39, making it the third deadliest community in Chicago.

"That summer was wild in Chicago, and going away cleared my mind, like a new beginning, like it was a new life," Rose says. "I knew I could change a lot of people's lives by the way I played basketball."

Returning home a year later as Rose did, as the No. 1 pick in the NBA draft and a member of the Bulls, was as strange and unlikely as doing it a newly minted millionaire, suddenly a household name.

During preseason training camp in the fall of 2015, Derrick Rose suffered a fractured orbital bone when he took an accidental elbow in the face from a teammate. Rose was in the lineup for the season opener, but wore a protective mask while the injury healed.

» **Born:** Oct. 4, 1988 in Chicago

» **Height:** 6-3'

» **Weight:** 190

» **College:** University of Memphis

» **Years in NBA:** 2008–

» **Acquired by Bulls:** June 26, 2008 in the 1st round (1st overall) in NBA Draft

Rose's family has moved away from Englewood, but he went back there last summer, "just to drive around." His mother's warning to be careful was a little unsettling.

"She didn't want me to get in trouble," he says. "It comes to you. Especially in my neighborhood, people are always looking to come up when they have the opportunity."

"I always kid his mom, 'Tell me how you did this,'" says Calipari. "Stars think the sun sets on them. This kid has other people's feelings at heart, he wants it to be more about you than him. She said, 'I told him to treat people how you want to be treated and I always told him you're no different than anyone else.'"

On **April 28, 2012,** Derrick Rose stood as the NBA's reigning most valuable player, the youngest in league history, leading his top-seeded Bulls to a matinee victory over the 76ers in the opening game of the playoffs.

You know the rest: With 1 minute, 22 seconds remaining, Rose came to a simple jump stop, elevated and crumpled to the ground, his left ACL torn and his too-good-to-be-true narrative irrevocably changed.

It might be simplistic to say Rose's torn ACL stands, for now, as the delineation between fortune and misfortune as far as his Bulls career goes. But it's accurate. Before: Rookie of the Year. Three All-Star Game appearances. The aforementioned MVP. After: Just 61 games played over the next three seasons with no mid- or postseason honors.

Ever since that fateful day, Rose's story has been defined more by off-the-court events than on.

Some of this dynamic—his poorly-delivered comments in November 2014 about preserving his body for post-career events—has been under Rose's control. Much of it—three knee surgeries, the almost hyperactive scrutiny of seemingly every decision or utterance—has not.

Since his MVP year in 2011, Rose missed in chronological order—deep breath here—five games each to a sprained toe and strained back; 16 games to groin, ankle and foot issues; the entire 2012–13 season to a torn left ACL; 76 games to a torn right meniscus; eight games to ankle and hamstring issues and 20 games to a second right meniscus tear.

Then, on Sept. 20, 2015, during the Bulls' first practice under new coach Fred Hoiberg, Rose caught an accidental elbow to his face, suffering a fractured orbital bone that caused him to sit out the entire preseason. Through the 2015–16 season, Rose missed occasional games for an assortment of reasons—not surprising considering what his body had been through.

"It's frustrating of course when you miss games," Rose said, "but (you) can't get mad at that. It's the reality."

Rose rarely refers to his 2010–11 MVP season. And expectations for him to play at that level again were unlikely to be fulfilled.

"I never worry about stuff like that. And as far as (public) criticism, I'm just numb to it," Rose said. "I always want to help my team win. So when I'm in the game, I let that other stuff slip by and just go ball out."

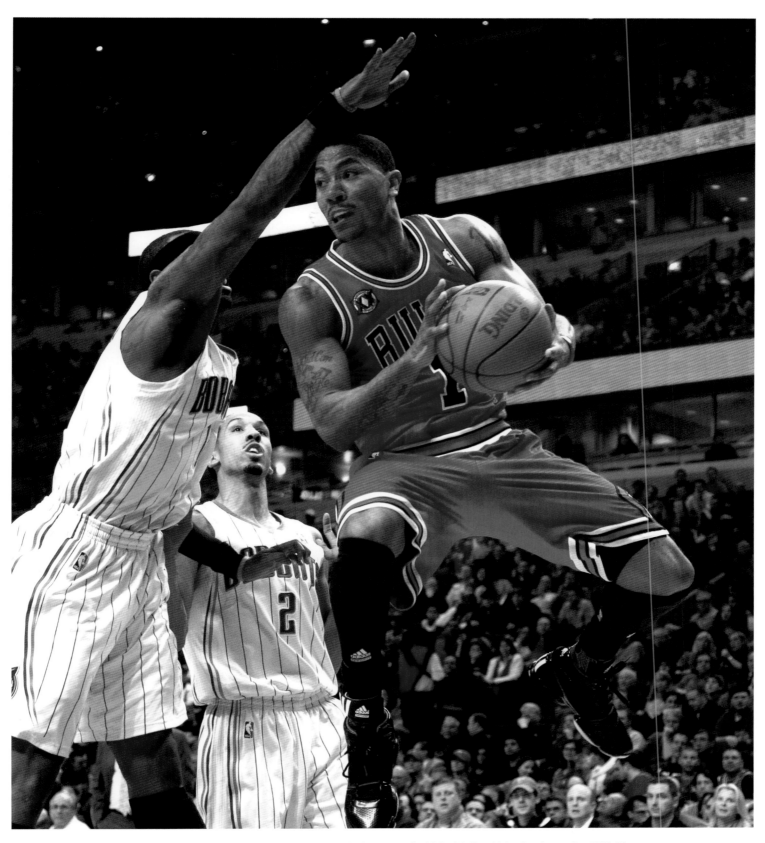

Derrick Rose's Bulls career was marked by a series of debilitating injuries, one of which sidelined him for the entire 2012-13 season.

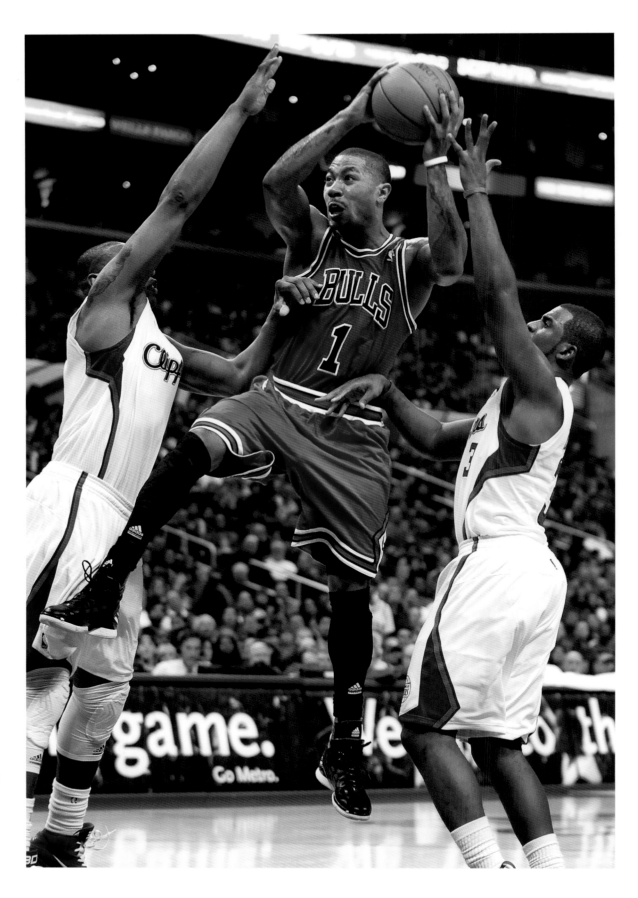

Derrick Rose was traded to the Knicks on June 22, 2016 along with backup guard Justin Holiday and a 2017 second-round draft pick. The Bulls received center Robin Lopez and guards Jerian Grant and Jose Calderon in return.

A late-starting season gets off to a flying start thanks to Derrick Rose's comeback-capping game-winner.

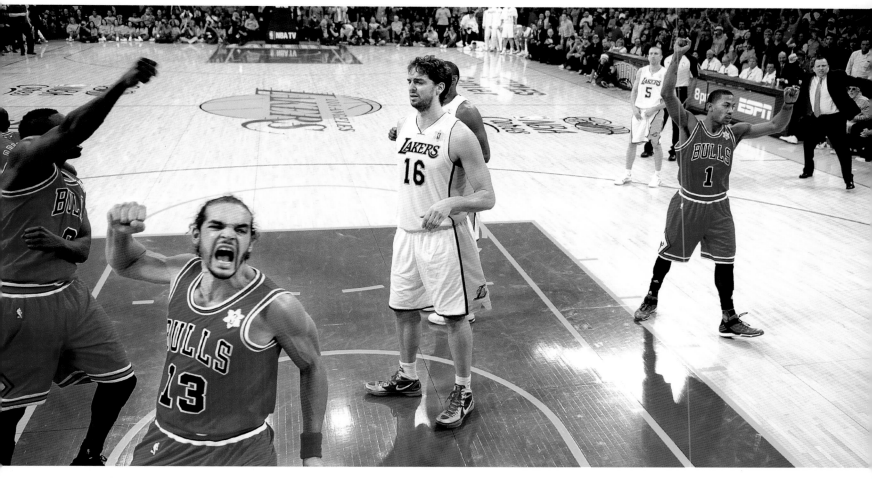

With future Bull Pau Gasol standing helplessly in the paint, Joakim Noah (13) pumps his fist after Derrick Rose (right) hits a go-ahead shot with 4.8 seconds left in the Bulls' season-opening 88-87 victory over the Lakers on Dec. 25, 2011. The 2011-12 season got off to a late start due to a labor dispute.

Rose's floater sinks Lakers

Dec. 26, 2011

Another Derrick Rose game-winning shot. Suffocating defensive plays, mostly by Luol Deng, down the stretch. Another Tom Thibodeau fist pump for the ages at the buzzer.

Labor strife may have claimed five months during the NBA lockout, but the Bulls sure look like they plan to pick up where they left off last regular season. You know, with character, talent and the occasional heart attack-inducing moment for the diehards.

Rose's 9-foot floater with 4.8 seconds left, following Deng's steal against Kobe Bryant, capped an improbable comeback in the season opener at the Staples Center, giving the Bulls a dramatic 88-87 triumph over the new-look Lakers.

"It's one big shot after the next," Thibodeau said. "And it's been that way certainly all last year and starting this year. He's something."

Deng, with great help defense from Joakim Noah and Taj Gibson, added the exclamation point by blocking Bryant's hanging shot from behind as the final buzzer sounded.

"Everyone knows by now we play hard," Deng said. "We stick together whether we're down 30 or down two. We're always going to play to the end."

Derrick Rose (left) gets
his Bulls teammates
fired up as they huddle
before a game against
the Hawks on Jan. 3,
2012 at the United Center.
The Bulls went on to win
76-74.

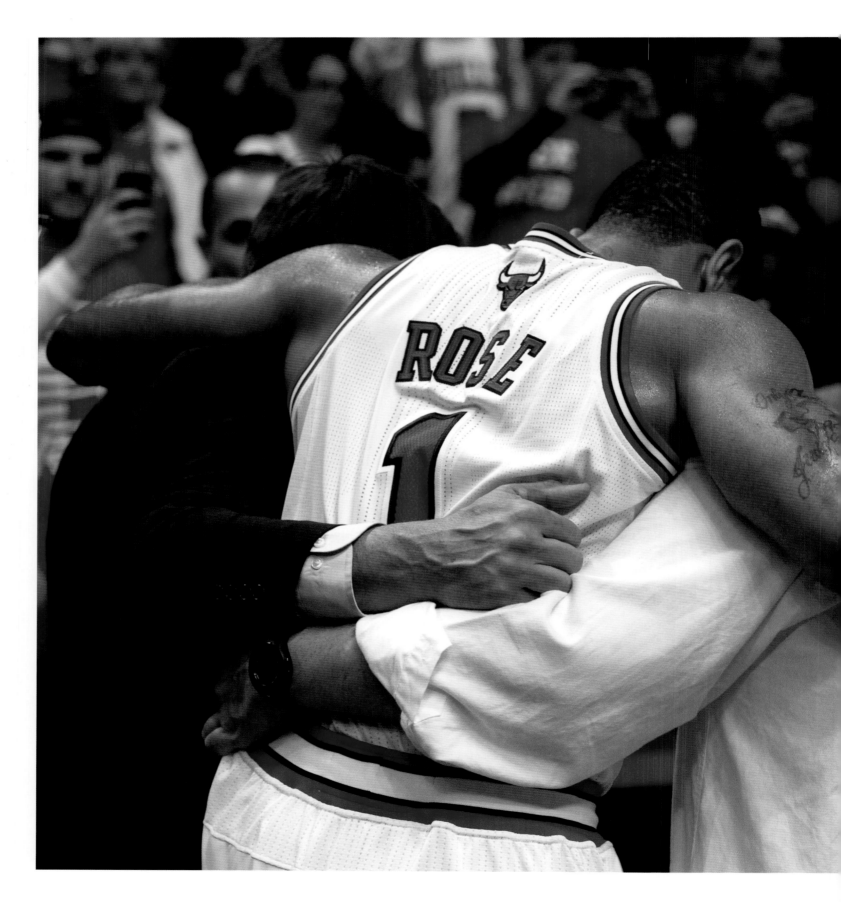

A promising playoff run ends prematurely after Derrick Rose is injured in Game 1 of the first round.

Won and done

·· **April 29, 2012**

After reaching all those dizzying heights and unfurling countless acrobatic moves in his first three spectacular seasons, Derrick Rose's fourth ended with an awful image.

A jump-stop. A clutch of his left knee as he rose two feet into the air. A crumple to the ground. And following a slow, supported walk off the United Center court, an exam that revealed a torn anterior cruciate ligament.

The Bulls won Game 1 of their Eastern Conference quarterfinals, downing the 76ers 103-91 before a raucous home crowd. But news of Rose's injury-plagued season ending with the biggest and cruelest setback of all made the postgame locker room seem funereal.

"Saddest win ever," Kyle Korver said.

Rose, who missed 27 games with five separate injuries during the regular season, stuffed the box score with 23 points, nine rebounds and nine assists before his injury, which came with the Bulls up 12 with 1 minute, 22 seconds remaining.

Some second-guessers were left to wonder why Rose was still in the game. Rose, who played 37:13, had returned with 7:53 left and the Bulls up 15.

But a series of turnovers and fouls helped the 76ers trim their deficit to 12. Tom Thibodeau, as is his nature, had four starters and Korver in down the stretch.

"A guy can get hurt in practice," Thibodeau said. "He can get hurt in the first five minutes of the game. He can get hurt at the end of a game. He can get hurt any time. The score was going the other way. He has to play. He has to work on closing."

Mercilessly, a Bulls season soon came to a close before anybody expected. After finishing with the league's best regular-season record for the second year in a row, the Bulls couldn't close out the eighth-seeded 76ers, who went on to win the series in six games.

What if Rose hadn't torn an ACL? What if Joakim Noah hadn't twisted an ankle in Game 3? What if Luol Deng had two good hands or hadn't been hit in the nose hard enough in the first quarter of Game 6 to require stitches?

Those "what ifs" would haunt the Bulls for the remainder of Thibodeau's tenure as coach.

Left: Derrick Rose is helped off the court after injuring his knee during the waning minutes of the Bulls' 103-91 victory over Philadelphia in Game 1 of the playoffs on April 28, 2012. The injury forced Rose to miss the entire 2012-13 season.

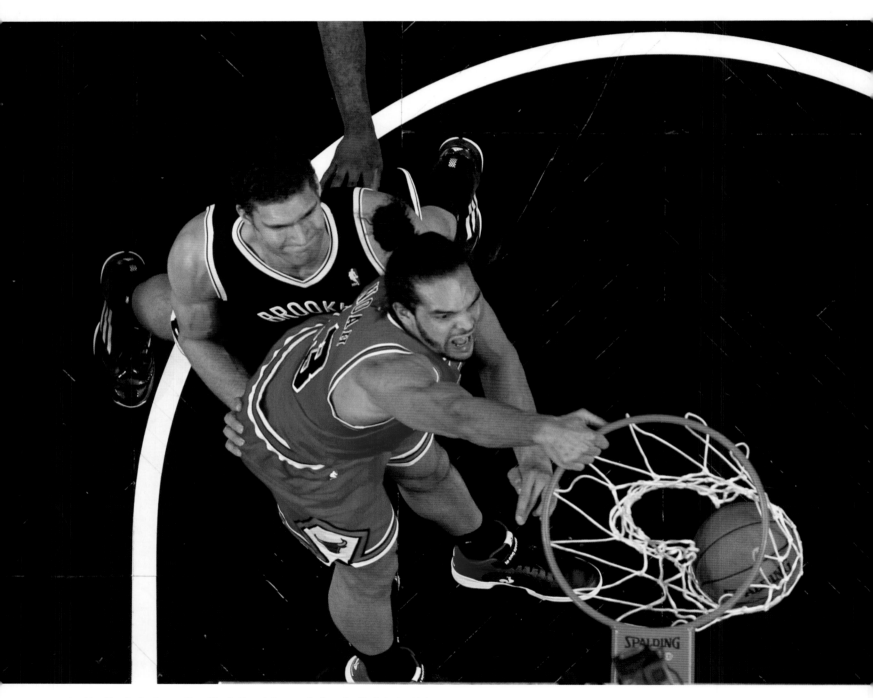

Joakim Noah dunks on Brooklyn's Brook Lopez during the Bulls' 106-89 loss to the Nets in Game 1 of a first-round playoff series on April 20, 2013. The Bulls went on to win the series in seven games. Lopez's twin brother, Robin, would later be one of three players acquired by the Bulls in a 2016 trade for Derrick Rose.

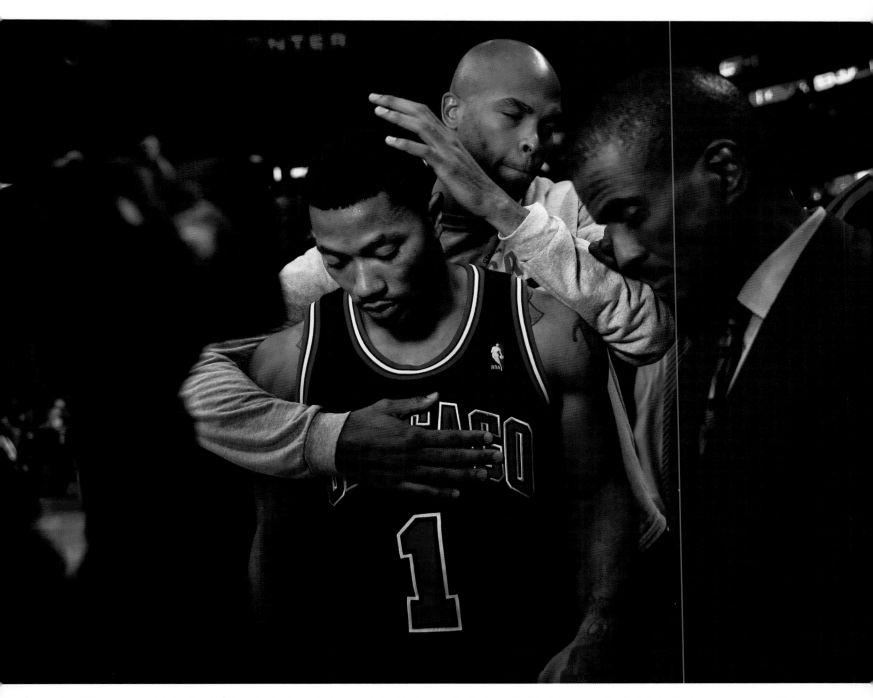

Taj Gibson congratulates Derrick Rose for hitting a last-second shot that gave the Bulls an 82-81 victory over the Knicks in the home opener on Oct. 31, 2013 at the United Center.

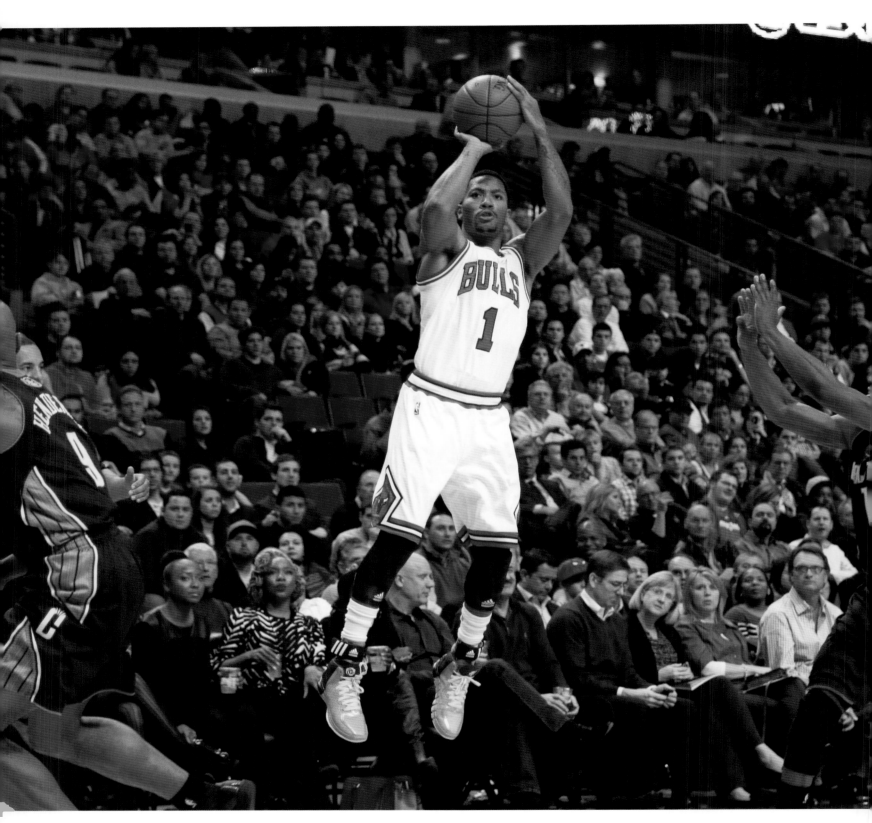

In 41 playoff games as a Bull, Derrick Rose averaged 23.7 points 7.1 assists and 4.8 rebounds—all higher than his regular-season averages.

After missing an entire season, Derrick Rose suffers a second knee injury that ends his comeback after 10 games.

Derrick Rose sidelined again

Nov. 24, 2013

Derrick Rose had so looked forward to the warm embrace that awaited him in Los Angeles.

With friends and family looking on from where he makes his offseason home, Rose was scheduled to play the Clippers in a matinee at the Staples Center. That's mere miles from where he spent so many grueling hours rehabilitating his torn left anterior cruciate ligament over many of the previous 19 months.

Instead, Rose was headed back to Chicago, facing more surgery and uncertainty after an MRI exam confirmed a medial meniscus tear to his right knee. The Bulls said Rose would be sidelined indefinitely.

"It's a huge loss," guard Kirk Hinrich said. "Everything we do is built around him. Losing one of the best players in the league obviously changes the landscape of things. I just feel bad for him personally."

How long Rose is out won't be known until surgeons do their work. Estimates range from one month to six; that's how wide the disparity is.

According to sources who have discussed Rose's medical care, if merely an arthroscopic process is needed to "clean up" the injury, his absence would be on the shorter end of that spectrum. If the meniscus needs more extensive surgery to be reattached or repaired, Rose would be out longer and could miss the entire season.

Oklahoma City All-Star guard Russell Westbrook tore his right lateral meniscus last April and had it reattached. He missed the start of this season before returning, more than six months after the injury.

Sources said Rose likely will opt to have the meniscus reattached, which would be better for the long-term but sideline him longer. Team physician Brian Cole, who repaired Rose's left ACL, is the leading candidate to perform this surgery as well.

However long Rose is out, this latest setback again will test his mental and physical toughness. That's what suffering two significant knee injuries in such a short span does to a player whose game is so reliant on explosion and speed.

"I know how much work he has put into his rehab and the type of person and player he is," coach Tom Thibodeau said. "So I feel for him because of all the things that he does and what they mean to our team."

Rose suffered the injury cutting on a non-contact play in Portland, Ore., and left the arena on crutches. Originally, team officials and teammates feared the

Derrick Rose makes his way to a press conference at the United Center on Dec. 5, 2013 to talk about his second major knee injury.

worst-case scenario given that Rose is so recently removed from missing all of last season as he rehabilitated his surgically-repaired left knee.

Defense and grit can only carry the Bulls so far as another playoff disappointment signals an offseason overhaul.

Down they go, changes on way

April 30, 2014

The Wizards eliminated the Bulls from the Eastern Conference quarterfinals in five games with a 75-69 victory, placing a period on another overachieving regular season and underwhelming finish.

The loss didn't merely mark the end of a season. It marked the end of an era.

The summer of 2014 always pointed to change, a process Derrick Rose's second straight season-ending knee injury and the subsequent trade of Luol Deng accelerated. And so the team that trudged off the United Center court won't be the same one that arrives at October's training camp.

Only offensive-minded applicants need apply.

The Bulls capped an offensive season—pun accepted—in which they ranked as the lowest-scoring and worst-shooting regular-season team with, fittingly, a season low for points. They shot 33.3 percent. They endured a first-half stretch of 1-for-15 and a second-half stint of 1-for-10, and they failed to break 15 points in the first and third quarters.

And they added injury to insult, losing Taj Gibson to a sprained left ankle in the fourth quarter and playing Joakim Noah as he limped his way through a left knee injury that sources said required fluid to be drained from it recently.

In that regard, Noah, who impressively gritted his teeth through six points, seven assists and 18 rebounds, epitomized this season. The Bulls fought and fought, overcoming odds and adversity but ultimately finished short.

"My knee's bothering me," Noah said. "I'm not sure what it is. I was limited. But it's no excuses. Now we have a lot of time to take care of it."

Gibson, who finished his breakout season with 12 points and four rebounds, badly rolled his ankle when he landed on John Wall's foot.

"We had a hard season and put in a lot of effort," Gibson said. "And you want to get rewarded when you put in a lot of effort. It's real disappointing. We put so much work into this season and came out of countless holes. I'm pissed."

"I'm proud of the team," coach Tom Thibodeau said. "They gave us everything they had. There was nothing left. That's all you can ask for as a coach."

Gasol finally arrives, ready to win

July 19, 2014

The Bulls had been linked to Pau Gasol seemingly forever.

Former general manager Jerry Krause scouted him before sandwiching the Twin Toddlers of Tyson Chandler and Eddy Curry around him when Gasol went to the Grizzlies as the third pick in the 2001 NBA draft. And Krause's successor, John Paxson, engaged in serious negotiations for Gasol in 2007 before backing off the Grizzlies' demand for Luol Deng.

Finally, Gasol is a Bull. The former Lakers star signed as a free-agent, agreeing to a three-year, $22 million deal. The third year is a player option.

"He's terrific in the low post with his back to the basket," head coach Tom Thibodeau said. "He can face up. He can pass. He's excellent in the pick-and-roll. He's very effective in the elbow area. So there are a lot of different ways we can use him."

Gasol, 34, turned down more money from the Lakers and other contenders including the Thunder and Spurs.

"I prioritized being on a championship-caliber team," Gasol said. "If I didn't believe we had that potential, I wouldn't have come here. I think we have all the pieces. Now it's a matter of getting to work. It's about actions and not talking."

Two of those pieces, Joakim Noah and Derrick Rose, played prominent roles in Gasol choosing the Bulls.

Noah traveled to Los Angeles for the Bulls' pitch to Gasol, who spoke to Rose by phone. Mike Dunleavy also reached out, as did Chairman Jerry Reinsdorf.

"They had big interest in having me on the team," said Gasol. "Their humility and not having a big ego made it a lot easier. They're hungry to win as well. I wanted to be a part of a hungry team."

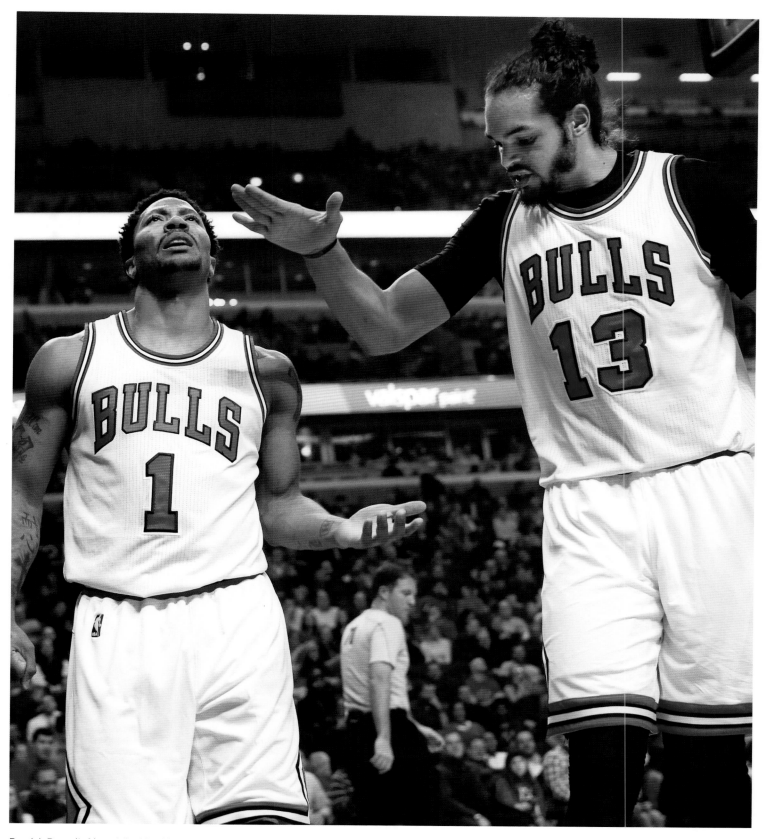

Derrick Rose (left) and Joakim Noah formed the core of the Bulls team that won a league-best 62 games and a Central Division title in 2010-11.

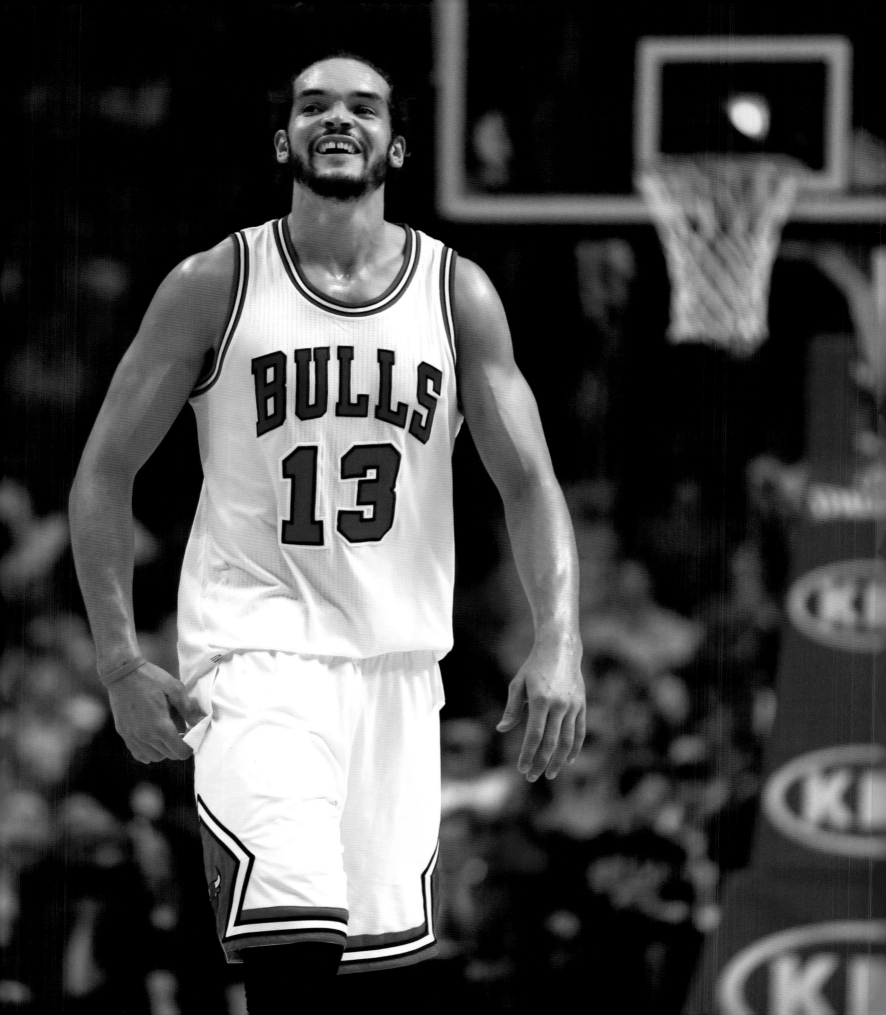

Joakim Noah

HUSTLE AND FLOW

13 CENTER

2007–2016

Joakim Noah descends the basement stairs in his north suburban home, beaming at the creation below.

Taped on the full-length mirrors that surround a health-club-worthy weight room are motivational pictures of opponents he wants to beat and comforting snapshots of family and friends.

There's a picture of his mother, Cecilia Rodhe, Miss Sweden in 1978 and now an artist and sculptor, celebrating after a Bulls victory at the United Center.

There's a poignant portrait of his grandfather, Zacharie, working in a French factory to make ends meet despite his professional soccer career in Cameroon.

There are pictures of Joakim's dorm room at Florida, where he won two NCAA titles; shots of Joakim playing pick-up basketball everywhere from the asphalt playgrounds of New York to the tropical fields of Hawaii; and a hilarious picture of a skinny Dwight Howard and a very feminine-looking Noah from the 2004 Roundball Classic at the United Center.

There's also Tyrone Green, a no-nonsense youth basketball coach from a gritty slice of New York and a major mentor.

And of course there's a shot of Joakim's father, Yannick, hawking a product in his first endorsement shortly after galvanizing France in 1983 by becoming the first countryman to win the French Open in 37 years.

"That room is the best investment he has done so far," Yannick says from Paris, where he is now a stadium-filling pop music star. "It's a nice space. He enjoys it. And best of all, he uses it."

Yannick suggested the weight room and decorations, and the pictures reveal plenty about Joakim's multiracial and multicultural upbringing.

As for the mirrors, they reflect a young, budding NBA star who acts at peace with himself and his place in the world, anchored by a trait both his father and Green say long has been in place.

"He never has thought he's better than anybody else," Green says on the phone from New York. "He might have traveled the world and been raised in a privileged lifestyle. But he doesn't act like it. He works for everything."

Adds Yannick: "Even though he wasn't the best on his team as he grew up, he was always trying. We'd play one-on-one and of course I was bigger and tried to push him. But at the end of the day, I always told him I was proud of him because he tried. He learned that you can lose but you cannot not try."

In the tense, turbulent transition of Noah's rookie season, teammates voted in almost unprecedented fashion to extend his suspension for berating an assistant coach. Now, Noah posts double-doubles with metronomic regularity, continuing a transformation much like the one he created in his basement.

He has looked inward to remake himself as he re-shaped himself.

"That's what it's all about, trying to become a better person throughout," Joakim said. "It's all about growing. I'm not going to say I've never made mistakes. I've definitely made them. You have to learn from them.

"I feel I'm in a really privileged situation, playing at the highest level, making money doing what I love to do. Not a lot of people get the chance to do that. That's why I really enjoy what I'm doing and always make the most of it. I owe that to the people who helped me."

The influences in Noah's life are many. His mother. His high school coaches. Friends and siblings. Florida coach Billy Donovan.

But Noah openly embraces his fortune in having a famous father serve as close friend and walking example of handling fame, as well as a strong shepherd in Green, whom he first met as a gangly teenager when he moved back to New York from France in 1998.

"I'm lucky that I have a father who I'm incredibly close to but also can relate to what I'm going through," Joakim says. "That's unbelievable. He's not going to tell me, 'This is how you should do it.' He's going to tell me, 'This is what happened to me and this is how I dealt with it.' He never has lectured me.

"Mr. Green showed me tough love. I actually never started once for Mr. Green in his tournaments. I think that was good because I grew up in France

Opposite: Joakim Noah is the type of player "who understands the dynamic of a team," said Billy Donovan, his coach at the University of Florida. Noah led the Gators to back-to-back national championships in 2006 and 2007.

The well-traveled son of a tennis star and a renowned model, Joakim Noah formed a foundation to combat violence in Chicago.

and everything was kind of easy. I would go on vacations to Africa or Hawaii with my mom or dad. I was a privileged kid.

"When I met Mr. Green, he was like, 'If you want to take this basketball thing seriously, you can't do that anymore. You have to get better in the summertime. So come and live with me.'"

Joakim was close to two years from being born when Yannick won his only Grand Slam title. But he has watched the video of that match many times and also fondly remembers Yannick giving him the 1991 Davis Cup trophy the day after Yannick captained the French team to an upset of a U.S. team with Pete Sampras and Andre Agassi.

"My father is the most famous person in France," Joakim says more matter-of-factly than boastfully. "He has a lot of love over there. He was always on TV growing up. He might say something a little out there and I'd have to go to school the next day. I'm going through my routine with my teachers and friends and you don't really understand everything as a kid. But my father always taught me not to be scared to speak my mind.

"He's very approachable. That's what people like over there. He's a people person. I remember growing

up that I wanted my dad to lose because I wanted to spend quality time with him. I didn't want to share my dad. But now I look back and understand people respected how he always gave them time. Instead of being a tennis champion, he's the people's champion."

After spending his first three years in New York, Joakim moved to Paris with his parents and younger sister, Yelena, in 1988. Though his parents divorced amicably a year later, he remained in France until 13.

Joakim says his father would crush him in basketball, never taking it easy on him, and that he would cry and throw basketballs because he was such a sore loser. Yannick says he would take the basketballs away as punishment. But inside, he was smiling.

"He was my first child and of course I'm going to share my passion for sport, for exercising, for sweating and trying hard," Yannick says. "We'd play soccer, basketball, tennis and I hated to lose. I'm now cured of that disease, but to be a professional athlete, you have to be a bad loser. You have to hurt.

"And Joakim has that too. That's what I'm really proud of. He doesn't make excuses. He's passionate about the game, loves the teamwork and most of all wants to win. I know people see it as a job after turning professional. He doesn't. He sacrifices whatever it takes to improve and to win."

This competitiveness sometimes can get obscured by both Yannick's and Joakim's reputation for seeking a good time.

"It's true," Yannick says. "I always told him be who you are. Don't try to hide. Don't be fake. Never hurt anybody. Go out and have a great time. But then the next day, make sure you have a good jog or work hard. We are athletes. We are most happy after a good win."

Joakim remembers early-morning jogs with his father in Central Park and through the streets of France. He says his appreciation for his father's accomplishments grew as his own career progressed.

"He never judged me for mistakes," Joakim says. "We talk every day of our lives. And we never talk about the actual game. We talk more about the mental aspect or distractions or things that happen once the game is over. It's a special thing."

Billy Donovan laughed at the memory of Noah walking around campus as a University of Florida freshman, a stereo boombox on his shoulder blasting reggae music, and excitedly offering to burn CDs for anyone who showed interest.

"The immediate tendency is to pass judgment on him because he's a unique and charismatic kid, and what you see is what you get with him," Donovan said. "But he has a great view on life. He's extremely positive, never negative or mopey. And while he has strong opinions, he respects other peoples'.

"He's very self-reflective. When you challenge him, his first instinct isn't to go into denial or get defensive. It's to look within. He's very perceptive with what he needs to do."

Donovan talks fondly of shared rides to and from airports with Noah, who always chose to ride with his head coach. Again, who does that?

"He'd get in my car and talk and talk and talk and ask questions," Donovan said. "After a tough loss, it might be 1 or 2 in the morning, and he'd be saying, 'Coach, you OK? Coach, we're going to be OK. Coach, don't be mad. We'll practice hard.'

"He's that type of kid who understands the dynamic of a team. He will understand when (his coach) says, 'We need your energy and rebounding and nothing else.' He's fearless and highly competitive, but he doesn't have the attitude that he's better than the next guy."

On the night the Bulls drafted him, Joakim interrupted a national TV interview to proclaim his intense love for a "Mr. Green." Even 12 years after moving from Paris to New York and meeting him, Joakim refuses to call his mentor Tyrone.

Green ran the Police Athletic League and later served as sports coordinator for Goodwill Industries in Queens.

"So my mom and sister would go to Africa or Sweden or Hawaii and I would stay in New York and live with Mr. Green," Joakim says. "I'd stay with him in Bedford-Stuyvesant in Brooklyn, which opened my eyes because I wasn't used to being around poverty. It made me tougher, especially on the court."

Green hung the nickname "Sticks" on Joakim because of his frail frame. But Green immediately recognized Joakim's insatiable desire to get better and made sure he became adept at using both hands.

"He's a very competitive guy, just like his father," Green says. "And he's very intelligent too."

Still, Joakim's street smarts didn't ease the

JOAKIM NOAH

» **Born:** Feb. 25, 1985 in New York City

» **Height:** 6-11'

» **Weight:** 232

» **College:** University of Florida

» **Years in NBA:** 2007–

» **Acquired by Bulls:** June 28, 2007 in 1st round (9th overall) of NBA Draft

A shoulder injury limited Joakim Noah to just 29 games in the 2015-16 season.

Joakim Noah entered the Bulls' world in 2007 with a goofy grin, a bow tie and a seersucker suit, endearing himself to fans with an individualistic and irrepressible spirit as the emotional epicenter of the franchise.

The final image of Noah in 2016 was him leaving the court in pain after dislocating his shoulder, an injury that required surgery and ended his season. His future with the Bulls—and in the NBA—was unclear.

What Rick Mahorn and Dennis Rodman were to the Pistons "Bad Boys," Noah always was to the Bulls since he arrived in that ugly pinstriped seersucker suit on draft night in 2007. Sporting such a flashy outfit suggested Noah would offer style over substance but, nine seasons later, nothing was further from the truth. Noah persevered through coaching changes and roster upheaval and, after steady maturation, eventually his attitude became the most consistent thing about Bulls basketball.

He accepted a reserve role for new coach Fred Hoiberg more selflessly than many in an ego-driven league ever could. He defended the reputations of moody teammates such as Rose and Jimmy Butler as aggressively as he did big men in the paint, the consummate leader who never felt the need to announce he is. Nobody in the Bulls locker room cared more about winning, nobody disguised injury as pain with less complaint and nobody on the city's sports landscape epitomizes the rugged no-excuses, all-in approach fans appreciate better than Noah.

Noah always walked the walk and you had to love his swagger—unless you lived in Indianapolis or Boston or Miami or Cleveland. Especially Cleveland.

It was April 2010 when Noah famously proclaimed before a series against the Cavaliers that "Cleveland sucks." Not backing down in the same way he played, Noah clung to his convictions when I asked him after a Game 2 loss at Quicken Loans Arena if he regretted his comment.

"No, not at all," Noah said. "You like it? You think Cleveland's cool? I never heard anybody say I'm going to Cleveland on vacation. What's so good about Cleveland?"

Let Ohioans debate that. In Chicago, everybody can agree that Noah always represented what was best about sports.

emotional sting when Green would bring him to the prestigious ABCD Camp he would work annually in New Jersey—to sweep the courts or run errands.

"He was pissed," Green says. "My wife would ask why he didn't play and I'd say, 'He's not embarrassing himself or embarrassing me.' He wasn't good enough yet. But I thought he could learn."

"I recognized Joakim's passion and love for the game," Yannick says. "But Tyrone was the first one to recognize and use his talent. I thought he was crazy the first time he told me Joakim was going to go all the way to the NBA. But Tyrone always had this vision.

"Cecilia was there all the time and I was around, but we didn't know anything about basketball. Tyrone was the mentor. He loves Joakim as a son and I'm glad they've always kept this bond. It's a real relationship."

"I'm blessed," Joakim says. "My dad helped me so much. And my dad knows what Mr. Green brought to the table. When you see me play, you're not like, 'Oh, he's just a rich tennis kid who grew up in a tennis environment.' I feel like when I play, I play tough. That's the New York in me. That's the street tournaments. And that goes to Mr. Green."

Both Green and Yannick say they're most proud of Joakim off the court.

"He's a good person," Yannick says. "He's real. He's a great son. He has three sisters and one brother and they adore him. He gives a lot of love. Regardless of what happens to his career, he will be a natural, nice person."

Joakim Noah dives after a loose ball during Game 4 of a second-round playoff series against Cleveland on May 10, 2015 at the United Center. After taking a 2-1 lead in the series, the Bulls lost the next three games—two of them at home—and were eliminated by the Cavaliers.

A hand-painted portrait of Derrick Rose, symbolically flanked by crutches, adorns the wall of a highway overpass in Chicago on March 9, 2015.

For the third time in three years, a knee injury threatens Derrick Rose's future.

Rose struck down again

Feb. 24, 2015

The hand-wringing over and scrutiny of Derrick Rose's up-and-down play as he attempted his second comeback from successive season-ending knee surgeries has defined this Bulls season.

Now, almost unbelievably, a familiar chapter has changed the narrative.

An MRI exam confirmed a medial meniscus tear in Rose's right knee, which will require surgery. A timeline for his return will be determined after the procedure, but two sources said the initial belief is that this tear isn't as extensive as the one Rose suffered in the same knee in November 2013.

Rose and his family and advisers opted to have team physician Brian Cole repair and reattach—rather than remove—the torn meniscus during the November 2013 surgery. This created a longer rehabilitation period, which is why Rose's 2013–14 season ended after those 10 games. But it also was considered better for long-term success and lack of arthritis after his playing career.

A source said Rose was told after that surgery that a second tear could happen and typically those are treated by cutting or removing the damage. That generally involves a shorter rehabilitation of three to six weeks.

Given Rose's extensive injury history, it's also possible Rose could miss the remainder of the season and whatever playoff run the Bulls are able to muster after another gut punch to their franchise centerpiece.

Remarkably, save for the one game in which he suffered a torn left ACL in April 2012, Rose hasn't appeared in the NBA playoffs since the Bulls advanced to the 2011 Eastern Conference finals.

Neither the Bulls nor Rose know when the latest injury occurred. He left the team's most recent game, a victory over the Bucks, in good spirits despite shooting 1-for-13, even joking about his poor outing because the Bulls won.

The day after the Bucks game, Rose missed a light workout after complaining of right knee soreness. But given he had played in 19 straight games and 30 of 31, nobody in the organization or Rose's circle saw this news coming.

Rose, 26, is scheduled to make $20 million next season and $21.3 million in 2016–17. Those are restrictive numbers for a franchise that is built around what once was Rose's transcendent talent.

Taking a step back

April 9, 2015

ORLANDO, Fla. – After missing 20 games, Derrick Rose made his return to the court without incident.

That was the good news.

The bad news was that the Bulls collapsed and lost to the Magic, 105-103. As the game wound down—a time Rose used to dominate—the former MVP was on the bench, imploring his teammates to communicate better on defense. They lost the game when Victor Oladipo blew past Jimmy Butler for the winning layup over late-arriving help from Joakim Noah.

"We were scoring, matching them, but defensively, we weren't getting there," Rose said. "Communication or whatever, it just wasn't there. Win the game on a layup so we just got to make sure we talk a little bit more and make sure that someone is over there."

Rose had nine points, four turnovers and two assists on 3-for-9 shooting in 19 minutes, 24 seconds.

"I didn't feel any discomfort at all, so that's a good sign," Rose said. "I'm just happy to be playing."

Rose finally showed the fire fans had wanted to hear by saying at the morning shootaround that he was "busting (his) ass to get back." He even turned back the clock with a vintage coast-to-coast drive for a layup. He also missed 5 of 6 three-pointers.

Rose admitted sitting the entire fourth quarter proved difficult but understood the plan to limit his minutes to around 20 per game. After returning two days before the team's four-to-six-week timeline ended, he knows he needs to achieve game shape.

"I think that I'll work toward it," Rose said. "The shots I put up, I felt they were good shots, hard shots. I'm more concerned with us losing more than anything."

The Bulls survive an up-and-down first-round series, but LeBron James awaits.

Outcome simply majestic

May 1, 2015

MILWAUKEE – The King will see you now, Bulls.

For the fourth time in six seasons, the Bulls will face LeBron James and the team for which he has chosen to display his singular talent. Each of the previous three times, once with the Cavaliers and twice with the Heat, James has vanquished his foe.

The Bulls earned the right to face James in his first season back with the Cavaliers after a 120-66 demolition of the scrappy Bucks at the Bradley Center. The Bulls won the first-round series in six games, set a playoff franchise record for margin of victory and handed the Bucks their worst loss in franchise history, playoff or regular season.

It also marked the largest margin of victory in a series-clinching victory in NBA postseason history. The Bulls now visit James' throne room—Quicken Loans Arena—for Game 1 of the second round.

"I never thought I'd say this, but I'm very excited to go to Cleveland," said Joakim Noah, who dissed the city in 2010.

Kevin Love is out for the playoffs with a left shoulder injury and J.R. Smith is suspended for the first two games.

"It's a lot more than just LeBron (James) and Kyrie (Irving)," coach Tom Thibodeau said. "They play very well as a team. They share the ball, have length at the rim and are good competitors."

If the Bulls play the way they did against the Bucks, shooting 51.1 percent with 31 assists on 46 field goals, it may not matter who suits up. The Bulls led 65-33 at halftime, a franchise-record margin and the sixth largest in NBA playoff history.

But that's the problem with these Bulls: All season, they have followed high moments showcasing their tantalizing talent with underwhelming, uninspired play.

"It's hard to pinpoint," Noah said. "When we play with that edge, we're tough. We had to do a lot of soul searching the last couple of days."

Mike Dunleavy's 20 points led the Bulls, who finally heeded their own words to push the tempo and try to not let the Bucks' active defense get set. Pau Gasol added 19 points with eight rebounds and Derrick Rose had 15 points with seven assists as all five starters reached double figures.

A 42-point victory over the Jazz in Game 3 of the 1998 NBA Finals had been the previous record for playoff margin of victory.

Derrick Rose salutes the United Center crowd during a 103-91 victory over Milwaukee in Game 1 of a playoff series on April 18, 2015. The Bulls took a 3-0 lead in the series and held on to win in it six games.

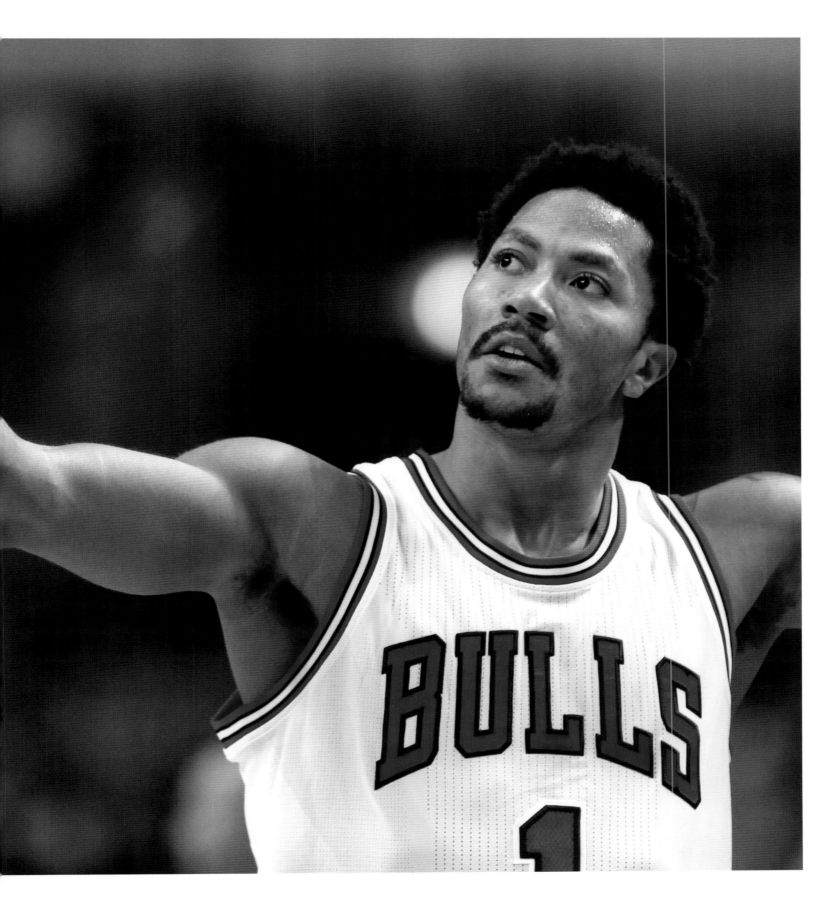

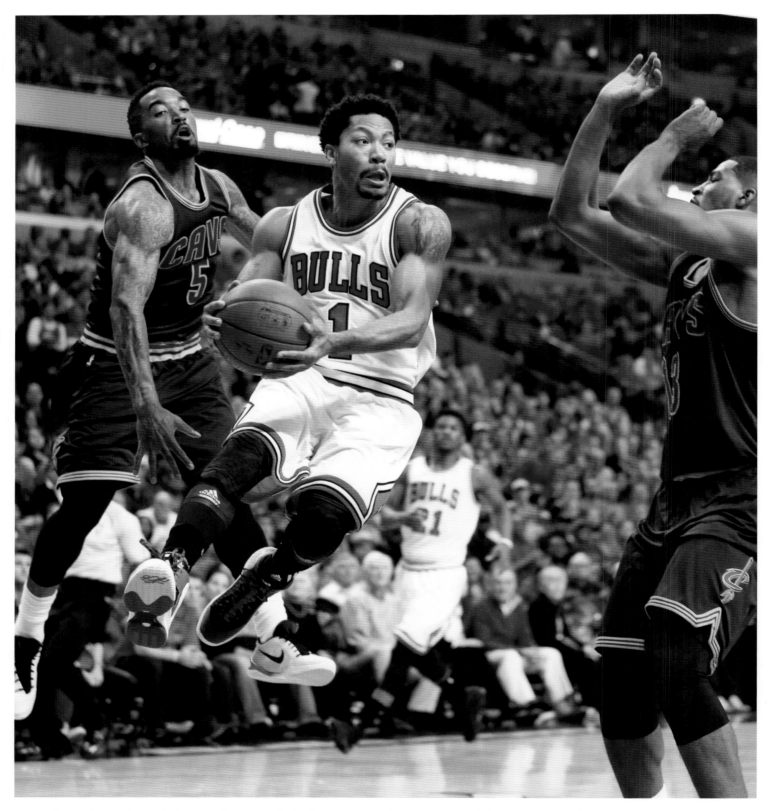

Derrick Rose drives to the basket as Cleveland's J.R. Smith (left) and Tristan Thompson offer defensive resistance in Game 4 of a second-round play-off series on May 10, 2015 at the United Center. The series marked the fourth time in six years that a LeBron James-led team eliminated the Bulls from the postseason.

Derrick Rose's heroics can't save Bulls from another playoff elimination at the hands of King James.

Power ball

May 5, 2015

CLEVELAND – The running play-by-play couldn't possibly capture the impact of the moment.

"Derrick Rose makes 26-foot, 3-point jumper."

That it came in LeBron James' face and in response to a Cavaliers run in the Bulls' 99-92 Game 1 victory at Quicken Loans Arena is what proved symbolic.

The reason the Bulls are so confident for this Eastern Conference semifinal series, even before Kevin Love exited to injury and J.R. Smith sat for a two-game suspension, is because unlike in 2011, James can't stop Rose.

Oh, sure, he may defend him ably now and then. And James, who mostly played power forward in Love's absence, mostly has other defensive duties now. But when James guarded Rose in the 2011 Eastern Conference semifinals with the Heat, the Bulls bogged down.

Now there are just so many more offensive weapons.

Rose finished with 25 points, five assists and five rebounds with just one turnover in 38 minutes, 33 seconds.

And there was Pau Gasol posting 21 points and 10 rebounds. There was Butler, doing yeoman's work on James and scoring 20 points with six assists and five rebounds. Mike Dunleavy scored 13 first-quarter points without a miss. Aaron Brooks sank a 3-pointer from Toledo. Heck, even Kirk Hinrich blew past James for a three-point play at one point.

"We have a lot of talent now offensively," Joakim Noah said. "Teams can't key in on one guy."

Take it to bank

May 9, 2015

Into Joakim Noah's arms Derrick Rose jumped.

A blank expression covered Rose's face as bedlam erupted around him, the calm amid the storm. Rose hardly looked surprised and more like a guy who had visualized doing something like this thousands of times during all those long days and nights of rehabilitation.

Rose banked in a 3-pointer at the buzzer to give the Bulls a 99-96 victory over the Cavaliers at the United Center. It was a game they had to win. It was a game Rose, who scored a game-high 30, wouldn't let them lose.

With three seconds left, Mike Dunleavy threw the inbounds pass to Rose, who used Taj Gibson's screen on Iman Shumpert to create a little daylight. Just before the final second ticked off the clock, Rose elevated and released the shot that banked off the glass and gave the Bulls command in this series. Afterward, Rose called it a broken play, but now, suddenly, everything fit together for the Bulls: They finally had beaten longtime nemesis LeBron James for a second time in a playoff series and maintained home-court advantage in this one.

Of all the proclamations of Rose's return, this perhaps was the loudest, clearest and most meaningful. This came within earshot of LeBron James.

"I don't want to sound cocky, but those are the shots you want to take as a player in my position," Rose said.

Dead end

May 15, 2015

If Game 6 marked Tom Thibodeau's final game as Bulls coach, and really, even if it didn't, the greatness of LeBron James will taint his tenure forever.

Just like Michael Jordan foiled so many great teams and coaches during the dynasty—the Lenny Wilkens-led Cavaliers, Pat Riley's Knicks, Jerry Sloan's Jazz—James is doing the same to the Bulls and Thibodeau.

That's four times in six seasons now that a James-led team has eliminated the Bulls, this time with a 94-73 victory at a stunned United Center that featured fans streaming to the exits well before the buzzer as the Cavaliers expanded their lead.

Because of Thibodeau's frayed relationship with management, the attention now shifts squarely to his future.

"Until they tell me I'm not, I expect to be here," Thibodeau said. "That's the way I approach it."

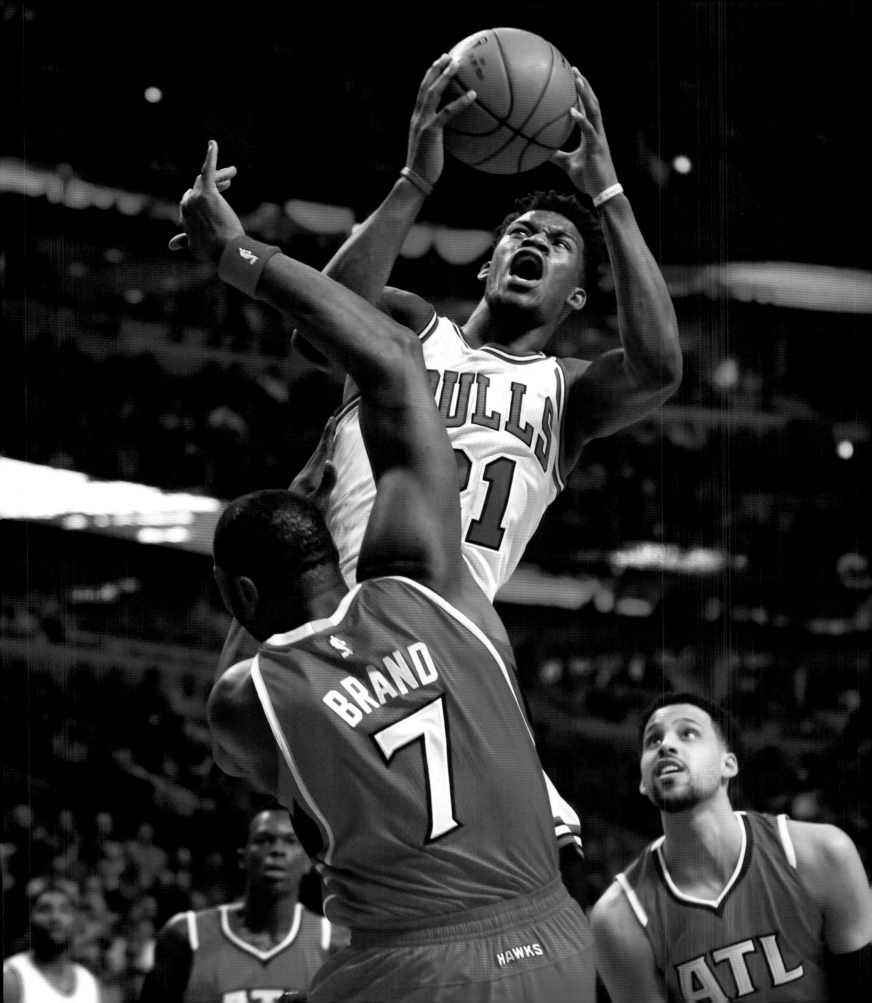

Jimmy Butler

CLIMB TIME

21 SHOOTING GUARD/
SMALL FORWARD

2011—

Merely a few games into Jimmy Butler's lone season at Tyler (Texas) Junior College, coach Mike Marquis called Bulls general manager Gar Forman, whom Marquis knew from Forman's college coaching days.

"I told Gar, 'There's something special about Jimmy,'" Marquis recalled of the 2007 phone call. "And it wasn't just his basketball. It was everything—work ethic, intelligence, drive, demeanor. I didn't know how high Jimmy was going to reach. But I knew he wouldn't back down from reaching it."

How high? How does the first Bull in franchise history to be named NBA's Most Improved Player sound? How does NBA All-Star sound? How about a five-year contract worth upward of $92 million?

The 30th overall pick in the 2011 draft, Butler broke out as a superstar in his fourth season, earning All-Star honors and paving the way for a huge payday. It was a long and somewhat unlikely road from Tyler Junior College, and before that, Tomball, Texas, where his rarely publicized backstory began.

You remember the one: Butler's father drifted out of his life when Butler was an infant. His mother kicked him out of the house at age 13 for reasons Butler has said he doesn't know. Butler bounced from friend's house to friend's house, sleeping on floors and couches for his first three years of high school before a deeper friendship with Jordan Leslie formed.

Jordan Leslie's mom, Michelle Lambert, had three children with her first husband, who died. She subsequently married Michael Lambert, who had three kids from his previous marriage. They added one child together.

A then-shy Butler became No. 8.

"This means a lot—to me and my family," Butler said. "This is something we always dreamed of. My brothers are here to experience it with me. And that's the way it should be done. I wouldn't be here without their support."

Butler doesn't discuss or dwell on his story much. He's not embarrassed by it. In fact, he's appreciative of the lessons of overcoming adversity and love and

acceptance that it taught him. Mostly, it's because Butler dwells on strength, not sympathy.

"Jimmy never really over-advertised his background," said Scott Monarch, a Tyler assistant who moved to Marquette for Butler's three seasons there and now is at North Texas. "It was, 'This is a part of my life and the hand I was dealt.'

> **"Being good was never enough for him. He always wanted to be better than that. A lot of kids think practice is enough. That was never enough for Jimmy. He always wanted to come in and take more shots, work on footwork, watch videotape. He just really pushed himself."**
>
> —BUTLER'S COLLEGE COACH MIKE MARQUIS

"But even in junior college, he always was giving to homeless people. It's something that later on, you say, 'Oh, that's why.' Marquette is a downtown campus, and he was always at the homeless shelter, laughing and joking with people there. It was never anything he said. It was what he did in his actions."

Added Marquis: "You knew what he had gone through, and there was a unique quality about him. But he didn't discuss it here. Jimmy is one of those guys whose glass is three-quarters full. And he's always nonstop looking ahead—the next day, the next game, the next workout."

This quality has served Butler well in basketball, which he pursued to the point that he attended Tyler despite being an academic qualifier coming out of Tomball High.

"He had fabulous grades," Monarch said. "He didn't have to go to junior college. He just didn't have any (Division I scholarship) offers."

Those came quickly after a dominant lone season at Tyler, where he not only befriended Derrick Rose's close childhood friend, Randall Hampton, but assimilated himself into a strong team by guarding everyone from point guards to power forwards.

"Early on, he often took a back seat because we had a lot of good players," Marquis said. "But after

Opposite: The final player chosen in the first round of the 2011 NBA Draft, Jimmy Butler blossomed into an All-Star with the Bulls.

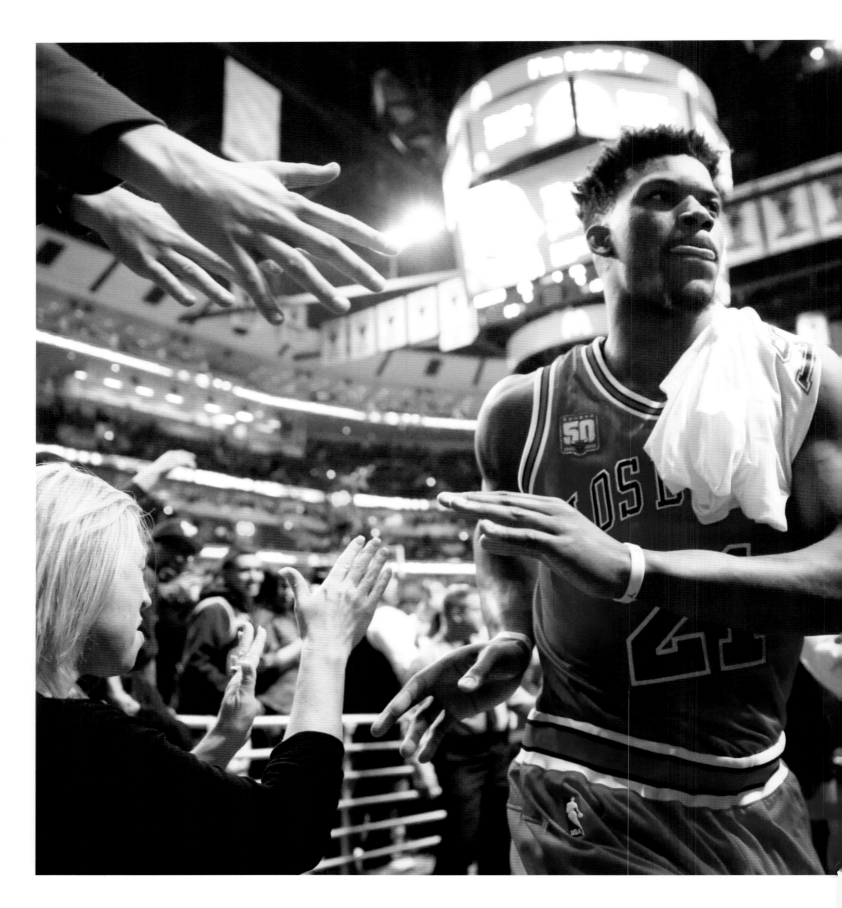

Jimmy Butler averaged 20 points per game in 2014-15 and 20.9 in 2015-16, earning NBA All-Star honors in both seasons. After his rookie year in 2011-12, Butler increased his scoring average in each of the next four seasons.

Christmas, he decided, 'OK, I'm not going to do that anymore.' And he got more and more aggressive.

"Being good was never enough for him. He always wanted to be better than that. A lot of kids think practice is enough. That was never enough for Jimmy. He always wanted to come in and take more shots, work on footwork, watch videotape. He just really pushed himself."

As in his junior college experience, Butler began at Marquette on an established team and established his role defensively before branching out. He accomplished this while then-Marquette coach Buzz Williams relentlessly pushed and prodded him.

"Buzz was really able to tear him down and build him back up," Monarch confirmed. "But that's because Jimmy wasn't like the rest of the guys. He didn't have all the AAU people around him, telling him, 'You're this or that.' He wasn't contaminated by a lot of the foolishness that goes on in today's game.

"He just really was open to everything and getting better and better. He carries himself like he has a plan."

Again, when you have lived through what Butler has, hard coaching doesn't faze you.

"Things that don't go his way don't make him quit," Marquis said. "They motivate him to be better, be stronger, be tougher. His inner drive is very special."

Monarch said Butler never needed extra tutoring while majoring in communication studies and displayed a charisma on campus that would have enabled him to succeed whether he played basketball or not.

"He didn't need that uniform to make it," Monarch said.

Butler attended Monarch's daughter's first few birthday parties and visited with him after the Bulls' recent game in Dallas. Most Septembers, Butler returns to Tyler Junior College to address Marquis' current team.

"He's the same person that he was when he was here," Marquis said. "I don't think the fame or the money or the attention has turned him into something that he's not. He has really stayed loyal to his values and who he is. That's what makes him so likable."

"I feel like I've come a long way from Tomball," Butler said. "I couldn't be prouder. I just want to continue to improve and help my team win. I want to win a championship. That's the final goal." 🏀

JIMMY BUTLER

» **Born:** Sept. 14, 1989 in Houston

» **Height:** 6-7'

» **Weight:** 220

» **College:** Marquette University

» **Years in NBA:** 2011–

» **Acquired by Bulls:** June 23, 2011 in 1st round (30th overall) of NBA Draft

Five consecutive playoff appearances and two division titles weren't enough to save Tom Thibodeau's job.

Thib-adieu

May 29, 2015

On Oct. 1, 2012, Bulls general manager Gar Forman opened a training camp full of championship expectations when he happily announced a four-year contract extension for Tom Thibodeau.

The coach then thanked Forman, executive vice president John Paxson and Chairman Jerry Reinsdorf, emphasizing one point over and over.

"I love being here," Thibodeau said then.

And now he's gone. The Bulls fired him Thursday after five seasons that produced historic regular-season success and five playoff flameouts mostly defined by Derrick Rose's knee injuries.

"I want to thank, and will deeply miss, our incredible fans and the entire city of Chicago," Thibodeau said in a statement. "I also want to thank my staff and all of the talented players and their wonderful families who have honored me and the Bulls by their effort, love, dedication and professionalism. I appreciate the opportunity that Jerry Reinsdorf gave me.

"We are proud of our many accomplishments, fought through adversity, and tried to give our fans the full commitment to excellence they deserve. I love this game and am excited about what's ahead for me with USA Basketball and the next coaching opportunity in the NBA."

Iowa State coach and former Bulls guard Fred Hoiberg is the runaway favorite to replace Thibodeau, who is owed $9 million unless a new job and salary offsets that amount before his contract with the Bulls ends in 2017.

In his hands

June 3, 2015

On a sun-splashed Tuesday afternoon when the Bulls introduced Fred Hoiberg as the 19th coach in franchise history, the symbolism couldn't be ignored.

The Bulls are hoping the dark clouds that mostly defined a turbulent 50-win season have departed.

Hoiberg, 42, signed a five-year deal to follow Tom Thibodeau, whose fallout with management and later ownership—with blame available everywhere—ultimately obscured his prodigious regular-season success.

The Bulls are looking for less drama and—a more difficult task—more playoff victories under Hoiberg.

"I'm a firm believer that leadership starts at the top," Hoiberg said at an introductory news conference. "You have to have synergy with the coaching staff and the front office or it's going to be tough to make it work. Players can see through that sometimes.

"I've been in (management's) shoes. I've lived their life. I understand how those relationships have to be."

Hoiberg spent almost as much time emphasizing his four years as a Timberwolves executive as he did his successful five-year coaching stint at Iowa State, offering insight into his plan for organizational harmony.

As for winning championships, that process can't be judged until games start. But the fact Hoiberg left his comfort zone and hometown shows that the former Bulls guard understands what he called "an unbelievable opportunity."

"You don't always walk into a roster that has championship potential, that absolutely can compete at that level," Hoiberg said. "I absolutely love this roster.

"I love the versatility of the players, the different lineups we're going to be able to play," said Hoiberg, who plans to start reaching out to players immediately. "We can play small, play big. You've got lineups that can get out and play with pace. You've got a great group of veteran players that know how to play.

"Tom Thibodeau is an excellent basketball coach, and he instilled a lot of unbelievable qualities in this team that hopefully I can build on."

That both Thibodeau and Vinny Del Negro were fired in part over discord with the front office didn't faze Hoiberg. Nor did Chairman Jerry Reinsdorf's scathing statement explaining Thibodeau's dismissal.

"I'm very confident in my relationship with these guys," Hoiberg said.

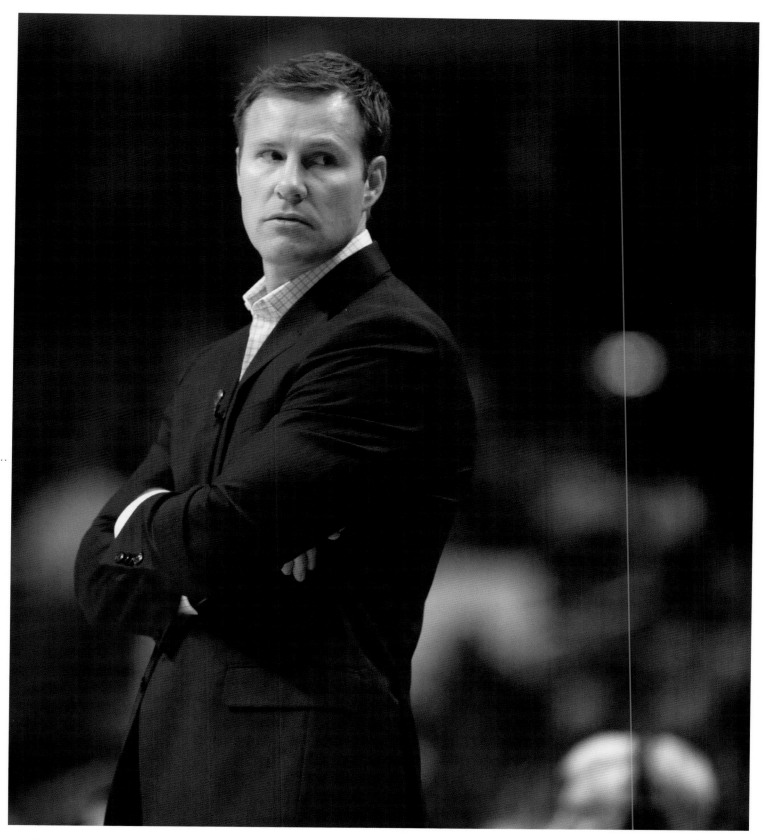

Fred Hoiberg, who played four seasons with the Bulls from 1999-2003, took over as the team's head coach after Tom Thibodeau was fired in May, 2015.

Tom Thibodeau led the Bulls to a league-best 62 victories in 2010-11, his first season as head coach.

Tom Thibodeau

'I HAVE NO REGRETS'

HEAD COACH

2010–15

How did the Bulls get to the point where they felt they had no choice but to fire one of the most successful coaches in team history?

How did the partnership with Tom Thibodeau end despite him becoming the fastest coach in NBA history to 100 regular-season victories and ranking eighth all-time with a .647 regular-season winning percentage, mostly without Rose?

How did an organizational decision that even drew comments from President Barack Obama and Mayor Rahm Emanuel, Bulls fans with Chicago ties, come to pass?

The $17.5 million, four-year contract extension in October of 2012 is as good a place as any to start.

It sat, unsigned, for six months. Thibodeau cited lawyers being lawyers for the delay. But his displeasure over management's personnel moves, including the losses of critical reserves Omer Asik and Kyle Korver for nothing, was a badly kept secret.

The oddity of the delay to sign the extension began a swell of distrust and contentious relations between Thibodeau and management. The feud evolved into questions over his offensive schemes, handling of the roster and minutes distribution for players.

It coalesced most spectacularly this season when Thibodeau openly and repeatedly bristled against minutes restrictions management and the medical staff placed on Rose and Joakim Noah, both of whom were coming off knee surgery.

Another season of championship expectations crashed and burned. Rarely has a 50-victory season felt so joyless.

Reinsdorf acknowledged as much in the Bulls' news release announcing the firing, using uncharacteristically strong language to dismiss such a successful coach.

"The Chicago Bulls have a history of achieving great success on and off the court. These accomplishments have been possible because of an organizational culture (in which) input from all parts of the organization has been welcomed and valued, there has been a willingness to participate in a free flow of information, and there have been clear and consistent goals,"

Reinsdorf said. "While the head of each department of the organization must be free to make final decisions regarding his department, there must be free and open interdepartmental discussion and consideration of everyone's ideas and opinions. These internal discussions must not be considered an invasion of turf, and must remain private.

"Teams that consistently perform at the highest levels are able to come together and be unified across the organization—staff, players, coaches, management and ownership. When everyone is on the same page, trust develops and teams can grow and succeed together. Unfortunately, there has been a departure from this culture."

Reinsdorf had served as one of Thibodeau's closest allies since endorsing his hire after receiving a glowing recommendation from then–Chicago Public Schools head Arne Duncan, whom Thibodeau coached at Harvard. Reinsdorf even served as an occasional oasis in his tumultuous dealings with management.

That, according to several sources, changed in late January of 2015, when ESPN broadcaster Jeff Van Gundy blasted the Bulls for historically undermining their coaches. Never mind that Van Gundy, who hired Thibodeau for the Knicks and Rockets during Thibodeau's two-decade career as an assistant, had made similar if less forceful comments before.

These and another set of comments in a later broadcast infuriated Reinsdorf, the sources said. A trust had been broken.

"It's our strong belief that there needs to be a culture of communication that builds a trust through this organization—from the players to the coaches to the management and to the front office, a culture where everybody is pulling in the same direction," said general manager Gar Forman, who also announced assistant coach and Thibodeau ally Andy Greer's dismissal. "When that culture is sacrificed, it becomes extremely difficult to evolve and grow. And (this) decision was about giving this team an opportunity to grow into the future."

Thibodeau's relationship with management had deteriorated to the point that he hadn't talked

substantively to Paxson since January. Forman initiated most conversations about the state of the team by moving from his second-floor office to Thibodeau's on the first floor, where the coach worked behind a closed door all day most days.

By the time players, some of whom had pushed back against Thibodeau this season for the first time in his tenure, stopped short of endorsing his return in exit meetings with management, the decision was made.

"Relationships are difficult," Paxson said. "When you have different personalities, there has to be open dialogue and no barriers. Everything should be about the best interests of the organization. So you should be able to ask any question you want to ask. You should be able to push the envelope in terms of anything to have some success. Obviously, there was a breakdown."

Paxson and Forman said Thibodeau participated in the preseason meetings when the organizational consensus to limit Noah's and Rose's minutes was reached. Reinsdorf and son Michael, the team president, team physician Brian Cole and players also participated.

"In our mind, it was absolutely the responsible thing to do," Paxson said. "And when we did get to the playoffs, we were as healthy as we had been in a long, long time."

Still, the Bulls failed to overcome their nemesis, LeBron James, whose teams have eliminated the Bulls from four of the last six postseasons. The Cavaliers prevailed in six games despite star Kevin Love sitting because of an injury, Kyrie Irving being hobbled and largely ineffective and J.R. Smith missing two games to suspension. The Bulls were without Pau Gasol for two games and Joakim Noah was less than 100 percent physically.

"We were all really disappointed in the way the season ended," Paxson said. "Cleveland's a great team and they're in the Finals. But we really felt like, given their injuries, the path was there for us and we could have seized it.

"We probably wouldn't be sitting here if we won a championship. But we haven't done that. And this year, we had a real missed opportunity. We love our players; we're around them a lot too. We value who they are as people. So it goes back to that communication and trust that you need in an organization."

Thibodeau's tenure will be remembered for

TOM THIBODEAU

» **Born:** Jan. 17, 1958 in New Britain, Conn.

» **College:** Salem State University

» **Years in NBA:** 1989–2015, 2016–

» **Hired by Bulls:** June 23, 2010

hard-playing, no-excuse-making, defensively elite teams. The Bulls rank first in the NBA in points per game allowed and opponents' field-goal percentage since his hiring in 2010.

But he ultimately failed at one of the most basic premises of employment, respecting one's bosses.

"I want to thank Thibs for all the work he put in," Noah said in a text message. "I wish him nothing but the best."

Thibodeau made phrases like "do your job" and "we have more than enough to win" part of the lexicon during his five-season stint as Bulls coach.

So his decision to steer toward the high road, stay true to his beliefs and make no excuses despite his dismissal shouldn't have surprised anyone, particularly since the Bulls were obligated to pay him for two more seasons unless he landed another NBA job.

"I have no regrets," Thibodeau said. "It was a great run. I had a great staff. The players were terrific. My whole experience there was great. In pro sports, it happens. You move on. I'd rather reflect on positives than think about any negatives because the good far outweighed any bad."

Under Thibodeau, who won Coach of the Year honors following his first season in 2010–11, the Bulls went 255-139 and made five straight trips to the playoffs despite widespread injuries. Playing without Derrick Rose for three of those appearances, Thibodeau compiled a 23-28 postseason mark.

"I'm very proud of what we accomplished," Thibodeau said. "To win the games we did, to deal with the adversity that we did, we dealt with Derrick and his injuries and survived that. We lost players along the way but always found a way to compete. I'm very proud of that."

While acknowledging "you never want to stay the same" and the desire to always seek improvement,

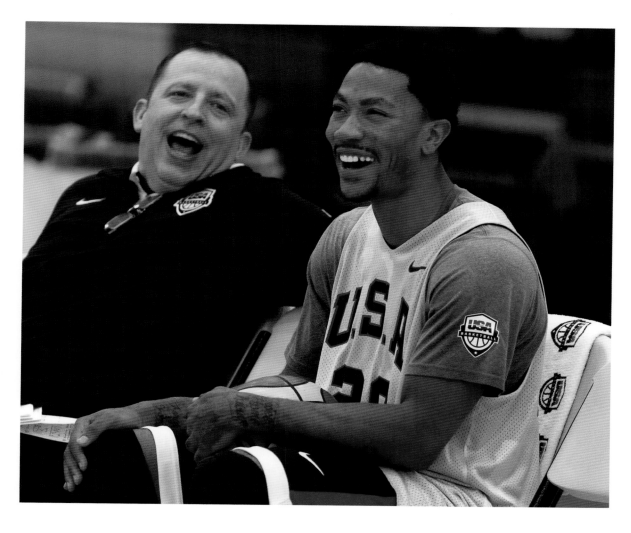

Tom Thibodeau (left) shares a laugh with Derrick Rose during a workout session for the national team on Aug. 15, 2014 in Chicago.

Thibodeau took slight exception when questioned about his reputation as a taskmaster who drove players into the ground.

"I don't think you make All-Star teams, become an MVP or Defensive Player of the Year unless the team wins at a very high rate," Thibodeau said, referencing individual success for Luol Deng, Jimmy Butler, Rose and Joakim Noah. "That was a reflection of the willingness of the team to commit to each other. When you look back over five years, just let the record speak for itself."

Thibodeau, who called the 2010–11 team his best, also defended his use of Butler and Deng, who led the NBA in minutes per game during his tenure. Thibodeau said their playing time mirrored that of other star forwards like LeBron James, Carmelo Anthony and Kevin Durant.

"The first two years, we had a deep bench so people weren't playing a lot of minutes," he said. "If you look at Jimmy's minutes, it changed after the Luol trade. We had less perimeter guys so we had to play him more to have a chance to win.

"Nobody's going to be perfect. You don't get every decision right. But I'm very proud of what the team did."

Thibodeau grew almost wistful when discussing the two seasons from 2010–12 when the Bulls led the NBA in regular-season victories. He rued Noah's gruesome ankle injury that piled on top of Rose's torn ACL in 2012's first-round bow-out to the eighth-seeded 76ers, even recalling Omer Asik's questionable late-game foul on Andre Iguodala.

Asik and Kyle Korver departed following that season, personnel changes that furthered the deteriorating relationship between Thibodeau and management.

"We were top-five in offense and defense," Thibodeau said. "Usually when you have that type of efficiency, you have a chance to win it all. We had a lot of depth. We had toughness. We had guys who could go off the dribble. I think Luol was a far different player then. Joakim kept getting better and better. Derrick as the MVP of the league at 22, that's a lot. But we also had quality depth.

"But that's how it goes in this league. It's fragile. You take an injury to the wrong guy at the wrong time, it hurts you. But that's life." 🏀

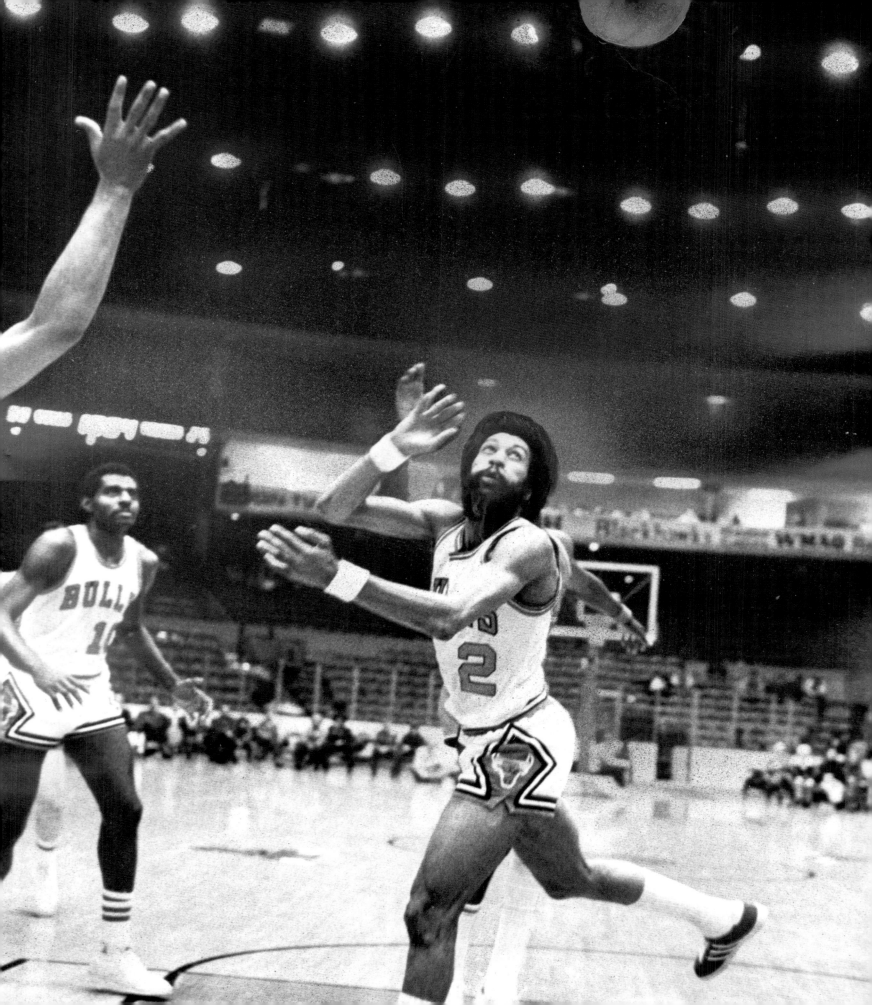

Overtime

BEST OF THE BULLS

While the Bulls' championships seasons are confined to a single decade, the 1990s weren't the franchise's only glory years. Right from the jump in 1966, the Bulls redefined pro basketball in Chicago and began building their legacy, posting the best record by a first-year expansion team in NBA history.

Who can forget the flash and dash of Reggie Theus, or the rugged, resourceful teams of the 1970s? Built around the offensive skills of Bob Love and Chet Walker and bolstered by the backcourt of Jerry Sloan and Norm Van Lier, those Bulls rocked the old Chicago Stadium to its rafters. Fast-forward to the 2000s, when the so-called Baby Bulls—led by Ben Gordon, Kirk Hinrich and Luol Deng—electrified the United Center. Later still, a team led by Derrick Rose and Joakim Noah lifted the team back to its proud place among the league's best.

In this chapter, we sort the franchise's history into a series of lists that we hope will spark some memories—and maybe even a few disagreements. It's the best of the Bulls (and in one case, also the worst of the Bulls), a snapshot-sized chronicle of one team's unforgettable 50-year journey.

Opposite: Norm Van Lier (2) was a three-time All-Star and his 3,676 assists in a Bulls uniform rank fourth in franchise history.

THE

HALL-OF-FAMERS

Nate Thurmond A force on both ends of the court, Thurmond played 14 seasons in the NBA—most of them with the San Francisco (later Golden State) Warriors—but only one full season and part of a second with the Bulls. He was the first player to record a "quadruple double," scoring 22 points with 14 rebounds, 13 assists and 12 blocked shots in a Bulls victory over the Atlanta Hawks on opening night in 1974. For his career, the well-balanced center averaged an even 15 points and 15 rebounds.

ENSHRINED IN 1985

George Gervin Nicknamed the "Iceman" for his composure under pressure, Gervin was an explosive scorer who averaged 25.1 points per game over a 14-year career in the ABA and NBA. As a member of the San Antonio Spurs in 1978, Gervin won the NBA scoring title by pouring in 63 points in the final game of the season, edging Denver's David Thompson by a fraction of a point. A 12-time All-Star in the ABA and NBA, Gervin played just one season with the Bulls, 1985–86, after which he retired.

ENSHRINED IN 1996

Robert Parish Known as "the Chief" for his stern countenance on the floor, Parish was one of the game's most well-rounded and accomplished centers. In 21 seasons, the nine-time All-Star averaged 14.5 points and 9.1 rebounds. He won two world championships with the Boston Celtics and appeared in 1,611 games, more than any player in NBA history. Parish played just one season with the Bulls, 1995–96, after which he retired.

ENSHRINED IN 2003

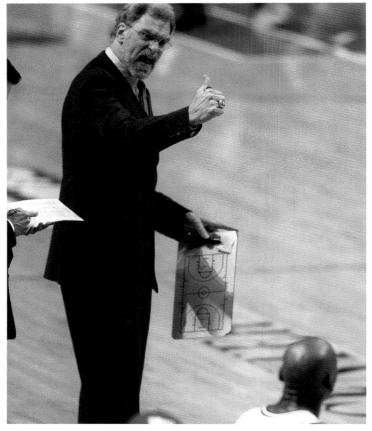

Phil Jackson led the Bulls to the playoffs in each of his nine seasons as head coach.

Phil Jackson Jackson won six world championships in nine seasons as Bulls head coach and led the Bulls to an NBA record 72 wins in the 1995–96 season. He compiled a regular-season record of 545-193 with the Bulls, a winning percentage of .738 and later won three more championships as head coach of the Lakers. Jackson—who also won an NBA title as a player with the New York Knicks in 1973—reached 900 wins faster than any coach in NBA history and his career coaching record stands at 902-610.

ENSHRINED IN 2007

Michael Jordan A 14-time NBA All-Star and five-time league MVP, Jordan led the Bulls to six world championships and was named MVP of the Finals six times. Jordan led the NBA in scoring 10 times and retired as the Bulls' all-time leader in scoring, rebounds, assists, steals and games played. He won an NCAA championship at the University of North Carolina in 1982, was the NBA Rookie of the Year in 1984–85 and won two gold medals as a member of the U.S. team in 1984 and 1992.

ENSHRINED IN 2009

 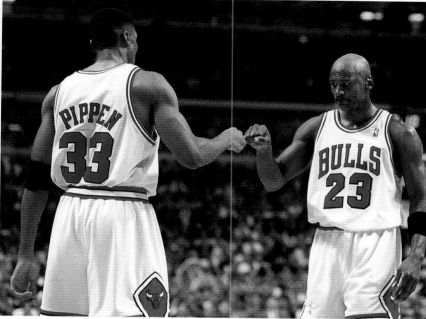

From left: Jerry Sloan was a two-time All-Star with the Bulls; Michael Jordan and Scottie Pippen rank 1-2 in points scored in a Bulls uniform.

Johnny "Red" Kerr Kerr, a Chicago native, was the Bulls' first head coach and led the team to the playoffs in its debut season, earning him NBA Coach of the Year honors. Kerr also served as a business manager for two seasons before joining the broadcast team. Always affable and quick with a quip, Kerr called Bulls games on radio and TV for 32 seasons. As a player, Kerr averaged 13.8 points and 11.2 rebounds over 11 NBA seasons with the Syracuse Nationals, Philadelphia 76ers and Baltimore Bullets.

JOHN W. BUNN LIFETIME ACHIEVEMENT AWARD IN 2009

Jerry Sloan A member of the inaugural Bulls team, Sloan played 11 seasons in the NBA, 10 of them with the Bulls. Known primarily as a gritty and tireless defender, Sloan was a complete player who averaged 14 points and 7.4 rebounds over his career. He was an NBA head coach for 26 seasons, three of them with the Bulls and the remainder with the Utah Jazz. Sloan led the Jazz to 15 straight playoff appearances (1988–2003) and reached the NBA Finals twice (1997 and 1998), losing to the Bulls both times.

ENSHRINED IN 2009

Scottie Pippen A versatile and tenacious defender who could guard all five positions, Pippen was a dominant force on six world championship Bulls teams. The seven-time All-Star played 17 seasons in the NBA, 12 of them with the Bulls. Over his two stints with the Bulls, Pippen averaged 17.7 points, 6.7 rebounds, 5.3 assists and 2.1 steals per game. He was named to the league's All-Defensive first team eight times and won two gold medals as a member of the U.S. team in 1992 and 1996.

ENSHRINED IN 2010

Artis Gilmore After five stellar seasons with the Kentucky Colonels of the American Basketball Association—including a championship in 1973—Gilmore joined the Bulls via the ABA dispersal draft in 1976. In two stints with the Bulls spanning seven seasons, Gilmore average 19.3 points, 11.1 rebounds and 2.1 blocks per game. When he retired in 1988, he held the NBA record with a career field-goal percentage of .599.

ENSHRINED IN 2011

Dennis Rodman Rodman's brash personality often overshadowed his basketball IQ and his tremendous ability as a rebounder and defender. Despite being just 6-foot-8, Rodman led the NBA in rebounding for seven consecutive seasons (1991–98) and averaged 14.9 boards over the course of a 14-year career. Rodman won two world championships as a member of the Detroit Pistons and three more as a member of the Bulls.

ENSHRINED IN 2011

Chet Walker Seven-time All-Star played 13 seasons in the NBA, the last six of them with the Bulls, and never once played for a team that failed to qualify for the playoffs. Walker was nicknamed "Chet the Jet" for his speed in the open court. In his six years with the Bulls, he averaged 20.6 points and 6.1 rebounds per game. Walker was a member of the 1966–67 world champion 76ers, a team that won 68 regular-season games, a record at the time.

ENSHRINED IN 2012

RINGMASTERS

The Bulls' six championship teams at a glance

1990–1991

HEAD COACH
Phil Jackson

ASSISTANT COACHES
Johnny Bach, Jim Cleamons, Tex Winter

REGULAR-SEASON RECORD
61-21 | .744 | 1st in Central Division
11 games ahead of second-place Detroit
No. 1 seed in Eastern Conference playoffs
2nd best record in NBA (Portland Trail Blazers, 63-19)

PLAYOFFS
FIRST ROUND W | 3-0 | New York Knicks
SECOND ROUND W | 4-1 | Philadelphia 76ers
CONFERENCE FINAL W | 4-0 | Detroit Pistons
NBA FINALS W | 4-1 | Los Angeles

STARTERS
Bill Cartwright, Horace Grant, Michael Jordan, John Paxson, Scottie Pippen

RESERVES
B.J. Armstrong, Craig Hodges, Dennis Hopson, Stacey King, Cliff Levingston, Will Perdue, Scott Williams

AWARDS
ALL-STAR Michael Jordan
MVP Michael Jordan
FINALS MVP Michael Jordan
SCORING TITLE Michael Jordan
ALL-DEFENSIVE TEAM Michael Jordan
(1st team), Scottie Pippen (2nd team)

1991–1992

HEAD COACH
Phil Jackson

ASSISTANT COACHES
Johnny Bach, Jim Cleamons, Tex Winter

REGULAR-SEASON RECORD
67-15 | .817 | 1st in Central Division
10 games ahead of second-place Cleveland
No. 1 seed in Eastern Conference
Best record in NBA

PLAYOFFS
FIRST ROUND W | 3-0 | Miami Heat
SECOND ROUND W | 4-3 | New York Knicks
CONFERENCE FINAL W | 4-2 | Cleveland Cavaliers
NBA FINALS W | 4-2 | Portland Trail Blazers

STARTERS
Bill Cartwright, Horace Grant, Michael Jordan, John Paxson, Scottie Pippen

RESERVES
B.J. Armstrong, Bobby Hansen, Craig Hodges, Stacey King, Cliff Levingston, Will Perdue, Scott Williams

AWARDS
ALL-STARS Michael Jordan, Scottie Pippen
MVP Michael Jordan
FINALS MVP Michael Jordan
SCORING TITLE Michael Jordan
ALL-DEFENSIVE TEAM Michael Jordan
(1st team), Scottie Pippen (1st team)

1992–1993

HEAD COACH
Phil Jackson

ASSISTANT COACHES
Johnny Bach, Jim Cleamons, Tex Winter

REGULAR-SEASON RECORD
57-25 | .695 | 1st in Central Division
3 games ahead of second-place Cleveland
No. 2 seed in Eastern Conference
3rd best record in NBA

PLAYOFFS
FIRST ROUND W | 3-0 | Atlanta Hawks
SECOND ROUND W | 4-0 | Cleveland Cavaliers
CONFERENCE FINAL W | 4-2 | New York Knicks
NBA FINALS W | 4-2 | Phoenix Suns

STARTERS
B.J. Armstrong, Bill Cartwright, Horace Grant, Michael Jordan, Scottie Pippen

RESERVES
Stacey King, Rodney McCray, Ed Nealy, John Paxson, Will Perdue, Trent Tucker, Darrell Walker, Corey Williams, Scott Williams

AWARDS
ALL-STARS Michael Jordan, Scottie Pippen
FINALS MVP Michael Jordan
SCORING TITLE Michael Jordan
ALL-DEFENSIVE TEAM Michael Jordan
(1st team), Scottie Pippen (1st team), Horace Grant (2nd team)

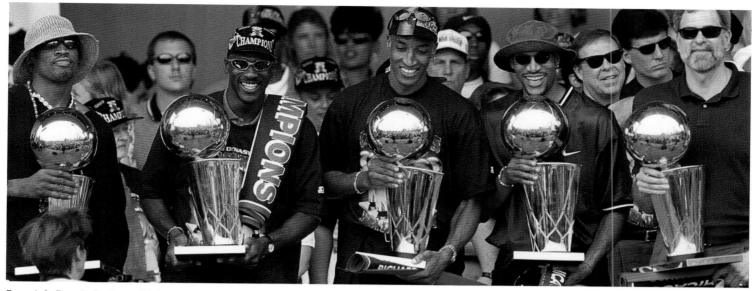

From left, Dennis Rodman, Michael Jordan, Scottie Pippen, Ron Harper and Phil Jackson pose with five of the Bulls' six NBA championship trophies.

1995–1996

HEAD COACH
Phil Jackson

ASSISTANT COACHES
Jim Cleamons, John Paxson, Jimmy Rodgers, Tex Winter

REGULAR-SEASON RECORD
72-10 | .878 | 1st in Central Division
20 games ahead of second-place Indiana
No. 1 seed in Eastern Conference
Best record in NBA
Best record in NBA history

PLAYOFFS
FIRST ROUND W | 3-0 | Miami Heat
SECOND ROUND W | 4-1 | New York Knicks
CONFERENCE FINAL W | 4-0 | Orlando Magic
NBA FINALS W | 4-2 | Seattle SuperSonics

STARTERS
Ron Harper, Michael Jordan, Luc Longley, Scottie Pippen, Dennis Rodman

RESERVES
Randy Brown, Jud Buechler, Jason Caffey, James Edwards, Jack Haley, Steve Kerr, Toni Kukoc, John Salley, Dickey Simpkins, Bill Wennington

AWARDS
ALL-STARS Michael Jordan, Scottie Pippen
MVP Michael Jordan
FINALS MVP Michael Jordan
SCORING TITLE Michael Jordan
ALL-DEFENSIVE TEAM Michael Jordan (1st team), Scottie Pippen (1st team), Dennis Rodman (1st team)

1996–1997

HEAD COACH
Phil Jackson

ASSISTANT COACHES
Bill Cartwright, Frank Hamblen, Jimmy Rodgers, Tex Winter

REGULAR-SEASON RECORD
69-13 | .841 | 1st in Central Division
13 games ahead of second-place Atlanta
No. 1 seed in Eastern Conference
Best record in NBA

PLAYOFFS
FIRST ROUND W | 3-0 | Washington Bullets
SECOND ROUND W | 4-1 | Atlanta Hawks
CONFERENCE FINAL W | 4-1 | Miami Heat
NBA FINALS W | 4-2 | Utah Jazz

STARTERS
Ron Harper, Michael Jordan, Luc Longley, Scottie Pippen, Dennis Rodman

RESERVES
Randy Brown, Jud Buechler, Jason Caffey, Steve Kerr, Toni Kukoc, Robert Parish, Dickey Simpkins, Bill Wennington, Brian Williams

AWARDS
ALL-STARS Michael Jordan, Scottie Pippen
FINALS MVP Michael Jordan
SCORING TITLE Michael Jordan
ALL-DEFENSIVE TEAM Michael Jordan (1st team), Scottie Pippen (1st team)

1997–1998

HEAD COACH
Phil Jackson

ASSISTANT COACHES
Bill Cartwright, Frank Hamblen, Jimmy Rodgers, Tex Winter

REGULAR-SEASON RECORD
62-20 | .756 | 1st in Central Division
4 games ahead of second-place Indiana
No. 1 seed in Eastern Conference
Tied for best record in NBA with Utah

PLAYOFFS
FIRST ROUND W | 3-0 | New Jersey Nets
SECOND ROUND W | 4-1 | Charlotte Hornets
CONFERENCE FINAL W | 4-3 | Indiana Pacers
NBA FINALS W | 4-2 | Utah Jazz

STARTERS
Ron Harper, Michael Jordan, Luc Longley, Scottie Pippen, Dennis Rodman

RESERVES
Keith Booth, Randy Brown, Jud Buechler, Scott Burrell, Steve Kerr, Joe Kleine, Toni Kukoc, Rusty LaRue, Dickey Simpkins, Bill Wennington

AWARDS
ALL-STAR Michael Jordan
MVP Michael Jordan
FINALS MVP Michael Jordan
SCORING TITLE Michael Jordan
ALL-DEFENSIVE TEAM Michael Jordan (1st team), Scottie Pippen (1st team)

THE

HONOR ROLL CALL

Bulls Retired Numbers

4 — JERRY SLOAN
RETIRED FEB. 17, 1978 AT
CHICAGO STADIUM

10 seasons as player (1966–76) | 3 seasons as coach (1979–82)

- Member of inaugural Bulls team
- Two-time NBA All-Star (1967, 1969)
- Started team-record 10 home openers

10 — BOB LOVE
RETIRED JAN. 14, 1994 AT
CHICAGO STADIUM

11 seasons as a player (1968–77)

- Three-time NBA All-Star (1971, 1972, 1973)
- Led Bulls in scoring for seven consecutive seasons
- Third-most points in franchise history (12,623)

23 — MICHAEL JORDAN
RETIRED NOV. 1, 1994 AT
UNITED CENTER

13 seasons with Bulls (1984–1993, 1994–1998)

- Member of six world championship teams
 (1991, 1992, 1993, 1996, 1997, 1998)
- Ten-time NBA scoring leader
- Five-time NBA Most Valuable Player
 (1987–88, 1990–91, 1991–92, 1995–96, 1997–98)
- Six-time NBA Finals Most Valuable Player
 (1991, 1992, 1993, 1996, 1997, 1998)
- Twelve-time NBA All-Star (1985, 1986, 1987, 1988,
 1989, 1990, 1991, 1992, 1993, 1996, 1997, 1998)
- Franchise leader in games played (930), points (29,277),
 rebounds (5,836), assists (5,012) and steals (2,306)
- Two-time Olympic gold medalist (1984, 1992)

33 — SCOTTIE PIPPEN
RETIRED DEC. 9, 2005 AT
UNITED CENTER

12 seasons with Bulls (1987–98, 2003–04)

- Member of six world championship teams
 (1991, 1992, 1993, 1996, 1997, 1998)
- Seven-time NBA All-Star (1990, 1992,
 1993, 1994, 1995, 1996, 1997)
- Two-time Olympic gold medalist (1992, 1996)
- Second-most playoff games in NBA history (208)

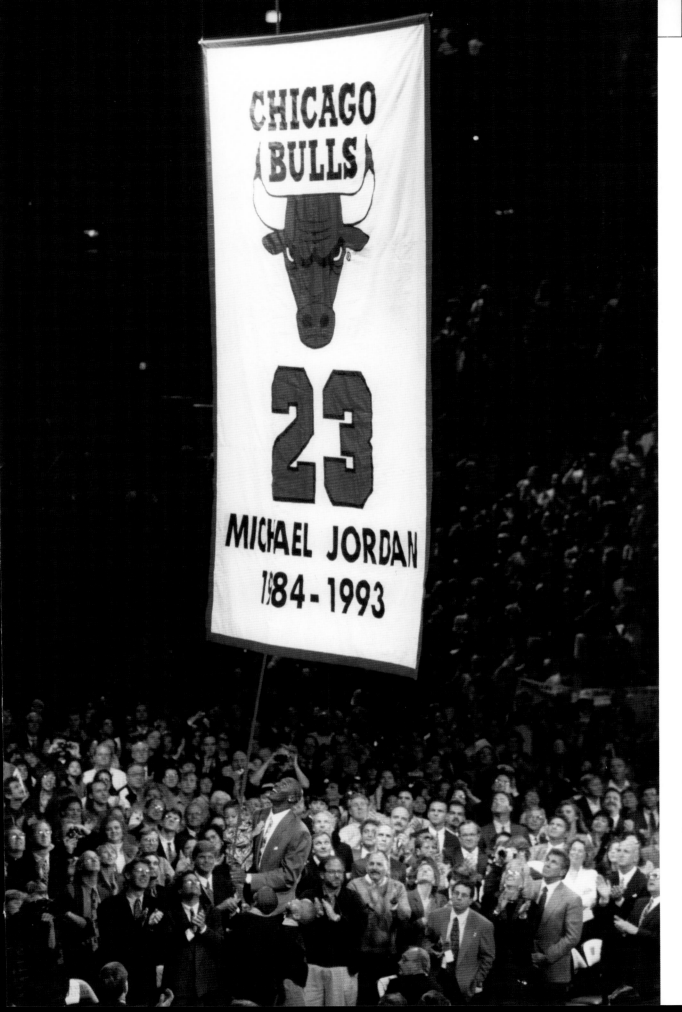

Michael Jordan's jersey number is lifted to the rafters of the Stadium after his first retirement in 1993. It would later be amended to include his second stint with the team and moved to the team's new home at the United Center.

THE
BEST (AND WORST) DRAFTS

We all know the best Bulls draft. It may have been the best draft in NBA history, because it produced the game's greatest player.

With the third pick in the 1984 draft, they reluctantly chose Michael Jordan. Not that they weren't pleased, but as general manager Rod Thorn said that June day as fans watched in the Hilton hotel ballroom, "We've taken a step in the right direction. Jordan isn't going to turn this franchise around. I wouldn't ask him to. I wouldn't put that kind of pressure on him. He's a very good offensive player, but not an overpowering offensive player.

"If we had our choice between [Sam] Bowie and Jordan, we still would have taken Jordan" said Thorn, now the New Jersey Nets' general manager. "But [Hakeem] Olajuwon was the big prize. We need a center. There wasn't one there."

Jordan's North Carolina coach, Dean Smith, likened Jordan to "more of a Sidney Moncrief–type with outstanding defensive ability."

No, this NBA talent evaluation is not an easy business. If they couldn't see it in Jordan, how are they supposed to see it in anyone? Yet, it is what everyone expects. Be right.

Olajuwon, as Thorn said, was the prize of that draft and the Bulls did their part to get him, losing 14 of their last 15 games to try to get the worst record in the league.

So though the Bulls didn't quite recognize it at the time, their 1984 draft was the best in team history and the one that put them on the path to greatness. It also may have been the first truly good draft by the Bulls, as the team's draft history ranked as one of the poorest in league annals until then.

Among their more notable blunders was the selection of Quintin Dailey in 1982, who came to town with a bad reputation and then proceeded to make it worse. The 2001 draft that brought the Bulls a pair of high-school seven-footers turned out to be a double-dud, with neither Eddy Curry nor Tyson Chandler living up to the hype.

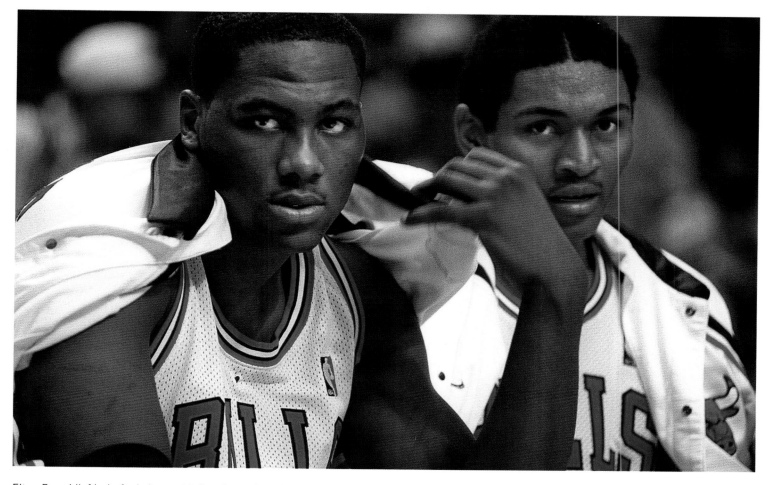

Elton Brand (left), drafted along with Ron Artest (right) in 1999, was named the NBA's co-Rookie of the Year for the 1999-2000 season, sharing the award with Houston's Steve Francis.

The best...

1984 Michael Jordan

Bulls "settle" for greatest player ever.

1987 Scottie Pippen, Horace Grant

Jerry Krause pulled off a coup by landing Pippen in a trade for draft pick Olden Polynice and then selecting Grant, two cornerstones of the future champs.

1999 Elton Brand, Ron Artest

With the first pick in a wide-open draft, the Bulls made the right choice by taking Brand over Steve Francis, Baron Davis and Lamar Odom. But trading Brand for the rights to Tyson Chandler led to Krause's eventual dismissal. The Bulls also had the No. 16 pick in the first round and used it on the colorful and volatile Artest, who would later be known as Metta World Peace. Artest went on to play 15 seasons in the NBA, though only the first two of them were with the Bulls.

1985 Charles Oakley

Even though Karl Malone went at No. 13 in 1985, Oakley was a solid choice and enabled the Bulls to deal him for the final championship piece, Bill Cartwright. Oakley was drafted at No. 9 by Cleveland, then traded to the Bulls for Keith Lee, whom the Bulls picked at No. 11, and second-year guard Ennis Whatley.

2004 Ben Gordon, Luol Deng

In one of John Paxson's more productive draft days, the Bulls took Gordon with the No. 3 pick overall, then traded for Deng, who was drafted at No. 7 by Phoenix. The Suns received the Bulls' No. 31 pick (Jackson Vroman) and a first-rounder in 2005, who turned out to be Nate Robinson.

2011 Jimmy Butler, Nikola Mirotic

Twenty-nine players were picked—including Norris Cole by the Bulls at No. 28—before Paxson grabbed Marquette swingman Butler with the 30th and final pick in the first round. Butler would become an All-Star in 2014–15. Side note: Cole was traded to the Minnesota Timberwolves in a draft-day deal that brought the Bulls the rights to European star Mirotic.

1989 Stacey King, B.J. Armstrong

The Bulls had three No. 1 picks in 1989. King, who was rumored to be going No. 1 to Sacramento—Pervis Ellison did—fell to the Bulls at No. 6 in one of the poorest drafts in NBA history. King wasn't what the Bulls expected and Tim Hardaway at No. 14 and Shawn Kemp at No. 17 were probably the best players. Armstrong, picked at No. 18, and King contributed to three Bulls titles. The Bulls also picked the forgettable Jeff Sanders at No. 20.

1990 Toni Kukoc

Without a first-round pick, Bulls were able to nab Kukoc early in Round 2. The Croatian-born big man, known as "The Waiter" for his ability to dish out assists, played 13 seasons in the NBA and was a member of three Bulls championship teams.

...and the blunders.

2001 Tyson Chandler, Eddy Curry

Custer had a good plan too. The trading of Brand and the selection of the high school kids sent the team into a spiral that took years to recover from. Curry finally was dispatched in 2005 amid medical issues, and Chandler was dealt a year later. Curry's career fizzled but Chandler became a successful defensive specialist and role player with several other teams.

1970 Jimmy Collins

It was not like the Bulls were the only ones having problems as the likes of Al Henry, John Valleley, John Hummer and Gary Freeman helped fill out the first round after Collins. But Collins had a tough time with coach Dick Motta, and Hall-of-Famers Calvin Murphy and Nate "Tiny" Archibald went at the top of the second round, with the first round then 17 picks. Krause was then a Bulls scout and Motta used to yell, "That's the guy who talked me out of Tiny Archibald" whenever he saw Krause, but Motta was in charge.

1980 Ronnie Lester

This pick came after he blew out his knee in the NCAA tournament. He probably would have been special but was never the same. The Bulls with the No. 4 pick took Kelvin Ransey and traded down, a Thorn specialty, to No. 10 for Lester and a future No. 1 the Bulls used the next season to trade up for Orlando Woolridge, who had a high scoring though troubled time in Chicago. He was let go for the draft pick the Bulls would use for Stacey King.

1982 Quintin Dailey

Some decent players went after him, such as Fat Lever, Sleepy Floyd, Paul Pressey and Ricky Pierce. But it was the public relations disaster of the era. Dailey had admitted to a rape in college and came to his opening news conference essentially unrepentant and then soon entered drug rehabilitation.

1983 Sidney Green, Ennis Whatley

You're getting the idea why things were so bad when Jordan came. Green had a competent career and was a solid pro, though they passed on Dale Ellis, Jeff Malone and Derek Harper. And then they traded Mark Olberding for the rights to Whatley, who joined the drug group quickly, and went one pick ahead of Clyde Drexler. Of course, Portland passed on Jordan in 1984 because they had Drexler.

2006 Tyrus Thomas

The Bulls had the No. 2 pick and used it to select LaMarcus Aldridge. But they traded Aldridge—and a 2007 second-round pick—to Portland for Tyrus Thomas (drafted by the Blazers at No. 4) and second-year forward Viktor Khryapa.

1977 The astronaut draft

Tate Armstrong in the first round, and in the second round Mike Glenn and Steve Sheppard. Armstrong barely played in two seasons and was out of the NBA. Right after him came Tree Rollins, Brad Davis and Rickey Green, and right before Glenn came Norm Nixon.

1976 Scott May

Picked No. 2 overall after John Lucas went No. 1 in a weak draft—though Adrian Dantley and Robert Parish were first-rounders and Alex English went in the second round.

2000 Marcus Fizer, Jamal Crawford, Dalibor Bagaric

To be fair, it wasn't a great draft with Kenyon Martin and Stromile Swift on top. But for the Bulls, this was to be the turnaround season from the championship conclusion. They traded Toni Kukoc for the No. 1 that was used for Chris Mihm in a swap for Crawford. The Bulls also had three second-round picks—Nos. 32, 33 and 34—and used them on A.J. Guyton, Jake Voskuhl and Khalid El-Amin.

1973 Kevin Kunnert

He was picked at No. 12, right before the Bullets took Illinois' Nick Weatherspoon. It was the midst of another bizarre draft with the Bulls set to grab Illinois State's Doug Collins in a trade with the 76ers for Cliff Ray and Bob Weiss. But Ray's surgery killed the deal and Kunnert never played for the Bulls.

1972 Ralph Simpson

Picked right before Julius Erving. The Bulls had problems outbidding the ABA as it was signing underclassmen (1974 pick Maurice Lucas and 1969 selection Larry Cannon) and the NBA was waiting, and the Bulls were being outbid for the top players.

THE

STARTING FIVES

There's no argument about who the best player in Bulls history is, but if you want to start a lively discussion, ask a Bulls fan to name an all-time starting five. In the franchise's 50-plus years, there have been dozens of great players who wore the red-white-and-black, including a fair share of Hall-of-Famers and All-Stars. Here are the top five players, as chosen by the Tribune, at each of the five positions. Let the arguments begin.

TOP 5 CENTERS

Artis Gilmore: After playing five seasons in the ABA, Gilmore joined the Bulls in 1976 and made the All-Star team four times in first six seasons in Chicago. "The A-Train" averaged 19.3 points and 11.1 rebounds as a Bull and is the team's all-time leader in blocked shots with 1,029. He also ranks first in career field-goal percentage with a .587 mark. Gilmore was inducted into the Hall of Fame in 2011.

Bill Cartwright: Acquired from the Knicks in a trade for the popular Charles Oakley in 1988, Cartwright quickly established himself as the low-post physical presence the Bulls had been missing. In his first season in Chicago, Cartwright made an immediate impact, averaging 12.4 points and 6.7 rebounds. He won three championships in his six seasons with the Bulls and later served as the team's head coach.

Tom Boerwinkle: A first-round pick in 1968, Boerwinkle became a key player on the outstanding Bulls teams of the mid-1970s. In 1969–70, he averaged a double-double with 10.4 points and 12.5 rebounds, then upped it to 10.8 and 13.8 in '70–'71. In the 1970 playoffs, Boerwinkle averaged 17.6 points and 14.4 rebounds and shot better than 50 percent from the field. His career average of 9.0 rebounds per game ranks 10th in team history.

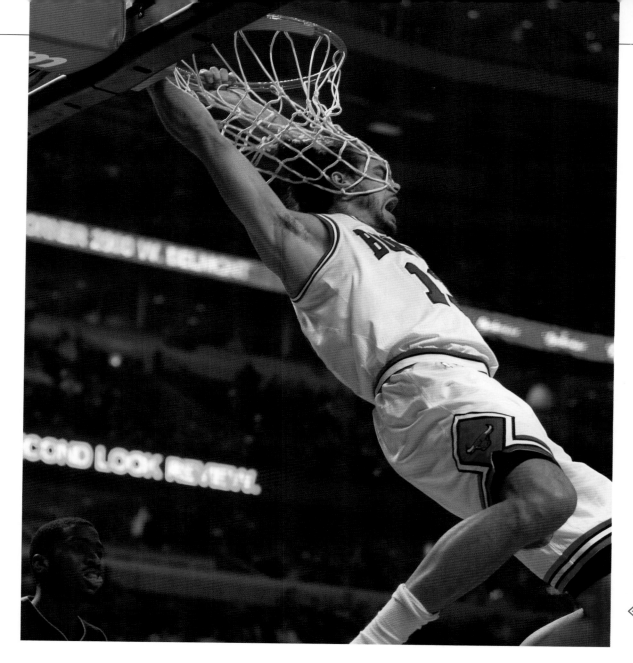

Joakim Noah is the team's all-time leader in offensive rebounds.

Joakim Noah: A two-time All-Star and the NBA's Defensive Player of the Year in 2013–14, Noah averaged a double-double in four of his nine seasons as a Bull. Noah has more offensive rebounds—1,910—than any player in team history and ranks fourth in overall rebounds with 5,387. He also ranks third in blocked shots, eighth in steals and ninth in games and minutes played.

Dave Corzine: Acquired in a 1982 trade with San Antonio, the former DePaul star played seven seasons with the Bulls and reached the playoffs five times. His best all-around season in Chicago was his first, 1982–83, when he averaged 14 points, 8.7 rebounds and 1.3 blocks per game. Corzine blocked 573 shots as a Bull, seventh-most in team history, and also ranks eighth in career offensive rebounds with 1,135.

TOP 5 POWER FORWARDS

Bob Love: Considered a "throw-in" piece in the 1968 trade that brought guard Bob Weiss from Milwaukee, Love became one of the greatest players in team history. Only Michael Jordan and Scottie Pippen scored more points for the Bulls. A three-time All-Star, Love averaged 21.3 points and 6.8 rebounds in nine seasons with the Bulls. He ranks eighth all-time in games played, sixth in minutes played, second in free throws made and 10th in total rebounds.

Horace Grant: In his seven seasons with the Bulls, Grant averaged 12.6 points and 8.6 rebounds and played a crucial role in the team's first three championships. Grant's 1,888 offensive rebounds in a Bulls uniform are second-most in team history and he ranks seventh in total rebounds with 4,721. He also ranks sixth in career steals and his field goal percentage of .529 places him third on the franchise leader board.

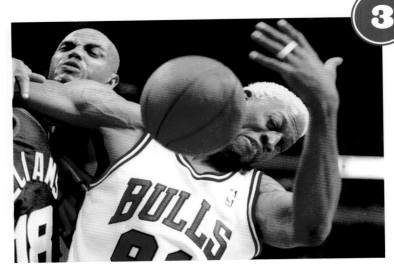

Dennis Rodman: A tenacious defender and one of the best pure rebounders ever to play the game, Rodman was critical to the Bulls' second three-peat. His 15.3 rebounds per game as a Bull are the most in franchise history. Rodman played just three seasons with the Bulls, but the team won a title in each of them. He was inducted into the Hall of Fame in 2011.

Charles Oakley: Acquired in a draft-day deal in 1985, Oakley was an imposing physical presence who played with an aggressive edge. In two of his first three seasons with the Bulls, he led the NBA in rebounds. As a Bull, he averaged 10.6 points and 10.6 rebounds per regular-season game, but 11.7 and 12.4 in 16 playoff games. Despite playing only four seasons in Chicago, Oakley's 2,195 defensive rebounds are ninth-best in team history.

Elton Brand: The first player chosen in the 1999 draft, Brand's stay in Chicago was short but spectacular. The 1999–2000 Rookie of the Year, Brand is one of only six players to average 10 or more rebounds per game as a Bull. He's also one of only six players to average 20 or more points while wearing the red, white and black.

TOP 5 SMALL FORWARDS

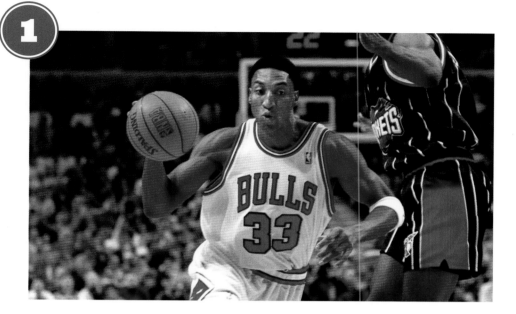

Scottie Pippen: With his athleticism, quickness and long reach, Pippen could defend almost any opponent at any position. He was often called a "point forward" because he could bring the ball up the floor and initiate the offense like a point guard. A seven-time All-Star and six-time NBA champion, Pippen also made the league's All-Defensive first team eight times. He was inducted into the Hall of Fame in 2010.

Chet Walker: Never the No. 1 star on any team he played for, Walker was a skilled and durable performer who could score and defend at a very high level. In each of his 13 NBA seasons, Walker's team made the playoffs, including his six years with the Bulls. He was named to four NBA All-Star teams as a Bull and was inducted into the Hall of Fame in 2012.

Luol Deng: Only three players in team history scored more points in a Bulls uniform than Deng. He ranks fifth on the team's all-time minutes-played list, fifth in steals, 10th in blocked shots, seventh in three-point field goals and ninth in total rebounds. In his 10 seasons with the Bulls, Deng made two All-Star teams. In the 2006–07 playoffs, Deng averaged 22.8 points and 8.7 rebounds in 10 games.

Toni Kukoc: A deft passer and clutch shooter, Kukoc was a key player on three Bulls championship teams. He won the Sixth Man of the Year award in 1995–96 when he averaged a career-high 18.2 points. Kukoc's 476 steals as a Bull rank ninth on the team's all-time leader board and his 1,840 assists rank 10th. In seven seasons with the Bulls, he averaged 14.1 points, 4.8 rebounds and 4.2 assists.

Orlando Woolridge: A first-round pick in 1981, Woolridge played the first five seasons of his career with the Bulls. His best was 1984–85, when he averaged 22.9 points and 5.6 rebounds. Woolridge appeared in only seven playoff games as a Bull, but he maintained his offensive productivity in that small postseason sample size, averaging 20.7 points. His .532 field-goal percentage as a Bull ranks second on the team's all-time leader board.

TOP 5 SHOOTING GUARDS

Michael Jordan: Unquestionably the greatest Bull and perhaps the greatest player of all time, Jordan's accomplishments speak for themselves: Six-time NBA champion, five-time NBA MVP, six-time NBA Finals MVP, Rookie of the Year (1985), 14-time All-Star, Defensive Player of the Year (1988) and nine-time All-Defensive First Team. Jordan is the Bulls' all-time leader in points, rebounds, assists and steals. He was inducted into the Hall of Fame in 2009.

Jerry Sloan: One of the original Bulls from the team's debut season, Sloan was a hard-nosed defender and underrated offensive player. In his 10 seasons with the Bulls, Sloan averaged 14.7 points, 7.7 rebounds and 2.2 steals. He ranks fourth in team history in games played and fifth in total points. Sloan also served one season as a Bulls assistant coach and two-plus seasons as head coach.

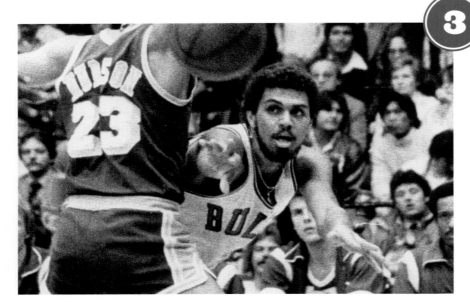

3

Reggie Theus: A fan favorite known as much for his style as his substance, the numbers show that Theus was a potent and productive player. A two-time All-Star, Theus never missed a game during his five-plus seasons as a Bull. He ranks sixth on the team's all-time leader board in assists, seventh in steals and ninth all-time in total points scored and points per game.

Ben Gordon: The third overall pick in the 2004 draft, Gordon was one of the "Baby Bulls" who helped bring the team back to prominence in the mid- to late-2000s. He was named the NBA's Sixth Man of the Year as a rookie, when he averaged 15.1 points off the bench. In his five seasons as a Bull, Gordon averaged 18.5 points in the regular season and 20.2 points in 29 playoff games.

Jimmy Butler: The last player chosen in the first round of the 2011 draft, Butler quickly developed into one of the game's best two-way players. A two-time NBA All-Star, Butler first earned his minutes as a defender before having a breakout season in 2014–15, when he averaged 20 points per game. He followed that by averaging 22.9 points and a league-best 2.4 steals per game in the playoffs.

TOP 5 POINT GUARDS

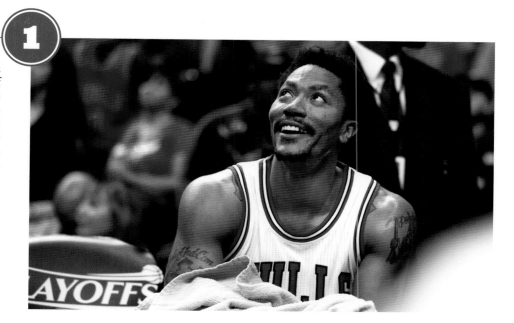

Derrick Rose: The first player chosen in the 2008 draft, Rose won the Rookie of the Year award by averaging 16.8 points and 6.3 assists in his debut season. The native Chicagoan became the only Bull other than Michael Jordan to win an MVP in 2010–11 when he averaged 25 points and 7.7 assists. He ranks fifth in franchise history in assists, 10th in total points and seventh in points per game.

Norm Van Lier: "Stormin' Norman" personified the gritty Bulls teams of the 1970s. He and Jerry Sloan formed one of the most fearsome backcourts in NBA history, both of them determined defenders who could contribute on offense. Van Lier played six-plus seasons with the Bulls, earning All-Star honors in three of them, and averaged 12.2 points and 6.9 assists. He later excelled as an outspoken analyst on the team's TV broadcasts.

John Paxson: A member of three championship teams, Paxson is best remembered for hitting a crucial three-point shot in the decisive Game 6 of the 1993 NBA Finals. Paxson ranks seventh on the team's all-time leader board in assists and 10th in steals. After retiring as a player, he later served as an assistant coach and TV analyst for the team before moving into the front office as an executive.

Kirk Hinrich: A first-round pick in the 2003 draft, Hinrich played two stints with the Bulls covering 11 seasons. "Captain Kirk" ranks third all-time in games played for the franchise and eighth in total points scored. He averaged six or more assists in each of his first five seasons with the team. Hinrich is the Bulls' all-time leader in three-point field goals with 1,049 and ranks third in steals and assists.

Guy Rodgers: Rodgers' Bulls career was brief but brilliant. The go-to player on the inaugural Bulls team, he led the NBA in assists in his debut season in Chicago. Rodgers averaged 17.6 points and 11 assists in 85 games as a Bull before being traded to Cincinnati in 1967. He was inducted into the Hall of Fame in 2014.

TEXT CREDITS

PHOTO CREDITS

Page iv-v: Bob Langer, Chicago Tribune
Page vi: Chicago Tribune
Page 2: George Carlson, Chicago Tribune
Page 4: Chicago Tribune
Page 11: Chicago Tribune
Page 14: Chicago Tribune
Page 16: Chicago Tribune
Page 17: Chicago Tribune
Page 18: Chicago Tribune
Page 20: Chicago Tribune
Page 22: Howard Borvig, Chicago American (Chicago Tribune)
Page 24: Chicago Tribune
Page 25: Chicago Tribune
Page 26: Chicago Tribune
Page 27: Chicago Tribune
Page 28: Chicago Tribune
Page 30: Chicago Tribune
Page 32: Phil Mascione, Chicago Tribune
Page 36: Chicago Tribune
Page 37: Chicago Tribune
Page 38-39: Ed Wagner, Jr., Chicago Tribune
Page 40: Ed Feeney, Chicago Tribune
Page 43: Ray Gora, Chicago Tribune
Page 44: Chicago Tribune
Page 45: Ray Gora, Chicago Tribune
Page 46: Ray Gora, Chicago Tribune
Page 48: Ed Wagner, Jr., Chicago Tribune
Page 49: Ed Wagner, Jr., Chicago Tribune
Page 50: Phil Mascione, Chicago Tribune
Page 51, top: Ed Feeney, Chicago Tribune
Page 51, bottom: Ray Gora, Chicago Tribune
Page 52: Chicago Tribune
Page 54: Phil Mascione, Chicago Tribune
Page 58: Chicago Tribune
Page 61: Walter Neal, Chicago Tribune
Page 62: Ray Gora, Chicago Tribune
Page 63, left: Chicago Tribune
Page 63, right: Walter Neal, Chicago Tribune
Page 65: Ed Wagner, Jr., Chicago Tribune
Page 67: Ed Wagner, Jr., Chicago Tribune
Page 68: Phil Mascione, Chicago Tribune
Page 71: Phil Mascione, Chicago Tribune
Page 74: Chicago Tribune
Page 77: Walter Neal, Chicago Tribune
Page 78: Phil Mascione, Chicago Tribune
Page 80: Bob Langer, Chicago Tribune
Page 84: Walter Neal, Chicago Tribune
Page 87: Dave Nystrom, Chicago Tribune
Page 88-89: Phil Mascione, Chicago Tribune
Page 91, top: Jose More, Chicago Tribune
Page 91, bottom: Bog Hogan, Chicago Tribune

Page 93: Phil Mascione, Chicago Tribune
Page 94: Chris Walker, Chicago Tribune
Page 96: Ron Bailey, Chicago Tribune
Page 98: Bob Langer, Chicago Tribune
Page 99: Bob Langer, Chicago Tribune
Page 103: Phil Mascione, Chicago Tribune
Page 104: Ed Wagner, Jr., Chicago Tribune
Page 105: Charles Cherney, Chicago Tribune
Page 109: Bob Langer, Chicago Tribune
Page 110: Charles Cherney, Chicago Tribune
Page 111: John Kuntz, Chicago Tribune
Page 112: Ed Wagner, Jr., Chicago Tribune
Page 113, both: Ed Wagner, Jr., Chicago Tribune
Page 114-115: Charles Cherney, Chicago Tribune
Page 116: Charles Cherney, Chicago Tribune
Page 118: Chris Walker, Chicago Tribune
Page 120: Bob Langer, Chicago Tribune
Page 123: Abel Uribe, Chicago Tribune
Page 126: Nuccio DiNuzzo, Chicago Tribune
Page 133: Chicago Tribune
Page 134: Chicago Tribune
Page 135: Milbert Orlando Brown, Chicago Tribune
Page 136: Michael Meinhardt, Chicago Tribune
Page 138: Chicago Tribune
Page 139: Bob Langer, Chicago Tribune
Page 142, both: Charles Cherney, Chicago Tribune
Page 144: Ed Wagner, Jr., Chicago Tribune
Page 145: Chicago Tribune
Page 146: Chicago Tribune
Page 148: Phil Velasquez, Chicago Tribune
Page 149: Chicago Tribune
Page 150-151: Bill Smith, Chicago Tribune
Page 153: John Kringas, Chicago Tribune
Page 154: Jim Prisching, Chicago Tribune
Page 155: Charles Cherney, Chicago Tribune
Page 156: Michael Meinhardt, Chicago Tribune
Page 157: Jim Prisching, Chicago Tribune
Page 158: Michael Meinhardt, Chicago Tribune
Page 161: Chuck Berman, Chicago Tribune
Page 165: Michael Fryer, Chicago Tribune
Page 166: Chicago Tribune
Page 167, both: Carl Wagner, Chicago Tribune
Page 168: Jim Prisching, Chicago Tribune
Page 170: Jim Prisching, Chicago Tribune
Page 172: Chicago Tribune
Page 173: Nuccio DiNuzzo, Chicago Tribune
Page 174, both: Jim Prisching, Chicago Tribune
Page 175: Nuccio DiNuzzo, Chicago Tribune
Page 176: Jose More, Chicago Tribune
Page 177: Chicago Tribune
Page 179: Charles Cherney, Chicago Tribune

INDEX

Note: Italic page numbers indicate photographs.